Introduction to Video Production
Studio, Field, and Beyond

Ronald J. Compesi
San Francisco State University

Jaime S. Gomez
Eastern Connecticut State University

PEARSON

Boston • New York • San Francisco
Mexico City • Montreal • Toronto • London • Madrid • Munich • Paris
Hong Kong • Singapore • Tokyo • Cape Town • Sydney

Series Editor: Molly Taylor
Editorial Assistant: Suzanne Stradley
Composition Buyer: Linda Cox
Manufacturing Buyer: JoAnne Sweeney
Production Editor: Patrick Cash-Peterson
Editorial–Production Service: Susan McNally
Text Design and Electronic Composition: Denise Hoffman

Library of Congress Cataloging-in-Publication Data

Compesi, Ronald J.
 Introduction to video production / Ronald J. Compesi, Jaime S. Gomez.
 p. cm.
 Includes bibliographical references and index.
 ISBN 0-205-36107-2
1. Video recordings--Production and direction. I. Gomez, Jaime S.
II. Title.
 PN1992.94.C65 2004
 84.55'8—dc23

 2005051536

Printed in the United States of America.

10 9 8 7 6 5 4 3 2 1 10 09 08 07 06 05

CONTENTS

CHAPTER 4

The Video Camera 57

CHAPTER 5

Audio and
Sound Control 95

CHAPTER 6

The Video Switcher 127

CHAPTER 7

The Role of the Producer 143

CHAPTER 8

Directing: Part 1 173

CHAPTER 9

Directing: Part 2 193

CHAPTER 10

Video Recording and Editing 221

CHAPTER 11

Video Editing Techniques 255

CHAPTER 12

Graphics and Set Design 277

CHAPTER 13

Video on the Web 293

CHAPTER 14

Anatomy of Production: Two Case Studies 309

PREFACE

Video production has become one of the most important tools of communication and self-expression in contemporary culture. Once the exclusive province of broadcast stations and networks, video production technologies are now found in a variety of other environments as well, including educational institutions, government agencies, corporate environments and individual homes.

Whether one is focused on producing video content for distribution on a broadcast station or a cable network or for one's own personal use, the basic techniques of production remain remarkably similar. Today's video producer has the challenge of keeping up with the rapid changes inherent in digital technology, adapting to working in settings that may require a high capacity for independent work, and making decisions that require critical analysis and creative problem solving skills.

Introduction to Video Production is presented as a basic textbook for students (at the university/college, community college, and upper-division high school levels) who want to learn the fundamental principles of video production and the technologies that are used in video production. The book covers the three principal areas in which video production takes place—studio production, field production, and postproduction—and is organized around the principal elements of the production process: preproduction, production, and postproduction.

Outstanding Features

1. A focus on the fundamental technologies (equipment hardware and software) used to produce video programs.

2. A thorough treatment of the principal production environments in which video is produced: the studio environment, the field environment, and the postproduction environment.

3. A fusion of aesthetic and technical concerns. The book discusses production strategies and processes as well as principles of equipment operation.

4. A full discussion of the three principal stages of video production: pre-production, production, and postproduction.

5. A detailed description of the most important issues related to the production and distribution of video via the Internet.

6. The book is thoroughly illustrated with line art, photographs, and color plates illustrating key concepts of visual production as well as production equipment and environments.

7. Key words are identified in boldface throughout the text. The book contains a comprehensive glossary of terms and a bibliography of books of interest to the video producer.

Video production has entered a new era. The advent of new digital technologies has drastically altered the video production environment. However, even though these new technologies have brought about a profound transformation in production settings and methods, many of the basic principles and production values that have made television a part of our lives for the past fifty years still persist.

Pedagogical and Didactic Concerns

We understand the need for active, hands-on, student-centered learning as a very valuable method to build strong video production skills. However, we also advocate the need for students to grasp a deep understanding of the theory behind the practice as a means to achieve a high level of production skills by incorporating conceptual frameworks that can be applied to most production environments or that can be adapted to most practical production situations. Furthermore, this book provides the theoretical foundation that will prepare students for the difficult task of learning how to learn: to periodically update their knowledge base on their own.

For this purpose we have developed many production models that will clarify technical principles, facilitate understanding of conceptual frameworks, and guide students through the complex process of video production from theory to good practice.

Acknowledgments

We owe a great debt of gratitude to the many people who have contributed to the making of this book. Our colleagues in the Broadcast and Electronic Communication Arts Department at San Francisco State University and the Communication Department at Eastern Connecticut State University have provided invaluable assistance.

At San Francisco State University we would like to thank Dean Keith Morrison for his encouragement and support; BECA Department Chair Phil Kipper; and faculty colleagues Larry Whitney, Lena Zhang, Jerry Barnaby, John Hewitt, Vinay Shrivastava, Chul Heo, Marty Gonzalez, John Barsotti, and Herb Zettl for their lively conversations on matters of production practice and aesthetics. Winton Tharp and Steve Lahey deserve special thanks for the guidance they provided on technical matters. Thanks also to Adam Vadnais, Alvina Cheah, C. J. Hunt, Rada Ivanov, Rui Zhang, Chul Heo, Brandi Brandes, and Mary Ford for their assistance with the production of a number of the photographs and illustrations used in the text.

At Eastern Connecticut State University we extend deep appreciation to Dean Patricia Kleine for her encouragement and support; to Communication Department Chair Donald Avery for his unwavering support of this project; to Edmond Chibeau for his generous offering of time and script materials; to John Zatowski, who shared his audio and broadcast expertise with us; to Denise Matthews for sharing her vision of teamwork and production planning; and to Andrew Utterback for his constant exchange of ideas. The Media Services Department team was particularly helpful, especially its director Nicholas Messina, who provided graphics and equipment setups for photographs, among other things. Paul Melmer, ECSU video engineer, and Craig Naumec, multimedia specialist, were especially valuable for this task. Thanks also to Juan Andrés Rodriguez, Lisa Simlick, Aaron Schultz, Monica O'Connor, and Keegan Stiles. Thanks also to students Sheena Williams and Jonathan Duvall, who served as models for photographs in the studio and in the field.

We are also indebted to those individuals who offered us the opportunity to visit their facilities and to be exposed to production processes and state-of-the-art-production facilities. Among them we particularly note Anthony Valentino, Manager for Technical Recruitment at ESPN in Bristol, Connecticut; Harold Kramer, Vice President for Strategic Planning and New Technology at Connecticut Public Television & Radio; and Jim Burke, Tim Visiglio, and Evan Bernstein of HB Communications.

We would also like to thank Robert Barnshaw and Alice Palmer (Avid Technology, Inc.), Joyce Fowler (Adobe Systems, Inc.), Nick Schiller and Kelsey Linnett (Digidesign), Jim Wickizer (Panasonic Broadcast & TV Systems, Company), and Carol Posnack (The Tiffen Company—Steadicam) for their assistance in providing photographs of production hardware and software interfaces. In addition, we thank Ivan Barrios, Programming Director, and Ramiro Franco, Production Supervisor, both of Telecaribe, the Colombian Caribbean Region Television. Thanks also to Edgardo "Nicky" Rodriguez, an expert in digital video compositing, who provided a wealth of information on graphics and digital video compression.

Special thanks to all of our students whose constant inquiry and motivation drive our quest for academic excellence and video production expertise.

Thanks also to those individuals who read earlier drafts of the manuscript and whose comments made it a better book, in particular to Tom Shaker, Dean College; John Schmit, Grand Valley State University; Joelle E. Meehan, Lynn University; William F. Burns, Brookdale Community College; Craig Crowe, University of Houston; LuEtt Hanson, Kent State University; C. Rod Metts, California State University, San Bernardino; and Julian Williams, University of Florida.

We would like to thank our editor, Molly Taylor, and Editorial Assistant Michael Kish for their oversight of this project and the members of the design and production team at Allyn and Bacon for their enthusiasm and attention to detail: production editor Patrick Cash-Peterson, production coordinator Susan McNally, copyeditor Barbara Willette, and text designer Denise Hoffman.

Finally, we are indebted to our families, who have been very supportive and encouraging: thanks to Sofia, whose technical skills were key for the design of models and diagrams, Jaime Jr., and Vanessa, and to Cathy, Cara, and Marisa.

Ronald J. Compesi

Jaime S. Gomez

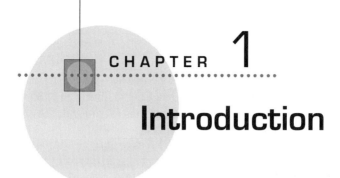

CHAPTER 1

Introduction

FADE IN:
Exterior Local Television Station

It is 7:00 A.M. There is not much traffic on the street. Viewed from the outside, the building is rather unremarkable. It is a largely windowless structure surrounded by a number of equally unremarkable warehouse buildings. Only the cluster of satellite dishes in front gives any indication that there is something special about this building. (See Figure 1.1.)

CUT TO:
Interior Television Control Room

A half dozen people sit in the relative darkness of the control room. In front of them is a bank of several dozen video monitors. Some display the broadcast images from the other local stations; others contain monitors for the

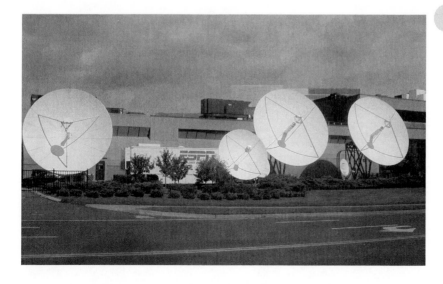

FIGURE 1.1
Exterior of a TV
Production Facility

feeds from various microwave and satellite sources that are being beamed to the station. (See Figure 1.2.)

In the center of the activity is the director, who is rapidly calling out commands to the members of his technical crew: camera operators, graphics specialists, and sound engineers. On the floor of the television studio is an elaborate set. The main news desk has room for the two principal news

FIGURE 1.2

Television Control Room

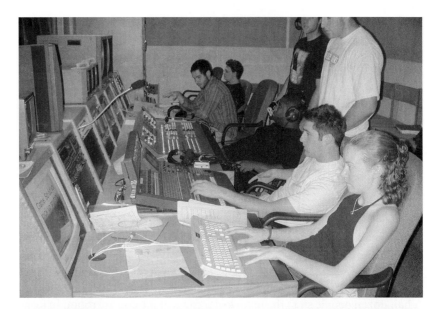

anchors who host this extremely popular morning program. At the other end of the set is an interview area, where the mayor of the city is about to be interviewed. At the far end of the studio is a green wall that serves as the backdrop for the weather reports. The director calmly calls commands for everyone to get ready; the program title sequence, which is stored on a video server elsewhere in the building, is cued and started, and two hours of live television have now begun to be broadcast from the studio.

CUT TO:
Exterior of State Capitol Building

A small van with the distinctive logo of the statewide public television network is parked outside the capitol building. A long antenna telescopes from the roof of the van. At the tip of the antenna a small dish points toward a receiving dish on the side of the main television transmission tower that serves the city. A reporter is getting ready to do a live shot on the status of the state budget hearings. A single cameraperson stands ready with a camera mounted on a tripod, framing the shot so that the reporter is visible in the foreground and the capitol building appears slightly out of focus in the background. In a minute or two the reporter's live report will be broadcast on the state public television network.

CUT TO:
Exterior of the Little Blue Whale Swim School—
Establishing Shot

DISSOLVE TO:
Interior Shot of Swim Lesson in Progress
at the Swimming Pool

Ten children are huddled in the water at the side of the pool. The swim instructor is standing on the pool deck. She is holding a large pole that is equipped with a series of remote control devices on the handle. At the end of the pole is a small video camera surrounded by a waterproof housing. As the first child begins to swim the length of the pool, the instructor walks quickly along the side of the pool, capturing an image of the swimming child on videotape. When all ten children have had their swimming strokes recorded, the instructor reviews the tape with them to point out elements of their stroke that work well and elements that need improvement.

CUT TO:
Exterior of a House on a Tree-Lined
Suburban Street

DISSOLVE TO:

Interior Shot of a Room. A Small Desk Holds a Personal Computer, Two Audio Speakers, a Videocassette Record/Playback Machine, and a Standard Television Monitor.

The computer is being used to edit video footage of a wedding. The editor deftly selects and trims picture clips, drags them into the program's time-line, and then adds video transitions and background music. In a few hours she has assembled a chronological account of her client's wedding, which she then burns to a DVD before delivering the final product to her client. (See Figure 1.3.)

The Expanding Universe of Video Production

Video production has become one of the most important tools of communication and self-expression in contemporary culture. Once the exclusive province of broadcast stations and networks, video production technologies are now found in a variety of environments, including educational institutions, government agencies, corporate environments, and individual homes.

The four examples of television and video production that were described above barely begin to give you an idea of the variety of ways in which television and video are put to use on a daily basis. Just thirty years

FIGURE 1.3
Home Video
Producer

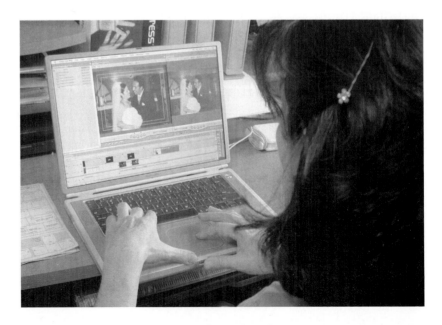

ago broadcast television was the only game in town for individuals who were interested in producing and distributing video material. Today, broadcast television is complemented by cable and satellite distribution of news and entertainment programming. Specialized applications of video production are found in a variety of industries and professions, such as medical television and legal video. And with the development of cost-effective digital cameras and video-editing software designed to run on personal computers, home video production has become extremely popular.

Whether one is focused on producing video content for distribution on a broadcast station or a cable network or for one's own personal use, the basic techniques of production remain remarkably similar. This book has been written for students who want to learn the fundamental principles of video production and the technologies that are used in production. The book will cover the two principal areas in which video production takes place: studio production and field production (location production outside of a video studio) and will discuss the integration of computer-assisted production technologies as well. In addition, we will discuss single-camera production and multicamera production, the two principal production techniques or strategies that are used in both studio and field production environments, as well as the principal elements of the production process: preproduction, production, and postproduction.

Television and Video: What's the Difference?

> "Television? The word is half-Latin and half-Greek.
> No good can come of it."
>
> —Anonymous

Two terms are used to describe the technologies and production processes with which this book concerns itself: *television* and *video*. *Television* is the more traditional term. As the anonymous quote above indicates, it is derived from *tele* (the Greek root that means "at a distance") and *videre* (the Latin verb that literally means "to see.") Taken together, the word **television** means to see at a distance. In the traditional sense, television is used to refer to television stations and networks as a locus of production as well as a means of distribution for programs.

In a technical sense, **video** refers to the picture part of a television signal (don't forget that television includes the sound or audio component as well). However, the term *video* has taken on a meaning that is broader than either the narrow technical definition of the word or, for that matter, the term *television* itself. Any image that is electronically recorded by a video camera and displayed on a television or video screen can be classified as

video, whether or not it is broadcast. Perhaps that is one reason that we use the term *home video* and not *home television* to describe video recording that is made for personal use. All broadcast television is in part video; but not all video is destined to be broadcast television.

The term *video* has been incorporated into the lexicon of multimedia producers as well. Individuals who are producing programs that are meant to be distributed over the Internet or viewed on a home computer via its CD or DVD drive frequently incorporate video (as well as text and sound) into their multimedia presentations.

Principal Elements Involved in Video Production

■ Technical and Aesthetic Elements

To be successful, television and video producers must have a basic understanding of the equipment that they work with (**technical elements** of production) as well as an understanding of how the manipulation of production elements such as lighting, sound, and editing (**aesthetic elements** of production) shape the meaning of the programs they produce. In addition, they recognize that a successful production is built step by step through a precise planning process.

Because video production is technology-dependent, if you are going to produce video projects, you need to know a little bit about how the equipment works. This does not mean that you need to be an electrical engineer and understand all of the electronic and physical principles that govern the operation of the equipment. What it does mean is that you must have an understanding of how the various components of the video production system interrelate. You need to know what the equipment you are working with can and cannot do—in other words, you need to know the potentials and limitations of the equipment you have at your disposal. No matter how extravagant a production may be, producers seldom have access to unlimited budget and facilities. So one of the first important lessons of video production is learning how to work within limits to complete a production on deadline and within the allocated budget.

Video producers also must understand how to manipulate the basic production elements they have at their disposal. Picture composition, sound, editing, and graphic design are some of the basic aesthetic elements of video production. Most professional producers have access to a similar set of production tools; what distinguishes one production from another is the unique way in which these production elements have been put to use in a particular program. Student and independent video producers typically do not have access to the high-end professional-quality equipment favored by broadcasters and television networks. However, with creativity and an

understanding of the limits and potential of the equipment at hand, non-broadcast producers often produce effective programs that rival those of their professional counterparts in terms of creativity and effectiveness, even if the technical quality is somewhat lower.

Finally, video production involves teams of individuals working together to achieve a common production goal. Recognizing the importance of the human element of the production process is a key characteristic of successful television and video producers.

■ Planning, Interpersonal Communication, and Teamwork

While the novice producer may think that learning the technology of production poses the greatest challenge, in reality the biggest problems in production may well be the need for thorough planning and organization and for dealing with people. Video production is a complex, team-oriented activity. (See Figure 1.4.) In the high-pressure, deadline-driven world of video production, thorough planning, good communication, and teamwork are three of the principal keys to success. Producers and directors need to motivate production crew members to do their best work; production crew members need to be positive contributors to the production at hand. And everyone needs to communicate with the other members of the production team.

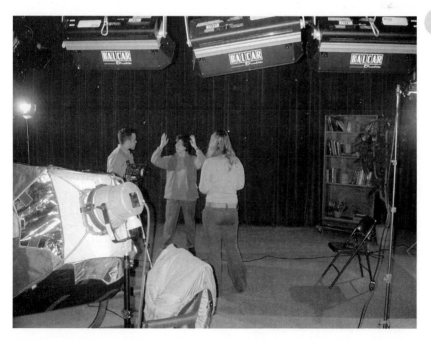

FIGURE 1.4
Video Production
Depends on
Teamwork and
Production Planning

The organizational and teamwork skills that are needed to guarantee successful productions are in high demand by production employers. The student who has developed organizational and planning skills as well as production skills often has a competitive edge when hiring decisions are made.

■ Creative Problem Solving

Video production, whether accomplished in a studio setting or in a field location, demands that a complex set of logistical and technical problems be efficiently solved for the production to be a success. Ultimately, everyone involved in video production is engaged in *creative problem solving.* Communication via video means that the producer/writer/director must understand the medium and how to use it. Finding the appropriate techniques to effectively express the idea and content of a program presents problems that must be solved creatively.

Development, Production, and Distribution

■ Television Is a Producer's Medium

Although every member of the production team who is involved in the completion of a video project is important, the principal responsibility for the control and completion of a project falls to the producer. For this reason, television is often referred to as a producer's medium. The **producer** (or executive producer of a large-scale project) is responsible for developing the program idea and then hiring the production crew to execute the production. The producer typically has responsibility for overseeing the budget of the production as well and making sure that the project is completed within budget and on time.

■ Development

All video productions go through a process that involves development, production, and distribution. The **development** phase of a project precedes any actual production activity. This is the phase in which the production idea is developed. Many dramatic television programs are developed from novels or from events that have actually taken place. In either case, during the development period a producer obtains the rights to the story (by negotiating either with the author and publishers of the novel or with the individuals involved in the real-life events the program will be based on) and then begins to develop a script for the program or an outline for the series. Once the initial development of the program or series is complete, it can then move into production.

■ The Three Stages of Production (The Three Ps)

All productions can be broken down into three stages: preproduction, production, and postproduction.

● **PREPRODUCTION** This stage of production describes the period of time after the initial development and approval of the program idea and before the actual production of the program begins. During **preproduction,** all of the logistical issues related to the production must be solved. The producer has responsibility for organizing the production and the production crew. Thorough preproduction is necessary to ensure that the production and postproduction phases are completed smoothly. Because of the great amount of detail involved in organizing a production, the program preproduction phase typically takes more time than either production or postproduction.

● **PRODUCTION** During **production** the program is actually produced. If the program is "live," the production phase is relatively short, extending over the time of the live broadcast and a short period afterward. Many programs are produced with postproduction editing in mind. Programs that are recorded to be edited later typically take longer to produce than live projects. Shooting may extend over days or weeks, depending on the length of the project.

● **POSTPRODUCTION** During the **postproduction** phase the program is edited. (See Figure 1.5.) For short projects such as news or feature stories that are a couple of minutes in length, postproduction editing may be

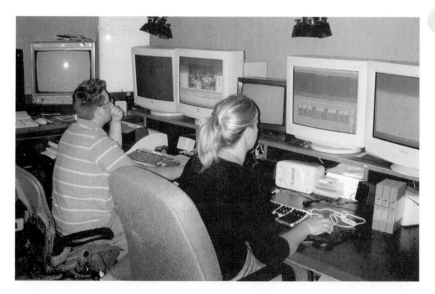

FIGURE 1.5
Postproduction
Editing

completed in a matter of hours. For longer-form programs such as documentaries and dramas, editing may extend over a period of weeks. And for feature-length projects such as made-for-TV movies, editing can take several months.

■ Distribution

The final phase of any project is the **distribution** phase. For projects that are completed as a course assignment in a college or university production class, distribution may be as simple as viewing the final project on the last day of class. For a program that is produced in the context of a local television station, distribution may be limited to a live broadcast of the program, with or without additional repeat broadcasts. For a corporate training video, distribution may mean that the program is made available on a video server to be accessed by employees via their desktop computers, connected to the central server via a local Intranet. Or your video may be designed and produced for distribution to a worldwide audience via a website. The production considerations for video that is meant to be distributed via the web are somewhat different than video that is meant to be broadcast, cablecast, or shown directly on a video monitor. These production and distribution concerns are the focus of Chapter 13, "Video on the Web."

As different as these examples are, the ultimate goal of any production is to reach a specified audience and to effect them in some way. In the following chapters we will take you step by step through the process of video production.

CHAPTER 2

Video Production Environments

Video production takes place in two different environments: in a **television/ video studio** that is specifically designed to accommodate the various technical needs for production or on location in the field. In either environment productions can be accomplished with a single camera or with multiple cameras. Many live productions (e.g., news and sports) feature multicamera production setups in either studio or remote locations. Single-camera production is often favored when postproduction editing is a part of the production process: on-location news productions, documentaries, and music videos are typical of this production style. Because it is such an important part of the process of production, the postproduction editing environment will be discussed as well.

The Video Studio Environment

The video studio environment comprises three principal areas: the video studio itself, the control room, and other production support areas.

■ The Video Studio

The video studio is a controlled environment designed specifically to accommodate the needs of television and video production. The concept of *control* is central to the notion of video production. For a production to be successful, the producer and his or her crew must take control of a variety of technical elements, such as lighting, sound, and electrical power, in addition to controlling the aspects of the performance that are central to the

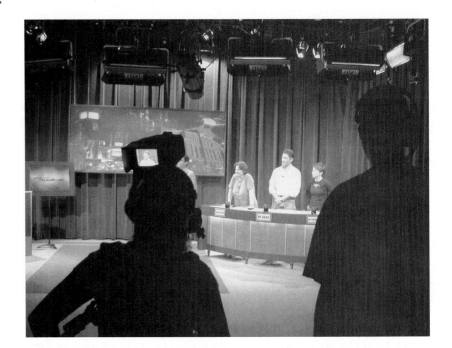

FIGURE 2.1
Video Studio

production. The video studio provides such a controlled environment. (See Figure 2.1.)

Typically, the video studio is a rather large space with a smooth floor to allow for camera movement. The ceilings are high to support lighting instruments, which are mounted above the action areas and out of the field of view of the cameras. The lighting system is supplied with sufficient electrical power for the lighting instruments that are in place. The walls of the studio contain material that provides sound insulation from outside noise and deadens the sound within the studio as well. Connections for microphones may be strategically placed around the perimeter of the studio.

One or more **cycloramas** encircle the studio walls, serving as a backdrop for the action. Cycloramas (abbreviated as *cyc*) may be made out of soft material (e.g., fabric curtains) or they may be constructed as hard walls. Typical cyclorama colors are black, beige, and blue or green. Black backdrops seem to disappear on camera and create the illusion of vast space behind the action. Beige backdrops can be illuminated with colored lights to create a particular mood. Blue or green backdrops are used for chroma key special effects: the action is shot against the blue or green wall or curtain. The backdrop is eliminated from the picture electronically, and new background information is supplied to create a particular effect. This technique is widely used in news production to insert weather map infor-

mation behind the weathercaster. It is also used in special effects production to provide dramatic backdrops to the foreground action.

Sometimes the cyclorama encircling the studio is made out of a hard wall material rather than cloth. Lighting can be controlled more precisely on a **hard cyc** because, unlike curtains, there are no wrinkles or folds to contend with.

Studios can accommodate one or more cameras. Many studios are used for **multicamera production.** For the typical newscast, three cameras are operated simultaneously to provide a variety of views of the action. Soap operas, discussion programs, and game shows are produced in this style as well.

■ The Production Control Room

The production control room is separate from the video studio space. (See Figure 2.2.) In some facilities, where the control room is adjacent to the studio, there may be a wall of windows between the control room and the studio to allow direct line of sight into the studio. But in many facilities the control room is physically separate from the studio, and the only way to see the action in the studio is to view the images produced by the cameras in the studio on the monitors in the control room.

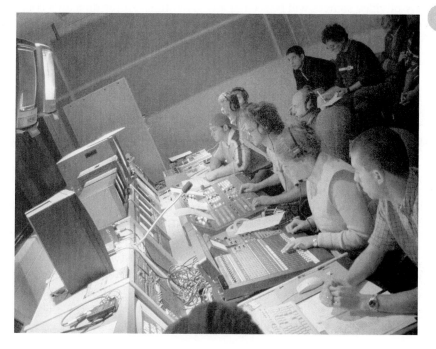

FIGURE 2.2
Production Control
Room with Switcher
and Audio Board

● **VIDEO MONITORS** The camera monitors are organized into a display that can easily be viewed by the production personnel in the control room. Each camera is assigned a monitor that shows the image the camera is producing. There will also be video monitors for the graphics generator, special effects generator, videotape players, and any other remote feeds into the control room. In addition there will be monitors labeled "program" and "preview." The **program monitor** shows the image that is being broadcast or recorded; the **preview monitor** allows the production personnel to set up special effects and view them before they go out on-line as part of the program feed.

● **VIDEO SHADING/CAMERA CONTROL** When multiple cameras are operating simultaneously in the studio, it is important that the quality of the image that is produced by each camera looks the same as the images produced by all of the other cameras. Each studio camera has a **camera control unit (CCU)** that contains controls that are used to adjust the picture and color quality of the camera. This process is called *camera shading,* and it is the responsibility of the video engineer.

● **VIDEO SWITCHER** Every video component that is capable of producing an image is routed through the video switcher: camera, videotape players, graphics generators, and so on. The **video switcher** is an electronic device that allows the technical director to select which one of a variety of video sources will be seen at any given time. At the director's command, the technical director punches the button that corresponds to the command (e.g., "Take camera 1"), and the image that is produced by the source is then broadcast live or sent to the videotape recorder that is recording what is being produced.

● **AUDIO BOARD** The **audio board,** also called the *audio mixer,* is similar to the video switcher in that it is used to control the various audio sources used in the program. Microphones, CDs, audio from videotapes, and all other audio sources are routed through the audio board, where the audio engineer controls their level and sound quality and mixes them together as the production progresses.

● **CHARACTER GENERATOR/GRAPHICS** In live studio production, graphic information is added to the program in real time. Program titles and name identifications are generated by a **character generator (CG),** essentially a small computer that produces electronic lettering. The output of the CG is routed through the video switcher, where it is combined with the background camera information to provide a composite image of lettering over the background image.

● **LIGHTING BOARD** The studio may contain dozens or even hundreds of lighting instruments. Each of the lighting instruments is controlled by a **lighting board,** which may be installed in the control room or on the studio floor. The lighting director can control the intensity of each instrument by manipulating the individual dimmer assigned to the instrument.

● **RECORD AND PLAYBACK VCRS** A series of record and playback **videocassette recorders (VCRs)** may be located in the control room as well. (See Figure 2.3.) The playback VCR is used to insert previously recorded material into the program in real time. For example, during a newscast, the playback VCR supplies the previously recorded news stories at the appropriate time. The **record VCR** is used to record the program output of the video switcher. In small studio operations the record and playback VCRs are located in the production control room. In larger facilities they may be located in a separate master control or tape operations area.

In many of the most modern production facilities tapeless digital recording systems are replacing tape-based VCRs for video and audio playback and recording. These high-capacity video servers are typically located in a separate area away from the production control room but can be accessed remotely from anywhere in the production facility.

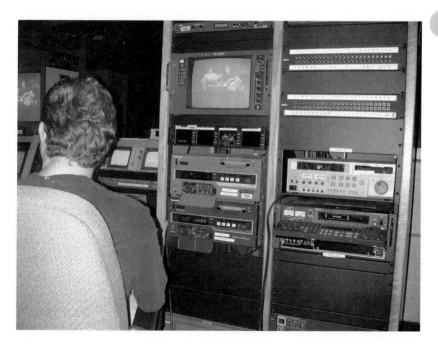

FIGURE 2.3
Record and
Playback VCRs
with Patch Panel

● **PRODUCTION CREW COMMUNICATION SYSTEMS** During a production the television director communicates with the other members of the production crew through a headset communication system called **private line (PL)** communication. Each member of the studio and control room production crew wears a headset that is equipped with a small microphone, but only the director's headset microphone is continuously turned on. Other members of the crew can activate their microphones to talk, but only if the situation seriously warrants it. For the director to keep command of the production, it is important to keep headset chatter to a minimum. It is also important to make sure that all of the headsets in use are secured to the heads of the production crew. An unused headset that is connected to the PL line may emit the director's calls loudly enough through the headphone speakers to be picked up by the live microphones in the studio.

Most control rooms are also equipped with a **talkback system.** This is a microphone mounted on the console near the director that is connected to a small loudspeaker in the studio that allows the director's voice to be heard by everyone in the studio. The talkback is used only during rehearsals and at other times when a program is not being recorded or broadcast live. The talkback should be used sparingly; if the director needs to communicate only with one person on the studio floor, communication via the headset system is preferable.

Another communication tool between control room personnel and the **talent** involved in the production is the **interruptable feedback (IFB)** device. This is a small earpiece worn by the talent that allows the producer and director to communicate directly with the talent while the program is in progress. If the producer or director needs to communicate changes in the program or provide information to the talent while the program is in progress, he or she communicates through the IFB.

▧ Other Production Support Areas

As was noted above, one of the greatest assets of the television studio is that it provides a controlled environment for production. However, it is important to recognize that the studio is an empty space, so every element of the production needs to be created and brought into that space. Many production facilities include a number of other production support areas to make this task easier.

Most video programs that are recorded in a studio take advantage of a **set** that has been uniquely designed for that production. Sets can be constructed in a scene shop that is equipped with sufficient equipment and tools to enable the set designer to construct a set for studio use. Once the set—basically, the furniture and walls or backdrop—has been built, it needs to be dressed with **properties** (or **props**) that give it a realistic look and feel. A

well-equipped property shop can help here. Some productions need costumes as well. Although many video programs feature on-camera performers in everyday contemporary dress, some programs do not. Continuing productions such as daytime television soap operas rely on costume shops that can make costumes on demand and also hold in storage thousands of other costume items that can be used as the situation demands.

Many university and college video courses are taught in colleges that also support theater arts programs. These programs typically have scene, costume, and properties shops that provide support for their productions and may be available to support your productions if your college is so organized.

● **MAKEUP AND DRESSING ROOMS** Large-scale productions frequently require the availability of makeup and dressing rooms for program talent. A combination makeup/dressing room is typically a large room with mirror-covered walls. Special lighting is used so that the makeup artists can accurately control the application of the makeup to the talent.

● **GREEN ROOM** Many video production facilities provide a green room for individuals who are going to appear on a program. This so-called **green room** is a waiting room for guests that frequently includes make-up mirrors and restrooms. It may also include a video monitor so that guests can watch the program in progress before they appear on the set themselves.

■ Studio Production Personnel: Roles and Responsibilities

Video studio productions, whether they are single-camera or multicamera productions, are characterized by large production crews. Of course, the size of the crew is determined by the needs of the production and the size of the budget. In addition, in many small-scale college and university productions, one individual may assume responsibility for more than one of the roles described below.

● **PRODUCER** Unlike feature films, in which the director is typically the most recognizable member of the production group, in television principal responsibility for the organization and creative control of a production falls to the producer. The producer has the principal responsibility for organizing the production. He or she hires the director and the rest of the production crew, administers the budget, and establishes the production schedule.

● **DIRECTOR** The **director** has principal responsibility for a program during the time of the actual production. The director is responsible for visualizing the program, that is, translating the written script into pictures and sound. Before the actual production date the director creates a storyboard of the script and determines how the action will be staged. This latter activity is called *blocking.* The director then coordinates the rehearsal of the program. Several rehearsals are typical. For example, in a dramatic program or situation comedy, the director may supervise a script reading with the actors. After that, the action is blocked; that is, all the characters' movements are carefully planned out or staged, and the actors rehearse without the cameras, typically outside of the studio. They then move into the studio and rehearse it again with the cameras. Finally, the program or scene is videotaped in the studio with the director calling each camera shot in real time from the control room.

In television news production the roles of producer and director vary somewhat from the descriptions given above. The news producer is responsible for organizing the news content of the newscast, including the number and order of the stories to be covered. The director is in charge of getting the program on the air, within the allotted time, and generally without the benefit of rehearsal.

● **ASSOCIATE DIRECTOR** The **associate director (AD)**—sometimes also called the assistant director—has principal responsibility for timing the show. Time is very critical in all of video production but particularly in live studio productions. Not only must the overall show be precisely timed, but also the length of the individual segments of the show must be closely monitored, particularly if commercials are to be inserted. The AD usually has several stopwatches or clocks at his or her disposal. This allows the AD to time each segment individually, to time the overall length of the program, and, as the program nears completion, to provide a countdown to the close of the program. In very complex productions the AD may also have responsibility for readying camera shots in advance of the director's call for them. The timing functions of the AD will be discussed in greater detail in Chapter 8.

● **TECHNICAL DIRECTOR** The **technical director (TD)** operates the video switcher. The TD has two principal responsibilities. Not only must the TD punch up the proper video source on the switcher as the director calls for it, but the TD must also read ahead in the script to anticipate special effects and composited shots that need to be shown in the preview monitor before the director calls for them. A good TD is like an extension of the director, anticipating the director's calls and then quickly punching them up on line at the appropriate time. A poor TD can ruin a production by not paying attention to the script and the director's calls.

● **SOUND ENGINEER** The **sound engineer** (or *audio engineer*) has principal responsibility for coordinating the audio elements of the program. This involves selecting the correct type of microphones for use in the program and setting them up and testing them before the production begins. The audio engineer may also have responsibility for the overall sound design of the program; that is, he or she may be in charge of selecting the individual cuts of music and sound effects that are used within the program. During rehearsal the sound engineer checks to make sure that all the audio components are functioning and in particular, with respect to microphones, establishes a sound level for each performer by asking each performer to speak into the microphone.

During the production the sound engineer controls the audio mixing console. Like the technical director, the audio engineer must both anticipate and respond to the director's commands. By reading ahead in the script, the audio engineer can anticipate who will speak next or which music selection or sound effect will be used next in order to be ready to execute the director's command as soon as it is given.

● **LIGHTING DIRECTOR** The **lighting director** coordinates all elements of lighting for the program. Working from the **floor plan** for the program—a diagram of the set and props and their location on the studio floor—the lighting director selects the appropriate lighting instruments to be used and installs them in the appropriate locations. Unlike film production, in which lighting setups are done one shot at a time, studio television production focuses on lighting large areas where the action will be staged continuously. There is no time to change the position of lights during a live broadcast or videotaping session, so all of the lighting instruments need to be positioned correctly before the program begins.

News and talk programs, which use the same set design day after day, rely on preset lighting. Once the lighting director has established the basic lighting setup for the program, it does not need to be changed. The lights can simply be turned on at the beginning of the day and turned off when the production is finished.

● **CAMERA OPERATORS** Multicamera video studio productions typically use three cameras, although depending on the complexity of the program there may be fewer or more. An individual camera operator controls each camera. Like the TD and the sound engineer, the camera operator listens for commands from the director (e.g., "Camera 1 get me a close-up of the puppet") and quickly executes the director's commands. Camera operators should always have a usable shot ready for the director. Camera operators should also make sure that they have correctly set the focus of the zoom lens so that if the director calls for a zoom in or out, the shot will remain in focus during the zoom.

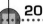

If a program is fully scripted, that is, if all of the shots for the entire program have been identified, each camera operator will have a shot list that specifies all of the shots assigned to a particular camera. The camera operator can look ahead in the shot list to see what shot is required next and then have that shot ready when the director calls for it.

Because unexpected things often happen during production, camera operators should always be ready to respond to the director. They need to keep their hands on the camera at all times and be ready to move the camera or zoom in or out at the director's command.

Many news studios have replaced cameras operated by human beings with **robotic camera systems.** Camera movements are controlled from the control room by a computer system that interacts with the camera's panning and zooming controls. The cameras can also be programmed to move along the studio floor. It is wise for people in the studio to be alert at all times to avoid being run over by a camera.

● **FLOOR DIRECTOR** If the TD is an extension of the director in the control room, the **floor director** is the extension of the director in the studio. The floor director's principal duties are to give cues to the talent and to help the camera operators move the cameras. Although all members of the production crew, including the floor director, can hear all the director's commands through the studio headset system, the program's performers do not wear headsets and cannot hear the director's commands. The floor director gives the program performers cues for when to begin to speak and when to end, which camera to look at, and so on. This is discussed more fully in Chapter 9.

Floor directors also help the camera operators to move the cameras as needed. Because each camera is tethered to the control room with a cable, moving the cameras during a production can sometimes seem like moving through an obstacle course. The floor director can help to keep the cables out of the path of moving cameras so that they can move smoothly from one position to another.

● **GRAPHICS DIRECTOR** Large production facilities may have a graphic design department that is charged with producing artwork and titles for productions staged in the facility. Today these graphics are produced almost entirely electronically by using sophisticated computer graphics systems. Smaller studios may rely on a simple character generator to generate titles as the program is produced. The graphics director or character generator operator creates a list of all of the graphics that are needed in the program and types the titles into the system's memory before the

program begins. It is very important to check and double-check all program titles and name superimposition titles for accuracy and correct spelling before the program begins.

● **VIDEO ENGINEER** The video engineer has principal responsibility for the technical integrity of the video signal and the look of the pictures the cameras are producing. The video engineer makes sure that the cameras and other video components are operating correctly. If technical problems emerge during a production, the engineer tries to fix them promptly. Before the beginning of a production session, the video engineer adjusts the white balance and aperture (exposure) of each of the cameras to make sure that they are reproducing the image accurately. During the production the video engineer operates the camera control units to make adjustments in picture quality as needed. This is called *camera shading.*

● **TAPE OPERATOR** The **tape operator** controls the videotape machines that are used to send prerecorded material to the video switcher during the production of a program. The tape operator also controls the videotape machine that is used to record the finished program. In some facilities the VCRs are located in the production control room; in other facilities they may be located elsewhere in the production facility. The tape operator, like the other members of the production crew, is connected to the director via the studio headset system.

The Video Field Production Environment

Although studio-based production remains popular because it provides a controlled, cost-effective shooting environment, location shooting is extremely popular as well. Video field production, which takes place outside of the studio environment, runs the gamut from small-scale single camera field production to large scale, multicamera production.

▪ Electronic News Gathering (ENG) and Electronic Field Production (EFP)

Electronic news gathering (ENG) is typical of small-scale single-camera production. It involves a small crew (usually no more than two or three people), recording with a single camera. The recorded footage is quickly edited into a short news story, or package, for broadcast on an upcoming newscast.

Location production of nonnews content is generally referred to as **electronic field production (EFP).** The production process and work roles are similar to those in ENG, but the material that is produced covers a broad range of content areas rather than being restricted solely to news.

◼ Single-Camera Field Production Personnel

Single camera video field production is accomplished with a production group that is significantly smaller than multicamera studio or field video production. (See Figure 2.4.) Typically, the principal roles involved in producing single camera remote productions are as described below.

● **PRODUCER** As in studio production, the producer is responsible for the overall organization of the production and for delegating responsibility to the other members of the production team. On small crews the producer may also function as the director by determining what is to be shot and from which angle.

● **DIRECTOR** The director coordinates the activities of the production crew and performers on location. The director is responsible for making sure that all the shots that are identified in the script are recorded on location.

FIGURE 2.4
Small EFP Crew in the Field, Including a Camera Operator, Audio Person, and Production Assistant (Holding a Light Reflector)

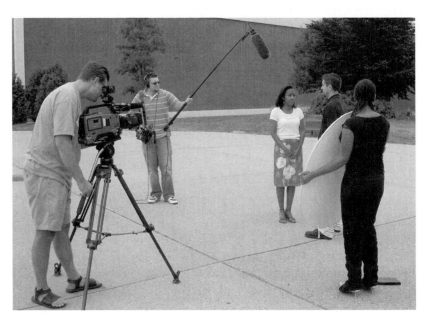

● **CAMERA OPERATOR** The camera operator, also called the **videographer,** or the *shooter* in ENG operations, is responsible for the physical operation of the camera. Unlike studio operations, in which the output of the cameras is routed through a video switcher and sent to a video recorder, single-camera video field production utilizes a camcorder, a combination camera and video recorder, which records the image as it is being photographed. Unlike studio production, in which shots are specifically called for in sequence by the director, in single-camera field production the field videographer may have a significant amount of responsibility for determining the visual treatment of the subject matter.

● **PRODUCTION ASSISTANT** The **production assistant (PA)** is responsible for providing general production support. The PA may be asked to label and log tapes as they are recorded, carry equipment to and from the location, and assist with setting up portable lighting instruments and microphones.

● **SOUND RECORDIST AND LIGHTING DIRECTOR** Productions that are more complex than the basic ENG and EFP situation described above may also include a sound recordist, who is responsible for microphone selection and placement and on-location sound recording, and a lighting director, who is responsible for the location lighting setup.

Once the field tapes have been recorded, they are given to a video editor, who is responsible for executing the vision of the producer and director in the process of postproduction editing.

■ Multicamera Video Field Production

Sports broadcasts are typical of large-scale multicamera production. Huge video production trucks (see Figure 2.5), equipped with sophisticated control rooms for video and audio control and outfitted with multiple cameras, are used to televise sports events from location sports facilities. The crews that are involved in this type of production are similar in size and function to crews involved in multicamera studio production; the only difference is the action that is being televised or recorded takes place outside the studio environment. Besides sports, award ceremonies such as the Grammy, Emmy, and Academy Awards presentations typify this production style.

■ The Issue of Control

One of the most important challenges in video field production is to take control of the location to maximize the chances of completing a successful production. Unlike studio video production, which takes place in an

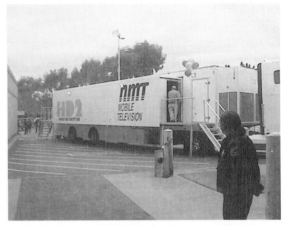

FIGURE 2.5
Large TV Remote
Truck

Remote Truck

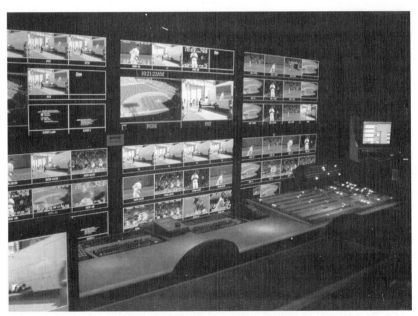

Remote Truck Control Room, Containing Multicamera Monitors
as Well as Audio, Video, and Graphics Controls

environment with controlled lighting, acoustics, and sound, video field
production is accomplished in remote locations where these elements may
vary greatly from location to location and from one time of day to another.
The ability to control these elements effectively is an essential requirement
for successful video field production.

The Postproduction Environment

Most video production that is done today does not end when the shooting ends. Whether a program is produced by using single-camera multicamera shooting techniques, postproduction editing is almost always a part of the process (see Figure 2.6).

▓ Linear and Nonlinear Editing

Two different technologies are employed in postproduction editing today. **Linear editing** utilizes source and editing videocassette recorders to edit sequences quickly in a linear fashion by transferring material from the source (playback) VCR to the editing (record) VCR. Linear editing systems are still widely used in ENG operations.

Computer-based, digital **nonlinear editing systems** have generally displaced linear editing systems in all other editing applications. Video footage is uploaded into a computer system that is equipped with video editing software. Once the final program has been edited, it is recorded back to tape or a video server for storage and playback.

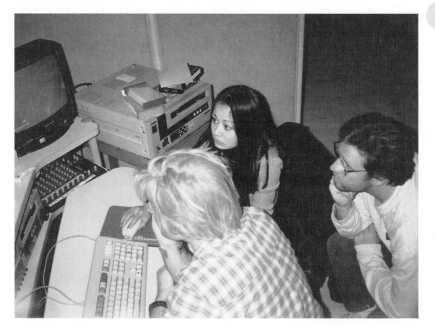

FIGURE 2.6
Editing Team
at Work

■ Graphics, Animation, and Special Effects

Video productions have become increasingly complex through the addition of sophisticated graphics, animation, and special effects. Each of these elements can be manipulated during the postproduction process with the use of the appropriate software applications.

■ Sound Sweetening

Although most attention of novice video producers is often focused on the pictorial elements of a production, the sound or audio portion of the program is at least as important as the picture, if not more so. Sophisticated computer-based audio editing and processing make up another important part of the postproduction process.

CHAPTER **3**

Lighting

Lighting is an essential element of video production. Like the human eye, video cameras need to have an adequate amount of light to produce an acceptable picture. Although today's video cameras require significantly less light than ever before, the central concern of lighting is not only to provide enough light for the camera to function properly, but also to provide light of a particular quality to achieve the desired aesthetic effect. Whereas the craft of lighting focuses on generating colors and visible detail acceptable to the viewing audience, the art of lighting involves controlling the aesthetic factors that are central to effective productions.

Basic Lighting Concepts

Whether you are producing a program in the studio or in the field, four principal lighting concepts must be considered before you turn on your camera and begin to record. These concepts are baselight, contrast range, color temperature, and light quality.

■ Baselight

The minimum amount of light that is necessary for the camera to function properly is called the base illumination level, or **baselight.** Each video camera manufacturer provides a measure of the baselight requirements for a camera. On the camera's technical specification sheet look for "optimum light level."

● **MEASUREMENT OF LIGHT INTENSITY** A value for the amount of light required will be given in one of the two basic ways to measure the amount of light: foot-candles or lux. A **foot-candle** is the amount of light

that radiates from a standard candle to a point 1 foot from the center of the flame. **Lux** are calculated in the same manner as foot-candles except that the calculation is metric: 1 meter replaces 1 foot in the formula.

Foot-candles can be expressed in terms of **lumens** per square foot. (*Lumen* is the Latin word for "light.") Whereas 1 foot-candle equals 1 lumen per square foot, 1 lux equals 1 lumen per square meter. This results in a ratio of lux to foot-candles of approximately 10:1. That is, 10 lux equal approximately 1 foot-candle; 2,000 lux equal approximately 200 foot-candles.

Most video cameras require about 150–200 foot-candles (or 1,500–2,000 lux) of baselight for optimum operation. This is the amount of light necessary to make a very good picture. A minimum light level may also be specified. This value will be significantly smaller than the optimum baselight level; indeed, for some cameras it may be as low as 1 or 2 lux. This is the amount of light necessary to make a visible image. Although you may be able to see the image produced by the camera, the image quality most likely will be quite poor. So don't be fooled into thinking that this very low light level is the baselight level you should try to achieve. In all situations your camera will need significantly more light than this to produce a good picture.

● **LIGHT METERS** Light is measured with a **light meter.** (See Figure 3.1.) A light meter provides a rough indication of the amount of light entering the camera and expresses the amount in either foot-candles or lux.

FIGURE 3.1
Incident Light Meter

Light-Sensitive
Surface

Scale in
Foot-Candles

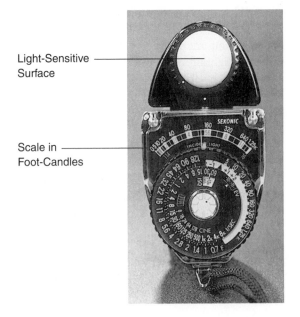

Light meters can be used to measure the amount of light falling on a scene, called **incident light,** or the amount of light reflected off a scene, called **reflected light.** Incident light is measured by placing the light meter in the subject's position and pointing it at the source of the light—either a lighting instrument or the sun. A more precise method of measuring the intensity of the light entering the camera involves placing the light meter in the camera position and measuring the light that is reflected from the subject to the camera. This method is more precise because it takes into account differences in the surface reflectance of objects in the scene. A whiteboard will reflect considerably more light back to the camera than will a similar board painted flat black.

Although both types of light meters are widely used in video production, incident light meters are the most common, largely because baselight requirements for cameras are most often reported in terms of the amount of incident light they require.

Some incident light meters have a light-sensitive area that is hemispherical rather than flat. The sphere approximates the shape of the human face and can be used to measure all the light falling on a subject from various directions.

FIGURE 3.2 Contrast Range

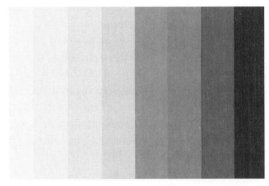

The Television/Video Screen Is Capable of
Reproducing a Limited Range of Brightness Values

■ Contrast Range

In addition to thinking about the amount of light necessary for the camera to function, some consideration must also be given to the contrast range of the scene before the camera. The **contrast range** is simply the range between the brightest and darkest parts of a scene. (See Figure 3.2.) It is typically expressed as a ratio of bright to dark. The human eye is able to process scenes in which the contrast range is 100:1 and greater; that is, the brightest part of the scene is one hundred times brighter than the darkest. Video cameras, on the other hand, can seldom process scenes in which the contrast range exceeds 50:1.

In practical terms, what this means is that the lighting on a scene should be relatively even. There should not be any extremely

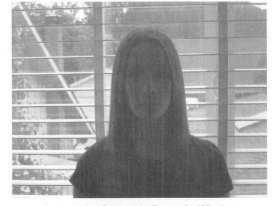

Placing the Subject in Front of a Window
Often Causes the Subject to Appear in Silhouette
Because of Contrast Range Problems

bright areas **(hot spots)** or dark areas. Even if the incident light level is consistent across the scene, differences in the reflectivity of surfaces in the scene can cause contrast range problems. Fortunately, any areas that are too bright or too dark will be immediately apparent in the camera's viewfinder, so lighting corrections can be made quickly and efficiently.

In field production situations contrast range problems typically arise when a subject to be interviewed is placed against a background that is too bright—a white wall or a window, for example. The simple solution to the problem is to move the subject or, in the case of the window, to close the curtains or blinds.

■ Color Temperature

Baselight and contrast range deal with the amount of light and its effect on a scene in terms of its overall brightness. The quality, or color, of that light constitutes the other half of the problem that must be solved to achieve a professional result.

The problem is that what appears to be white light to the eye may not appear to be white to the camera because of differences in the color temperature of the light source. **Color temperature** is a measure of the relative reddishness or bluishness of light measured in **degrees Kelvin (°K).**

Differences in color temperature are easily demonstrated by looking at the information in Table 3.1 (also see CP-7). This table presents a list of common light sources and the color temperature of the light they emit. As

■ **TABLE 3.1** Color Temperature of Various Light Sources

Color Temperature	Light Source	General Description
1,800°K	Open flame	Warm (red evident)
2,000°K	Warm-shaded household lamp	
2,800°K	Unshaded frosted white household lamp	
3,200°K	Television studio standard (tungsten halogen) lamp	
3,500°K	Home-type photo floodlight	
4,800°K	Household fluorescent lamp	
5,600°K	Direct sunlight (noon)	
6,500°K	Overcast daylight	
8,000°K	Blue sky	Cool (blue evident)

you can see from the chart, the flame that is produced by a candle emits light in the range of 1,800°K. The light has a warm, reddish quality to it. At the other end of the scale, outdoor color temperatures may range from 5,600°K to 8,000°K. This light is much cooler and bluer in comparison to the warm flame of the candle.

The problems created by differences in color temperature produced by different light sources are controlled in two ways: by controlling the light sources and by adjusting the camera itself to compensate for different color temperatures.

● **CONTROLLING THE LIGHT SOURCE** Video studio lighting systems solve the problem of color temperature in a simple way. Studio lighting instruments use lamps that emit light at 3,200°K so that color temperature remains constant regardless of camera position or time of day. Because no light is present in a video studio except the light the lighting director puts on the scene, the problem of color temperature is solved.

In video field production the situation is more complex. The color temperature of indoor light produced by household incandescent lamps is different from the color temperature of sunlight. If lighting instruments need to be used to augment the available light, the color temperature of the lighting instruments (which differs both from the color temperature of indoor incandescent lamps and that of outdoor sunlight) must be adjusted to match the existing light. A blue gel can be used to make 3,200°K lighting instruments match the color temperature of daylight (5,600°K, bluish), or a reddish gel can be used to make the 3,200°K instrument a bit warmer to match the color temperature of indoor incandescent light.

● **WHITE BALANCE** **White balance** controls on the video camera are used to adjust the camera for the color temperature of the dominant light source. Typical camera settings allow the camera operator to choose from a series of preset positions for different lighting conditions. These may include incandescent, fluorescent, tungsten halogen, and outdoor settings for foggy or overcast or bright sun conditions. Or the white balance may be set manually by focusing the camera on a white card that is illuminated by the dominant light source. In most cases the most accurate white balance is achieved by following the manual white-balancing method.

■ Quality of Light

In addition to the amount and color quality of the light, the overall quality of light, in terms of how soft or hard it is, should be considered. Bright sunlight produces a very hard light, with sharp, distinct shadows on the subject. On the other hand, soft light is produced on an overcast or foggy day; the light is more diffused, and the shadows that are produced are softer and

Direct Sunlight Is Hard Light
That Produces Harsh Shadows.

Soft Light Produces a More Pleasing Effect.
Shadows Are Lighter and More Transparent.

FIGURE 3.3 Quality of Light

less distinct. (See Figure 3.3.) A variety of lighting instruments have been produced that mimic these qualities of light. These are discussed in more detail later in the chapter.

Lighting Equipment: Types of Lamps

Three principal types of lamps are commonly used in professional video production: tungsten halogen lamps, fluorescent lamps, and HMI (halogen metal iodide) lamps. The type of lamp with which you are probably most familiar, household incandescent light bulbs, is not used in professional production applications because they emit light at a color temperature that is a bit too low, and consequently is too red, for use in professional video production.

■ Tungsten Halogen Lamps

Tungsten halogen lamps, also called *quartz halogen* or *quartz lights*, are the industry standard and are found in many professional video lighting instruments. The filament in these lamps is tungsten, and the quartz glass bulb is filled with halogen gas. (See Figure 3.4.) The halogen prevents the tungsten filament from evaporating and coating the inside of the bulb with particles of tungsten that would cause the color temperature of the light to decrease (and become redder) over time. The tungsten halogen lamp maintains a constant color temperature of 3,200°K throughout its life.

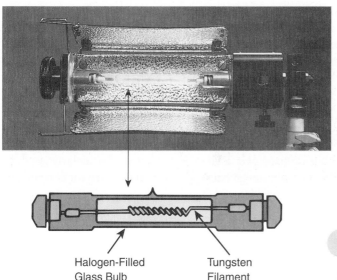

FIGURE 3.4
Tungsten Halogen
Lamp

Tungsten halogen lamps get extremely hot when they are in use. Care needs to be taken not to place the instruments too close to flammable materials such as curtains in field production applications. In addition, the tungsten halogen lamp must never be touched by bare fingers; if oil from the skin is deposited on the glass, it may cause the bulb to explode when it gets hot. For this reason, when changing a tungsten halogen lamp, always use cotton gloves or hold the lamp in the foam packing material in which it is shipped.

■ Fluorescent Lamps

Fluorescent lamps provide the standard illumination in the American workplace and in the kitchens and bathrooms of many homes. However, the lamps that are designed for the consumer market do not produce light at a color temperature that is acceptable for video production. Professional fluorescent instruments designed specifically for video production are available with lamps that produce light either at 3,200°K (to match the color temperature of tungsten halogen instruments) or at 5,600°K for use outdoors in daylight. In addition, some manufacturers provide lamps at color temperatures slightly lower than 3,200°K (e.g., 2,900°K and 3,000°K) for use when a warmer lighting effect is desired.

Fluorescent lamps consist of a small or large gas-filled tube. The inside of the tube is coated with a fluorescent material that glows when electrical energy is applied to the gas within the tube.

Fluorescent instruments have become extremely popular in video production in recent years because they consume very little power and generate

very little heat in comparison to tungsten halogen instruments. They are very widely used to light newscast sets, and video production facilities that have converted to fluorescent lighting report significant savings over tungsten halogen because of decreased energy and air-conditioning costs.

Although the initial generations of these instruments were large and bulky, today's units are not. A variety of instruments designed for studio and field are available, as well as extremely small instruments for special lighting situations. (See Figure 3.5.)

Finally, because fluorescent instruments produce an extremely soft, flat light, which is diffused over a large area, they are particularly good for lighting the blue or green screen backgrounds that are used for chroma key effects (which are discussed later in this chapter).

■ HMI Lamps

Hydragyrum Medium Arc-Length Iodide (HMI) lamps produce light that matches the color temperature of daylight. For this reason they are used for daytime outdoor shooting.

These instruments are twice as efficient in terms of foot-candles per watt as tungsten halogen instruments and four times as efficient as tungsten halogen instruments to which filters have been attached to correct their color temperature for daylight. For example, a 2,500-watt HMI unit produces the same amount of light as a 10,000-watt tungsten halogen source with a daylight conversion filter.

Because HMI instruments are often used to add light to large outdoor areas, the instruments themselves tend to be fairly large. In addition, each instrument contains its own ballast, which is used to convert standard 120-volt electrical sources to the direct current the HMI lamps require.

FIGURE 3.5 Fluorescent Lighting Instruments

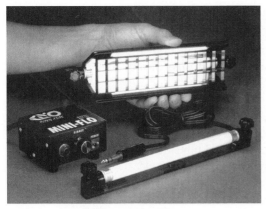

Small Instrument Studio Instrument

Common Lighting Instruments

Lighting directors have a variety of lighting tools at their disposal. They include a variety of floodlights, spotlights, and softlights designed for use in the studio and/or in the field.

■ Spotlights and Floodlights

The two basic types of lighting instruments are spotlights and floodlights. **Spotlights** produce a narrow beam of hard-edged light that produces harsh shadows on the subject; **floodlights** and **soft lights** produce a wider beam of softer light that minimizes the presence of shadows on the subject. (See Figure 3.6.)

In recent years there has been a marked trend toward the use of soft lights in video production. Because today's cameras require less light to operate than their predecessors did, producers do not have to rely on the high-powered spotlights of an earlier era. And because soft lights have a more natural, less artificial look, they are often the right choice for aesthetic reasons as well.

■ Fixed Beam versus Variable Beam Instruments

Lighting instruments may be fixed beam or variable beam. Variable beam lighting instruments allow the lighting director to adjust the beam of light produced by the instrument. On some instruments the adjustment can be rather significant—varying the beam from floodlight to spotlight, for example. On other instruments the adjustment may be more minor.

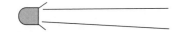

Spotlight: Narrow Beam of Hard, Focused Light

FIGURE 3.6 Spotlight versus Floodlight

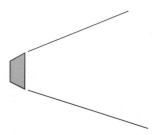

Floodlight: Wide Beam of Soft, Diffuse Light

■ Fresnel Spotlight

Fresnel spotlights (see Figure 3.7) contain a lens at the front of the instrument that focuses the beam of light produced by the instrument. Fresnel (pronounced "fruh-*nel*") spotlights often include a focusing device, which allows the beam of light to be adjusted from a spotlight (narrow beam) to a floodlight (wider beam).

The Fresnel spotlight is named after Augustin Fresnel, the French inventor of the focusing lens. These lenses were first designed for use in lighthouses in the early nineteenth century. With the use of the Fresnel lens, the light produced by the lighthouse, often fueled by burning whale oil, would be visible as a point of light many miles out to sea.

Fresnel spotlights that are used in studio applications are typically fairly large; 1,000-watt, 2,000-watt, and 5,000-watt instruments are quite common. In small-scale field production situations small 100- to 250-watt Fresnel instruments are popular. Depending on the manufacturer, they may be called Inky or Pepper lights.

■ Parabolic Floodlight

The **parabolic floodlight**, or *scoop* (so called because it looks like an old-fashioned ice cream scoop), is widely used in studio video production. (See Figure 3.8.) The instrument itself is a parabolic reflector, typically constructed out of brushed metal. Unlike the Fresnel spotlight, it is open-faced; that is, it does not contain a lens.

Parabolic floodlights produce a wide beam of soft, diffuse light. They are widely used to establish baselight levels in large action areas.

FIGURE 3.7 Fresnel Spotlight

Lens Lamp Reflector

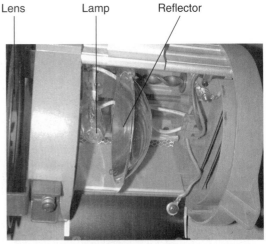

Exterior

Interior. Moving the Lamp and Reflector Forward or Back Changes the Beam of the Light from Wide (Floodlight) to Narrow (Spotlight).

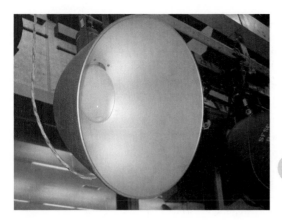

FIGURE 3.8
Parabolic Floodlight,
aka "Scoop"

Ellipsoidal Spotlight

Ellipsoidal spotlights are used to throw a controlled beam of light over a great distance. (See Figure 3.9.) These instruments contain a Fresnel lens and use an ellipsoid-shaped internal reflector to provide greater control of the light they produce. Ellipsoidal spotlights also contain four internal shutters that can be used to create a variety of light patterns. Ellipsoidal spotlights are frequently used in conjunction with cookies, small metal patterns that are inserted into the instrument to project a pattern (e.g., clouds, trees, and cityscape) onto the background. Sometimes ellipsoidal spotlights are called Lekos or Lekolites, reflecting the brand name given to the ellipsoidal instruments produced by the Century Lighting Company.

Fluorescent Floodlight

Fluorescent floodlights are extremely popular studio lighting instruments because they produce a diffuse light in an instrument with low power consumption and low heat generation. One or more fluorescent lamps are mounted in front of metal reflectors in a rigid housing. To provide a more

FIGURE 3.9
Ellipsoidal Spotlight

focused quality of light that is capable of producing slightly harder shadows and modeling effects, some fluorescent instruments are equipped with a clear plastic focusing lens. Aluminum or plastic grids or louvers that resemble a honeycomb may also be attached to the front of the fixture to focus the light and reduce the amount of spill light by providing more control over where the light falls. (See Figure 3.5.)

Portable fluorescent instruments are available for field video production as well. However, because the light output of the instruments is rather low, they tend to be used principally to light interview subjects rather than to light large action areas.

■ Soft Lights

Soft lights are widely used in field and studio production settings. They provide a bright light that is even more shadow-free than is the light produced by floodlights. The quality of light produced is particularly flattering for interviews and product demonstrations.

Soft lights that are designed for use in field production typically use a collapsible frame that surrounds the lamp. One type of soft light employs a cloth reflector that is stretched over the frame. The interior of the cloth reflector is covered with an aluminized coating or other reflective material. Another type of soft light system relies on the use of a cloth hood equipped with a front screen composed of diffusion material. The instrument's light source passes through the layer of diffusion material that softens and diffuses the light. (See Figure 3.10.)

Soft lights for studio applications are considerably larger than field instruments and typically are constructed of metal. The diffusion layer is constructed from rigid translucent plastic that is mounted on the face of the instrument.

FIGURE 3.10 Soft Light

■ Open-Faced Portable Instruments

Lighting instruments that are designed for use primarily in field production settings need to be smaller and lighter than their studio counterparts. Although fluorescent instruments have gained popularity in recent years, the majority of instruments that are used for small and medium scale ENG and EFP applications are *open-faced* (they have no lens), contain a 500- to 1000-watt tungsten halogen lamp rated at 3,200°K, and operate on common 110-volt, 60-cycle power. The most common instruments are variable beam spotlights and fixed beam floodlights. (See Figure 3.11.)

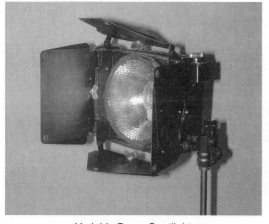

Variable Beam Spotlight

Fixed Beam Floodlight

FIGURE 3.11 Open-Faced Portable Lighting Instruments

Light Mounts

◼ Field Lights

● **FLOOR STANDS** Portable lights used in the field are often attached to a telescoping floor stand. The stands are usually made of lightweight aluminum and provide a reasonable amount of stability for the lighting instrument.

● **CAMERA MOUNTS** Camera-mounted lights attach directly to the camera and operate on battery power. (See Figure 3.12.) They are widely used in electronic news-gathering production activities to provide quick illumination of the reporter or interview subject. Increasingly, camera-mounted lights are equipped with focusing lenses and diffusion filters to produce a softer quality of light.

FIGURE 3.12 Camera-Mounted Light

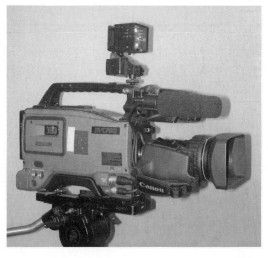

● **HANDHELD SUPPORTS** Some lighting instruments contain an insulated handgrip that allows the light to be positioned and moved to fit the needs of the scene and to enhance the modeling of the subject as the subject moves.

■ Studio Lights

One of the advantages of a studio over a field location is that studios are equipped with a smooth floor that makes it easy to move the cameras. To provide a large area with few obstacles to camera movement, studio lights

FIGURE 3.13

Studio Lighting Systems

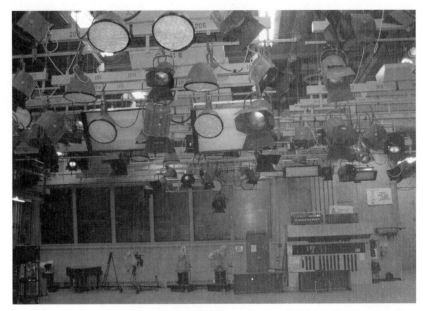

Moveable Battens

Adjusting Lights on a Lowered Batten

are mounted above the action. (See Figure 3.13.) Some facilities use a *fixed pipe grid*. Instruments are attached to the grid with C-clamps and a safety chain. Other facilities use moveable **light battens,** which are counter-weighted so that they can be raised and lowered to allow for adjustment

Fixed Pipe Grid

C-Clamp and Chain

without the use of a ladder. Still other facilities use remote-controlled instruments whose position can be adjusted from the control room with the use of a robotic control to pan, tilt, lower, and raise the light. Lights mounted on floor stands may be used as well, particularly when the light source needs to come from below or to the side of the action rather than from above.

Light Modification and Control

A variety of devices are used to provide additional control of the light source.

■ Barn Doors

Barn doors are small metal flaps attached to the top, bottom, and sides of a lighting instrument. (See Figure 3.14.) They are used to control the direction of the light and to keep it from spilling onto unwanted areas of the scene. Barn doors are found more often on spotlights than on floodlights, because spotlights produce more directional light to begin with, which is easier to control than the light produced by a floodlight.

■ Flags

Flags are pieces of opaque material of assorted sizes that are used to keep the light of one instrument from illuminating the wrong part of a set or, as is often the case in field production, to keep sunlight off a subject. Flags may be hand-held, or they may be clamped to a floor stand.

FIGURE 3.14 Barn Doors on a Fresnel Spotlight

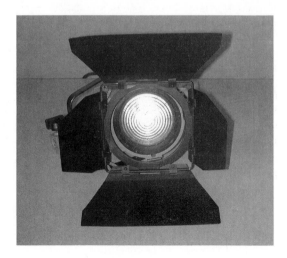

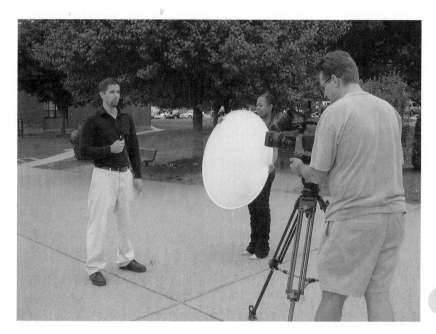

FIGURE 3.15
Reflector

Reflectors

Reflectors are used to redirect light back onto a scene. (See Figure 3.15.) Commercial products are available, or they can be made from cardboard or foam core. A plain white card will effectively bounce light back onto the subject, or the card can be covered with aluminum foil. Smooth foil will reflect a hard light; pebble-grained or wrinkled foil will diffuse the light that it reflects and soften the edges of the shadows. If gold foil is available, it will give the reflected light a warmer quality.

FIGURE 3.16 Parabolic Floodlights with Scrims

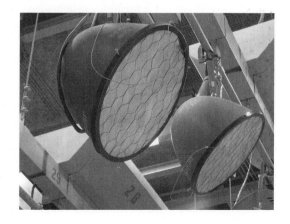

Diffusers

Light diffusers, also called **scrims,** are often used in production to change the amount and quality of light that falls on a scene. (See Figure 3.16.) Professional lighting instruments are fitted with frames or slots to hold the diffusion material. If a frame is not available, a wooden clothespin—also known as a *C-47* in professional lighting supply catalogs—can be used to attach diffusion material to the front of a lighting instrument.

Silks are giant diffusers that are used to control light intensity and quality in outdoor productions. They are used like an awning or a tent—placed above the scene and situated to filter all the light from the sky.

■ Gels

Gels are plastic or polyester filters, also sometimes called *color media.* In studio production gels are most often used to change the color of a light source. Gels may be attached to floodlights or spotlights so that they can throw colored light onto a background curtain or wall. In field production gels are most often used to change the color temperature of a light source. When tungsten halogen instruments are used outdoors to augment daylight, blue gels are attached to the front of the lighting instruments to convert their color temperature from 3,200°K to the daylight standard of 5,600°K.

■ Dimmers

Gels, scrims, barn doors, flags, and reflectors give the lighting director a fair amount of control over the direction and quality of the light. However, a more direct control over the amount of light is often needed. Short of adding or subtracting lighting instruments, this is the function of the lighting **dimmer**. (See Figure 3.17.) Dimmers work by varying the wattage that is supplied to the lighting instrument. If a light is too bright, the wattage can be reduced until the light is at the proper intensity.

Dimmers are used extensively in television studio production as part of a larger lighting control system. Such systems usually include the lighting instruments themselves and a lighting patch panel that works in conjunction with the lighting board. Individual instruments are patched (or connected) to an input on the patch panel that corresponds with a dimmer on the lighting board.

Each lighting instrument may be patched into its own dimmer, or several instruments may be collected together into a group. Lights can be dimmed and brought up in intensity individually, in groups or scenes, or all together. Old-style lighting control systems were operated manually; modern systems are computer controlled.

Portable dimmers are available for field use, but they are seldom used in small-scale productions. Instead, the lighting director might adjust the focus of the light to increase or decrease its intensity, add or subtract diffusion material to make it dimmer or brighter, or move the instrument closer to or farther away from the subject.

Doubling the distance from the lamp to the subject reduces the light that reaches the subject to one fourth of its original strength. This is the **inverse square rule,** and it is an important tool in remote video production.

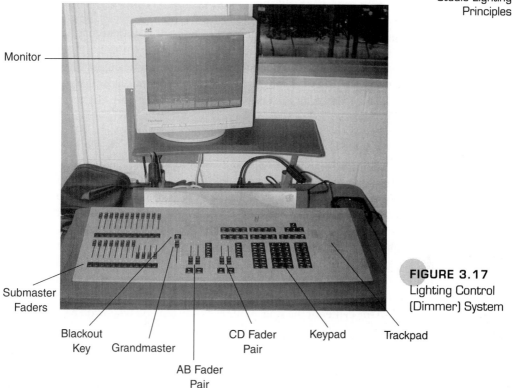

Monitor

Submaster
Faders

Blackout
Key Grandmaster

AB Fader
Pair

CD Fader
Pair

Keypad

Trackpad

FIGURE 3.17
Lighting Control
(Dimmer) System

Studio Lighting Principles

■ Base Illumination and Modeling

The video studio provides an environment in which the lighting director (LD) can achieve total control of the lighting design. The reason for this is quite simple: There is no light in the studio except the light that the LD decides to use. In approaching a basic lighting design, two goals will have to be met. First, adequate baselight illumination must be supplied to meet the operational needs of the camera or cameras. Second, the lighting design must be consistent with the production style and desired goals of the program.

Much attention in lighting is focused on meeting the camera's general baselight requirement. However, the baselight or overall illumination level is only half of the problem; modeling is the other half. **Modeling** is a lighting effect that is used to create the illusion of three-dimensionality on the subjects that are being illuminated. Baselight, if evenly applied to a scene, often creates a picture that appears to be flat and lifeless. By varying the illumination on the subject—that is, creating a lighting design that includes both highlights and shadows on the subject—a more lifelike three-dimensional lighting effect can be achieved.

■ The Photographic Principle

Lighting to create the illusion of the third dimension involves three tasks: establishing the form of the object (achieved with the use of a key light), reducing the intensity of the shadows created by the key light (this is the function of the fill light or lights), and separating the object from its background (the back light). This technique is known as **three-point lighting.** (See Figure 3.18.)

● **KEY LIGHT** The **key light** is used to establish the form of the object being photographed. It is typically the brightest light on the scene (although sometimes the backlight may be brighter, as you will soon see). Because of its brightness, the key light illuminates the object so that it can be seen but also produces shadows on the subject. The position of the light is important: the key light is placed on a line from 30 to 45 degrees above the camera–subject axis and from 30 to 45 degrees to the right or left of that axis. (See Figure 3.19.) A pattern of highlighs and shadows created by the key light on the subject's face that makes the subject appear normal is found somewhere within these angles. Be careful not to position the light too high or low or too far to the center or the side. Your eyes will tell you when you have achieved an aesthetically pleasing effect. (See Figure 3.20.)

● **FILL LIGHT** The **fill light** increases the overall light level on a scene and fills in somewhat, but not completely, shadows created on the subject by the key light. (See Figure 3.20.) If you are using a light meter, you might start by adjusting the fill light to one half to three fourths of the intensity of the key and then adjust to the desired point by looking at the image as it is produced by the camera. If the fill light intensity is too high and all or most of the shadows produced by the key are eliminated, the image will appear to flatten out, and the modeling effect will be lost. If the fill light illumina-

FIGURE 3.18 Three Point Lighting Diagram

FIGURE 3.19 Typical Angle of Key Light

tion is too low, the fill side of the image may be too dark and/or, depending on the quality of the camera you are using, may exhibit unwanted color or signal artifacts (the colors may seem unnatural, or the picture may appear to be noisy or grainy).

● **BACK LIGHT** The **back light** has two functions: It separates the subject from the background by outlining the subject's head and shoulders with a thin line of bright light; and it supports the modeling effect by revealing facets of the form that are untouched by the key light. The back light is extremely valuable in giving form and highlights to hair or clothing that would otherwise blend into the background. (See Figure 3.20.) The back light is frequently as bright as the key and may be brighter if the subject has dark hair or clothes that disappear into a dark background. The back light should be placed above and behind the subject. However, care must be taken not to position it too high, in which case the subject's hair

FIGURE 3.20 Three-Point Lighting: Effects of Key, Fill, and Back Lights

Effect of Key Light

Effect of Key and Fill Lights

Effect of Back Light

Key, Fill, and Back Lights

and nose may be illuminated out of proportion with the rest of the picture, or too low, in which case the light may radiate directly into the camera lens and produce a distracting lens flare.

● **BACKGROUND LIGHT** Although traditional three-point lighting does not include the use of a **background light,** this light can be extremely useful, particularly in interview situations. Background light is different from back light; background light falls on the background of the scene, not on the subject. Often in studio situations an ellipsoidal spotlight with a pattern projector is used to project a pattern onto the background of the scene. This not only provides light, which adds energy and interest to the shot, but also may provide supporting expositional detail if the pattern chosen reinforces the subject of the program.

■ Lighting for Mood and Effect

Although many different techniques for lighting for mood and effect can be described, two basic approaches underscore most lighting designs. **Low key lighting** and **high key lighting** refer not to the position of the key light, but to the overall impression of brightness conveyed by the scene. Low key scenes appear to be darker, usually because the background illumination is kept to a minimum. This lighting technique is often used in trying to create the illusion of night in an indoor setting. Such a lighting approach may also suggest an emotional tone that is somber or ominous, depending on the situation. High key scenes are brightly lit. They may convey a sense of brightness, an emotional tone that is upbeat or happy. The lighting design for a murder mystery that is set in an interior location would almost certainly feature low key lighting; a situation comedy staged in the same room would probably utilize high key lighting.

Colored gels on the lighting instruments can also be employed to set the emotional tone of a scene. A futuristic medical experiment might be lit in cool blue tones; a romantic scene in front of a fireplace would probably be enhanced with warm reds.

■ Background Shadows

One of the great challenges of lighting in the studio is to make what is essentially an artificially constructed environment appear to be realistic and natural. Lighting can help to create the illusion, or it can completely destroy it. Nothing is more damaging to maintaining the creative artifice of studio scenes than shadows cast by people in the scene onto the background; this draws attention to the artificiality of the lighting.

To avoid unwanted background shadows, follow these two simple rules: First, make sure that lighting instruments are placed high enough that shadows cast by the people in the scene are relatively short. The higher the key light is positioned, the shorter the cast shadow will be; the lower the

key light is positioned, the longer the shadow will be. Second, maintain a reasonable distance (at least 6 to 8 feet) between people in the scene and background curtains or scenery. By doing this, the cast shadows that are created by the key and fill lights will fall onto the floor rather than on the background.

Lighting Action Areas

Lighting a scene would be easy if the subjects did not move. Lighting an interview presents a situation in which movement is completely controlled. Lighting a dramatic scene in which actors move about in a set presents another set of challenges. When confronted by a situation in which there will be a lot of movement, you will need to light the overall action area. You may still apply the photographic principle to the problem using multiple lighting instruments for key, fill, and back light functions, although with less precision than you could if your subject were not moving. Overall illumination and separation from the background should be fairly easy to achieve; modeling may be a bit more difficult because of the movement of the characters.

Lighting for Chroma Key Backgrounds

Often termed **chroma keying** (*chroma* is the Greek word for color), the *blue screen* technique (sometimes *green* is used instead of blue) has been used in video production since the advent of color.

In a chroma key composited image the foreground subject is typically recorded in a studio against a blue or green screen background. (See Figure 3.21 and CP-8.) The chroma key background may be either a seamless hard wall or a blue or green cyclorama (curtain). A different background image is recorded separately or, as is the case in the typical news weathercast, is generated via computer. When the two images are combined by using a video switcher (for live production) or in postproduction with image compositing software, the blue or green chroma key background is subtracted from the foreground picture, which is then combined with the new background image.

For the effect to work properly, the blue or green chroma key background must be evenly illuminated and free from shadows. Fluorescent lighting instruments are particularly well suited to this lighting task because they emit an even, soft light at precisely controlled color temperature that can provide relatively shadowless illumination across large background areas.

Any color can be used for a chroma key background, but blue and green are the most popular choices for several reasons. First, they are both primary colors (color television works on a system based on the primary colors of light—red, green, and blue) and therefore can be easily isolated and electronically subtracted from the picture. In addition, there is not much blue in the mix of colors that represent the range of skin tones the

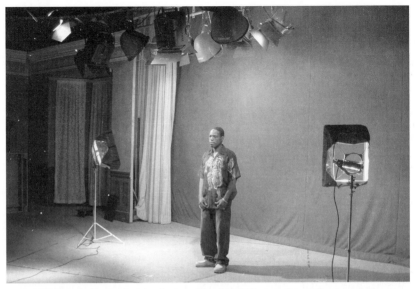

Subject Is Recorded Against an Evenly Lit Blue or Green Background

Subject as He Appears on Camera against the
Chroma Key Background

Background Image Is Recorded Separately

FIGURE 3.21
Chroma Key

Blue or Green Background Is Subtracted,
and the Foreground Image Is Combined
with the Background Image

camera is likely to see—red is more significantly present. Because people are often featured in the foreground, there is less chance that the face of the on-camera talent will disappear when the chroma key effect is engaged against a blue background. Unfortunately, blue is a popular color for clothing. Because green is seldom worn, a bright shade of green was chosen as an alternative to chroma key blue.

Field Lighting Principles

▪ Augmenting Existing Light

As was noted above, in the studio environment the lighting designer creates a lighting plan from scratch: All of the light on the scene comes from instruments in the studio that have been purposefully selected and placed. In the field the situation is somewhat different. The challenge is often to control and/or augment existing location light outdoors (from the sun) or indoors (from incandescent or fluorescent fixtures) to achieve the desired lighting effect.

▪ Taking Control of Color Temperature

The problem with field locations is that if the location light needs to be augmented with lighting instruments, you have to make sure that your lighting instruments are the same color temperature as the ambient light on the location. The easiest way to do this is to convert the color temperature of the lighting instrument by using an appropriate gel.

Blue gels or *dichroic filters* (filters that allow only certain frequencies of light to pass through them) can be attached to lighting instruments with tungsten halogen lamps to convert them to the color of average daylight. If you are working with professional fluorescent lighting instruments instead of tungsten halogen, you can replace the 3,200°K professional fluorescent lamps with lamps that are balanced for daylight (5,600°K).

Many videographers find themselves shooting in indoor locations in which a significant amount of illumination is coming from daylight that is entering the scene from a window or skylight. If tungsten halogen instruments need to be used to augment the ambient light in this situation, there are two solutions to the problem of maintaining similar color temperature: Blue gels can be applied to the instruments and white balance the camera for daylight, or the color temperature of the daylight can be changed to match the tungsten halogen instruments. This is done by placing amber gels on the windows to convert the color temperature of the daylight coming through them to 3,200°K. But this is not an easy process. The gel must be large enough to cover as much of the window as is visible in the shot, and it must be applied smoothly with no distracting air bubbles or creases that might be visible to the camera. It is almost always easier to gel the lights and/or to close the window shades to block out the offending daylight.

Household fluorescent instruments provide their own set of challenges. Some video cameras have a white balance setting for fluorescent light sources. This is a help, but if daylight is coming in through the windows, you have the same problem as described above but with a different set of light sources.

When fluorescent fixtures are present and additional light is being provided by tungsten halogen instruments, the picture will take on a greenish tint if the camera is white balanced for 3,200°K to match the tungsten halogen instruments. If you cannot turn off the fluorescent lights, the next best solution is to obtain some "minus green" gels from a photographic lighting supply store. These gels will filter out light in the green area of the spectrum, making the light from the fluorescent fixtures warmer and suitable for use with the tungsten halogen instruments.

■ Electrical Power Requirements on Location

Because lighting instruments require a lot of power to operate, the field video producer must consider how many lighting instruments will be used and how much power is available to power them. Generally speaking, two or three portable, open-faced lighting instruments can usually be operated safely on one electrical circuit. (Remember that each circuit may include a number of different electrical outlets.) Usually, all the outlets in one or two adjacent rooms are on the same electrical circuit. To identify the available circuits, find the circuit breaker box. Plug a light into an outlet, and then turn off the circuit breakers one at a time. When the light goes out, you will know which circuit it is on and which circuit breaker controls it. You can then move the light to a different outlet and repeat the process. In this way you will be able to identify all the outlets that are on the same circuit.

You can calculate how much power is available to you by using a simple formula:

watts = amps × volts.

You can determine the number of amps the circuit is rated for by looking at the circuit breaker. The amperage rating will be engraved in the switch. In most houses, circuits of 15 or 20 amps are common. Next, plug the line electrical voltage into the formula, using 120 volts as the standard. So if you have a 20-amp circuit, $20 \times 120 = 2,400$ watts. If it is a 15-amp circuit, $15 \times 120 = 1,800$ watts. Next, look at the wattage rating for each of the instruments you are using, and add them up. If you have two 500-watt spotlights and one 1,000-watt floodlight, the total wattage used = 2,000 watts ($2 \times 500 + 1,000$). Your three lighting instruments can be operated safely on the 20-amp circuit, but if the circuit is rated only at 15 amps, your three lights will blow the fuse or trip the circuit breaker because they will exceed the 1,800-watt capacity of the 15-amp line.

Lighting an Interview Indoors

One of the most common lighting situations on location is the indoor interview. To light the interview, first assess the light that is available in the room in which you plan to record the interview. Be careful not to position your subject in front of a window; and to avoid background shadows, keep the subject at least 6–8 feet away from the back wall.

Figure 3.22 illustrates several typical lighting setups. Figure 3.22a uses standard three-point lighting and assumes that your lighting instruments are providing all of the light on the subject. Figure 3.22b uses light coming

FIGURE 3.22 Three Field Lighting Setups

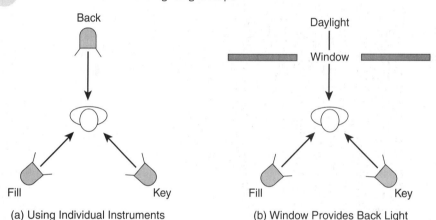

(a) Using Individual Instruments for Key, Fill, and Back Light

(b) Window Provides Back Light

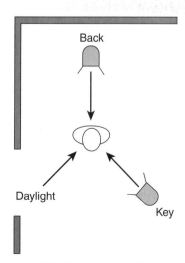

(c) Window Provides Fill Light

in from a window as a back light and augments that light with a key light and a fill light. In Figure 3.22c the light from the window is used as fill, and the key light and back light are supplied by individual lighting instruments.

▓ Outdoor Lighting Problems

The two most common outdoor lighting problems both involve shadows. In shooting on a bright sunny day, the sun will produce harsh shadows on your subject. Besides moving to a different location where the sun is not a factor, two possible solutions to the problem are diffusion and fill light. Just as the light that is produced by a lighting instrument can be softened by the use of diffusion material, so can the sun. Attach a sheet of commercially available diffusion material to a frame made out of plastic pipe. Hold the frame above the subject, allowing the sunlight to pass through it. (Be careful to avoid casting a shadow from the frame on your subject.) The diffusion material will soften the light and create a soft modeling effect on your subject.

An alternative solution to the problem is to use fill light to soften the shadows. A lighting instrument, color corrected for daylight color temperature, will do the trick. Unfortunately, electrical power is often not readily available in outdoor locations. A simpler way to provide the fill light is to use a reflector. A white or silver reflector can be used to reflect a soft or harder light back on the subject, filling in the shadows created by the sun.

The second most common outdoor lighting problem occurs when shadows cast by an object fall on the subject—for example, the shadows of leaves and branches in recording under a tree. This can be a difficult situation to overcome, even with the use of fill lights, diffusers, and reflectors. A better solution is to move the subject either to a place where the subject is completely in the shade or to one where the subject is completely in the sunshine. A reflector or lighting instrument can be used to add some sparkle to a subject that is completely in the shade. If the subject is completely in the sun, you can use one of the techniques described above to soften the light and reduce the shadows.

Lighting Safety

A few practical cautions are in order with respect to lighting safety. Lighting safety is the responsibility not only of the lighting director, but also of all of the other members of the production team who will be working around the lights. Consider the following points in lighting in a studio or on location:

1. *Dress for success.* Setting up and moving lights involve a fair amount of physical activity. Dress properly for this work. Wear sensible shoes (flat-soled, closed-toe) and comfortable pants or shorts. Women should avoid wearing dresses and jewelry.

2. *Make sure lights are securely mounted.* In the studio, make sure all C-clamps are tightened, and check that safety chains are in place for all instruments. In the field, if possible, place small sandbags on the base of floor stands to give them more stability. Make sure all of the screws that hold the telescoping rods in their extended position are securely fastened. Tape the electrical cord to the floor at the base of the floor stand so that if someone accidentally pulls on the cord, the shock will be absorbed by the tape and the lighting instrument will remain standing.

3. *Do not overload electrical circuits.* In the studio, know the capacity of each circuit on the dimmer board. In the field, calculate the amount of power your lighting instruments draw and compare that with the amount of power the electrical circuits deliver.

4. *Make sure all electrical outlets are properly grounded.* This is seldom an issue in the studio, where lighting systems are designed to high standards. In the field, only connect lighting instruments to grounded (three-pronged) outlets. Do not use three-to-two prong adapters to connect three-pronged connectors to ungrounded, two-prong outlets. When electrical equipment is not grounded, it increases the possibility of receiving a serious electrical shock if the lighting instrument is touched by someone.

5. *In the studio, alert other crew members if you are going to raise or lower an instrument.*

6. *Keep fingers off tungsten halogen lamps.* When replacing a burned-out bulb, always use cotton gloves, a piece of soft cloth, or the foam rubber that is supplied with the lamp to shield it from your skin.

7. *When using open faced-lighting instruments in the studio or in the field, keep the face of lighting instruments a safe distance away from any flammable surface.* These lights get extremely hot. They can easily ignite curtains, and if the folding reflectors on an open-faced floodlight (see Figure 3.11) are not fully open, the instrument may get so hot that the lamp explodes and the instrument melts. This is not good!

8. *Wait for lighting instruments to cool down before you move them.* Carry insulated electrician's gloves. If you have to move a hot light in an emergency, insulated gloves will protect you from the instrument's heat.

9. *Water and electricity do not mix.* Keep lighting instruments far away from any source of water on the set or on location.

Planning

Clearly, there is a lot to consider in designing and implementing a lighting plan for a studio or remote production. The key to success is thorough planning. Make sure that you have an accurate floor plan of the studio set or remote location. Draw a tentative **lighting plot** (see Figure 3.23), along

with a list of all the lighting equipment you will need. Once your lights are set up and turned on, be sure to look at the image produced by the camera, and be prepared to make adjustments in your lighting setup until you are satisfied with the outcome.

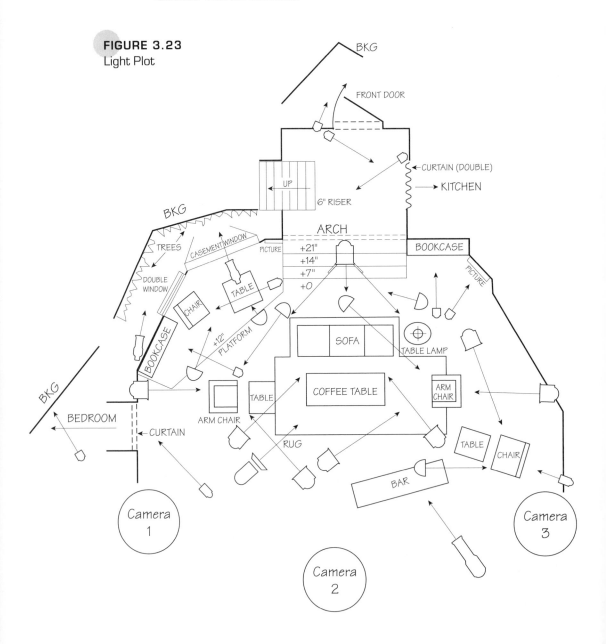

FIGURE 3.23
Light Plot

CHAPTER 4

The Video Camera

With the development and proliferation of low-cost portable camcorders, video cameras seem to have become omnipresent in American culture. No longer are professional video producers the only ones with access to video production tools; cameras appear to be everywhere.

The main function of the video camera is to translate the optical image captured by the camera's lens into an electrical signal that can be recorded and transmitted. Although all video cameras perform this basic function, there are significant differences in the ways in which cameras are configured and the markets to which they are targeted.

Camera Equipment Quality and Target Markets

Video equipment makers produce a wide range of equipment that is designed to meet the needs of consumer users, video enthusiasts, and production professionals. (See Figure 4.1.) Video equipment varies greatly in terms of features, quality, and cost.

■ Consumer and Prosumer Equipment

At the low end of the scale is **consumer equipment,** which is marketed to home video users for their personal use. Consumer camcorders can be bought for fewer than five hundred dollars, and the quality of the images that they produce and record is remarkable given their relatively low cost. This type of equipment tends not to be very durable, and many of the basic camera control functions have been automated to eliminate operator errors.

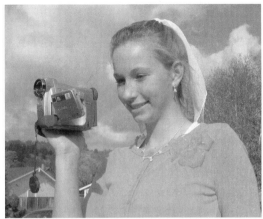

Consumer Camcorder

FIGURE 4.1 Consumer and
Professional Camcorders

Professional Camcorder

Prosumer equipment is a step up from consumer equipment in cost, quality, and feature sets, but this equipment generally is not used in a professional environment. A serviceable prosumer camcorder might cost in the neighborhood of one thousand to three thousand dollars and will provide the operator with a bit more durable quality and more controls that feature manual as well as automatic settings.

■ Professional/Broadcast Equipment

At the high end of the scale is equipment that is designed for the **professional/broadcast** market. This equipment is the most rugged and contains a wider set of controls for the professional operator. Prices for professional cameras and camcorders vary widely, depending on how they are to be used. High-quality camcorders used in electronic news gathering can easily

cost between ten thousand and twenty thousand dollars; high-end cameras and camcorders designed for high-definition television production may cost up to one hundred thousand dollars.

It is generally important to match the quality level of production equipment to the situation at hand. Most broadcast outlets expect programs to meet technical standards that are more easily achieved with professional quality equipment than with consumer- or prosumer-level equipment.

Camera Configurations

■ Camera versus Camcorder

A video camera can be configured either as a video camera with no built-in recording capability or as a camcorder—a video camera with a video recorder that is either built in or attached to the camera. Consumer-level camera equipment is generally available only in the camcorder configuration; professional/broadcast equipment may be configured as either a camera or a camcorder.

■ Video Camera: Studio Configuration

A video camera designed for studio use may be a fairly large camera mounted on a heavy pedestal or tripod with a set of external controls that allow the camera operator to control principal camera functions such as zooming the lens to change the angle of view and focusing the lens. (See Figure 4.2.) The camera is connected to the video control room with a

FIGURE 4.2
Studio Camera

cable that delivers power to the camera and carries the video signal from the camera to the control room. A large viewfinder will typically be mounted on top of the camera to allow the camera operator to easily see the image that the camera is producing as he or she stands behind the camera and controls it.

This type of camera may be used in a multicamera studio environment or on a large remote production. For example, telecasts of sporting events typically involve the use of multiple cameras whose signals are all routed back to a central control room, where a director calls the shots and where the program is either transmitted live or recorded for later broadcast.

■ Convertible Studio/Field Cameras

Convertible cameras are designed to be used either in the studio or in the field with several others in a typical multicamera configuration or as a single-camera portable unit in the field. These cameras are generally smaller and cheaper than their full-size studio counterparts, may be equipped with either an eyepiece or a studio-type viewfinder, and may be operated with conventional AC power or with battery power. (See Figure 4.3.) Some convertible cameras have the capability to be converted into camcorders by removing the back end of the camera and adding a dockable video-recording device.

FIGURE 4.3 Convertible Camera

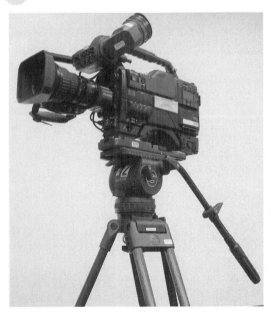
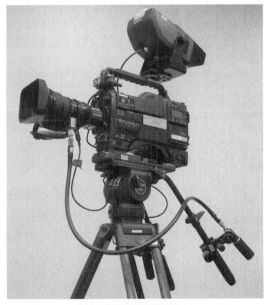

Field Configuration Studio Configuration

One-Piece Camcorders

A camcorder combines the video signal–producing camera component of a video camera with a video recording device. Unlike dockable camcorders, in which the camera head and video recorder are separate components that can be disconnected from each other, in one-piece camcorders the components that produce and record the video signal are integrated into one solid piece of equipment. Like other equipment, camcorders vary widely in price and features depending on the target market for which they have been produced.

Parts of a Video Camera

A video camera system is composed of four principal parts: the camera itself (sometimes called the camera head), lens, camera control unit, and viewfinder.

Camera Head

The **camera head** contains the optical and electronic components that produce the video signal. This consists of the imaging device, the beam splitting-system, and the camera's internal electronics. (See Figure 4.4.)

● **IMAGING DEVICE** One of the main functions of a video camera is to change the light reflected off the scene in front of the camera into electrical energy—the video signal. This is the principal function of the camera's imaging device. The imaging device in most modern cameras is a **charge-**

FIGURE 4.4 CCD Sensor and Prism Block

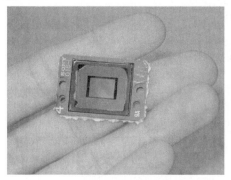

CCD Sensor (½-inch)

Red CCD

Green CCD

Blue CCD

Prism Block

coupled device (CCD), a small silicon chip inside the camera head. (Increasingly, **complementary metal oxide semiconductors,** or **CMOS,** are used as camera imaging devices as well.) CCDs and CMOS chips are referred to as optical video transducers because they convert light focused onto them by the camera lens into electrical energy. An **electronic shutter** regulates the length of time the light is exposed to the imaging device.

The surface of the CCD or CMOS chip contains a grid of **pixels,** or picture elements, arranged in a precise series of horizontal rows, or lines, and vertical columns. (See Figure 4.5.) The camera lens focuses the scene before it on this array of pixels, each of which is responsible for reproducing one tiny part of the picture. Each pixel contains a semiconductor that converts the incoming light into an electrical charge. The strength of the charge is proportional to the brightness of the light hitting the pixel and the amount of exposure time. After the incoming light is converted into an electrical charge, it is transferred and stored in another layer of the chip, and then the information is read out one pixel at a time in a line-by-line sequence in conformity with normal television scanning rates.

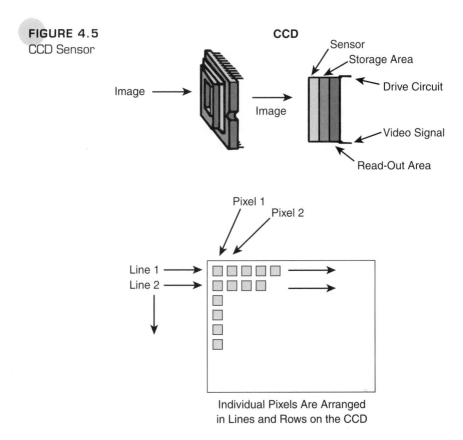

FIGURE 4.5
CCD Sensor

Individual Pixels Are Arranged
in Lines and Rows on the CCD

CCDs and CMOS chips are popular as imaging devices because they are rugged, cheap, and small and use very little electrical power. They are wafer thin and are manufactured in various sizes: 1/6, 1/4, 1/3, 1/2, or 2/3 inch, measured diagonally. Consumer cameras tend to use the smaller chips (1/3 inch or smaller); professional cameras tend to use the larger chips. In addition, consumer cameras typically use one CCD chip to create the signal, whereas professional cameras use three.

● **BEAM SPLITTER** Before the light that is focused onto the imaging device can be changed into electrical energy, it needs to be broken down into its essential color components. Color video cameras work by breaking down the incoming light into the **additive primary colors** of light: red, green, and blue. (See Figure 4.6 and CP-3 and CP-4.)

In professional- and prosumer-quality cameras this is done by passing the light through a **prism block,** a glass prism equipped with filters that assist in the color separation process. Three CCDs are employed to generate the video signal; one CCD is assigned to each of the principal color components: red, green, and blue.

In consumer-quality cameras a single CCD is charged with the responsibility of creating the entire color signal. Light hits the CCD and is

Prism Block System

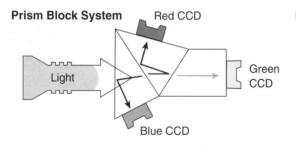

FIGURE 4.6 Prism Block System

Stripe Filter System

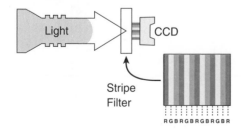

sequentially broken down by a **stripe filter** into its red, green, and blue components. As you may imagine, the quality of the signal that is produced by single-chip systems and the resulting video image are not as good as the signal and image produced by three-chip systems.

■ Camera Control Unit and Camera Internal Electronics

Video cameras contain complex electronic circuitry to process, store, and transmit the video signal. Various controls that affect the signal are located in the camera control unit (CCU). These include controls to adjust the size of the lens iris or aperture, controls to adjust the amplification or gain of the video signal, and controls to adjust the white balance and black balance of the video signal. (These are discussed in greater detail in subsequent chapters.) Depending on the type of camera, the CCU controls may be integrated into the camera head, as is the case with field-use-only camcorders, or they may be located in a remote control unit located in the control room, as in the case for cameras used in a multicamera studio or field production environment. (See Figure 4.7.)

FIGURE 4.7 Camera Control Unit (CCU)

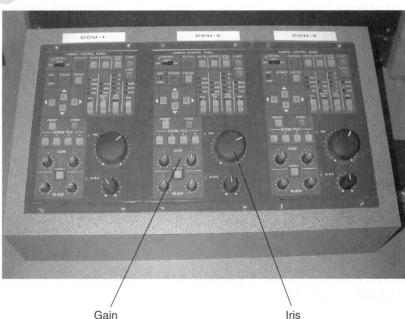

Gain Iris

■ The Camera Lens

Aside from the camera head itself, the camera lens is the most critical part of the camera system when it comes to identifying components that have the greatest effect on image quality.

● **ZOOM LENS** Color video cameras are equipped with a zoom lens. A **zoom lens** is a variable focal length lens that allows the camera operator to change the angle of view without changing the lens. A point of comparison here is fixed focal length lenses, which are often used by still photographers and in feature film production. A **fixed focal length lens** produces only one angle of view. To make the image appear closer or farther away, the camera needs to be physically moved closer to the subject or farther away from it. With a zoom lens, all the camera operator has to do is **zoom** in or zoom out to change the size of the subject.

● **STUDIO LENSES AND EFP LENSES** Studio cameras and cameras used for multicamera sports and event telecasts are typically equipped with very large, heavy, studio-type zoom lenses. (See Figure 4.8.) These large lenses often have great magnification power that enables the camera operator to get very high-quality close-up shots even from a great distance.

FIGURE 4.8 Studio Lens versus EFP Lens

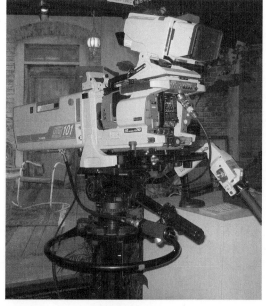

Studio Lens

EFP Lens

Lenses that are used on camcorders for electronic field production (EFP) and electronic news gathering (ENG) need to be lighter so that the camera operator can easily carry the camera. And because cameras that are used in EFP and ENG are usually placed fairly close to the action (e.g., an interview), they do not need to have the magnification power of lenses used in large studios or in large-scale event production. Therefore these lenses are significantly smaller than their full-size studio counterparts. (See Figure 4.8.)

■ Viewfinder

The camera **viewfinder** is a small video monitor that displays the image the camera is producing. Three types of viewfinder systems are in use: studio viewfinders, eyepiece viewfinders, and LCD viewfinders. (See Figure 4.9.)

FIGURE 4.9 Camera Viewfinder Systems

Studio Viewfinder

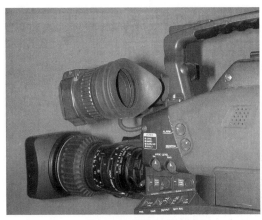

Eyepiece Viewfinder

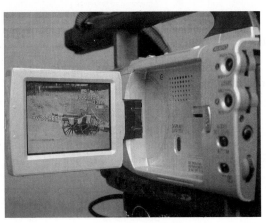

LCD Viewfinder

Studio viewfinders are mounted on top of the camera. They are typically 5 to 7 inches in diagonal. The camera operator stands behind the camera as he or she operates the camera.

Eyepiece viewfinders are used on EFP/ENG cameras and camcorders. Typically, they are mounted on the left side of the camera (to accommodate right-handed camera operators). A small rubber eyepiece is attached to a diopter that is positioned above a very small (usually 1- to 1½ inch) video monitor. The camera operator holds the camcorder on his or her shoulder and presses one eye to the viewfinder. Many eyepiece viewfinders contain a focus control that allows the camera operator to focus the image for his or her vision. This allows camera operators who wear eyeglasses to shoot without using their glasses.

LCD viewfinders are found on an increasing number of consumer and professional cameras and camcorders. Typically, these displays are mounted on the side of the camera and flip out for easy viewing. LCD viewfinder systems allow the camera operator to see the viewfinder image while the camcorder is held at arm's length, making it possible to record from difficult or unusual angles that might not be possible with a conventional eyepiece viewfinder system.

Viewfinders on professional and prosumer cameras may contain a **zebra-stripe** exposure indicator. In this system, a series of black-and-white lines appears over the brightest portion of the picture when the maximum video level has been reached. In some camera viewfinders the zebra stripes are set to appear when the correct exposure for skin tones is achieved.

■ Video Monitors

Video monitors reverse the process of the CCD: Their job is to take the electrical video signal and turn it back into a picture, in the form of light energy displayed on a screen. Several different video display systems are now in use.

Cathode-ray tube (CRT) systems are based on analog-type vacuum tube technology. An electron beam scans the inside face of the monitor screen, which is coated with a series of red, green, and blue phosphors, which glow when they are hit by the electrical charge of the electron beam. (See Figure 4.10 and CP-2.)

FIGURE 4.10 Cathode Ray Tube (CRT) System

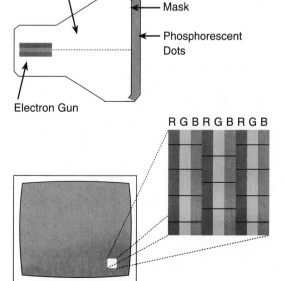

FIGURE 4.11

Plasma Display
Panel

Liquid crystal display (LCD) systems are flat-panel screens that are widely used in laptop computers and increasingly as video display panels. They are based on liquid crystal material that emits light when stimulated with an electrical charge.

Plasma display panel (PDP) systems are similar to LCDs in that they are flat-panel screens, but instead of liquid crystal they use neon gas compressed between two layers of glass embedded with crisscrossing horizontal and vertical electrodes to excite the red, green, and blue phosphors in the screen. (See Figure 4.11.)

How the Video Camera Makes a Picture: Analog and Digital Standards

The process of transducing light energy into electrical energy is accomplished by the camera's imaging device—the CCD or CMOS chips—as we discussed above. To produce a video signal that can be displayed on any video monitor, camera and video recorders must adhere to a set of technical standards that govern how the video signal is created and displayed. Currently, two sets of standards are in use in the United States: the original **NTSC (National Television System Committee)** standards adopted for

69

How the Video
Camera Makes
a Picture:
Analog and
Digital
Standards

analog television by the Federal Communications Commission in 1941 and the **ATSC (Advanced Television System Committee)** standards for digital television adopted by the FCC in December 1996. These standards cover a wide range of technical specifications for how the video signal is constructed and transmitted. For the purpose of this discussion the important elements of the standards on which we will focus include the aspect ratio of the image, frame and line rates, and scanning patterns.

▧ NTSC Video:
The Analog Standard

The NTSC video standards were developed in the United States in the 1930s and have been in use since over-the-air broadcast television was initiated in the United States in the early 1940s. Anyone reading this book who grew up in the United States has been watching television that was based on the NTSC standard.

● **ANALOG SIGNAL** In the NTSC system the video signal is an analog signal. In cameras an **analog signal** is one in which the recorded signal varies continuously in proportion to the light that produced it. The video signal can be viewed on a piece of monitoring equipment called a waveform monitor. The **waveform** that is produced by an analog video camera corresponds to the bright and dark areas of the scene the camera is recording. (See Figure 4.12.)

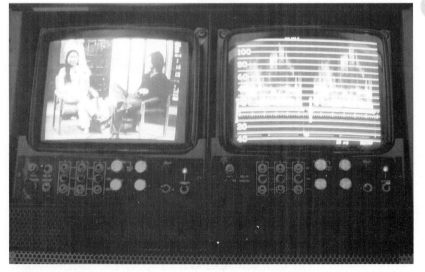

FIGURE 4.12
Camera Display
and Waveform

● **ASPECT RATIO** The most noticeable feature of the NTSC standard is the shape of the video screen, also known as its **aspect ratio.** In NTSC video the screen shape is a standard ratio of 4:3 (width:height). No matter how large or small the screen is, it will retain these standard rectangular proportions in which the screen is only slighter wider than it is tall. (See Figure 4.13.)

● **FRAME AND LINE RATES** The video image is composed of a number of **frames** and **lines** that play out at a specified rate. In the NTSC system cameras produce 30 frames of video information per second, and each one of those frames is composed of 525 lines of information. Furthermore, each of the individual scanning lines is composed of a series of about 700 light-sensitive pixels.

In reality, the precise frame rate for NTSC video has been 29.97 frames per second since the color television standards were developed in the early 1950s. And of the 525 actual lines, only 480 are actively used to transmit picture information. However, this text follows the widely adopted convention of referring to the NTSC standard as 30 frames per second and 525 lines per frame.

● **INTERLACED SCANNING** In the NTSC system each television frame is constructed through a process called **interlaced scanning.** When the video signal is output through the CCD, instead of sending out lines

FIGURE 4.13
Aspect Ratio

Conventional Screen

4:3

Wide Screen

16:9

71

How the Video
Camera Makes
a Picture:
Analog and
Digital
Standards

Interlaced Scanning

Each Television Frame Is Composed of Two Fields

262.5 Odd Lines

262.5 Even Lines

The Odd Lines Are Scanned First

Then the Even Lines Are Scanned

Progressive Scanning

Starting with Line 1, Each Line Is Scanned
Progressively to the Bottom of the Frame

FIGURE 4.14 Interlaced
and Progressive Scanning

1–525 sequentially, each frame is broken up into two **fields:** One is composed of the odd-numbered lines, the other of the even-numbered lines. First the odd-numbered lines are read out, and the even-numbered lines follow. At the receiver, the image is constructed field by field and line by line. (See Figure 4.14.)

This somewhat complex system was developed to overcome the technical limitations of early television display and transmission systems. Monitors of the time used CRTs coated with phosphorescent material that would glow when they were scanned with an electron beam.

Unfortunately, if the 525 scanning lines that composed the picture were scanned sequentially from top to bottom, the top of the screen would fade out before the picture was complete. This created a flickering effect in the image. By splitting the frame into two fields, scanning the image one field at a time, and interlacing the lines, the problem of flickering was solved, and the picture maintained its brightness throughout the program.

The interlaced scanning system also solved a signal transmission problem. By breaking each frame into two fields, each with only half of the picture information, the bandwidth that was assigned to each television station was able to accommodate the signal.

Of course, one of the consequences of interlaced scanning is reduced picture quality. Because only half of the lines of each frame are displayed at one time, the picture resolution is significantly poorer than it would be if all of the lines were displayed at once.

■ ATSC Video: The Digital Standard

In 1996 the Federal Communications Commission adopted a new set of video standards that had been developed by the ATSC. Adoption of these standards was the culmination of over a decade of discussions centered on converting the existing analog television system to one based on a digital standard. ATSC differs from NTSC in many significant ways. One of the most significant differences is that unlike NTSC, in which aspect ratio, frame rate, and line rate all meet a single standard, ATSC is an open standard that is able to accommodate signals with various line and frame rates and two different aspect ratios. (See Table 4.1.)

● **DIGITAL SIGNAL** In the ATSC system the video signal is **digital.** In digital camera systems light hits the CCD and creates an electrical charge. That electrical charge is then sampled and converted into a binary digital numerical code consisting of **bits** made up of a pair of off/on (0/1) pulses. This is called **quantizing.** (See Chapters 5 and 10 for a more detailed discussion of digital audio and video.)

In comparison to an analog signal, which varies continuously in relation to the phenomenon that produced it (e.g., variations in the amount of

■ **TABLE 4.1** The ATSC Digital Television Scanning Formats

Vertical Lines	Horizontal Pixels	Aspect Ratio	Picture Rate*	HDTV/ SDTV
1,080	1,920	16:9	60I 30P 24P	HDTV
720	1,280	16:9	60P 30P 24P	HDTV
480	704	16:9 and 4:3	60I 60P 30P 24P	SDTV
480	640	4:3	60I 60P 30P 24P	SDTV

*"I" means interlaced scan, and "P" means progressive scan.
HDTV = High-definition television.
SDTV = Standard-definition television.

Source: Advanced Television System Committee.

73

How the Video
Camera Makes
a Picture:
Analog and
Digital
Standards

light hitting the CCD), in a digital system only selected points are sampled. As you may imagine, the higher the sampling rate and the more bits assigned to each sampling point, the more accurate the digital code will be.

● **ASPECT RATIO** Early in the discussions that led to the development of the ATSC standard one of the goals was to develop a new set of standards for **high-definition television (HDTV)**—television with an increased line rate that could deliver substantially improved picture quality. Another one of the issues that the standards makers had to confront was the fact that all of the feature films of the day were produced in a variety of wide-screen formats. Fitting those films onto a television screen means cutting off parts of the picture so that it will fit onto the 4:3 frame. ATSC settled on a 16:9 aspect ratio for HDTV to better accommodate the transmission of feature films. Because so much program material had already been developed in the standard 4:3 aspect ratio, the ATSC standard can accommodate that as well.

● **FRAME AND LINE RATES** Just as the ATSC standard can accommodate various aspect ratios, it is also flexible in its ability to transmit pictures with various numbers of lines. In addition to the 480 (active) line × 704 pixel standard used by NTSC (now called **standard-definition television,** or **SDTV**), the ATSC standard contains two HDTV standards with either 1,080 lines and 1,920 pixels per line or 720 lines and 1,280 pixels per line, as well as the 480 line × 640 pixel variant that is equivalent to the super VGA standard used to display graphics on computer screens.

The ATSC standard includes the 60 field per second (30 frame per second) interlaced scanning standard on which NTSC is based, and also can accommodate signals based on a standard of 24 or 25 frames per second. Twenty-four frames per second is the standard projection rate for feature films. Twenty-five frames per second is the standard used by European broadcasters and in other countries throughout the world that are not based on NTSC.

● **PROGRESSIVE AND INTERLACED SCANNING** Improvements in video displays have eliminated the technical issues that required interlaced scanning. If you have ever sat in front of a computer monitor, you have viewed an image in which each of the lines is scanned progressively. In **progressive scanning,** each of the lines in the frame is scanned successively. In the 720-line system, scanning begins with line 1 and continues to line 720; then the process repeats. (See Figure 4.14.)

The ATSC standard accommodates progressive scanning as well as interlaced scanning. For example, one of the popular HDTV formats uses 720 scanning lines, scanned progressively. Another popular HDTV format relies on 1080 scanning lines, interlaced.

Production equipment has been produced to accommodate some of these standards, and more is in development. Many of the new cameras that are available to professional video producers have selectable frame rates and aspect ratios, allowing the cameras to be used to provide program material in a variety of the digital formats. Even many inexpensive camcorders allow for aspect ratio changes from 4:3 to 16:9, and some are capable of 24-frame-per-second progressive scanning as well.

Camera Operational Controls

Most cameras and camcorders have a standard set of operational controls with which you should be familiar with if you are going to be the camera operator. (See Figure 4.15.)

FIGURE 4.15
Camera Operational
Controls

Camera Section VCR Section

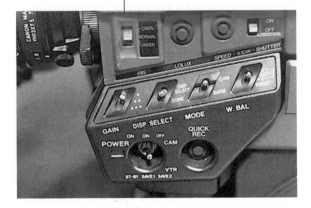

Power Switch

All cameras and camcorders run on electrical power supplied either by a battery (DC—direct current) or by regular electrical power (AC—alternating current). The power switch may be a simple ON–OFF switch, or it may be a three position ON–OFF–STANDBY switch. The standby mode is used to conserve power, particularly on battery-operated camcorders. When the camcorder is in the standby mode, the camera electronics are on, but the image sensor and viewfinder are not activated. This not only conserves battery power, but also prolongs the life of the image sensor. When the switch is moved to the ON position, the viewfinder and image sensor are activated, and the camera becomes fully operational.

Color Bars/Camera Switch

The color bars/camera switch allows the camera operator to select the signal that the camera will produce. In the CAMERA position the camera output is the video signal generated by the image sensor. In the COLOR BARS position the camera generates a standard pattern of yellow, cyan, green, magenta, red, and blue bars that are used as a standard color reference by video engineers. (See Figure CP-5 in the color insert.) It is standard practice to record color bars at the beginning of each studio production and on each tape recorded in the field.

Color Correction Filters

Most professional and prosumer cameras and camcorders contain a series of filters that are used to compensate for differences in the color temperature of the light falling on the scene. (See Figure 4.16.) The two most essential settings are 3,200°K (equivalent to the color temperature of tungsten halogen lights used in television studio production) and 5,600°K (equivalent to the color temperature of daylight). On consumer equipment these switches may be labeled INDOOR and OUTDOOR.

Professional cameras are likely as well to have one or more **neutral density filters.** These filters reduce the amount of light that reaches the image sensors without effecting the color temperature of the light. The neutral density filter is typically used in conjunction with the lens iris when shooting outdoors in very bright conditions to control depth of field. Under very bright outdoor lighting conditions the lens will generally produce an image with great depth of field. To shorten the depth of field, the neutral density filter is engaged, which then requires the lens iris to open up to let in more light. As the iris gets larger, the depth of field gets shorter. This allows the camera operator to exercise a degree of aesthetic control over the portions of the image that are in focus and out of focus.

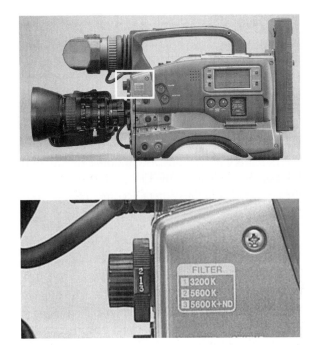

FIGURE 4.16
Color Correction
Filters

■ White and Black Balance

Because the color temperature of light varies so much, all color video cameras contain electronic circuitry designed to correct the white balance of the camera. White balance adjusts the relative intensity of the red, green, and blue color channels to allow the camera to produce an accurate white signal in the particular light in which the camera is recording. Once the camera is set to produce white accurately, it can produce all of the other colors in the scene accurately as well (see CP-7).

There are three common white balance modes. *Automatic white balance* continuously and automatically regulates the camera's electronic color circuitry even if the color temperature of the light changes while the camera is recording the scene. *Preset white balance* controls allow the camera operator to manually choose from a variety of preset settings, such as 3,200°K (tungsten halogen) or 5,600°K (daylight), or from a menu of various light sources, such as incandescent, fluorescent, daylight, and overcast lighting conditions. *Manual white balance* controls require the camera operator to set the white balance for the existing light conditions by focusing the camera on a white card and activating the manual white balance switch. If the lighting conditions change or if the camera changes position, the white balance procedure needs to be repeated.

Professional cameras may include a **black balance** control in addition to white balance. Black balance adjusts the video signal to produce black at a preset point in the video waveform.

■ Gain Boost/Sensitivity

The function of the **gain boost** switch is to amplify the video signal. This is most often used in low-light situations to electronically brighten the picture when not enough light is falling on the scene to produce an acceptable image. However, the benefit is not without a cost; increased brightness may come at the expense of picture quality, which may suffer from an increase of visible electronic noise.

■ Electronic Shutter

The electronic shutter controls the amount of time that light passing through the camera lens hits the CCD image sensors. The normal shutter speed for cameras operating on the NTSC standard is one sixtieth of a second, which corresponds to the exposure time for one field of video information. In recording situations in which the camera image tends to flicker or become blurred because of high-speed movement of the subject in front of the camera, shutter speed can be increased to reduce these picture artifacts and improve the sharpness of the image. Shutter speed can also be adjusted in conjunction with the camera iris to increase or decrease depth of field.

Shutter speeds commonly range from 1/60 to 1/10,000 of a second, with incremental settings of 1/100, 1/250, 1/1,000, 1/2,000, 1/4,000, and 1/8,000. In addition, some cameras feature a variable shutter speed, which can be used to eliminate the screen flicker that becomes visible when a computer screen or video monitor appears in a shot.

Camera Supports

Although both consumer- and professional-level camcorders are light enough to be shoulder carried, or hand carried as in the case of many of the smaller consumer models, a variety of camera supports are used to provide stability and control to studio and field camera systems.

■ Studio Pedestal

The combined weight of a large studio camera equipped with a full-size lens can be quite significant, and to provide adequate support, a camera **pedestal** may be used. (See Figure 4.17.) In addition to supporting the

FIGURE 4.17
Studio Pedestal

weight of the camera, viewfinder, and lens, the pedestal has two other advantages: The base of the pedestal is equipped with wheels that make it easy to move the camera on a smooth studio floor, and the height of the camera on the pedestal can be raised or lowered, allowing for high- and low-angle shots.

■ Tripod

Tripod mounts—or **sticks,** as they are often called because of the wooden legs on some models designed for use in the field—are widely used as camera supports. Tripods are lighter and more portable than pedestals. (See Figure 4.18.)

Tripods equipped with a wheeled **dolly** are often used in studio applications. (See Figure 4.19.) The wheels allow the camera and tripod to be moved from one place to another but generally do not provide the kind of fluid movement that can be achieved with a pedestal.

Tripods that are used in field production situations may be equipped with a **spreader,** a device that works well on a flat surface and holds the

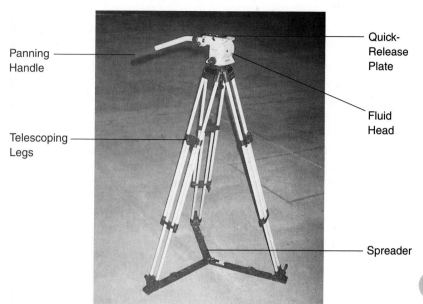

Panning
Handle

Quick-
Release
Plate

Fluid
Head

Telescoping
Legs

Spreader

FIGURE 4.18
Tripod

tripod legs firmly in place. Tripods usually contain telescoping legs that allow the height of the camera to be adjusted, but in contrast to the studio pedestal, height adjustments cannot be used as a production technique— once the height of the camera is set, the tripod legs are securely fastened.

Some camera operators prefer the use of a **monopod,** a telescoping rod that is attached to the base of the camcorder and is inserted into a special belt pouch. Monopods work best with lightweight cameras and camcorders.

FIGURE 4.19
Studio Tripod Dolly

■ Gyroscopic Camera Support Systems

A number of manufacturers produce camera-mounting systems that incorporate gyroscopes in their design. They are often called by the trade name of the product produced by the best-known manufacturer of these systems: **Steadicam®.** (See Figure 4.20.) Depending on the size of the camera and the corresponding size of the mounting system, it may be worn by the camera operator, as in the case of large cameras, or hand-held, as in the case of small consumer-level camcorders. In either case, the use of these gyroscopically stabilized systems allows for extremely fluid camera motion, even when the camera operator walks or runs with the camera. The effect is almost as if the camera is floating through the scene.

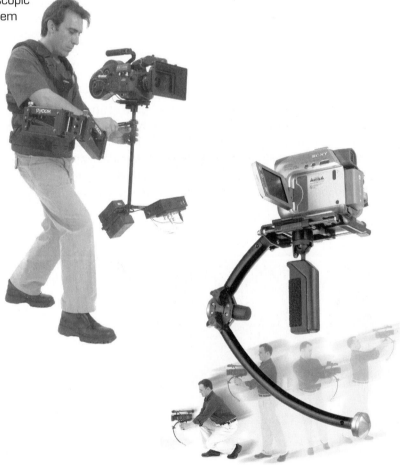

FIGURE 4.20 Gyroscopic Camera Support System (Steadicam®)

■ Jib

A **jib** is a fulcrum-mounted camera support system that allows the camera to be raised high above the scene to be recorded. (See Figure 4.21.) The camera is attached to the end of the jib arm, which is raised and lowered by the camera operator. A series of remote controls govern the zoom, pan, tilt, and focus functions. On some systems the length of the jib arm can be extended; on others it is a fixed length. Jibs are widely used in studio and field applications because they provide a relatively simple way to achieve very dramatic high and low camera angles.

■ Robotic Camera Systems

Studio cameras used for the production of television news may be operated by *robotic remote control* rather than by individual camera operators. In robotic systems control of the cameras and their supports is automated. A computer system is used to program the individual shots and camera moves for each of the cameras. One technician can operate multiple cameras from the control room instead of committing one camera operator to

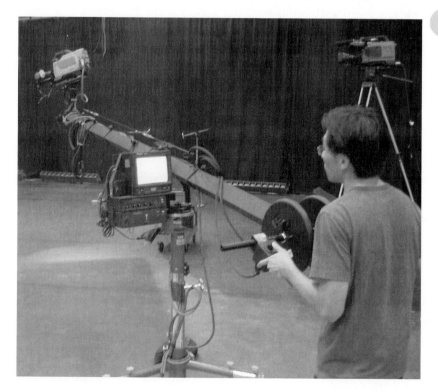

FIGURE 4.21
Camera Jib

each camera. For many television stations the use of robotic cameras is extremely cost-effective because the expense of the robotic systems is quickly recouped from savings in crew salaries.

The Zoom Lens

Most modern video cameras are equipped with a zoom lens. (See Figure 4.22.) The zoom lens is used to change the angle of view of the image the camera produces. By adjusting the zoom control, the operator can zoom in (make an object appear larger and closer) or zoom out (make the object seem to decrease in size or move farther away). (See Figure 4.23.)

■ Focal Length and Zoom Ratio

Technically speaking, a zoom lens is a lens with a continuously variable focal length. **Focal length** is defined as the distance from the optical center of the lens to the point where the image is in focus—the surface of the CCD. Lens focal length is measure in millimeters (mm). Because the zoom lens is capable of being adjusted to a variety of focal lengths, these lenses are often described by their **zoom ratio:** a ratio between the lens at its narrow (close-up) angle to its wide (long-shot) angle. For example, a zoom lens with a wide-angle focal length of 8 mm and a zoom ratio of 20:1 has an effective focal length of 160 mm when it is zoomed in all the way (160:8 is a ratio of 20:1).

FIGURE 4.22
Zoom Lens

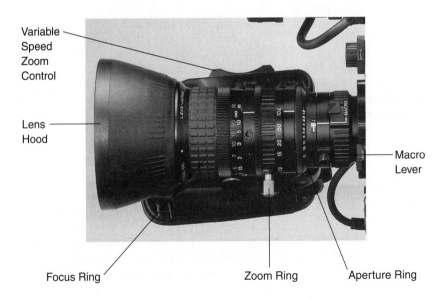

Variable
Speed
Zoom
Control

Lens
Hood

Macro
Lever

Focus Ring

Zoom Ring

Aperture Ring

Lens

Lens Zoomed Out: Wide Angle of View

Lens

Lens Zoomed In: Narrow Angle of View

FIGURE 4.23
Focal Length and
Zoom Ratio

A zoom lens with a zoom ratio of 20:1 or higher is particularly useful for outdoor shooting. Distant objects can be magnified simply by zooming in on them. In a small studio environment a lens with a zoom ratio between 10:1 and 15:1 may well be sufficient.

Operating the Zoom Lens

There are three principal operational controls for the zoom lens: focus control, zoom control, and aperture control. Each of these plays a major role in controlling the quality of the image that is delivered to the camera's image sensor. On studio cameras, the focus and zoom controls are mounted on the **pan handles,** which are attached to the pedestal or tripod.

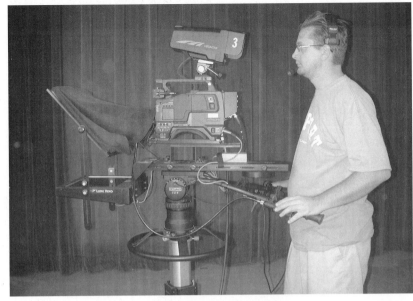

FIGURE 4.24
Zoom and Focus
Controls on a
Studio Camera

Camera Operator in the Studio

Zoom Control on the Right Pan Handle

Focus Control on the Left Pan Handle

(See Figure 4.24.) This allows the camera operator to change the angle of view and focus the camera while standing behind the camera and looking into the viewfinder. On camcorders that are designed for EFP/ENG and equipped with an eyepiece viewfinder, the camera is held on the camera operator's shoulder and the camera operator adjusts the zoom and focus controls directly on the lens housing. (See Figure 4.22.)

CP-1 Color Video Camera Systems

Color video systems work with the **additive primary colors** of light: red, green, and blue. As light enters the lens, the color video system breaks the light into its red, green, and blue components. This can be done in two different ways. Incoming light can be passed through **a prism block** (see left below), or a **stripe filter** can be attached to the face of the image sensor to break the light into its color components (see right below).

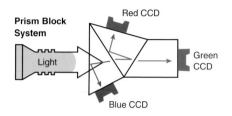

CP-2 Color Reproduction

The color picture on a home television CRT receiver is created in a way similar to the camera color process. The picture tube in a television set is covered with a series of phosphorescent dots arranged in groups that consist of one red, one green, and one blue dot. The color video signal is composed of varying amounts of these three colors, depending on the scene that is being shot. When the color video signal is fed into a monitor, it triggers the electron gun at the back of the tube to scan the face of the picture tube, and it activates the red, green, and blue dots on the screen in relation to their relative strength in the signal. What you see when watching the screen is a full-color picture.

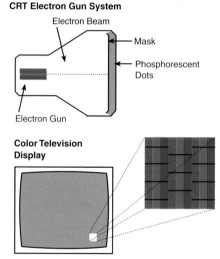

CP-3 Additive Primary Colors of Light

Red, green, and blue are called the additive primary colors of light because they can be combined to form white light as well as any other color of the spectrum. No other three colors can do this.

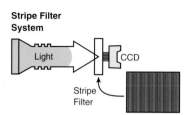

CP-5 Color Bars

A standard display of white, yellow, cyan, green, magenta, red, and blue bars is used as a color reference to adjust video camera and monitors.

CP-4 Additive Secondary Colors of Light

Note how the additive primary and secondary colors of light correspond to the colors on the color bar display in CP-5.

CP-6 Composite, S-Video, and Component Video Outputs on a VCR

The composite (Line Out) video output mixes together the luminance (brightness) and chrominance (color) signals. The S-Video output separates the luminance and the chrominance signals. The component video output separates the signal into its luminance (Y), blue (Pb), and red (Pr) color components.

CP-7 White Balance

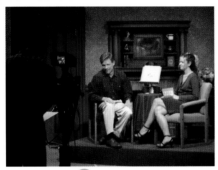

Correct white balance under tungsten halogen studio lights.

Incorrect white balance under studio lights. ▶
The camera was white balanced for daylight, so the picture appears to be too red.

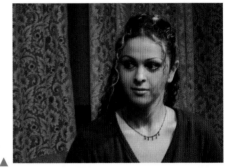

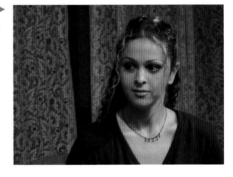

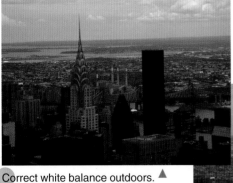

Correct white balance outdoors. ▲

◀
Incorrect white balance outdoors. The camera was white balanced for tungsten halogen lights, so the picture appears to be too blue.

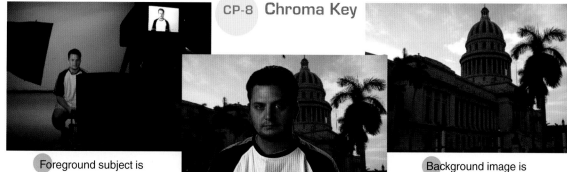

CP-8 Chroma Key

Foreground subject is recorded against a blue or green background.

Background image is recorded separately.

Blue or green background is subtracted, and foreground image is combined with the background image.

CP-9 Contrasting Colors

Lettering that contrasts with the background is easier to read than is lettering that is similar in color to the background.

CP-10 TV Graphics

TV graphics are most effective when they use bold simple designs and contrasting foreground/background colors.

CP-11 High Energy Expressive Colors

The San Francisco Conservatory of Flowers

Welcome to San Francisco,
City by the Bay

Visit the Golden Gate Bridge

Visit the Palace of Fine Arts

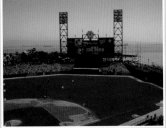

Go to the ballpark by the bay

But don't miss the Conservatory of
Flowers: the famous Crystal Palace

Enjoy its exterior gardens

Come and see the aquatic plants

The exotic tropical flowers

The living museum of tropical plants

Admire the dome: the dome is back!

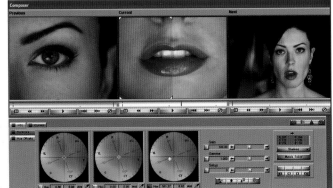

CP-13 Color Correction

Avid's Media Composer nonlinear
editing system provides sophisticated color correction tools for the postproduction editor.

● **FOCUS CONTROL**　The image is *in focus* when the important parts of the image are seen in sharp detail, and it is *out of focus* when it is fuzzy and unclear. The focus on all professional cameras is adjusted manually by the camera operator, either by adjusting the focus ring at the end of lens on EFP/ENG cameras or by adjusting the remote control on the pan handle of a studio camera. Rotating the focus control clockwise or counterclockwise brings the image into and out of focus. To keep an image in focus throughout the zoom range, zoom in to the tightest shot possible on the subject you are shooting and focus the lens. Then zoom out. The image should stay in focus, and as long as the distance between the camera and the subject doesn't change, the image will be in focus when the camera zooms back into its close-up shot.

If the lens is unable to focus an image at the widest angle of the zoom (when the lens is zoomed out all the way), the camera's **back focus** needs to be adjusted. On some cameras there is a back focus adjustment on the lens housing. On other cameras a technician may need to make this focus adjustment.

Most consumer grade camcorders are equipped with an **automatic focus (autofocus)** mechanism that focuses the lens by emitting a beam of infrared (invisible) light or ultrasound (inaudible sound). The beam bounces off the object being recorded and travels back to the camcorder. A servomechanism then automatically adjusts the lens for correct focus.

Autofocus can be helpful, particularly for inexperienced camera operators, because it guarantees sharp focus in shooting situations that may be difficult for the novice to control. For example, autofocus will keep the image in focus in low-light situations in which it may be hard to see the image in the viewfinder, and it will keep the image in focus if you zoom in or zoom out.

● **ZOOM CONTROL**　Modern lenses contain a motor-driven zoom lens. The zoom lens control (mounted on the lens on EFP/ENG cameras and on the pan handle of studio cameras) has a *zoom-in* position at one end and a *zoom-out* position at the other end. These are often labeled "T," to indicate the tight, telephoto, zoomed-in position, and "W," for the wide, zoomed-out position. (See Figure 4.25.)

Some zoom lens controls have one or two preset speeds that allow the operator to set the speed selector switch for a fast or slow zoom. More sophisticated zoom lenses have continuous variable-speed motors hooked up to the lens. The zoom speed is controlled by the amount of pressure that is put on the control—the zoom speed increases with increased pressure and decreases with decreased pressure. This guarantees extremely smooth zooming over the whole zoom range of the lens.

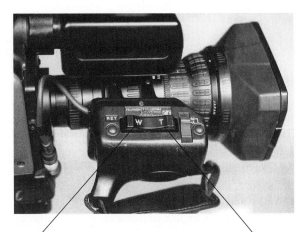

FIGURE 4.25
Motor-Driven
Zoom Lens

Wide Angle
(Zoom Out)

Tight/Narrow Angle
(Zoom In)

Many professional-quality ENG/EFP lenses also contain a manual zoom control. This disengages the zoom lens motor and allows the camera operator to manually control the speed of the zoom by rotating the **zoom ring** on the barrel of the lens.

● **APERTURE CONTROL** The **aperture,** or **iris,** of the lens regulates the exposure of the image by controlling the amount of light that passes through the lens and hits the CCD image sensors. The iris of the lens works like the iris of the eye. In low-light situations the iris needs to be opened up to allow more light to hit the image sensor. In bright situations, the size of the iris needs to be reduced to decrease the amount of light hitting the sensors.

Its **f-stop number,** a standard calibration of the size of the aperture opening, describes the size of the aperture or iris opening; f-stop numbers usually vary from about 1.4 to 22. Typical f-stop settings on a lens are f-1.4, f-2, f-2.8, f-4, f-5.6, f-8, f-16, and f-22. Small f-stop numbers correspond to large aperture openings; large f-stop numbers correspond to small aperture openings. (See Figure 4.26.) In addition, most lenses have an iris setting in which the aperture can be completely closed to prevent any light from hitting the image sensors during those times when the camera is not in use.

● **OTHER LENS COMPONENTS** EFP/ENG camcorders and convertible cameras typically include a soft rubber lens hood attached to the end of the lens. The **lens hood** works like the visor on a hat to prevent unwanted light from hitting the lens and causing lens flare. **Lens flare** is an optical aberration that is caused when light bounces off the elements within

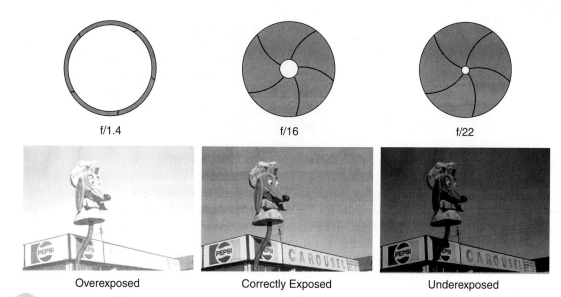

f/1.4　　　　　　　　f/16　　　　　　　　f/22

Overexposed　　　Correctly Exposed　　　Underexposed

FIGURE 4.26 F-Stop Numbers and Aperture Size

a lens. Most often, lens flare is caused by pointing the camera directly at the sun or a studio lighting instrument. (See Figure 4.27.)

The **lens cap** is a cover that is attached to the end of the lens to protect the lens class from damage when the camera is not in operation and to prevent light from hitting the image sensors when the camera is off. The lens cap should always be used when the camera is not in operation; in field

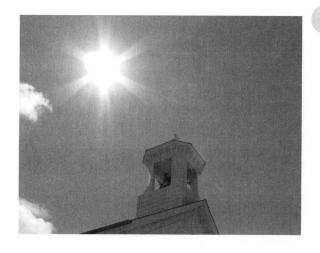

FIGURE 4.27
Lens Flare

recording situations it should always be used when the camera is being transported from one location to another.

A **macro lever** is a device that converts the lens to a macro lens, allowing the camera to take extreme close-up shots of very small objects by moving them very close to the lens. In the normal zoom lens mode most lenses are not capable of focusing on objects that are closer than two or three feet from the end of the lens. When the macro lens function is activated, the camera can focus on objects that are only inches away from the lens and magnify their size so that they fill the video frame.

A variety of lens filters are available for use with studio and field lenses. Filters may be used to change the quality or amount of light passing through the lens, or they may be used to achieve special effects. *Fog filters* and *star filters* are popular special effects lens filters.

Aperture Control and Depth of Field

Depth of field refers to the portion of the scene that is in focus in front of the camera. Depth of field can be very long or very short, depending on the amount of available light, the aperture setting, the distance between the

▦ **TABLE 4.2** Depth of Field Relationships

+ amount of available light + f-stop number (– aperture size) – focal length of the lens + distance from camera to subject	Depth of field increases[a]
– amount of light – f-stop number (+ aperture size) + focal length of the lens – distance from camera to subject	Depth of field decreases[b]

[a]With an increase in the amount of available light, the f-stop number increases (aperture size decreases) and depth of field increases. With a decrease in the focal length of the lens, depth of field increases. With an increase in distance from camera to subject, depth of field increases.

[b]With a decrease in the amount of available light, the f-stop number also decreases (aperture size increases) and depth of field decreases. With an increase in the focal length of the lens, depth of field decreases. With a decrease in the distance from camera to subject, depth of field decreases.

subject and camera, and the zoom lens setting. Table 4.2 shows these relationships. In addition, let's consider two typical situations that illustrate how these variables work together.

■ Example 1:
Low Light in the Studio

Let's assume that you have set up a romantic scene in the studio. You are trying to create the illusion that it is evening in a cozy living room. To create the illusion, you have brought down the overall light level on the set, and you have worked hard to reduce the amount of light falling on the walls of the living room. Although you are still within the baselight range for the camera, you are at the lower end of it. As a result, you may need to open the aperture to achieve the correct exposure.

Because this is a romantic scene focused on two individuals, you decide to use a lot of close-up camera shots. To achieve these close-ups, you move your cameras close to the actors and have your camera operators zoom in on your subjects. When they do this, you notice that the background quickly falls out of focus. Why? Because all of the elements have conspired to reduce the depth of field. The low light level caused you to open the camera iris. As you can see in Table 4.2, when you increase the size of the aperture, depth of field decreases. Moving the cameras close to the subjects and zooming in, which increases the focal length of the lens, also contributes to shortening the depth of field.

■ Example 2:
Daylight Outdoors

Contrast the studio scene in Example 1 with the following field production situation. You have been assigned to photograph a parade at noon on a bright, beautiful summer day. To be able to show the magnitude of the event, you position yourself at the top of the reviewers' grandstand along the parade route. This puts you quite a distance from the parade. When your camera is on a wide shot (lens zoomed out), you notice that everything in front of the camera is in focus as far as you can see. Again, look at Table 4.2. You have great depth of field because there is a lot of light on the scene, causing the aperture size to decrease. You have decreased the focal length of the lens by zooming out, and the camera is a significant distance from the main subject. All of these elements contribute to increase the depth of field.

If you change only one of these elements—the focal length of the lens—you immediately see a dramatic change in the depth of field. When you zoom in to get a close up of the action, you notice again that the people

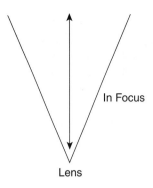

In Focus

Lens

Long Depth of Field: Lens Zoomed Out

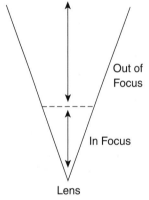

Out of
Focus

In Focus

Lens

FIGURE 4.28
Long and Short
Depth of Field

Short Depth of Field: Lens Zoomed In

and objects behind the subject go out of focus, as they did in the studio. By zooming in, you increased the focal length of the lens, and this has resulted in shortening the depth of field. (See Figure 4.28.)

Camera Movement

In addition to zooming the lens to change the angle of view on the subject, there are several other types of camera movement that are commonly used in video production.

■ Panning and Tilting

When the camera is mounted on a tripod or pedestal, the camera can smoothly be panned or tilted. A **pan** is a horizontal movement of the camera head only. The word *pan* is short for *panorama*, and the purpose of the

pan is to reveal a scene with a sweeping horizontal motion of the camera head. A **tilt** is a vertical (up-and-down) movement of the camera head.

Professional tripods and pedestal heads contain controls to help control panning and tilting. Pan and tilt **drag** controls introduce varying degrees of resistance to the head so that the camera operator can pan and tilt smoothly.

Cameras mounted on tripods shoot from a fixed height. The camera can be raised or lowered by manually extending or retracting the tripod legs. Needless to say, this cannot be done while the camera is shooting the picture.

High-quality studio pedestals, on the other hand, often have the ability to raise or lower the camera smoothly while the camera is photographing the scene. This allows the camera operator and video director to introduce dynamic motion effects into the program.

Dolly, Truck, and Arc

Movement of the camera and its support unit (either a pedestal or tripod with a three-wheel dolly attached to the legs) produces the movement of dolly, truck, and arc. A **dolly** in or out is the movement of the entire camera toward or away from the scene. A **truck** left or right is the horizontal movement of the camera and its support in front of the scene. An **arc** is a semicircular movement of the camera and its support around the scene.

Of course, to achieve these effects, you must have not only a wheeled pedestal or tripod, but also a smooth surface to move the camera across. This is an advantage that studios provide over field shooting.

When dynamic trucking or dollying shots are needed in the field, a set of rigid tracks can be constructed for a camera dolly to roll on. This practice gave rise to the term *tracking shots.*

Hand-Held Camera Movement

Effective camera movement can be achieved with a hand-held camera, but it takes practice to master the technique. Novice camera operators tend to move the camera too quickly. This applies to panning and tilting as well as to zooming. Remember that one of the essential qualities of a successful production is the quality of control. Camera movement, like lighting and other production elements, needs to be controlled to be effective.

Because the ground needs to be smooth for tripod dollies to be effective and track systems take a considerable time to construct, increasingly, when smooth camera movement is called for in field production, a gyroscopic camera mount system like the Steadicam® system described earlier in this chapter will be used. With it the camera seems to float effortlessly through the scene as the camera operator walks or even runs along with the action.

Operating the Video Camera

■ In the Studio

The camera operator's call to action in the studio often begins with the director saying, "Cameras to headphones" over the studio talkback system. This is the camera operator's cue to go to his or her camera, uncap the camera, put on the headsets, and listen to the director's instructions.

Before the program begins, all of the cameras will need to be white-balanced. This requires focusing the camera on a white card that is positioned on the set in the studio light. Once the camera is white-balanced, the camera operator can refer to the director's calls and the camera shot sheet—a list of each of the shots for each camera—for direction as to which part of the scene to focus on.

Whether the show is fully scripted or not, the camera operator's duty is to be alert, to pay attention to what is happening on the set, and to have a usable shot ready for the director at all times. Camera operators should make sure that the zoom lens focus is set by zooming in to the tightest shot possible on the subject, focusing the lens, and then zooming out. Assuming that the distance between the subject and camera does not change, the shot should hold its focus as the camera zooms in and out.

At the end of the production the camera operator should replace the lens cap on the camera and return the camera to its normal position in the studio. The pedestal or tripod head tilt and drag controls should be securely locked, and the camera cable should neatly be coiled.

■ In the Field

In multicamera field productions the field camera operator functions much as he or she would in the studio environment, listening for headset instructions from the director about shot selection and framing. In single-camera field productions the camera operator often does not have access to a headset. Rather, the program may be recorded shot by shot, with the director giving instructions for the setup of each shot before it is recorded.

When shooting with a portable camcorder, you will need to pay attention to a number of additional details:

1. Remember to bring enough batteries because most productions shot with a single camcorder in the field rely on battery power.

2. Remember to bring enough videotape.

3. White balance the camera whenever you move to a different location or if the lighting conditions change in the location you are shooting in.

4. Monitor audio levels closely when you are recording. Most camcorders will display audio levels in the viewfinder.

5. To stop or start recording, simply push the record button (on the lens housing or at the back of the camcorder) and release it. Make sure to record five to ten seconds of extra material at the head and tail of each shot. As we will discuss in the chapter on editing, this will help to make the editing process easier and will help to protect the head or tail of your shot from being accidentally trimmed off in the camcorder.

6. Label your field tapes clearly, preferably before you put a new tape into the camcorder. When you remove a tape, move the record safety switch on the cassette to the position that will prevent you from accidentally rerecording onto the tape.

7. When you have finished shooting, make sure that all equipment is stowed safely in its travel bags.

Video Connectors

When working in the studio or in the field, you may need to connect several pieces of video equipment together—for example, to display the camera output on a monitor or to transfer the video signal from one VCR to another. To work efficiently, you should know the differences between the principal types of video connectors that are now in use. (See Figure 4.29.)

Much professional video equipment uses the **BNC bayonet connector** for video inputs and outputs. This is a twist lock connector that snaps securely into place when it is properly connected.

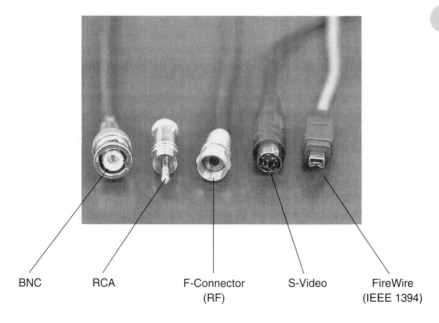

FIGURE 4.29
Video Connectors

BNC RCA F-Connector S-Video FireWire
 (RF) (IEEE 1394)

Another type of connector that is used for video is the **RCA/phono connector.** This type is most often found on consumer-quality digital video and VHS machines. It is the same time of connector that is often used to connect audio inputs and outputs on home stereo systems.

The cable television connection to your home receiver is made with a cable that ends in an **F-connector.** This cable connector has a small threaded sleeve, and a thin copper wire protrudes from the center of the cable.

Consumer and prosumer camcorders with **S-Video** inputs and outputs use a special four-in connector that is used to make direct S-Video connections (separate luminance and chrominance signals) between camcorders, VCRs, and video monitors that are equipped with similar connectors.

Digital video (DV) equipment may use a six-pin digital video connector known as **FireWire,** or IEEE 1394, to move digital video (as well as audio, time code, and machine control commands) from one DV VCR to another or from a DV camcorder or VCR directly into a computer equipped with a FireWire input. On Sony equipment this connector is called *iLink*.

CHAPTER 5

Audio and
Sound Control

In television and video sound is as important as the picture. Even though the word *video* is derived from the Latin *videre,* which means "to see," television is an audiovisual medium in which both picture and sound are important.

Despite this, until relatively recently, there has been a tendency to pay far more attention to the picture than to the sound. For the first forty years or so of television broadcasting, the sound portion of the program was monaural (single channel), and the quality of the speakers on most television receivers was poor. Television sound began to improve significantly with the introduction of new audio technologies and production techniques, starting with stereophonic sound in the 1980s and followed by digital surround-sound in the 1990s. With the introduction of digital audio workstations producers and directors gained access to a sophisticated set of tools that enabled them to greatly enhance the technical and aesthetic elements of sound in video productions.

We can define **sound** as any aural component of a program that is intentionally present. **Noise,** on the other hand, interferes with sound—it obscures sound and makes it more difficult to understand. In many cases noise is an unintentional element that has been introduced into a program.

In this chapter we will discuss the technical and aesthetic aspects of sound in studio and field production. Also, because more and more digital technology is being introduced into the audio field, we will provide an overview of some of the most important aspects of digital audio.

Technical Aspects of Sound

Sound versus Audio

Before we begin to discuss specific characteristics of sound, it is useful to make a distinction between the terms *sound* and *audio.* Sound can be thought of simply as a pattern in the vibration or movement of molecules

of air that our ears are capable of hearing. When a sound is made, air is moved in waves, thus the term *sound waves.* For example, when a musician strums a guitar string, it vibrates and creates pressure variations—sound waves—in the air surrounding the string. When the waves reach our ears, we hear the sound of the guitar.

The term **audio** is used to describe sound that has been changed into an electrical signal so that it can be recorded, transmitted, and replayed. Technically speaking, video programs contain two major technical components: video (the picture) and audio (sound).

Although our definition of sound indicated that sound waves travel through the air, sound waves can propagate through other materials such as metal and water as well. On the other hand, did you know that sound waves cannot travel in a vacuum or in outer space? Think of a scene in a movie or television show you may have seen depicting battles in outer space that uses dramatic sound effects of explosions. In reality, you would not be able to hear explosions in space because the sound waves would not have a medium to travel through.

A sound wave has four main characteristics: amplitude, velocity, wavelength, and frequency. For the purposes of our discussion amplitude and frequency are the two most important characteristics to consider in the context of video production and our discussion will focus on them. (See Figure 5.1.)

FIGURE 5.1

Differences in
Amplitude and
Frequency of Two
Sound Waves

Amplitude

Wave A and Wave B have the same frequency—one cycle per second. The amplitude and intensity of B are greater than those of A.

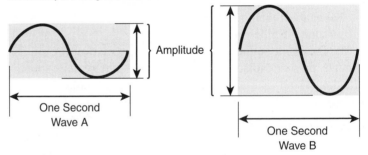

Frequency

Wave A and Wave B have the same amplitude but different frequencies.

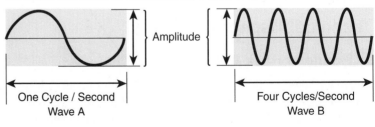

■ Sound Amplitude

Differences in the loudness or intensity of a sound can be seen as differences in the **amplitude** or height of a sound wave. When a sound wave is created, a series of longitudinal waves spread out from the source of the sound. The amplitude is the height of the wave, and it corresponds to how much force was used to create the sound wave. The larger the amplitude of the wave—the more energy it contains—the harder it will hit the eardrum and the louder the sound that is perceived. The guitar can be strummed lightly or hard; the corresponding sound will be soft or loud. (See Figure 5.1.)

Loudness is measured in **decibels (dB).** This is a logarithmic scale: a scale based on multiples of 10. An increase of 10 decibels indicates that loudness has increased 10 times. Consequently, 20 decibels is 100 times more intense than 10 decibels ($10 \times 10 = 100$), and 30 decibels is 1,000 times more intense than 10 decibels ($10 \times 10 \times 10 = 1,000$).

The human ear can respond to a great range of sound intensities, from very quiet sounds at 0.1 dB (0 dB is the threshold of hearing) to sounds at 120 dB (the threshold of pain). At the high end of the scale, sounds louder than 120 dB can cause pain or damage to the ear. (See Table 5.1.) A 120-dB sound is more than 1 billion times more intense than a 0.1-dB sound.

It is important to mention that the intensity of a sound is a very objective quality that can be measured with adequate instruments. On the other hand, the loudness of a sound, that is, how loud it sounds to an individual who hears it, is a more subjective quality that may vary according to

■ **TABLE 5.1** Intensity of Various Sound Sources

Sound Source	Intensity Level (dB)
Threshold of hearing	0
Soundproof room	10
Quiet room	40
Average conversations	60
Busy street	70
Alarm clock	80
Subway	100
Rock concert	110
Threshold of pain	120
Jet engine	140
Instant perforation of eardrum	160

circumstances. Although it is true that the more intense a sound is, the louder it is likely to be perceived, the same sound may not be perceived with the same loudness by everyone, owing to individual differences in our perceptual abilities. For instance, a sound with a given intensity most likely would not seem as loud to your grandfather as it would to you because your grandfather's hearing abilities have most likely diminished with age.

■ Sound Frequency or Pitch

Pitch refers to how high (e.g., violin, female voice) or low (e.g., bass guitar, male voice) a sound is. Pitch describes the tonal quality of the sound and is determined by the frequency of the sound wave.

The frequency of a wave is the number of complete cycles of the wave that occur in one second. **Frequency** is measured **in cycles per second (CPS).** Cycles per second are also called **hertz (Hz)** in honor of the nineteenth century scientist Heinrich Hertz whose influential work on electromagnetic wave theory led to the invention of radio. A frequency of 100 Hz indicates the sound wave is completing 100 cycles per second.

Metric abbreviations are used to simplify the representation of waves with frequencies above 1,000 Hz; 1,000 Hz = 1 kilohertz, which is abbreviated as 1 kHz.

The human ear can detect a range of frequencies from about 20 Hz to about 20,000 Hz, or 20 kHz. A 20-Hz sound is very deep and bassy; a 20-kHz sound is very high in pitch.

Sound intensity and frequency are important concepts in both the theory and practice of audio for video production. Audio meters (Volume Unit, or VU, meters and Digital Peak Level meters) are calibrated in decibels and used in audio production to determine the relative strength of an audio signal. Moreover, frequency response is a very important characteristic to be taken into account in choosing a microphone to be used in a specific recording environment or situation.

Microphones

Live sound in television is picked up with a **microphone**. (*Microphone* is often abbreviated as *mic,* pronounced "mike.") A microphone is a transducer—a device that changes one type of energy into another. Just as the function of a CCD in a camera is to change light into electrical energy, a microphone changes sound into electrical energy—the audio signal.

There are several ways to classify microphones depending on the way they are built and the way they perform their function. We will discuss four principal characteristics of microphones: pickup pattern, type of construction, frequency response, and their uses and applications.

■ Pickup Patterns

Pickup pattern refers to the direction a microphone is sensitive to incoming sound. Microphones do not all pick up sound the same way, or from the same direction. (See Figure 5.2.)

Microphone pickup patterns are important to understand and use in production because microphones, unlike the human ear, are not selective about what they hear. They respond to all incoming sound; they cannot distinguish between important sound and unimportant sound. Pickup patterns also dictate the best place to position a microphone for optimal recording of a sound source.

Microphones used in television and video production typically utilize one of two pickup patterns: They may be either omnidirectional or unidirectional. **Omnidirectional** microphones pick up sound equally from all directions. They are widely used for recording interviews in the studio and in the field and for picking up crowd sounds at sporting events.

Unidirectional microphones have a narrower, more directional pickup pattern. The terms **cardioid** and **supercardioid** are sometimes used to describe different unidirectional pickup patterns. Cardioid microphones have a heart-shaped pickup pattern. They are extremely sensitive out front but somewhat less sensitive to the sides and rear. These microphones experience the **proximity effec**t (a boost in sensitivity to low frequencies) when worked very close to the sound source.

Supercardioid pickup patterns exaggerate the sensitivity in front even more than cardioid microphones do. They are very directional and generally are most sensitive to sounds in a very narrow angle in front of the microphone. A **shotgun microphone** is an extremely long, narrow supercardioid or hypercardioid microphone.

■ Type of Construction

In addition to differences in pickup patterns, microphones also differ in the way they are constructed. Microphones work by sensing changes in the sound waves created by the sound source. Inside each microphone is a diaphragm that is sensitive to changes in sound intensity and quality. The diaphragm converts the sound waves into an electrical audio signal. There are three basic diaphragm technologies that accomplish the conversion from sound waves to electrical current: dynamic, condenser, and ribbon.

● **DYNAMIC MICROPHONES** **Dynamic microphones** contain a diaphragm that is attached to a coil of wire wrapped around a magnet. (See Figure 5.3.) When the diaphragm moves, so does the coil; this causes a change in the magnetic field within the microphone and generates a corresponding amount of electrical voltage. This is the audio signal. The

FIGURE 5.2
Omnidirectional and Unidirectional Microphone Pickup Patterns

Omnidirectional

Unidirectional
(Cardioid)

Unidirectional
(Supercardioid)

Dynamic

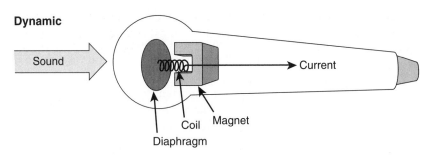

Condenser

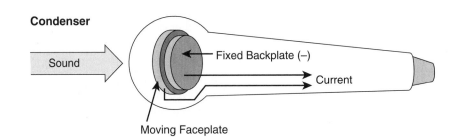

FIGURE 5.3
Microphone
Construction

variations in the amount of voltage that is produced correspond to the variations in the frequency and loudness of the sound waves hitting the microphone's diaphragm.

Dynamic microphones are very rugged and are among the most widely used microphones in television production. They are relatively inexpensive and usually have good frequency response. However, they tend to be somewhat less sensitive to high-frequency sounds than are condenser microphones.

● **CONDENSER MICROPHONES** **Condenser microphones** use an electric capacitor or condenser to generate the signal, so they are also called *capacitor mics.* The condenser consists of a moving faceplate at the front of the microphone and a backplate in a fixed position behind it. Both plates are electrically charged, and a sound hitting the faceplate causes a change in voltage. (See Figure 5.3.) Because the voltage produced by condenser microphones is very weak (much weaker than the signal produced by a dynamic microphone), condenser microphones need a source of power to amplify the signal.

Condenser microphones can be powered by one of three methods: a battery, phantom power, or a permanent charge applied to the backplate. Battery-powered condenser mics are very popular. Part of the microphone housing screws open to reveal a small compartment that holds the microphone battery. (See Figure 5.4.)

In **phantom power** microphone systems the power is supplied to the microphone via the ground wire of an audio cable from a mixer, a phantom power box, or a battery pack. This eliminates the need to check and replace batteries.

The **electret condenser** microphone is manufactured with a permanent electric charge in the capacitor and therefore requires the use of only a very small battery as a power source to boost the output signal of the microphone to a usable level. As a result, electret condensers tend to be significantly smaller than other condenser microphones. They are frequently used as built-in microphones on portable cameras and in other situations that require a small, inconspicuous microphone.

Condenser microphones have several advantages over dynamic microphones. They are highly sensitive, particularly to high-frequency sounds. In addition they can be manufactured in extremely small sizes. On the negative side they can be expensive and fragile, and they need a power source. Because the typical power source is batteries, they can be expected to fail at the least convenient time. Always begin recording with fresh batteries, and carry a supply of replacement batteries in case of failure.

● **RIBBON MICROPHONES** **Ribbon microphones** contain a thin ribbon of metal foil mounted between the two sides of a magnet. Ribbon microphones are also called *velocity microphones*. Early ribbon microphones, designed for use in radio and noted for their excellent voice pickup, were generally large and bulky. Modern ribbon mikes are much smaller, but like their radio counterparts, they are very fragile. They are an excellent choice when high-quality voice pickup is required, particularly in sound studio recording environments. Because of their fragility they are not a good choice in field recording situations.

FIGURE 5.4 Condenser Microphone

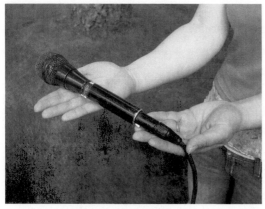
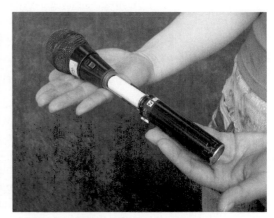

Battery Compartment Closed Battery Compartment Open

Frequency Response

Frequency response refers to a microphone's ability to accurately reproduce a wide range of frequencies. No microphone is capable of capturing the full spectrum of frequencies from 20 Hz to 20,000 Hz. However, professional-quality microphones are generally able to pick up a wider range of frequencies than are inexpensive microphones. Many microphones are designed with specific uses in mind. A microphone that is designed for voice pickup will not have the high-frequency response that characterizes microphones designed for music pickup.

Specifications for microphone frequency response are provided by the manufacturer. Correct microphone usage and selection depend on matching the proper microphone—in terms of its frequency response—to your particular recording situation. In addition, it is important to note that the frequency response of a microphone also depends on correct placement of the microphone in relation to the sound source.

Microphone Impedance

Impedance (Z) is a measure of the amount of resistance to electrical energy in a circuit. Impedance is measured in ohms, and two impedance categories are commonly found in audio equipment. *Low-impedance*, also called *low-Z,* refers to equipment rated at an impedance of 600 ohms or below. *High-impedance,* or *high-Z,* equipment is rated above 600 ohms.

All professional-quality microphones are low-impedance and are usually rated at 150 ohms. Similarly, VCR and camcorder audio inputs and inputs on audio mixers are low-impedance inputs. The rule of thumb is simply to match the impedance levels of the audio sources that you are connecting. Low-impedance sources connect to low-impedance inputs, and high-impedance sources connect to high-impedance inputs.

The principal advantage to using low-impedance microphones is that the audio signal can be sent over several hundred feet of cable with very little loss in the signal quality. High-impedance lines, on the other hand, tend to noticeably affect signal quality if cable length exceeds 25 feet or so.

Wireless Microphones

Wireless microphones, also called **radio microphones,** eliminate many of the problems associated with the use of microphone cables; therefore they are extremely popular in studio and field production. A wireless microphone sends its signal to a receiver via RF (radio frequency) transmission rather than through a cable. That is, it actually broadcasts the audio signal to the receiving station and thereby eliminates the need to use long cables to connect those two points. Wireless microphones contain three components: the microphone itself, a small transmitter attached to the micro-

phone that transmits the signal, and a small receiver that receives the transmitted signal. (See Figure 5.5.) The output of the receiver is then connected by cable to the appropriate audio input on the camcorder (for field recording) or the audio mixer (for studio recording).

In some wireless systems the transmitter is built into the microphone itself; these are typically hand-held microphones. Wireless systems in which the transmitter is a separate unit to which the microphone must be connected are called **body packs,** in reference to the fact that the transmitting unit is typically attached to the body of the person who is the source of the sound. Body pack transmitters are usually used with lavaliere microphones because the lavaliere is too small to contain its own built-in transmitter.

Many types of microphones—hand-held, lavaliere, and shotgun—can be obtained in a wireless configuration. For maximum flexibility and mobility wireless systems designed for field use are battery powered, with both the transmitter and receiver operating off battery power. Wireless systems that are designed for studio use feature battery-powered transmitters, but the receiving stations operate on conventional AC power.

Wireless microphones have several great advantages over wired microphones. They do not restrict the movement of the sound source, the

FIGURE 5.5 Wireless Microphone System

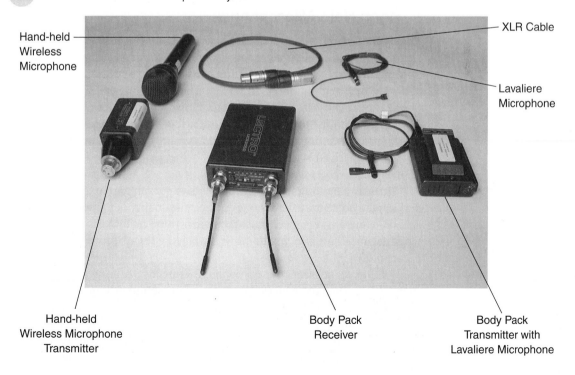

Hand-held Wireless Microphone

XLR Cable

Lavaliere Microphone

Hand-held Wireless Microphone Transmitter

Body Pack Receiver

Body Pack Transmitter with Lavaliere Microphone

microphone remains in the same relationship to the sound source even if the sound source moves, and there are no obtrusive cables to be seen.

Wireless microphones do present some problems, however. Because they demand power, adequate AC or battery power must be available. More than one production has been ruined by failing batteries late in the day. Although the transmitting part of wireless body pack units is small, it nonetheless must be carried by and concealed on the sound source. Depending on how the subject is dressed, this can present problems. If you plan to use wireless microphones for sound pickup as you videotape a wedding, you may find that the transmitter and microphone can be easily concealed on the groom, whose jacket offers a good hiding place, but the bride's dress may not offer a suitable place to hide the equipment.

Because wireless microphone systems are actually small radio transmitters and receivers, they are susceptible to interference from other radio sources, such as police radios and CB radios. This is more of a problem in field production than in studio production, although studio wireless systems are not entirely immune to outside interference.

The final and perhaps greatest disadvantage of wireless microphones for most producers is that they can be expensive. A professional-quality wireless system (microphone, transmitter, and receiver) can easily cost five to ten times as much as an equivalent wired microphone.

▮ Hand-Held Microphones

Vocal performers often prefer to use a hand-held microphone when singing, and hand-held mics are also commonly used in ENG-type production, particularly when an on-camera newscaster conducts an interview and only one microphone is available. The barrel of a hand-held microphone is relatively insensitive to sound. However, this does not mean that it is totally immune to picking up barrel noise—no microphone is. If you tap your fingers along the barrel, it most certainly will pick up this sound. But in comparison with other microphone types, the hand-held microphone is relatively insensitive along the barrel.

In using a hand-held microphone, it is important to remember that the person who holds the microphone controls the quality of the sound pickup. The on-camera interviewer must remember to speak into the microphone when asking a question and to move it when the respondent answers. (See Figure 5.6.)

Failure to position the microphone correctly to keep the principal sound source on-axis reduces the quality of the sound pickup. In addition, many directional microphones contain small openings, or ports, that cancel sound coming from unwanted directions. Be careful not to cover the ports on the barrel of the microphone with your hand as you hold it because this will interfere with the directional pickup of the microphone.

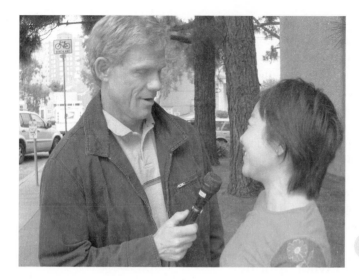

FIGURE 5.6 Hand-Held Microphone

◼ Lavaliere Microphones

Lavaliere microphones are very small microphones that are pinned onto the clothing of the people who are speaking. By design most lavalieres are either electret condensers or dynamic microphones. The electret condensers are the smaller of the two varieties and are widely used in studio and field production. The dynamic microphones are slightly larger but considerably more durable.

In using a lavaliere, try to position the microphone close to the subject's mouth. (See Figure 5.7.) Quite often, it is pinned onto a jacket lapel or shirt collar. However, be careful when positioning the microphone to

FIGURE 5.7 Lavaliere Microphone

Wide View Close View

avoid placing it where the subject's clothing or jewelry may rub against it and create distracting noises.

When using a condenser lavaliere, be careful not to place it too close to the subject's mouth. Condensers are extremely sensitive, and if the sound source is too loud (which often happens if it is too close to the microphone), it may distort the audio signal. This is known as *input overload distortion.*

If you are using a battery-powered electret condenser, remember to check the battery before you being recording. Make sure that it is correctly placed inside the microphone's battery compartment. If the positive and negative poles of the battery are not correctly seated in the compartment, the microphone will not work. Always carry a spare battery or two in case one of the microphone batteries dies during production.

■ Shotgun Microphones

Shotgun microphones are widely used in video production. Because they have a very directional pickup pattern, they are often held off camera and aimed at the principal sound source. Thus they do not intrude into the picture, but they provide sound pickup on a precise spot. They can be used to isolate sound pickup to one or two people in a crowd or to a particular location where activity is taking place. Episodic dramas and soap operas make much use of shotgun microphones for voice pickup.

FIGURE 5.8
Shotgun
Microphone with
Windscreen

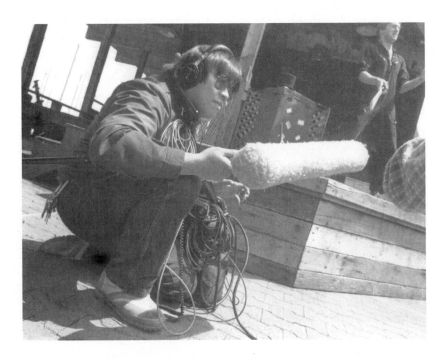

Most shotgun microphones are extremely sensitive to barrel noise. For this reason some have **pistol grips** attached to the microphone, which are used when it is hand-held. When shotguns are attached to microphone booms or fishpoles, **shock mounts** are often used to insulate the microphone from the noise of the boom, and a **windscreen** is almost always needed when shooting outdoors. (See Figure 5.8.)

◼ Hanging Microphones

Hanging microphones are sometimes used in studio productions. These microphones are hung directly over the area where the action will take place or slightly in front of the action area and then aimed at it. In either case, by hanging the microphones, you can usually get them out of the field of view of the camera. However, sound pickup usually suffers because the microphones tend to pick up a lot of the ambient background noise in the studio.

◼ Microphone Stands and Mounting Devices

Various types of stands and mounting devices are used to support microphones. Stands have the advantage of holding a microphone securely in a fixed position. They also insulate the microphone from noise on the surface where it is positioned. (See Figure 5.9.)

Desk stands, for example, are small stands that are used to hold microphones on a desk or table in front of the person or persons who will speak. One microphone on a desk stand can be positioned to pick up the sound from two or more people. This is very useful in panel discussion programs.

Floor stands are taller stands that telescope upward. They consist of a base, which supports the stand, and a telescoping rod, which allows the microphone height to be adjusted for correct sound pickup. Microphones on floor stands are frequently used to pick up sound from musical instruments and from people standing up to speak.

Fishpoles are extremely popular in field production. A fishpole is a metal rod that extends to allow placement of the microphone close to the sound source. It has many of the advantages of a hand-held microphone, but it is insulated from barrel noise and allows the person holding it to remain off camera and move with the person who is talking.

A **boom,** a three-legged contraption that sometimes comes equipped with wheels and a telescoping boom rod, allows the microphone to be aimed, extended, and retracted. Booms are used primarily in studio dramatic production, in which the movement of the actors is tightly controlled and limited to a relatively small action area.

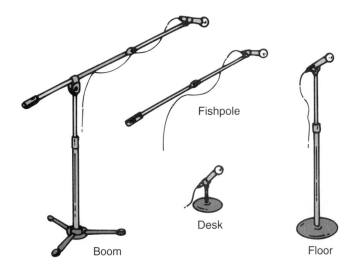

Fishpole

Desk

Boom

Floor

Microphone Stands

FIGURE 5.9
Microphone Stands
and Mounting
Devices

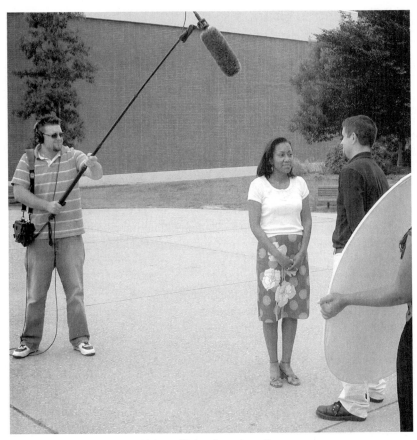

Using a Fishpole on Location

Connectors and Cables

■ Audio Connectors

As equipment becomes standardized, so do the connectors that carry the audio signals in and out. Currently, however, a wide variety of connectors perform essentially similar functions. (See Figure 5.10.) Professional-quality equipment utilizes three-pronged **XLR connectors,** also called *cannon connectors,* for all audio inputs and outputs. These connectors carry either line-level or microphone-level signals.

Microphone inputs on many consumer-level camcorders often accept **mini-plug connectors.** Line-level inputs and outputs on consumer- and industrial-grade equipment frequently utilize RCA/phono connectors. Finally, some machines use **phone connectors** for microphone or line level signals.

If you are not working with professional-quality video equipment with standardized audio connectors, it is to your advantage to acquire a set of audio adapters that will enable you to adapt any type of microphone or cable to any type of input connector. Adapter kits are available from most audio-video supply houses, or you can simply go to a local electronics store and buy the ones you will need. The importance of making connections properly cannot be overemphasized. If you cannot get the audio signal into

FIGURE 5.10
Typical Audio
Connectors

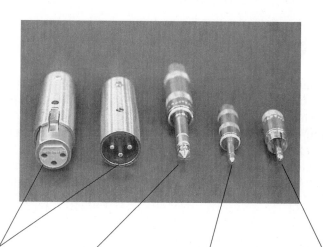

XLR (Cannon)
• Used for
 Microphone-
 and Line-Level
 Signals
• Professional-
 Quality

Phone
• Used Mainly
 as a Headphone
 Connector or
 for Microphone
 or Line-Level
 Audio Signals

Mini-Plug
• Used Mainly
 for Microphone
 Inputs and
 Earphones

RCA/Phono
• Used Mainly
 for Line-Level
 Inputs and
 Outputs

the mixer or camcorder, you cannot record it. Finally, when working with audio (and video) connectors, be sure to indicate whether the connector you need is male (output connector) or female (input connector).

▊ Balanced and Unbalanced Lines

Two types of cables, or lines, are commonly used to carry the audio signal to the mixer or recorder. Professional, high-quality systems utilize cables that are called balanced lines. A **balanced line** is a cable that contains three wires. Two wires carry the signal, and the third acts as a shield to protect the other two from outside interference. **Unbalanced lines** contain two wires. The wire in the center of the cable carries the signal, and the other wire acts both as a grounded shield and as a signal lead. Unbalanced lines are cheaper to manufacture, but they are also significantly more susceptible than balanced lines to interference from electrical lines, radio and television transmitters, and so on.

Cables that are equipped with three-pronged XLR (cannon) connectors are always balanced lines. Cables with mini-plugs and phone connectors may be either balanced or unbalanced, and cables with RCA connectors are unbalanced. Incidentally, connecting a balanced line to an unbalanced input causes the line to become unbalanced, and the effect of the shield will be lost. This does not affect the signal quality, but it may make the signal more susceptible to interference. Unbalanced lines do not become balanced by connecting them to a balanced input.

Audio Mixers

When multiple audio sources must be incorporated into a production an audio mixer may be used. An audio mixer or audio board is a production device that that allows you to combine, or mix, a number of different sound sources and adjust the relative volume of each to achieve the appropriate production effect. For example, it is common practice in productions that include voice and music to set the voice at a high level and the music at a lower level. With the use of an audio mixer this effect can be easily achieved.

▊ Types of Audio Mixers

● **STUDIO MIXING CONSOLES** Audio mixing consoles may be designed for use in the studio or in the field. Studio mixing consoles are generally large devices that have the capability to accept a large number of signal inputs from microphones, digital audio tape recorders, playback VCRs, and other sources. Studio mixing consoles with 16, 32, or more input channels are common in many production facilities. (See Figure 5.11.)

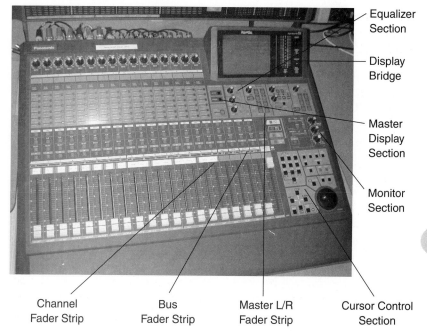

Equalizer
Section

Display
Bridge

Master
Display
Section

Monitor
Section

Channel
Fader Strip

Bus
Fader Strip

Master L/R
Fader Strip

Cursor Control
Section

FIGURE 5.11
Studio Audio Mixing
Console

● **PORTABLE FIELD MIXERS** Portable audio mixers for use in field production situations are smaller than their studio counterparts and typically can be operated by battery power as well as standard AC electrical current. They usually have many fewer inputs than their studio counterparts; four channels is a common configuration, although you may find portable mixers with as few as two channels or as many as eight. (See Figure 5.12.)

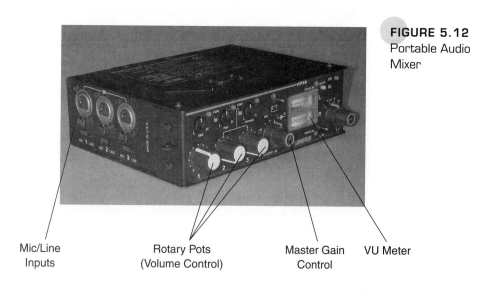

FIGURE 5.12
Portable Audio
Mixer

Mic/Line
Inputs

Rotary Pots
(Volume Control)

Master Gain
Control

VU Meter

■ Sound Control

An audio mixer has the capability to control at least three different elements of each of the sound sources that is being fed into it: loudness or gain, stereo balance, and equalization. (See Figure 5.13.)

● **INDIVIDUAL CHANNEL LOUDNESS OR GAIN CONTROL** Each signal that is fed into the mixer is fed into a separate channel where the signal can be manipulated. One of the most basic types of manipulation is control of the loudness or **gain** of the source. This is achieved by using individual channel slide faders or rotary potentiometers. A **slide fader** is a simple device that increases the amplification of the signal when it is pushed up and decreases the amplification when it is pulled down. **Rotary potentiometers**—or **pots**—do the same thing by turning them to the right to increase amplification or to the left to decrease amplification. Slide faders are typically found on studio consoles; rotary pots are more often used on field mixers.

● **MASTER GAIN** In addition to the gain controls for each of the individual sound input channels, the audio mixer will contain a **master gain control.** Again, this may be a slide fader on a studio console or a rotary pot on a field mixer, but the function is the same in either case. By adjusting the master gain up or down, the overall loudness of all the mixed sources is increased or decreased. So if you want to fade out all of your audio sources simultaneously, the way to do it would be to bring down the master gain.

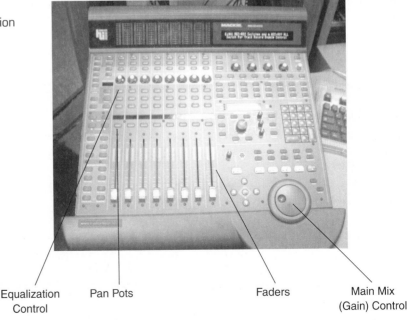

FIGURE 5.13 Gain, Balance, and Equalization Controls on a Studio Mixing Console

Equalization Pan Pots Faders Main Mix
Control (Gain) Control

● **STEREO BALANCE** Sound sources may be **monaural** (single channel) or **stereo** (dual channel). The **pan pot** controls determine how a stereo signal will be sent out of the audio mixer. With the pan pot in the center position the signal is sent equally to the left and right output channels, so when you listen to the signal on a stereo monitor, you will hear the sound coming out of the the left and right speakers. The relative position of the output sound can be changed by adjusting the pan pot: Turn it to the left to increase the presence of the sound on the left side side and diminish the right; turn it to the right to increase the presence on the right speaker and diminish the left.

● **EQUALIZATION** The **equalization (EQ)** control is used to modify the sound quality of a particular source by adjusting the amplification of specific frequency ranges within the overall signal. A typical set of equalization controls on a studio mixer might allow adjustment of the low frequencies (20–250 Hz), the mid-range frequencies (250 Hz–5 kHz), and the high frequencies (5–20 kHz). Adjusting the EQ control for each of these frequency ranges will amplify or diminish the frequencies within the range. So if you wanted to make a source sound lower, or bassier, you could turn up the EQ control for the low-range frequencies. Similarly, if you wanted a voice to have a brighter, crisper sound, you could adjust the mid-range or high frequencies until you achieved the desired effect.

● **MONITORING SOUND** All audio mixers contain a series of meters that are used to monitor the overall sound level or loudness of the signals the mixer is controlling. These are described in more detail in the next section.

Although level meters give you information about the overall sound level or loudness of your audio signal, it is also extremely important to monitor the overall sound quality and the relative mix of the sounds. This can be done only by listening to the sound, through either headphones or high-quality speakers.

Because most productions are viewed in situations in which the listener hears the sound through loudspeakers, it is almost always preferable for the sound engineer to monitor the sound during production with loudspeakers rather than with headphones. An exception to this rule is in field production, in which headphones must be used to isolate the sound that is being recorded from other environmental sound.

● **AUDIO SOURCES** Audio mixers can accommodate signals sent from a variety of audio sources. In field applications the most common audio sources are microphones. In studio applications in addition to microphones the sound engineer may be working with audio sources that include CD players, DAT (digital audio tape) recorders, analog audiotape recorders (cassette, reel-to-reel), turntables, playback VCRs, MP3 players, digital audio/video servers, remote satellite feeds, and perhaps other sources as well.

Working with Audio Levels

Input Levels

It is important to know the kind of signal the input on a mixer, camcorder, or VCR is capable of accepting. There are two types of signals: microphone-level signals and line-level signals. A **microphone-level** signal is very weak because the electrical signal that the microphone produces is not amplified. **Line level** signals, by contrast, are amplified. This makes them considerably stronger than microphone-level signals. Line-level audio signals include the output from CD players, audiotape recorders, turntables, preamplifiers, and so on.

The level of the output signal must be correctly matched to the level of the input on the mixer or camcorder. Microphones should be connected to microphone-level inputs, and line-level outputs should be connected to line-level inputs.

Even if you have a microphone-level source connected to a microphone-level input on an audio mixer, you may find that the signal coming from the microphone is too weak to be useful. Weak microphone-level signals can be adjusted by using the **trim control,** a small potentiometer that allows you to boost the signal to a usable level. (See Figure 5.14.)

On professional-quality equipment audio input levels can often be switched from microphone-level to line-level. A small two-position switch near the input allows you to select the appropriate input level for your audio. (See Figure 5.15.) Most consumer-quality camcorders, however, are equipped only with microphone-level inputs.

FIGURE 5.14
Microphone Trim
Control on an Audio
Mixing Console

Types of Audio-Level Meters

Every audio signal has a certain dynamic range, which we defined earlier as the range from the lowest to the highest level that can be acceptably reproduced without noise or distortion. Audio meters help us to set optimum levels for the lowest (quietest) and highest (loudest) levels the system can

FIGURE 5.15 Switchable
Microphone/Line-Level
Audio Inputs

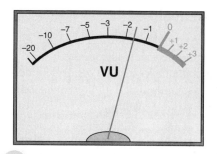

FIGURE 5.16 Analog
VU Meter

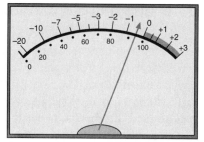

FIGURE 5.17 Two-Scale
VU Meter

FIGURE 5.18
LED VU Meter

handle. Two types of audio metering systems are found on most equipment or software that process audio signals: the volume unit meter and the peak program meter.

The **volume unit (VU) meter** measures average sound. It is the simplest form of meter and has been around since the early days of the recording and broadcast industries. There are two types of VU meters: needle and LED. A VU meter has a scale that is a standard calibration of signal strengths used in all audio production facilities. The scale is calibrated in decibels and ranges from a low of –20 dB (on some meters, –40 dB) to a maximum of +3 dB. Ordinarily, the –20 dB to 0 dB range of the scale is represented in black, and the 0 dB to +3 dB range is presented in red. A small needle indicates how high or low the signal is. (See Figure 5.16.)

Sometimes the scale also contains a percent scale, with –20 dB representing 0 percent and 0 dB representing 100 percent. (See Figure 5.17.)

Two types of VU meters are used. One type uses a needle to indicate the volume of sound. In the other type the needles are replaced by light-emitting diodes or bar graph displays that correspond to the various points on the VU scale. (See Figure 5.18.)

Regardless of the VU metering system used, loud, dominant sounds should be kept in the range of –3 dB to 0 dB. Sounds that are recorded above 0 dB ("in the red" or peaking) may be distorted; sounds that are recorded too low ("in the mud") will lack clarity and may need to be amplified, which will add noise to the signal.

Peak program meters (PPM) are becoming very popular because of the rise of digital audio-processing technology. A PPM shows us the peaks in the audio signal, with 0 dB being the maximum level for a signal to be recorded without distortion. A signal should never go into the red part of the scale. (See Figure 5.19.) PPMs are somewhat more accurate than VU meters in terms of responding to rapid changes in the peak level of an audio signal.

FIGURE 5.19 Digital Peak
Program Meter

■ Analog and Digital Audio Levels

There is a substantial difference in dealing with audio levels in digital and analog environments because optimum audio levels are different for the two environments. Although an analog signal exceeding 0 dB may be perceived as having a richer, more saturated sound, digital audio that exceeds 0 dB will be badly distorted and cannot be fixed. An important concept to be introduced here is that of headroom.

Typically, in analog systems a 1-kHz tone should register as 0 dB on the VU meter as the standard operating level (SOL). For digital systems the SOL varies between –20 dB and –12 dB, depending on the system used. **Headroom** in audio is the safe range beyond the SOL. For instance, if I set my SOL to be –20 dB (the 1-kHz tone registers on my PPM as –20 dB) then the area between –20 dB and 0 dB is called my headroom. In general it is wise to set your peak level (SOL) at least 10 dB below 0 dB. (See Figure 5.20.)

FIGURE 5.20

Digital Audio Level

Audio Reference
Tone Is Set to –12 dB
for Digital Recording

Digital Audio

There is no doubt that a very significant transition is happening in the world of television and video production—a transition from analog systems to digital systems. Although analog devices are still widely used in many audio production environments, they are increasingly being replaced by devices that record and process audio signals digitally.

Any audio production has two main technical goals. The first goal is to record the signal with high fidelity; that is, there should be high similarity between input and output signals. The second goal is to achieve perfect reproduction; that is, the recording should sound the same regardless of how many times it is played back. Digital audio recording and processing technology accomplishes these two goals by converting the analog audio signal into a digital signal. The analog sound wave is sampled at different points in time (sampling rate), and each of the points that is sampled is assigned a numerical value in a digital binary code consisting of bits made up of a pair of off/on (0/1) pulses. This is called *quantizing* or quantization. (See Figure 5.21.)

FIGURE 5.21 Analog versus Digital Audio

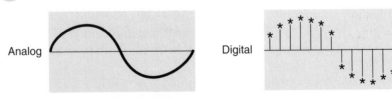

Analog — Sound Wave Is Continuous

Digital — Sound Wave Is Sampled and Quantized

To give you a basic understanding of the principles of digital audio, the following section will discuss these important concepts: codecs, compression, sampling rate/bit depth and quantization, bit rate, and dynamic range. We will also describe the major digital audio formats and describe digital audio workstations, using as examples a Pro Tools workstation and an Audition workstation. These are two of the most commonly used digital audio workstations in the audio production industry.

■ Codecs

The term **codec** is an abbreviation for *compression/decompression.* In some areas of the telecommunications industries it stands for *coder/decoder.* In either case a codec is basically a specialized computer program, or algorithm, that is used to reduce or compress the size of a file when it is saved to disk and that also allows the user to expand it later (decompress it) for playback. Most digital audio systems use some sort of compression so that the files do not take up as much storage space as they would if they were not compressed. Codecs are also used to compress streaming media for broadcast over the Internet.

■ Compression

Compression refers to the reduction in size of a digital data file or a stream of digital information. There are two types of compression: lossy compression and lossless compression.

Lossy compression works by eliminating repetitive or redundant information. However, because it eliminates information, the audio file that we end up with is not the same as the one we started with. Lossy compression is the most popular method of compression and is based on the application of the **perceptual coding principle,** which results in removing parts of the original information that the end user will not perceive. In other words, it tries to make certain that the end file tricks the human ear into thinking that it is listening to the original file.

Lossless compression works by compressing an audio file without removing any data. The playback audio file is identical to the original file, although the size of the file is reduced. Of course, the end file will not be as small as it would be if lossy compression had been used.

Compression is expressed as a ratio; higher numbers indicate greater compression. For instance, if an audio clip is 20 MB (megabytes) in its uncompressed form and becomes 1.8 MB after compression, then the **compression ratio** that was applied to that file is 11:1 (20 ÷ by 1.8 equals 11.1). Incidentally, this is the compression ratio for MP3 music files. Different digital audio formats use different compression ratios. In general, the lower the compression ratio applied to an audio signal, the better is the quality of the sound when it is reproduced. There has to be a compromise between the size of the file and the quality of the audio signal.

Sampling Rate/Bit Depth and Quantization

Digital audio technology is based on sampling techniques. The process of digital recording can be described in two steps: sampling rate/bit depth and quantization. The **sampling rate** refers to how many times per second the analog waveform is **sampled** in order to be converted into digital data. The sampling rate is expressed in hertz. (In this case Hz describes the number of samples per second instead of cycles per second, as in wave frequency.) Quantization refers to the process of converting a sampled sound into a digital value—0s or 1s. In other words, through quantization the continuous variations in voltage that represent a sound wave in the analog domain are converted into discrete numeric values. It is the equivalent of taking a snapshot of the analog audio signal (wave) a given number of times every second and converting it into numbers (0s and 1s), which then can be manipulated, shuffled around, and converted back to an analog audio waveform. (See Figure 5.22.)

A logical question to ask at this point is "How often must we sample?" How many "snapshots" do we need per second to accurately reproduce our original signal? The answer to this question is given by the Nyquist Sampling Theorem (named after the physicist Harry Nyquist), which simply states that the sampling rate should be twice the highest frequency we want to capture.

For instance, the sampling rate for CDs is 44.1 kHz, which means that it can reproduce frequencies up to 22 kHz. This is well above the approximately 20 kHz that can be detected by the human ear. This means that to encode a song in a CD, 44,100 snapshots of the sound wave are taken every second. If the song lasts 3 minutes, you can then do the math (44,100 samples/second × 60 seconds/minute × 3 minutes) and determine how many samples are taken all together. (Answer: 7,938,000 samples.)

The standard sampling rate for broadcast-quality digital audio is 48 kHz. From the discussion above, you can deduce that the more frequently the sound is sampled and the more bits are assigned to each sampling point, the more accurate the digital code will be and therefore the more accurate the signal reproduction will also be. In summary, sampling rate

FIGURE 5.22 Digital Signal Processing

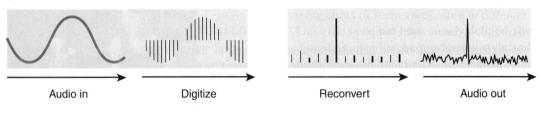

| Audio in | Digitize | Reconvert | Audio out |

Analog-to-Digital Recording **Digital-to-Analog Playback**

combined with quantization determines the quality of a digital signal that has been converted from an analog source.

Another important variable to consider is bit depth. **Bit depth** refers to the number of bits that are used to describe each of the samples or snapshots. (See Figure 5.23.) (Remember that a bit, or binary digit, is a two-digit value, such as 00, 01, 10, or 11.)

The more bits are used to describe each of the snapshots, the higher will be the fidelity to the original waveform. CDs are sampled at 16-bit depth. This means that there is a 16-bit number that describes each of the 44,100 samples per second. Many consumer-level camcorders sample the audio at a 12-bit rate, which yields a lower-quality signal than professional-quality camcorders that use 16-bit sampling.

▧ Bit Rate

Bit rate is defined as the number of bits that are transferred between devices in a given amount of time, usually 1 second. Audio files are measured in kilobits per second. The higher the rate at which the signal is encoded, the better is the quality of the resulting signal. The most common bit rate used is 128 kilobits per second.

▧ Dynamic Range

In digital audio dynamic range is defined as the range from the lowest audio level to the highest audio level that can be reproduced. This range is expressed in decibels. For example, we can say that the dynamic range for human hearing is about 120 dB—from 0 dB (the threshold of hearing) to 120 dB (the threshold of pain). Digitally speaking, the dynamic range

FIGURE 5.23 Sound Quality and Bit Depth

Analog Audio Waveform

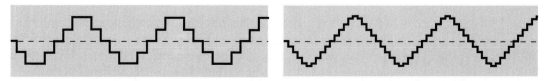

Waveform Sampled at 8 Bits Waveform Sampled at 16 Bits

The Higher the Number of Bits, the Closer to the
Original Waveform the Sound Becomes.

equals the bit depth times 6. So the dynamic range of a sound that is digitized with 8-bit sampling is 48 dB, and 16-bit sampling produces a dynamic range of 96 dB (16 × 6 = 96). Obviously, a 16-bit sampling rate will have much greater clarity and fidelity than an 8-bit sampling rate will.

■ Digital Audio File Formats

File format refers to the structure of the data stored within the file. In the digital world there are a variety of file formats for graphics, video, and audio files. There are a number of digital audio formats. They are extensively used for different tasks, including creating film and video effects, video games, and Internet downloads. Some of the most common audio digital formats are described below. File extensions follow each format in the parentheses.

● **AIFF (.AIFF OR .aiff)** This is the default format for the Macintosh platform. Files can be compressed or uncompressed, which means that the sound quality can vary depending on the sample size.

● **MIDI (.mid)** *MIDI* stands for "musical instrument digital interface." This format started out in the 1990s as a synthesizer controller. MIDI is very different from the other formats because it is not compressed audio. It essentially works as a language commanding instruments to play notes at a given time.

● **MP3 (.mp3)** This is perhaps the most popular and best-known format for sending music over the internet. The high compression of MP3 (which stands for "MPEG-1 layer 3") files makes music downloading possible because of the small size of the files. MP3 uses the perceptual coding process to reduce the amount of audio data.

● **REAL AUDIO (.ra)** The Real Audio file format was developed by Seattle-based Real Networks. This is perhaps the most popular format for streaming audio on the Internet. Real Audio files are very small because of their high compression rate. This makes it possible to transmit them quickly without using much bandwidth, but sound quality is sacrificed. Real Media Player software is required to play back the files, but it is compatible with all common platforms such as Windows, Linux, and Macintosh.

● **WAVE (.wav)** Wave, developed by Microsoft, is the audio standard for the Windows platform. Even though Wave files can accommodate different compression schemes, they are mostly uncompressed, and therefore the files are quite large. Wave supports both 8-bit and 16-bit stereo audio files.

● **WINDOWS MEDIA AUDIO (.wma)** This is Microsoft's competing format for MP3. This format has undergone many changes since it first

appeared, and the latest versions include different codecs for different applications, such as lossless compression for high-quality music reproduction and low bit rate for voice reproduction.

■ Digital Audio Workstations

A **digital audio workstation (DAW)** is a collection of hardware and software used to manipulate and edit sound. DAWs come in many different configurations—from a PC with a sound card, simple editing software, and a CD burner to professional digital audio recording workstations with very specialized software and hardware. (See Figure 5.24.)

DAWs allow us to record audio on different tracks, edit the results, and output the finished audio files, with the highest quality possible, to different media. Some are capable of playing and recording simultaneously. These are called *full duplexing* systems. Other systems can record and play but not at the same time. These are *half duplexing* systems.

Most DAWs support multiple digital audio file formats and perform nondestructive editing (they manipulate audio files without modifying the original file) or destructive editing (they manipulate and modify the audio file itself).

DAWs may be built around a combination of computer hardware and software, or they may be turnkey systems built on dedicated hardware. The computer and software-based systems are keyboard and mouse driven and typically allow for the connection of external devices such as fader controls

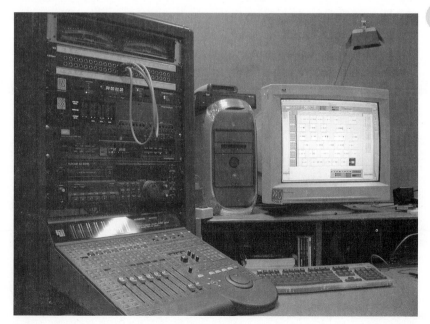

FIGURE 5.24
Digital Audio
Workstation

or equalizers. These systems may be based on either PC or Macintosh computers, both of which provide operating systems and user interfaces that are familiar to most of their users. The dedicated hardware systems are based on a particular manufacturer's proprietary software and hardware, and they usually are sold as a complete, self-contained package, with built-in components for capturing, transporting, editing, and storing audio files. Although they may look like regular computer packages, the systems serve a specific purpose—audio manipulation—and they do not allow users to load any other type of software application.

Two of the most popular digital audio workstations are Digidesign's Pro Tools LE and Adobe's Audition.

● **PRO TOOLS LE** Pro Tools LE is the scaled-down version of the professional Pro Tools software bundle. It runs on both Macintosh and PC platforms. (See Figure 5.25.)

The system is capable of performing all the principal audio file manipulations: It can be used to record, edit, mix, master, and output to different file formats. The Pro Tools LE package includes a hardware interface for getting audio into and out of the computer, plug-ins that enhance the operation of the system (third-party application software), and sound design

FIGURE 5.25 Pro Tools LE Digital Audio Workstation Screen Shot

tools. In four basic steps you can install and run Pro Tools LE on your personal computer:

1. Connect the input/output (I/O) box to your Macintosh or PC with the provided FireWire rack or USB box. This will allow audio files to flow back and forth between the computer and the I/O box.

2. Install the Pro Tools LE software on the computer.

3. Connect audio sources such as microphones and electronic instruments to the I/O box.

4. Launch Pro Tools and create a new session.

● **AUDITION** Audition was originally developed as Cool Edit by Syntrillium and then was acquired by Adobe, which changed the system's name to Audition. Audition is a single application that offers a complete audio editing environment that is capable of handling multitrack mixing as well as viewing video frames in the timeline for video soundtrack editing. (See Figure 5.26.)

FIGURE 5.26 Audition Digital Audio Workstation Screen Shot

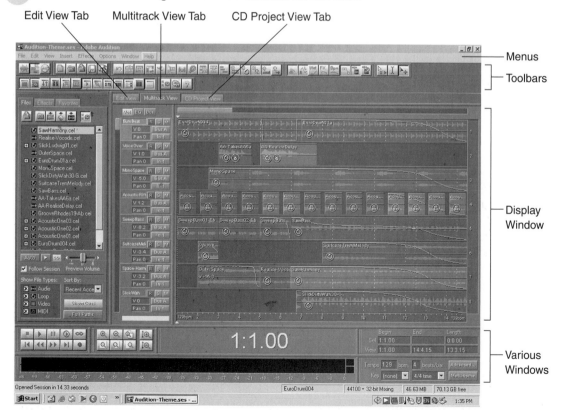

Audition works with up to 32 inputs and uses real time effects. It allows users to work with 32-bit files and standard sampling rates such as 44.1 kHz for CD-quality sound and 96 kHz for DVD-quality sound. The Audition package includes royalty-free music, audio restoration filters, and audio analysis tools such as frequency and phase analysis.

● **DIGITAL AUDIO TAPE RECORDER** Digital audio tape (DAT) recorders are capable of recording significantly better sound quality than are their analog relatives. **DAT** tapes are smaller than traditional audiocassettes and are not subject to the tape hiss problems of the analog formats. Frequency response and dynamic range are much better than those in analog cassettes. As a result, voice and music recordings made with DAT recorders can provide high-quality sound during video production and postproduction. Digital tapes can be reproduced with minimal or no loss in quality.

● **FLASH MEMORY RECORDERS** Another type of stand-alone digital audio recorder utilizes small **flash memory** cards to record the digital audio signal. (See Figure 5.27.) Flash memory cards use silicon chips instead of magnetic media to store data; unlike the situation with digital audio tape recorders, CDs, and computer hard disk drives, no moving parts are involved in the recording process, so these systems are rather rugged and durable.

Sound Design

Up to this point our discussion has focused largely on technical issues related to sound acquisition and recording and the hardware and software that is involved in these processes. Of course, there is another dimension to

FIGURE 5.27 Audio
Flash Memory Recorder

Flash Memory Card

sound in television and video: the aesthetic impact that sound has on the program you are producing. There are four basic different types of sound that are manipulated in the production of video programs: voice, music, sound effects, and natural sound. When you begin your production, you should have a sense of the overall sound design of your program; that is, you should know which of these elements you will use and how you will use them.

■ Voice

Voice is the predominant type of sound found in most video programs. But voice can be used in a variety of different ways. **Dialog,** conversation between two or more people, may be scripted, as in the case of dramatic programs, or unscripted, as in the case of interview programs. **Narration,** another typical use of voice, is commonly used in documentary and news programs.

The narrator may be on or off camera. In terms of script conventions, narration that is delivered by an on-camera narrator is referred to as **sound on tape (SOT).** We refer to off-camera narration as **voice-over (VO).** In this form of narration we hear the narrator's voice, but we don't see the narrator. Instead, we see visuals that are related to what the narrator is talking about. In ENG type news production and documentary production these visuals are called B-roll.

■ Music

It would be hard to imagine a modern video program without music. Television programs universally use theme music. **Theme music** is music that is used at the beginning and end of a program to cue the viewer to the upcoming program, to set an appropriate mood, and then finally to signal the end of the program that has been viewed. It doesn't matter whether the program is a drama, a situation comedy, a documentary, or a news program; one element they all have in common is the use of appropriate theme music.

Within a program music serves a number of important functions. It is important in setting or changing the mood and determining the pace of the program. It can be used to foreshadow an event that is about to happen or to signal the transition from one scene to the next. Music is important in establishing time and place, and it generally has the effect of adding energy to the scenes in which it is used. Music can also be used to give a sense of unity to a series of otherwise disparate shots.

Within the program itself music tends to move from foreground to background. A program theme might begin the program in the foreground (loud/high level) and then fade under spoken voice (softer/background level).

■ Sound Effects

Sound effects (SFX) are widely used in studio and field production. Explosions, car crashes, rocket launches, and other events of proportions that are difficult to stage can be represented effectively though the use of sound effects. Even natural sounds that can be difficult to record, such as waves crashing on rocks or birds chirping, may effectively be replaced by appropriate sound effects. Libraries of sound effects are widely available on CDs and via the Internet.

For a sound effect to be effective, it must be believable to the audience. Believability is achieved if the sound effect accurately represents the sound of the phenomenon in question. To do this, the sound effect must be characteristic of the phenomenon; that is, it must sound like the event that is being portrayed, and it must be presented at the proper volume and have the proper duration. A car crash sounds different from a bottle breaking, and the sound of the engine of a passenger car is different from the sound of the engine of a high-performance racer. To be effective, these and any other sound effects must accurately match the sound of the event depicted.

■ Natural Sound

Natural sound is sometimes called *location sound* or **ambient sound;** it is the sound that is present in the location in which the action is taking place. For example, in an interview with a shipyard welder the natural or location sound would be the sound produced by the workers and machinery in the shipyard or the sound produced by the welding equipment itself. In a sequence on hydroelectric power generation the natural sound would be the sound of water rushing through the intakes and the sounds of the electrical turbines spinning as they generate electricity.

Natural sound adds an important dimension of detail to remote productions. Tape that is shot in the field that does not include natural sound seems flat and lifeless. We expect to hear natural sound any time we see a picture because this is how we experience things visually and aurally in the real world. The importance of recording natural sound, particularly when shooting B-roll video footage that will be edited to match the voice-overs, cannot be overemphasized.

Natural sound is important during interviews that are recorded in the field as well. Most field producers will set up their camera and microphone and record a minute or so of "room tone," the ambient sound in the room where the interview is to be conducted, before they record the interview itself. This room tone can be very useful later, in the editing process, when bits and pieces of the interview are being edited together. Consistent room tone in the background can help to give the interview a seamless quality by smoothing the edit points and making them less obvious to the viewer or listener.

CHAPTER 6

The Video Switcher

The video switcher is a production device that allows the technical director (TD) to combine or manipulate different video sources on the director's command. Its function parallels that of an audio mixer but for video sources. A number of different video sources can be fed into the switcher, and the TD selects the source or combination of sources that will be sent out of the switcher to the video recorder (if the program is being recorded) or the transmitter (if the program is being broadcast live).

Types of Video Switchers

■ Distribution Switchers

Two types of video switchers are commonly found in video facilities: distribution switchers and production switchers. A **distribution switcher,** or *routing switcher*, is used to send video signals to different destinations, such as a monitor or a videotape recorder. For example, in a large production facility several VCRs might all be connected to a distribution switcher, and the output of the switcher might be connected to one high-quality monitor for viewing the output of any one of the VCRs, thus avoiding the expense of multiple monitors. By pressing each of the buttons on the switcher, the output of each of the VCRs can be viewed in turn on the monitor.

■ Production Switchers

Video **production switchers** are designed for use in multicamera television studio or field productions. (See Figure 6.1.) All of the video sources, including cameras, videotape recorders, and character generators, simultane-

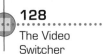

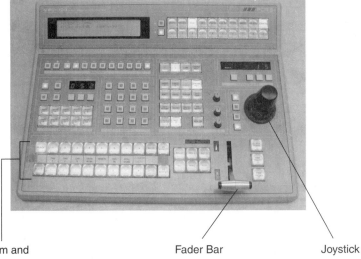

FIGURE 6.1
Production Switcher

Program and Fader Bar Joystick
Preset (Preview)
Buses

ously feed their signals to the video switcher. The director sits in a control room, where each video source is visible on its own monitor. The director calls out the source that is to go out on line. The technical director then quickly pushes the appropriate button ("punches it up") on the video switcher to make the switch. (See Figure 6.2.)

FIGURE 6.2 Technical Director
Operates the Video Switcher
While the Director (Standing)
Calls the Camera Shots

For the switcher to make a clean transition between video sources, all incoming video signals must be synchronized. Therefore, all cameras are simultaneously driven by an external **sync generator,** which ensures that each camera is at exactly the same scanning point in the frame as that of the other cameras at all times. When the cameras are synchronized, they all reach the end of the frame at the same time, so the switch from one camera to another takes place in the vertical interval of the video signal—the time after one frame ends and before the next one begins.

Some video sources are *asynchronous;* that is, they are not driven by the same sync generator as the cameras. Previously recorded videotapes and signals that are sent to the production facility via microwave or satellite transmission are several examples of asynchronous sources. To bring signals like these into sync with the studio cameras, a **frame synchronizer** or **time base corrector** is used. These devices compare the internal timing pulses that control the asynchronous signals with the timing pulses of the synchronous sources and adjust them so that all the video sources coming into the switcher are synchronized.

■ Manual versus Programmable Switchers

Some switchers are manual, and others are programmable. A *manual switcher* lacks automation or memory features. The technical director must execute all transitions and effects in real time. *Programmable switchers*—also known as smart switchers—have automation and memory features. For example, transition rates for dissolves and other special effects may be programmed into the switcher. (See Figure 6.3.) When the TD pushes the button to perform the transition or effect, the switcher automatically plays out the transition or effect in the amount of time and with the parameters that were previously specified.

Programmable switchers are particularly important for television news production, because often hundreds of transitions and effects need to be performed in a single newscast. Before the broadcast the TD programs each of the transitions and effects into the switcher's memory. Each of the switcher events is given a number and held in the switcher's memory. Then during the newscast they are recalled at the correct point in the script. This helps to eliminate embarrassing switching errors.

FIGURE 6.3 Switcher Auto Transition Control. The Automatic Transmission Rate Is Set to 30 Frames (1 Second)

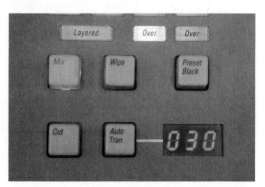

▇ Hardware Switchers versus Software Switchers

In most production facilities the switcher is a dedicated piece of hardware with real buttons and levers that are operated by a TD. Some switchers, however, are created with computer hardware and software. The switcher layout appears graphically on a computer screen, and instead of pushing buttons on a piece of hardware, the TD mouse-clicks the button icons on a computer screen to perform transitions and effects. These software-based switchers are often part of what some manufacturers call a "production system in a box." They may integrate a video switcher, graphics generator, animation software, and nonlinear editing into an integrated, computer-based package.

▇ Different Switchers for Different Types of Signals

Video switchers must be compatible with the type of video signals that are routed through them. Many older facilities still rely on analog signals routed through analog switchers. However, today video signals are increasingly digital signals, and the video switchers that are used to control them are digital switchers. In addition to the difference between analog and digital signals, there are differences in the way the color information within the video signal is processed. In addition to serial digital signals, there are component, composite, and S-Video signals. (These are discussed in more detail in Chapter 10.) Modern switchers increasingly have the ability to process a variety of different kinds of signal inputs.

Operational Characteristics of a Video Switcher

Video switchers rely on a system of buttons and buses. Each video source fed into the switcher (cameras, VCRs, graphics generators) is assigned to a button on the switcher. These buttons are arranged in rows across the switcher, and each row is called a **bus.** Most switchers contain a number of buses. Each of the sources is arranged in the same order in each bus. (See Figure 6.4.)

Three types of buses are typically found on video switchers: program, preview or preset, and mix/effects. Decisions about which video sources will go out on line are made in the **program bus.** When the TD depresses the button corresponding to a particular video source in the program bus, that source becomes the switcher's output. If the switcher output is con-

Program Bus ———

Preview/Preset ———
Bus

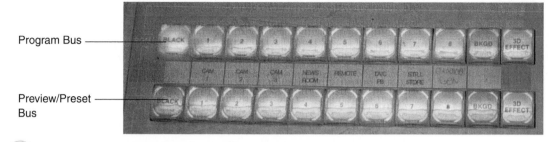

FIGURE 6.4 Program and Preview/Preset Buses

nected to a VCR, the signal will go to that machine. In a live television broadcast the signal goes to the transmitter and is broadcast live. The output of the program bus can be seen in the control room on the line monitor.

The output of the **preview** or **preset bus** is connected to a special preview monitor, which allows the production personnel to see the source before it goes out on line. This bus works independently of the program and mix/effects buses. The preview/preset bus is typically used to preview or rehearse a special effect before it is sent out on line through the program bus. Or the TD can use the preview/preset bus to preset or get ready the next shot that the director will be taking when the director gives the "ready" signal for that shot.

Special effects are performed through **mix/effects buses.** Dissolves, superimpositions, fades, wipes, and keys are varieties of special effects that are commonly found on video switchers and will be described later in this chapter.

Simple switchers may have one program bus, one preview/preset bus, and one mix/effects bus. More complex switchers are more versatile and may have three or four pairs of buses that can be assigned to one of the different switcher bus functions (program, preview, or mix/effects).

Multifunction Switchers

Older video switchers frequently used dedicated buses to perform different functions (e.g., program, preview, and mix/effects), but the buses on modern switchers typically are multifunction; that is, their function is designated by using a function assignment button on the switcher. For example, in the case of a simple two-bus switcher—program and preview/preset— on a multifunction switcher the function of the buses could be changed to mix/effects, with the program bus becoming Mix/Effects A and the preview/preset bus becoming Mix/Effects B. This would then allow you to use these buses not only as program and preview buses, but also as production buses for fades, dissolves, wipes, and keys.

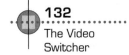

Switcher Transitions

A typical switcher can do four types of transitions: cut, fade, dissolve, and wipe.

■ The Cut

A **cut** is an instantaneous transition from one source to another. To cut, you simply depress the appropriate button in the program bus. For example, if camera 1 is on line, to cut to camera 2 you depress the button for camera 2, in the program bus. (See Figure 6.5.)

FIGURE 6.5 Cut

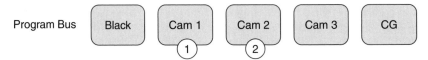

Direct Method

Program Bus | Black | Cam 1 ① | Cam 2 ② | Cam 3 | CG |

To cut from Camera 1 to Camera 2:

① Camera 1 is on line in the Program Bus.

② Depress the button for Camera 2 in the Program Bus to make the cut.

Preset Method

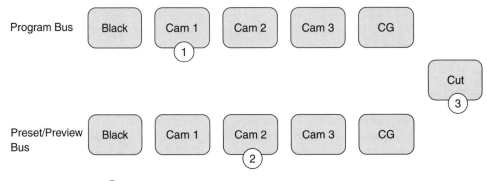

Program Bus | Black | Cam 1 ① | Cam 2 | Cam 3 | CG |

Cut ③

Preset/Preview Bus | Black | Cam 1 | Cam 2 ② | Cam 3 | CG |

① Camera 1 is on line in the Program Bus.

② Select Camera 2 on the Preset/Preview Bus.

③ Select Cut in the Automatic Transition section of the switcher. Camera 2 will go out on line.

■ The Fade

Fades are a bit more complex. A **fade** is a gradual transition from black (or any other color) to a source or from a source to black (or other color). A typical production convention is to fade up from black at the beginning of a program and to fade out to black at the end. To achieve a fade, the effect must be set up in one of the mix/effects (M/E) buses. To fade from black to a source, punch up black in the M/E A or Program bus. Then press the button for the source you want to fade to on the M/E B or Preset bus. You select which bus (A or B) goes out on line with the fader bar at the end of the buses. If it is moved to the A position, M/E A (Program) will go out. When it is moved to the M/E B (Preset) position, the switcher output gradually changes from A to B. (See Figure 6.6.)

■ The Dissolve

A **dissolve** is executed in the same way as a fade except that it involves a gradual transition from one video source to another rather than to black. Punch source 1 on M/E A and source 2 on M/E B. With the fader bar in the A position source 1 goes out on line. When the bar is moved to the B

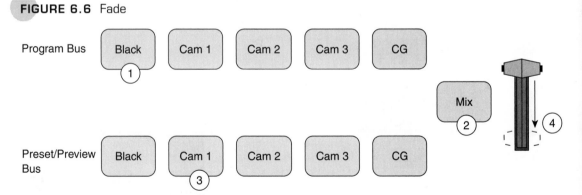

FIGURE 6.6 Fade

To fade up from Black to Camera 1:

(1) Black is on line in the Program Bus.

(2) Select Mix in the Transitions/Effects area of the switcher.

(3) Depress the button for Camera 1 in the Preset/Preview Bus.

(4) Move the fader bars down from Program to Preset/Preview.

FIGURE 6.7 Dissolve

Dissolve

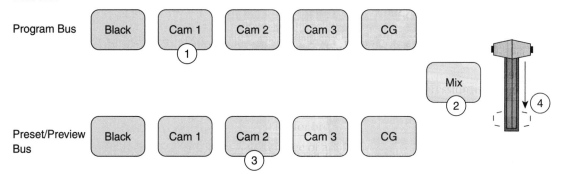

To dissolve from Camera 1 to Camera 2:

(1) Camera 1 is on line in the Program Bus.

(2) Select Mix in the Transitions/Effects area of the switcher.

(3) Depress the button for Camera 2 in the Preset/Preview Bus.

(4) Move the fader bars down from Program to Preset/Preview.

To superimpose Camera 1 over Camera 2, stop the fader bars halfway between the Program Bus and the Preset Bus.

Superimposition (Halfway through a Dissolve)

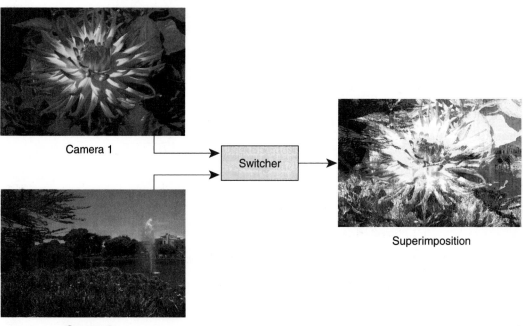

position, A gradually fades out and B fades in. When the fader bar is positioned in between A and B, the two sources appear superimposed over each other on the line monitor. The intensity of each source can be adjusted by moving the fader bar. As the fader bar is moved toward A, source 1 becomes stronger and brighter. As it is moved toward B, source 2 becomes stronger and brighter. (See Figure 6.7.)

On multifunction switchers the dissolve function is sometimes identified as "mix." (As an interesting aside, in Great Britain video switchers are called *vision mixers.*)

■ The Wipe

A **wipe** is a transition effect in which one picture is partially or fully replaced by another with a specified geometric pattern. Wipes are performed by first selecting the wipe pattern and then selecting the wipe sources. Most switchers have a number of wipe patterns, how many depends on how complex the switcher is. (See Figure 6.8.)

The wipe is set up in much the same way as a dissolve. Punch up source 1 on M/E A and source 2 on M/E B. Select the wipe pattern by depressing the button with the wipe pattern that you want to use. The wipe is now controlled with the fader bars. As the bar is moved from M/E A to M/E B, the wipe pattern will move through the picture and reveal the shot on source 2 (M/E B).

FIGURE 6.8 Wipe Patterns

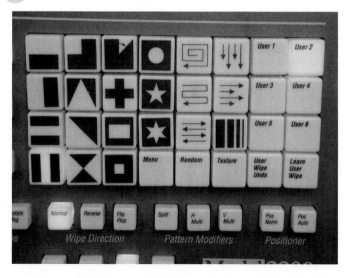

Wipes can be used to achieve a **split screen** effect. A horizontal wipe that is stopped at the halfway point will produce the split screen effect. (See Figure 6.9.)

There are a number of variations on the basic wipe. The speed at which the wipe is executed can be controlled by varying the speed at which the bars are moved or, on programmable switchers, by programming the length of the wipe into the switcher. (The longer the specified length, the slower the wipe will be.) The definition of the edge of the wipe can also be controlled. Most switchers allow the operator to select either a hard-edge wipe or a soft-edge wipe and to add color to the edge. In addition, the position of certain wipes on the screen, usually circles or diamonds, can be changed by using the **joystick,** sometimes called the *wipe positioner.* The joystick is used to move the wipe pattern up, down, and around on the screen.

Keying

During production a video switcher is used to electronically insert titles over the background picture. Two common methods of inserting titles are keys and mattes.

FIGURE 6.9 Split Screen Wipe

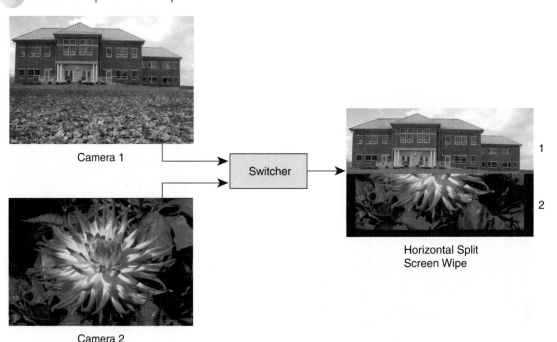

Camera 1

Switcher

1

2

Horizontal Split
Screen Wipe

Camera 2

■ The Key

The most frequently used titling effect is the **key.** Simple keys, or **luminance keys,** electronically insert lettering over the background picture on the basis of the brightness of the lettering. If the titles to be inserted feature bright lettering on a dark background, the switcher eliminates all frequencies of light that are darker than the lettering, thereby allowing only the lettering to be seen. The bright lettering appears over the background picture, and the dark background around the lettering disappears. (See Figure 6.10.) The key effect can be achieved with dark lettering over a bright background as well. In this inverse key, the black letters are electronically inserted, and the bright background is eliminated.

■ The Matte

Another effect that is commonly used for titling is the matte, sometimes referred to as a matte key. A **matte** involves the use of three separate video sources: lettering, background picture, and another source to fill in the letters. Typically, the letters are first cut into the background by using the

FIGURE 6.10 Key

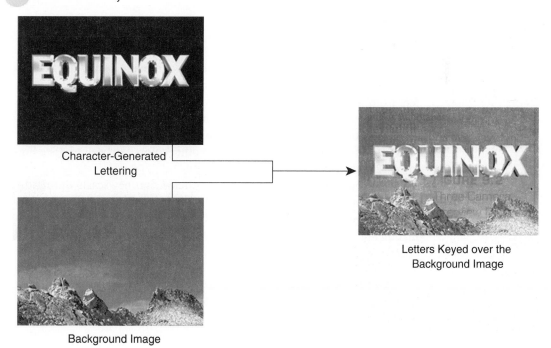

Character-Generated
Lettering

Background Image

Letters Keyed over the
Background Image

Letters Are Electronically
Generated.

A Fill Pattern Is Generated.

Letters Are Filled with
the Pattern.

FIGURE 6.11 Matte

switcher's keyer, and then the letters are filled with another source. (See Figure 6.11.)

Often the switcher's background color generator is used to fill the lettering with a different color. Matting in color is a simple way to make lettering more visible; sometimes white letters are not visible if they are keyed in over a white or very bright background. The addition of color can make the lettering stand out from the background source.

■ The Chroma Key

Another special effect that is part of the key and matte family of effects is the chroma key, sometimes called a chroma key matte. A chroma key differs from a luminance key in the way in which the background is subtracted from the source to be keyed. In a chroma key, the background is subtracted on the basis of color, not brightness. The typical chroma key backgrounds are blue or green, although other colors can be used. (See Figure 6.12 and CP-8.)

Chroma keys are frequently used in television newscasts during the presentation of weather information. The weathercaster stands in front of a chroma key background in the studio. Computer-generated maps and animation appear to be placed behind the weathercaster when the chroma key effect is engaged. The weathercaster has in effect been keyed in over the maps and animation.

Sometimes the term *Ultimatte* is used to describe what is essentially a chroma key effect. Ultimatte is the trade name for compositing equipment produced by the Ultimatte Corporation.

Foreground Subject Is Recorded against a
Blue or Green Background.

Background Image Is Recorded
Separately.

Blue or Green Background Is Subtracted
and Foreground Image Is Combined
with Background Image.

FIGURE 6.12 Chroma Key

■ Downstream Keys

Most modern production switchers include a **downstream keyer,** which
introduces matte or key effects over the output of the switcher, leaving the
production buses free to perform other effects. For example, if you have a
switcher with one pair of mix/effects buses, you could set up a split screen
or other effect in the main mix/effects buses and then add titles over the

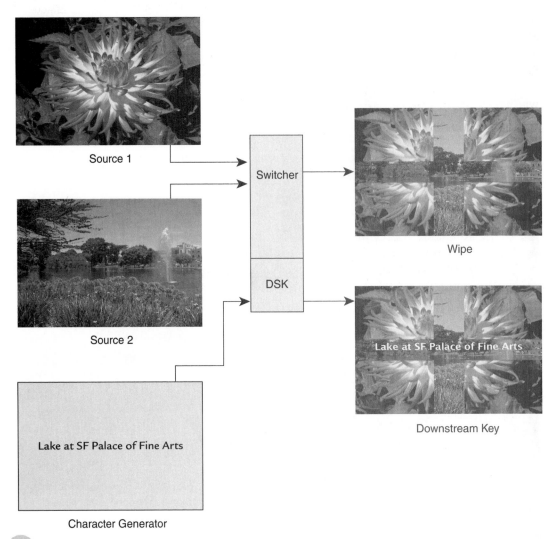

FIGURE 6.13 Downstream Key (DSK = Downstream Keyer)

effect with the downstream keyer. The downstream keyer essentially allows an additional layer of effects beyond what can be achieved in the available mix/effect buses. (See Figure 6.13.)

Digital Video Effects

Digital video effects (DVE) can be used to manipulate the size, placement, and movement of images on the screen. Digital video effects are widely used in production. They are used to place relevant images over the

newscaster's shoulder during a newscast. On discussion programs they are used to compress the images of the participants so that multiple individuals, often in different locations, appear on the screen at the same time. They are also widely used to fly, push, or pull keys into and out of the frame.

Common digital effects include image compression and expansion, which result from stretching or squeezing the vertical dimensions of the picture. Through image compression a full-frame image can be reduced to any size and positioned anywhere in the frame. Similarly, through expansion a reduced image located in a section of the frame can be increased in size until it fills the frame. (See Figure 6.14.)

FIGURE 6.14
Image Compression
and Expansion

Compressed Image

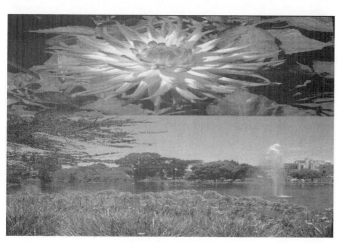

Stretched Images

Other digital video effects include **page push** and **page pull** (the picture appears to be pushed or pulled off the screen by another), **page turn** (this looks like the page of a book or magazine turning), and a host of three-dimensional effects that transform the image into a sphere, a cube, and so on. (See Figure 6.15.)

Many digital switchers now contain a **digital still store (DSS)** feature. Working in conjunction with the switcher's frame synchronizer, still frames can be "grabbed" from videotape or live sources and saved in the still store. Then, by using DVE compression tools, the still image can be squeezed down to the desired size and placed in the appropriate location in the frame.

FIGURE 6.15
Page Peel and Cube
Effects

Page Peel

Cube Effect

CHAPTER 7

The Role of
the Producer

The Creative Producer

Earlier, we learned that although every member of the production team involved in the completion of a video project is important, television is a producer's medium. The successful producer needs to manage a complex organization to produce a successful program. To do that, the producer needs to have two significant sets of skills. Managing the human aspect of the production—dealing with cast and crew—requires the producer to have the people skills characteristic of a good communicator and manager. To manage technical aspects of production—dealing with equipment and facilities—the producer needs to be skilled in production techniques as well.

The producer decides the content that goes into a program, the visual style of the program, and the makeup of the team in charge of producing the program. In many cases, as in most television episodic series, the producer may also be the creator of the story idea behind the program. Regardless of the type of television program, whether it is a reality show, a news program, an episodic drama, a religious program, or a game show—it is the producer's responsibility to design programs that engage audiences with compelling stories and exciting visual materials.

To illustrate this point, consider the following ad for a news-producing job that recently appeared on a web page advertising job openings for television producers:

News Producer

We are looking for a creative team leader who loves crafting a bright newscast with great writing, the best video, live cameras and intelligent graphics. We have an excellent newsroom environment, competitive on stories, and eager to recognize fresh ideas, no matter who has them . . .

But creating a visual style and defining the look and feel of the production are not the only responsibilities of a producer. The producer is a multi-

talented individual who must perform different activities in all stages of the production process. The producer must assume a variety of managerial, technical, and creative responsibilities. A producer must deal with administrators, performers, technicians, and a range of different issues, such as legal matters, salaries, schedules, and securing and managing the financial resources necessary to mount the production.

Depending on the complexity of the production and the extent of his or her financial participation in the project, an executive producer may assume different roles and levels of control, and in turn more than one person may be required to fulfill all the producing responsibilities. A **line producer** may be hired to take charge of all daily production activities, work very closely with the director, and ensure that all deadlines are met. In addition, an **associate producer** may be needed to assist the executive producers with financial, logistical, or creative matters. In small markets or on smaller projects, the producer may also serve as director, camera operator, or editor or may perform other work on the production as needed.

The Production Process Model

The television production process is, above all, a communication process. It all begins with intentionality: the reason why the producer is making the television program. There is also a sender, there is a message, there is a channel, there is a receiver, there is interpretation, and, finally, there is an effect on the viewer. The process is mostly unidirectional—from sender to receiver—with very little feedback from the receiver to the sender (viewers have very few opportunities to have an input on what they watch), although digital **interactive television (ITV)** may expand the opportunities for an audience for feedback. The model in Figure 7.1 depicts the process.

Each of the process components has its own subcomponents, which in turn has its own, and so forth. The communication process of television or video production takes place in different environments that in turn influence the effectiveness of the message.

The television production environment has experienced many changes throughout its history. The advent of new technologies such as the

FIGURE 7.1 The Video Production Process as a Communication Model

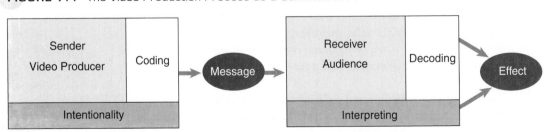

■ **TABLE 7.1** Stages of the Television/Video Production

Design	Production	Distribution
• Defining need or problem • Developing vision or idea	• Technical • Aesthetic	• Evaluation • Distribution

electronic field production equipment that was developed in the early 1970s and today's digital production tools has altered many of the production procedures used to produce programs. Changes in the visual style of new programs typified by "reality" programs and by many of the programs produced by MTV have altered many of the values and principles of visual production as well.

However, despite these evolutionary changes in production technology and program styles, all video programs are developed through a process that follows the four stages of design, production, evaluation, and distribution. Table 7.1 describes these different stages of the production process, and Figure 7.2 provides a graphic representation of the various elements of the television production process.

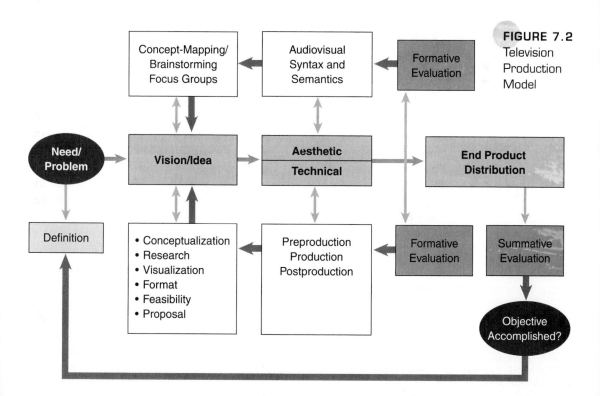

FIGURE 7.2
Television
Production
Model

The Design Stage

During the design stage the blueprint for the project is created. Just as in a construction project there is a stage in which aesthetic and technical elements are literally brought to the drawing board to define the look and feel of a structure before the actual building takes place, there is also such a stage in television production. There are two main steps during this stage: defining the need or problem and developing the vision or idea.

■ Defining the Need or Problem

The first step in the development of a project is to identify and define the need or the problem the video program intends to address. Video programs are produced to fulfill different needs. Commercial television broadcast programs need to succeed in the ratings. One recent consequence of this is the proliferation of reality shows which have been extremely popular with the viewers. Public service announcements about the harmful consequences of smoking address the need to change the attitudes or behavior of the audience in relation to smoking. Television commercials are designed to satisfy the advertiser's need to sell products. As a student in an introductory video production class you may need to design and produce a project to fulfill the requirements for a class assignment.

Any time you begin to work on a production, you should always ask the question "Why does this television program need to be produced?" The answer to this question must be stated very clearly before you begin to produce the program.

■ Developing a Vision or Idea

Once the need for the program and its intentionality have been established (i.e., will the program inform, educate, entertain, or persuade to address a need or solve a problem?), there are two steps to follow next: to begin the process of creative thinking and to write down the idea for the program based on the results of the creative thinking process.

● **CREATIVE THINKING** During the creative thinking process the producer needs to come up with an idea or a vision for the content and look of the program. There are several well-established techniques that producers use to develop new creative ideas to achieve their objectives. Three of the most common techniques are concept mapping, brainstorming, and focus groups.

Concept Mapping Concept mapping is a tool developed in the 1960s by Joseph Novak of Stanford University. A **concept map** is a visual representation of the interrelationship between concepts or ideas arranged in a hier-

archical way, with the most general concept at the top or center of the map and the less general or more specific ones in branches radiating from the central idea below or to the sides of the main concept. As you can see in this example the central idea is "poverty."

The concept map diagram in Figure 7.3 is the roadmap or guide for producing a documentary video on the topic of poverty. To the right side of the central concept there are issues related to poverty in some of the developing countries of the world in Latin America, specifically Colombia. On

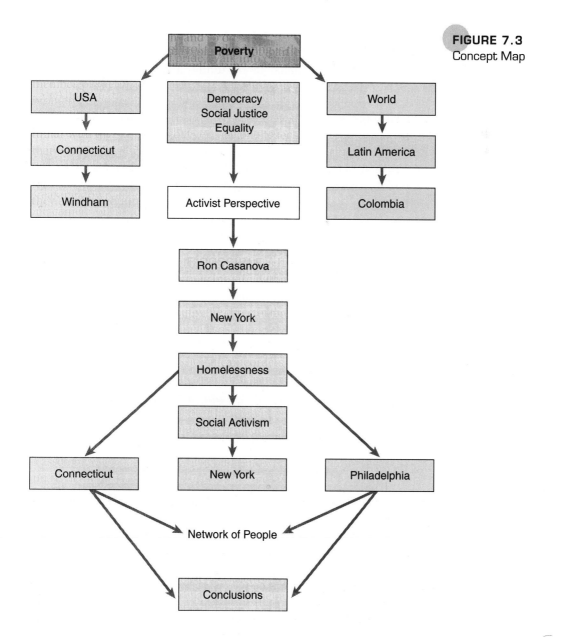

FIGURE 7.3
Concept Map

the other side we look at poverty issues closer to home in a developed country, the United States, by focusing on the state of Connecticut and specifically Windham County.

As we return to our central idea, poverty is then related to the issue of democracy and equality, which is seen through the eyes of community organizer and social activist Ron Casanova, a black Puerto Rican raised in New York and once himself homeless. Casanova became a leader among community organizers in Philadelphia, New York, and Connecticut, where they established a network of activists looking for ways to eradicate or alleviate the problems associated with poverty. The documentary concludes with a look at a paradoxical reality: poverty in the richest country in the world—the United States.

This technique is similar to **clustering,** a type of unstructured free writing that works more by free association of ideas than by the clear relationships between the ideas as in the concept mapping technique. In many cases the terms *clustering* and *concept mapping* are used interchangeably.

Here are some basic steps in the creation of concept maps:

- Use unlined paper, and have on hand all your research material, such as books, magazine articles, material printed from websites, and pictures.
- Define the central idea, and place it on the top or at the center of the page. You can also use small pieces of colored paper with geometrical shapes and paste them on your paper.
- Think of a visual structure for your map. Associate this visual structure with the visual potential of your story.
- Link all ideas, words, or phrases with lines or arrows to the central idea or to the branches deriving from that idea. On the connecting lines write words or phrases explaining the relationship between ideas or concepts.
- Write down your ideas as quickly as they come to mind without any editing so as not to interrupt the mapping process. Do not pause to organize or order any material; just write it down.
- When you feel that you are finished, review your material to see whether anything has been left out.

Following are some of the advantages of concept mapping:

- It clearly identifies the central idea by positioning it at the top or center of the page.
- It allows you to see relationships between ideas and the relative importance of each one of them, and all the information is conveniently organized on a single page.
- It allows you to view information from different perspectives and add more information whenever you consider it necessary.

Brainstorming **Brainstorming** is a group activity (a group size of four to fifteen participants is recommended) that encourages participants to generate possible solutions to a problem without making any value judgment on any of them. Brainstorming—also known as *listing* when it is performed by a single person—may be seen as a type of concept mapping or clustering, but it relies more on random input such as unrelated wild and exaggerated ideas. The purpose of a brainstorming session is to generate as many ideas or solutions to a problem as possible. If you have ever been asked to decide on a production idea for a group project to fulfill a video production class assignment, you probably used the brainstorming technique in your group meeting.

Here are some steps or rules to help you organize and conduct a brainstorming session:

- Choose a person to coordinate the brainstorming activity, and make sure the person provides a clear introduction explaining the purpose of the session.

- Depending on the complexity of the topic or the nature of the problem, a session could last from ten minutes to two hours or longer if necessary. However, keep in mind that a long session and an overworked group may not produce fresh ideas and may therefore defeat the purpose of the session.

- Define your main topic, and stay focused on that topic.

- Ask one person in the group to write down the ideas as they are called out by the participants. Use a flipchart or a blackboard to write things down so that the entire group can see them. You can also use a recording device to record the session and review it later.

- Encourage participants to make as many contributions as possible without anyone commenting on each other's contribution. Remember, in the initial brainstorming process, every idea is as valuable as every other.

Once the session is over, the participants can go over the ideas that were presented and combine them as necessary to come up with a solution to the problem or the idea for the television program. In the professional production environment the brainstorming technique is most often used for writing and designing television commercials and advertising campaigns.

Focus Groups As its name suggests, a **focus group** is an activity in which a group of people—usually from five to twelve representatives of the intended target audience—are gathered together to discuss their views on a particular topic. Although this technique is used mostly for purposes of evaluation (it allows the producer to test ideas that were generated during concept-mapping or brainstorming activities or to test a video program in

the context of the audience) it is sometimes also used to generate new ideas or new solutions to a problem.

Once an idea has been generated, it needs to be tested so that the producer can get valuable feedback on content, techniques, choice of talent, or any other feature of the program. In a focus group there is a facilitator who, according to a previously established discussion guide, asks the group a series of questions and records the results for analysis. This technique is commonly used in television commercial and communication campaigns such as those designed to advance public health messages.

Here are some guidelines to help you design and conduct a focus group session:

- Clearly define the objectives, the information needed to achieve them, and how the information will be used.

- Determine who the focus group participants will be. Will they be part of your target audience, people who are familiar with the characteristics of your target audience, or both? In addition, think about an appropriate location to hold the focus group meeting.

- Develop a discussion guide or questionnaire and provide training to the facilitators to avoid bias and to ensure that each of the sessions will be conducted similarly.

- Record the focus session for later review, preferably on videotape. Body language and voice inflection may provide you with valuable feedback on a specific point. Transcribe the recordings.

- Make sure that all of the participants are allowed the opportunity to speak freely and ensure they understand that there is no right or wrong answer or comment.

- Design a method for analysis and interpretation of the transcribed comments, and be prepared to implement your findings.

▇ Writing It Down

Next, the producers or a team led by the producer must develop the creative idea, shape it into the form of a video program, and formalize the findings in writing. There are several steps to take during this phase: conceptualization, research, visualization, format, feasibility, and proposal.

● **CONCEPTUALIZATION** Once the need has been clearly defined, the objectives have been established, and an idea for the production style and content has been chosen, a producer must put together all the elements and refine them into a coherent form. The producer must identify and interpret the creative concept or the "big idea" for the show. A theme that expresses

what the story is about is determined, and the decision on how to tell the story is made. The theme (e.g., immigrants' fears, love on the Internet) is the essence of the story, and the producer (creator) must choose the aesthetic concepts and technical needs that must be met to project his or her artistic vision of the theme to the target audience. During this phase the video program begins to take shape.

● **RESEARCH** You must learn as much as you can about the subject you will be dealing with so that you are operating from a position of knowledge, not ignorance. In addition, you must identify the resources you will need to have to shape your artistic vision into a video program. Producers regularly draw on resources such as the Internet, libraries, interviews with experts, and visits to potential remote locations.

● **VISUALIZATION** The mind's eye that has been active during the creative process determines the visual potential of the story. Creative concepts can be put into drawings or sketches with different visual interpretations of the idea. Symbols, metaphors, visual and aural aesthetics, and their impact on the audience should be considered. Another important consideration is how the issue of continuity will be treated. That is, the aural and visual elements of your story must exhibit an internal consistency throughout the program so that your audience can move through the story without feeling lost.

● **FORMAT** Format refers to the form in which the program will be presented or *packaged* for audience consumption. In the 1940s, when television sets first became available in the United States, most television programs mirrored radio formats. Since then, television programming has evolved into a wide variety of formats that address the various needs and tastes of audiences, program producers, and advertisers.

Even though many of the early television formats such as quiz, music, and variety shows are still very popular, the proliferation of special-interest channels and the development of specialized audience target markets have brought about a variety of new, more complex formats targeted to well-defined audiences. Talk shows, music videos, and reality TV shows are just a few examples of highly successful formats that have appeared in recent years. In addition, with the emergence of digital production and transmission technologies that allow for the transmission of multiple streams of programs in the bandwidth that it now takes to transmit a single program, we should expect that new and highly interactive formats will emerge as this state-of-the-art digital technology becomes more available to U.S. and international audiences.

■ **TABLE 7.2** Six Television Program Genres

Factual	Reality-Based	Entertainment
News	Reality TV	Feature films
Documentaries		Episodic series
Lifestyle		Soap operas
Magazines		Situation comedies
Current affairs		Game shows
Community TV		Music shows

Infotainment	Educational	Persuasive
Talk shows	Children's TV	Commercials
Demonstrations (cooking or how-to)	Instructional TV	Public service announcements
		Infomercials

Table 7.2 presents a classification of formats based on genre. It is important to differentiate between format and genre, as the terms are sometimes used interchangeably. The word *genre* comes from the French word for "class" or "kind." Definitions of genres are sometimes based on codes of content such as themes or settings, or they can be based on elements such as structure and style. For our purposes we identify six television genres: factual, reality-based, entertainment, infotainment, educational, and persuasive.

● **FEASIBILITY** This is perhaps one of the most important aspects of the design process. Critical analysis and thorough research will help the producer to determine whether the program is producible. At this point all the previous steps must be reviewed carefully to find any potential production problems that may exist. Make sure that the technical and human resources that are required for the successful completion of the program are within the reach of the producer.

● **PROPOSAL** A proposal is a written argument designed to persuade your source of funding or production supervisor that your proposed program is worth producing. It should be presented only after serious thinking and planning have taken place and the feasibility of the project has been established. There is no standard format for a proposal, but keep in mind that because the basic objective is to "sell" an idea, you must clearly address the needs of your client or supervisor. The proposal should be brief and concise and include the following information.

Program Title What is the title of your program? Keep it short (two or three words are usually sufficient), and make it interesting. Consider, for example, the following titles: *Another Man's Treasure*—a program in which artists scavenge trash from a local garbage facility and fashion it into artworks; *Painting the Town*—an examination of a group of artists who paint murals that express the values of their community on the walls of public buildings; *Art on Wheels*—a profile of an art program that is housed in a bus that travels to inner-city neighborhoods to provide after-school art instruction to junior high school children. Consider also that the titles of many of the most popular television programs are often one word long (e.g., *Frazier, Seinfeld, Cops*).

The title is your first opportunity to grab the attention of the producer and your target audience. If the producer or audience fails to perceive the relevance of the title to their own interests, they may well tune out the rest of your proposal.

Subject and Needs Assessment This section establishes the *why* of the program. How does your program addresses a particular social need or propose to solve a problem? The proposal should start with a sentence that states the need or the problem and then explains what your program will do to address this need or problem.

Target Audience and Delivery Time (Distribution) Be specific about the audience for which the program is intended. Information about audience needs and desires can be gathered by conducting basic research. It is also important to describe the best time at which your target audience can watch the program or how you intend to distribute your program to your intended audience. For example, a program aimed at school-age children would best be scheduled on a weekday afternoon, after school gets out, or on a weekend morning.

Treatment and Synopsis The terms *treatment* and *synopsis* are used interchangeably in many cases, but they may mean different things to producers, writers, or other television production professionals. For our purposes a **synopsis** is a short summary of the story or show, and a **treatment** is a brief narrative description of how the program is going to be presented. It should describe the basic program design or style and provide an outline of major components of the format that is chosen.

The length and content of a treatment depend on the program genre. A dramatized program may require that the treatment include descriptions of characters' personalities and their environment as well as some dialogue, and as a result the treatment may be several pages long.

A magazine program treatment, by contrast, may require only a couple of paragraphs describing the look and feel of the show, the host's performance characteristics and appearance (appealing to the target audience

FIGURE 7.4 Sample Treatment

Canvas: A TV Sitcom

Treatment by Edmond Chibeau

Logline: The lower Manhattan art community has many strange characters, but none are more outrageous than Santoz, the abstractionist who refuses to compromise and never fails to make a spectacle of himself when he is at a gallery opening.

Santoz is out of control and on the edge of madness, yet many people seem to feel that he is talented and fun to be around. His outrageous behavior puts art patrons and gallery owners on edge, but it provides comic relief for those who feel that the art world takes itself a bit too seriously. He bursts into the apartment of Laural and Robert, looking for his girlfriend Marcella and ranting that he will not go to the opening of his own art exhibition being held in a prestigious uptown gallery. He helps himself to their wine and generally makes a nuisance of himself. He brings out the maternal instincts in Laural, and she tries to calm him down. Santoz sees every woman as a mountain to be climbed, a challenge to his powers of seduction. Unfortunately, his seduction technique has all the subtlety of a bull in a china shop. Laural finds this harmless and cute. Her husband Robert is not amused.

Robert is also a painter, but his painting, like his personality, is cool and intellectual, while Santoz's is pure feral emotion. One is a precise photorealist, while the other "throws his paint at the canvas." Robert does not see the humor in Santoz's carrying on. He feels that wherever Santoz is the world seems to revolve around him because he won't be anything less than the center of attention. And to make matters worse, it works—people are interested in Santoz's paintings

As they make their way through the streets of lower Manhattan, Santoz sees a young graffiti artist spray-painting the side of a building. Expressing an abiding interest in urban arts, Santoz offers to buy the spray-painted wall of the building from the young artist. At first the young man thinks Santoz and his companions are the police, then he tries to explain that he doesn't own the building, he is just "tagging" the outside wall. Unfazed by the explanation, Santoz negotiates for ownership of "the piece" being created in wild-style bubble letters by the graffiti artist. Not sure whether Santoz is crazy or just an easy mark, the young man sells the paint, but not the bricks it is painted on, to Santoz. Santoz is thrilled. "It's a conceptual thing." He then buys the can of spray paint that was used to make the graffiti painting.

As they arrive at the gallery, they see Santoz's girlfriend Marcella talking to a very thin, very well-dressed man. Robert and Laural go over to talk to Marcella as Santoz heads straight for the buffet table to get himself some wine and cheese. The crowd at the gallery is a mixture of art patrons dressed in the latest fashions and bohemian artists who see their clothing and their lives as an extension of their art. Several people wear electronic jewelry that pulses with light; many have extreme coiffures.

Four thugs carrying guns and wearing masks barge into the gallery and order everyone to put their hands against the wall. "Don't nobody try nothin' and don't nobody get hurt. Otherwise we start shootin' and it looks like the Saint Valentine's Day Massacre in here."

At first Santoz complains that "These Philistines will ruin my work." But as the thieves are taking money and jewels from the people who have their hands up against the canvases, Santoz has an inspiration and fishes a can of spray paint out of his pocket and starts to spray the hands of the people leaning against his canvases.

The crooks are distracted, and the gallery owner moves behind her desk to throw a silent alarm. When she is seen moving around, she explains that she was just getting some paper towels to wipe the hands of the "artist's models" who were "posing" with their hands against the canvases. She asks them what they think of the new paintings, and as the crooks become involved in a discussion of aesthetics, the police arrive.

Santoz and the gallery owner are heroes, and all of the paintings are sold.

155

The Production
Stage:
Aesthetic
and Technical
Aspects

of the show), and a short sample list of general story topics to be covered. The production method can be described here, but only the most important aesthetic and technical elements should be included. (See Figure 7.4.)

Aesthetic and Technical Considerations Special attention must be paid to these issues. The audiovisual potential of your program must be explored and then addressed in the proposal. Careful thought must be given to the manipulation of the different aesthetic variables, such as lighting, editing, and sound, and also to the technical aspects that will be involved during production and postproduction, such as the type of camera to be used, tape format, and the type of editing system.

Production Schedule This section must include a complete breakdown of production activities. It should include the rehearsal schedule, the actual videotaping dates and times, the postproduction schedule, and a list of the human and technical resources needed to accomplish the task.

Script/Storyboard Depending on the type of program you are trying to produce and the type of organization to which the proposal is being submitted, you should include a full or partial script. A storyboard may be required as well, particularly if you are proposing the production of a public service announcement or commercial campaign. We will discuss scripts and storyboards in more detail later on in the chapter.

Evaluation Most programs are conceived, designed, and produced with a specific goal in mind. The proposal must include a description of the methods that you will employ to perform formative (during the process of production) and summative (at the end of the process of production) evaluation. This is discussed in greater detail at the end of this chapter.

Budget A realistic estimate of all the production costs must be included. You must consider every production aspect and include all preproduction, production, and postproduction costs.

The Production Stage:
Aesthetic and Technical Aspects

As we mentioned earlier, the production of a video program is a communication process in which many elements come together to achieve the program's objective: change attitudes, sell a product, entertain the audience, or whatever it may be. The proper application of production techniques (media aesthetics) and production equipment and technology (technical aspects of production) make up the two major components of the production stage.

■ Aesthetics: Audiovisual Syntax and Semantics

Video programs provide a rich environment for structuring content, interpreting messages, and affecting audiences. The interaction of audio, video, and graphics makes video a highly effective communication tool. As a communication tool video uses a series of aesthetic manipulations that, in the end, will determine a program's effectiveness. It is imperative that the video producer become well versed in the aesthetic principles that guide every production. The most common methods that are used to describe oral and written communication, syntax and semantics, can also be applied to the video communication process.

Audiovisual syntax refers to the way in which the different production elements—sound, color, text, and images—interrelate to create a defined structure. In creating a video program, different shots, sounds, and transitions are combined to create a scene. Scenes can be combined to create a sequence, and so on. In summary, the purposeful arrangement of small units or elements in a video program form a much larger, meaningful syntactical structure.

Audiovisual semantics refers to the meaning that the arrangement of elements—the syntactical structure—may convey to an audience after the audience is exposed to it. The semantics of a video program depend on the context in which the viewer is exposed to the content and form of the program. These elements determine the structure, which in turn produces meaning for the viewer. Figure 7.5 shows this relationship.

■ Technical Aspects: Preproduction, Production, and Postproduction

● **PREPRODUCTION** This is the planning phase. Conceptualization has already been done, a proposal has been submitted and approved, and now you are ready to actually begin making your program. Depending on the complexity of the project, there will be different activities to carry out in order to produce a successful program. Among the most common preproduction activities are scripting and/or storyboarding, scheduling, budgeting, selecting the cast and crew, location surveying, and attending to legal matters. All of these activities require managerial skills.

FIGURE 7.5 The
Semantic Process

157

The Production
Stage:
Aesthetic
and Technical
Aspects

Scripting and/or Storyboarding The script is the map that will guide your production. A script is simply a written, detailed account of what is going to happen in your program. It describes what the viewer will be seeing and hearing and for how long. It is the end product of your design stage. A good script should reflect the connection between the elements of the story—both emotional and technical—and there should be a natural flow between scenes or segments.

Keep in mind that writing for television does not adhere to the general rules of writing for print media. In print, you write for the eye; that is, what you write will be read, so sentence structure and word choice are much different from what they would be if you were writing a script. In television and radio you write for the ear. Your viewers will listen to the performers speak the words you have written. To test your script, read it aloud. Does it sound right? Does it flow easily?

Most television programs are scripted. Producers or writers usually start the process by creating an outline of the program, then a rough draft is developed, and then a final script is written.

Some programs, such as newscasts and episodic series, are fully scripted. Every single spoken word, every audio and video effect, and all other production elements are described in the script. Other programs, such as game shows, interviews, and live sports transmissions, are partially scripted because no one knows exactly what is going to be said or what is going to happen. In these program formats the script outline may contain only the host's introduction and closing and notes about special transitions or effects.

People who work in television production are accustomed to seeing a variety of standard script formats. They expect the script to look a certain way, with margins, notations, headings, and other conventions conforming to a standard layout. There are a variety of well-established script formats in the television industry, and when creating television scripts, you must use one of the standard script formats.

There are many ways to categorize script formats. For our purposes the most important formats to consider are single-column scripts, multiple-column scripts, and storyboards.

Single-column scripts are also known as the standard screenplay format or film-style script. This format is used for movies, episodic series, and sitcoms and for the dramatic genre in general. (See Figure 7.6.)

Multiple-column scripts are also known as audio/video scripts or the two-column script because in its most common form it is designed around two columns describing audio and video, respectively. This script format is used for news, magazine shows, instructional programs, and documentaries. (See Figure 7.7.) A **storyboard** presents a visual representation—shot by shot—of the major elements of the story. Storyboards are sometimes used in conjunction with single- and multiple-column scripts and are almost always used in the production planning for commercials and public

FIGURE 7.6 Single-Column Screenplay Format Script

CANVAS

Episode #1 "The Visit"
Written by Edmond Chibeau

ACT 1

FADE IN:

EXT. CITY STREET — NIGHT

SANTOZ pulls at the neck of his black turtleneck sweater, hikes up his black jeans as he walks down a deserted SoHo street. Lights from storefronts spill onto the sidewalk, changing the color of his face as he walks past. He is talking to himself.

 SANTOZ
 Try to stay calm. It is all about power, it's all about fame,
 and it's all about you Santoz. Ha! I'll show them what is
 who. I'll show them all!

As a taxicab drives past:

 SANTOZ
 They think they can buy greatness.

CUT TO:

MAIN TITLES

INT. NICELY DECORATED ARTISTS LOFT — NIGHT

LAURAL and ROBERT are spending the evening at home. They SIT QUIETLY.

 LAURAL
 Robert, we need to talk. Santoz has an exhibition of his
 work in a gallery on 57th Street, and we're going to go
 to the opening because he's a friend of ours, and the
 art community has got to stick together.

The DOOR OPENS without a knock, and Santoz STORMS IN.

 SANTOZ
 Is Marcella here? She said she'd meet me at your
 place, and here we are. Your place. This is it, right?!

 LAURAL
 (Hand on heart)
 Santoz, you frightened me half to death! How did you
 get in here?

159

The Production
Stage:
Aesthetic
and Technical
Aspects

FIGURE 7.6 Single-Column Screenplay Format Script

ROBERT
Sorry, I must have forgotten to lock it.

SANTOZ
(pacing)
I see an open door, I walk in. Santoz does not knock!

ROBERT
(sarcastic)
Are you an artist or a burglar?

SANTOZ
The door wasn't locked.

LAURAL
We're glad you're here. We were just getting ready to go
to your opening.

Santoz helps himself to a glass of wine.

SANTOZ
Only the dead can appreciate my greatness.

ROBERT
Santoz, you need to see a shrink.

SANTOZ
I buy everything pre-shrunk.

LAURAL
Maybe we should all go together. I'm sure Marcella will
meet us there.

SANTOZ
(pacing)
She said she would meet me here. Maybe I shouldn't
go at all.

ROBERT
You can go or not, but you can't stay here.

LAURAL
(whispers)
Robert, be polite.

ROBERT
He makes me crazy.

LAURAL
Santoz, we can all go together and everything will be all
right.

service announcements. Indeed, sometimes the storyboards are so detailed that there is no need for a written script. Following are descriptions and samples of the script formats and storyboard described above. Table 7.3 shows the categorization of fully scripted formats used in this chapter.

The single-column screenplay format is used mostly for comedy and dramatic programs. Figure 7.6 shows a sample of a single-column script for a dramatic series. It lists all elements scene by scene, including scene transitions (fade, cut, etc.), scene location, the time of day, characters, dialog, and so on. Each scene is numbered.

The script describes the mood of the characters, the general environment where the action is taking place, and whether the action happens outside (EXT. = Exterior) or inside (INT. = Interior). Dialog is typically indented to separate it from the description of the scene. However notice that no shot descriptions, such as long shot (LS), medium shot (MS), or close up (CU), are presented, nor are transitions (dissolve, wipe, etc.) indicated between shots. As we will see in the chapters on directing, this is because it is up to the director to interpret and visually present the story to the audience.

Two-column scripts are the most common form in the multiple-column script category. The left column of the script describes the video elements of the program, including the type of shot (angle of view) and any character or camera movement. The right column describes the audio elements, including dialogue, voice-over, music, and sound effects.

The multiple-column script format is widely used in a multicamera environment. It is used in newscasts, most magazine shows, and most documentaries. It is also commonly used for partially scripted programs, such as interview programs and panels. Figure 7.7 shows an example of a two-column script.

The storyboard is a visual script, a graphic sequential description of your program as it will appear on the screen. Television production is a collaborative endeavor in which many individuals with different skills work on the same project. A storyboard depicting camera angles, angles of view,

■ TABLE 7.3 Full Scripted Formats

FULLY SCRIPTED FORMATS		
Single-Column (screenplay)	Multiple-Column (audio/video)	Storyboards
Drama (episodic/movies)	News	Commercials/political ads
Sitcoms	Magazines	Public service announcements
Soap operas	Documentary	Music video

161

The Production
Stage:
Aesthetic
and Technical
Aspects

FIGURE 7.7 Two-Column Script Format

Eastern Zine
Host: Edmond Chibeau

VIDEO	AUDIO
STANDARD OPEN VCR	SOT
Establishing Wide Shot	SOT
Slow push in to MCU Host	Host: Good evening and welcome to Eastern Zine, the magazine format program that brings you Eastern and the world. Today we will be taking a look at an unusual piece of art that is both practical and aesthetically pleasing.
Cut to location. Reporter in front of Sun Bench	Reporter: Hello I'm Susan Scribe standing in front of the ECSU library where the Sun Bench is located.
CU Bench showing lights	Reporter: As you can see, the light coming from inside the Bench is quite unusual.
MS Student walking toward library	Reporter: Let's ask this person what she thinks of this piece of sculpture.
2-Shot Reporter & Person	Reporter: Excuse me. I wonder if I could ask you what you think of this bench?
MCU Reporter	Reporter: Have you ever noticed the way it lights up at night
MCU Person	Person: Is it a bench or a sculpture? Are we allowed to sit on it?

and framing and containing information about motion and sound provides a useful blueprint for everyone who is involved in the project.

Although the storyboard does not have to be a work of art, it does need to be detailed enough to serve its purpose: to provide a clear picture of what the final program will look like. Storyboards are presented in many different formats. You can choose the format that best suits your needs, but always remember that it must provide a blueprint of what the program will look and feel like. Figure 7.8 and CP-12 show an example of a storyboard.

Welcome to San Francisco, City by the Bay

Cross the Golden Gate Bridge

Visit the Palace of Fine Arts

Go to the ballpark by the bay

But don't miss the Conservatory of Flowers: the famous Crystal Palace

Enjoy its exterior gardens

Come and see the aquatic plants

The exotic tropical flowers

The living museum of tropical plants

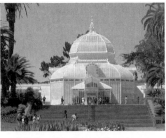

Admire the dome: the dome is back

FIGURE 7.8
Storyboard Format

163
The Production
Stage:
Aesthetic
and Technical
Aspects

It is important to note that a variety of commercial software tools are available to help with script formatting and with creating a storyboard. Popular scriptwriting programs include Final Draft, Movie Magic Screenwriter, and Scriptwizard for MS-Word. Popular storyboard programs include Frame Forge 3D, BoardMaster, and Storyboard Quick. Many of the storyboard programs include clip art that allows you to construct the pictorial frame without actually having to draw the images.

Scheduling There are generally three kinds of schedules that need to be made during the preproduction stage:

1. Production team meetings and other logistical activities, such as schedules for location surveys, research, casting sessions, interviews to hire crew members, and rehearsals.

2. A tentative shooting schedule, which is generally worked out with the director after a careful analysis of the script has been performed. It is very important that all personnel involved in the production, including associate or assistant producers, cast, and crew, be kept informed of all scheduling matters at all times. Keep in mind that depending on the genre and format of the program, the shooting may take place in studio or in the field and that scenes may be shot in a different order than the one in which they appear in the script. Scenes that share the same set, location, or lighting scheme are typically grouped together and shot out of the sequence in which they appear in the script. Shooting schedules are closely linked to production costs; therefore the producer's managerial skills come in very handy during this step.

3. Airtime/broadcast schedule, which in many cases was specified in the proposal and arranged with station managers or executive producers when the production proposal was accepted, or it may simply be determined by station managers or other executives when the program is delivered.

One point that deserves special attention is deadlines, which in general are abundant in television production projects. Many producers use a decidedly low-tech method to keep track of deadlines: They may draw a big chart and hang it on the wall so that they will have it in view at all times. The high-tech solution to the problem is project management software that may help to make scheduling more methodical and reliable.

Budgeting In real life your ability to take a nice vacation may well depend on how well you manage your income, savings, and time. In television production financial planning is extremely important. Financial planning is important in all phases of your project if it is to be successful. An overrun of the budget means big trouble for the producer. The producer must find a way to solve the problem; otherwise, there is the great risk of

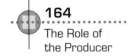
not finishing the project. Remember, every production requires the investment of many resources that have to be brought together and maximized to make that program a reality. How well you have done your conceptualization, research, scheduling, scripting, and/or storyboarding will have a direct bearing on your budget projections.

There are many ways to develop budgets. The most common approach is to project it according to (a) preproduction, (b) production, (c) postproduction, and (d) distribution. Some producers like to create separate categories for the "above the line" costs (performers, writers, producer, and director) and "below the line" costs (technical personnel, production crew). In any case, total costs are computed, and the expected return on the investment (profit) is calculated.

Return on investment does not necessarily have to be calculated in terms of money. For example, for a public health campaign on safe-sex behavior designed to reduce the spread of AIDS, the return on investment could be a real change in adolescents' sexual behavior brought about by being exposed to the video messages. Or an A grade on a student's video project could be a much-desired return on the student's investment of time, creativity, and perhaps a little money.

Figure 7.9 shows a sample of a budget. Keep in mind that even though this budget shows a typical breakdown of a production into its different elements, productions may have more or less complex breakdowns. Again, a variety of software packages are available for budgeting that address the needs of both television and film producers.

Selecting the Cast and Crew Now that you have finished working on your budget, it is time to put together the team that will bring your production to a successful completion. In general, whom you hire will depend on the type and complexity of your production, the size of your budget, and the particular needs of your production with respect to expertise and experience crew members may need to have. For example, if your production involves the use of moving cameras supported by Steadicams or jibs, you will need to hire crew members who are proficient in the operation of these camera support systems.

Assuming that you have a reasonable budget for your production, the best strategy is to hire the best people you can afford. However, remember that, above all, you must create a team. As you search for your performers and crew, keep in mind that besides their artistic and technical skills, they must also have "people skills" and be able to communicate and work as part of a team.

Depending on the type of production you are working on, you may need to conduct auditions for on-camera talent for all or part of your cast. There are several ways to go about casting for independently produced programs or programs that are produced in the context of a college or university video production class. Two popular methods are to place advertisements in local theatrical trade magazines and to post announcements at

165

The Production
Stage:
Aesthetic
and Technical
Aspects

FIGURE 7.9 Video Production Budget

Video Production Budget for 60-Minute Documentary

Up and Out of Poverty: An Activist Perspective: Remote Shooting Locations,
10-day Shoot, On-Camera Spokesperson

	Quant.	Unit		Per Unit	Sub Total
A. PREPRODUCTION					
Scriptwriting/Research	18	fin min*	@	20	3,600
Producer	5	days	@	350	1,750
Director	3	days	@	350	1,050
Preproduction/Subtotal					**6,400**
B. PRODUCTION					
1. Field Production					
Field Shoot Package	6	days	@	1100	6,600
Producer	6	days	@	350	2,100
Director	6	days	@	350	2,100
Prod. Asst.	6	days	@	225	1,350
Lighting/Crew	6	days	@	750	4,500
Dolly	6	days	@	125	750
2. Field Production Logistics					
Airfare (6 trips, 3 people)	18	trips	@	500	9,000
Accomodations	18	rooms	@	75	1,350
Meals/Per Diems	18	days	@	50	900
Van Rental	6	days	@	75	450
Travel Day Rates	18	trips	@	200	3,600
3. Line Production					
Footage/Logging	3	days	@	800	2,400
Camera/Transfer	4	hours	@	95	380
Talent Fee-On-Spokesperson	2	days	@	850	1,700
Voiceover Recording	2	hours	@	150	300
Music Production	8	hours	@	95	760
Music Licensing	1	flat	@	650	650
Producer	3	days	@	350	1,050
Director	3	days	@	350	1,050
Segment Graphics	4	elements	@	400	1,600

*fin.min.: final minutes of actual program

(continued)

FIGURE 7.9 continued

Production Assistant	4	days	@	175	700
Offline Edit (rough cut)	2	days	@	900	1,800
Production Subtotal					**44,790**
C. POSTPRODUCTION FINAL					
Final Edit	15	hours	@	250	3,750
Online Audio Sweetening	2	hours	@	250	500
Producer	3	days	@	350	1,050
Director	3	days	@	350	1,050
Production Assistant	2	days	@	225	450
Postproduction/Final Edit Subtotal					**6,800**
D. DISTRIBUTION					
Field (1-hour Beta SP)	20	tapes	@	35	700
VHS Window Dubs	10	tapes	@	6	60
Edit Tape Stock	4	Tapes	@	80	320
Dub Master	4	tapes	@	60	240
Approval Dubs	8	tapes	@	25	200
Distribution Subtotal					**1,520**
TOTAL PRODUCTION					**59,510**

local colleges and performing arts companies. Perhaps the best way to select your principal crew members, including the director, camera operators, audio engineer, lighting designer, and so on, is to ask your production peers for references to people they know who have the skills to fill the positions you need.

Location Surveys During the conceptualization and visualization phases of production planning you defined the look that you want your program to have. As part of that process, you probably thought about the shooting locations that best would express the spirit of your design.

Finding the right location requires that you evaluate each potential location by looking at it with the eyes of a producer. You will need to assess the location from an aesthetic perspective, to see how the location will contribute to the overall look and feel of your production. In addition, you will

167

The Production
Stage:
Aesthetic
and Technical
Aspects

need to look at if from a technical perspective to analyze how your production requirements will be met. Can your lighting, audio, and camera requirements be met at this location? Is power available to run the equipment?

We mentioned earlier that there are two basic kinds of production environments, each with different levels of complexity. They are the studio and field production environments. Productions can be done in both locations in either single-camera or multicamera style, and the program can be recorded or transmitted live.

Studio productions are commonly multicamera productions, and most technical elements of the production are under tight control by the video engineering staff and other technical crew members. Remember, the studio lighting and audio systems and the camera and video switcher systems were specifically designed to fulfill the needs of a complex, multicamera production.

Field production presents an entirely different set of circumstances. Most likely, the location that you choose will not provide you with the amount of control (e.g., available lighting system, sound board, and microphone inputs in place) that you find in the studio. The production infrastructure that exists in the studio will have to be assembled from scratch in the field.

To anticipate the production problems that will need to be solved at the location, it is common practice for video producers to conduct a location survey of the proposed remote production site. It is preferable to try to conduct the survey at the same time of day when the shooting is to take place in order to assess the lighting conditions. You want to know the exact position of the sun to avoid backlighting or other problems.

Depending on the complexity of the production and whether it is going to be shot single-camera style or multicamera style, the producer and his or her team will have to account for different items. Following is a list of some basic issues to check out.

- *Permits and Logistics.* Can you legally gain access to the location? You may need to obtain a permit to shoot in locations such as municipal buildings and state and national parks. If you are shooting on private property, you should obtain a location release from the owner or manager of the site. Do you have an appropriate means of transportation to bring your equipment to the location and keep it there safely? Is sufficient parking available at the remote location? How many people will be in your cast and crew? Will the location have to be catered to provide food and water for everyone? What about on-site communication? Will you use two-way radios? Telephones? Have you checked the weather reports?

- *Cameras.* How many will be needed? Is this a single-camera or multicamera production? If it is single-camera, will the camera be placed on a tripod, or will it be hand-held? Will you dolly it? If so, is the terrain

appropriate for this? Do you have an adequate dolly? What about the camera's angle of view and the subject's movements? Are they compatible? Will a long shot maintain the framing and angle of view desired without showing unwanted objects or subjects? If the production will be shot with multiple cameras, is there room enough to effectively position all of the cameras? Where will they be placed so that you can effectively capture the action? On platforms? How high will they be, and how will they be constructed? To maintain continuity of the subject, have you taken into account the 180-degree rule (to be discussed in Chapter 8)? What about video switching? Will you record each camera individually in addition to recording the switched feed from the video switcher? How will the director communicate with the camera operators? You will need an intercommunication system.

- *Audio.* What kind of sounds will you be capturing? Natural sound? Dialogue? What are the appropriate microphones for obtaining the best sound quality? How many of each kind will you need? Will your audio mixer be able to handle them? Is there a lot of background noise? If so, where is it coming from? Can you do something about it? If not, will special pickup microphones help?

- *Lighting.* Will there be enough light for the cameras at the time you plan to shoot? If not, how many lighting instruments will you need? Will you be mixing color temperatures? Do you need gels? Or would your production be better served by using HMI lighting instruments that are balanced for daylight color temperature? Is it possible to place the lighting instruments without interfering with the camera shots and at the same time provide adequate lighting? If you are shooting single-camera, can you keep lighting continuity when you move your camera for a shot from a different angle?

- *Power.* Will you have access to a power source? If not, do you have a generator? Will you need batteries for certain equipment? What about available AC power at the location? How many electrical circuits are available? Do they supply enough amps to support the wattage needed for your cameras and lights? Where are they located? Do you need AC extension cords?

Legal Matters One of the most important jobs of a producer is to ensure the legality of all matters concerning the production. Given the complexity of many productions it may be necessary for the producer to hire a legal consultant to help resolve any important legal issues. Some of the important legal issues to be concerned about include the following:

- *Contracts.* The producer must ensure that every member of the production team has a proper contract establishing the person's rights and obligations. Where applicable, the producer will need to pay special attention to union matters.

169

The Production
Stage:
Aesthetic
and Technical
Aspects

- *Copyright.* One of the worst things that can happen to a producer is to find out after a production has been completed that the final product cannot be aired or released because the producer failed to obtain clearance for copyrighted materials such as music, video clips, and photographs that were used in the program. Laws against copyright violation are being strictly enforced, and the penalties for violating these laws may be harsh.

- *Releases.* The producer must get releases from every person who appears in the program. (See Figure 7.10.) If that person happens to be a minor, then a release must be obtained from the child's parent or legal guardian. Also, there must be releases for the locations in which the program was videotaped. (See Figure 7.11.)

FIGURE 7.10 Talent and Labor Release

SFSU
San Francisco
State University

**San Francisco
State University**
1600 Holloway Avenue
San Francisco, CA 94132

**Broadcast and Electronic
Communication Arts Department**
415 / 555-1787
415 / 555-1168 FAX

TALENT AND LABOR RELEASE FORM

I (PRINT NAME) _____ hereby assign to the Broadcast

and Electronic Communication Arts Department, San Francisco State University, all rights in and to any

photographs, motion pictures, video tapes, and/or audio recordings taken in the production of

_____ at any time. I hereby authorize the Broadcast and Electronic

Communication Arts Department, San Francisco State University, to reproduce, copy, exhibit, publish,

or distribute any and all such photographs, motion pictures, videotapes, and/or audiotapes.

I understand and agree that the Broadcast and Electronic Communication Arts Department, San Francisco State University, will be held free and clear of any responsibility or claim for personal liability during the production of

I certify that I am over the age of eighteen (18).

Signed _____

Witness _____

Address _____

Parent/Guardian (if under age of 18) _____

Phone _____

Date _____

Place _____

FIGURE 7.11 Location Release

San Francisco State University
BECA Department
1600 Holloway Avenue
San Francisco, CA 94132
415 / 555 1787

KTVU FOX 2
Two Jack London Square
P.O. Box 22222
Oakland, CA 94623
510 / 555 1212

LOCATION RELEASE

Date: _____

Name of Program: _____

Description of Premises: _____

Shooting Date(s): _____

For good and valuable consideration, receipt of which is hereby acknowledged, I hereby agree that representatives of San Francisco State University ("SFSU") for KTVU FOX 2 and all production equipment required by SFSU representatives may be in and around the Premises on the above Shooting Date(s) for the purpose of recording (by tape, film or otherwise) the Premises in connection with the Program. I agree that KTVU FOX 2 may incorporate such recordings, in whole or in part, into the Program. The foregoing shall include the right to use likenesses of the Premises for Program packaging, promotion and publicity purposes.

I represent and warrant that I have the legal right and power to grant KTVU FOX 2 the rights granted above.

Accepted and Agreed:

Name: _____

Signature: _____

Address: _____

● **PRODUCTION** Most of a producer's work is done in preproduction. The producer's role during the production stage varies depending on the type of program (format) being produced and its complexity. For instance, the role of an on-location documentary producer is completely different from that of a news or sitcom producer.

During the production stage, the producer works closely with the director (who takes greater responsibility for the control of the program during this stage) and makes sure that all the production elements (e.g., set, wardrobe, copies of script, talents, technicians, equipment) that were determined during preproduction are in place so that the look and feel of the program will be achieved. One of the most important responsibilities of a producer, regardless of format or complexity, is to make sure that all production schedules and deadlines are met and that the planned length of the program is not compromised.

● **THE POSTPRODUCTION STAGE** Programs that are going to be edited in postproduction require an additional set of planning steps. Footage that is shot in the field must be logged; that is, a description of each shot and its beginning and end points must be noted. Editing scripts must be developed, and in the case of digital nonlinear editing systems a list of all the footage that needs to be imported into the computer-based nonlinear editing system must be compiled. Postproduction planning is described in more detail in Chapters 10 and 11.

Evaluation and Distribution

Every product that enters the marketplace must be evaluated and distributed. A video production is no different. Each production proposal should include information about how the program will be evaluated, and how it will be delivered to the intended audience.

▓ Evaluation

Two types of evaluations are performed in video productions: formative and summative.

Formative evaluation is an assessment of the project that is conducted while the program is being produced. From the initial conceptualization of the video and throughout the production process there is the need to constantly evaluate what is being done to ensure the objectives of your program are being met. Formative evaluation should permeate the whole production process to provide continuous feedback that can be used to adjust the production as changing circumstances or new ideas come into play.

There are many ways to perform formative evaluation. The most common are commentaries by peers, colleagues, or friends; focus groups with members of the intended target audience, experts on the subject, or other video producers; screenings of the program to observe viewers' reactions; questionnaires; and interviews.

Summative evaluation refers to evaluation that is done after the production has been completed. A producer needs to know whether the program met the goals that were established for the program. For an educational program summative evaluation may involve measuring what viewers learned from the program. Commercial producers might look at the impact the commercial has had on product sales. Entertainment producers might look at the program's ratings or critical reviews of the program.

■ Distribution

Producers produce programs with the idea that, ultimately, the appropriate target audience will see them. A wide range of outlets is available for program distribution. Depending on the nature of the producing entity—a television network, a university, a nonprofit organization, or whatever it may be—and the program's content and target audience, a program may be distributed via broadcast or cable television. Programs that are not meant for broadcast or cable distribution may be duplicated and distributed on videotape or DVDs, or they may be posted on a website for viewing on the Internet.

Directing: Part 1

The Role of the Director

Earlier, we learned that television is a producer's medium. Many observers of the television production process believe that the television director plays a role secondary to that of the producer. Most of us are familiar with the fame and glamour that are associated with film directors, and you can probably name the directors of your favorite movies. On the other hand, rarely are we able to recall the name of the director of our favorite television show. It is more likely that the producer's name shines in the credits.

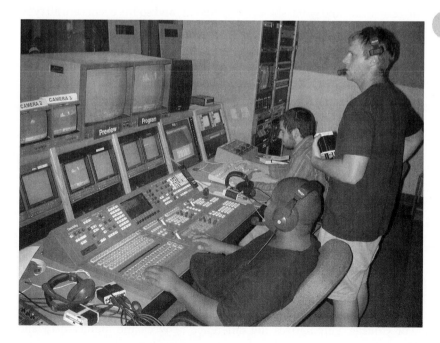

FIGURE 8.1
A Director in the Control Room

So the big question arises: "What is the role of the director in the creative process of television production?" The answer to this question varies depending on the type of television program a director is in charge of. But in general for a director to be successful, two traits are essential: creative leadership and creative problem-solving skills. As Jack Shea, former President of the Director's Guild of America (DGA), said, "A director wears many hats—counselor, cheerleader, artist, craftsman, storyteller, technician—but above all a director is a leader."[1] (See Figure 8.1.)

This chapter will examine the director's role and responsibilities during the complete production process, including preproduction, production, and postproduction for multicamera and single-camera programs. However, before we go on to explain the television director's role, a short discussion of multicamera and single-camera production is in order.

◼ Multicamera Production versus Single-Camera Production

Multicamera production is a live or live-on-tape approach in which the talent's performance is done in real time and visual continuity is achieved by switching between several cameras placed at different angles and having different views of the action. Shot selection is done in real time. This demands that the director watch several camera monitors at the same time and not only be conscious of which camera is on-line, but also be prepared to call for the camera that is coming on next. This type of production results in instantaneous editing of the program as it is being produced. News programs, talk and game shows, soap operas, and sports events are all typically produced as multicamera events.

Single-camera production, sometimes called film-style production, uses a repeated-take approach. In single-camera production each shot is staged individually. Shots are generally not shot in the sequence in which they appear in the script. Rather, they are shot out of sequence according to the location where the action takes place. The staged action is repeated as many times as the director considers necessary. Most television episodic drama series are produced by using the single-camera method.

There is also a mixed form of production that is often used in the production of situation comedies (sitcoms). Some sitcoms are shot with multiple video or film cameras, each one recording the scene from its own particular angle. The recorded tape or film is then edited in postproduction. As in the single-camera method of production, actions are stopped and repeated as many times as needed. Lucille Ball and Desi Arnaz's 1950s sitcom *I Love Lucy* was the first program to use this production approach. During the 1960s and 1970s many sitcoms were shot single-camera film-style and later moved to the multicamera approach.

David Tetzlaff, a professor in the Film Studies Program of Connecticut College, summarizes the difference between the multicamera and

single-camera approaches as follows: In multicamera production the visual scheme adjusts to the performance, and in the single-camera approach the performance adjusts to the visual scheme.[2]

Factors That Influence the Director's Role

In general, the television director is responsible for leading a team of technical personnel and creative collaborators to the successful completion of a television program. The director's job is to take the script he or she receives from a producer and turn it into the final product: a television program. Even though a producer may have created the original look and feel of a show, it is the director who interprets the producer's vision by establishing camera shots and angles, controlling the program's pace and rhythm, and coaching the performers. Although the television director's role may be influenced by the complexity of the production, there is general agreement that directing is mostly about leadership. Accordingly, a director's responsibilities fall within the following three areas: creative leadership, production management, and knowledge of production technology.

The Director as Creative Leader

One of the most appreciated characteristics of a director is creative leadership. To tell the story at hand, a director must be able to guide the production team through the successful visual interpretation of the script. In doing so, a director needs to apply his or her artistic skills, as well as those of the team, to achieve a variety of aesthetic manipulations that will enhance the overall effectiveness of the show. Artistic principles are the basis of visual thinking. This means that a director will break down a script into shots and scenes and will abide by rules of good framing and composition—head room, lead room, and so on—as well as a good balance between the motion of the performers and camera angles.

The director engages in a process of visual thinking and effective storytelling practices. Most of the time, effective storytelling practices in television abide by certain conventional principles that have evolved within the television field. (Remember, however, that creative rules are sometimes meant to be broken!) Fact-based programs, such as news or talk shows, do not adhere to the same visual principles as are applied in the production of sitcoms, music shows, or sportscasts. They each tell their own story in their own particular way, adjusting to the type of event and, in many cases, to the particular makeup and expectations of their audiences.

Regardless of program genre, a director should always be guided first by intuition (What is it that the director wants to share with the intended audience?) and by the following questions: What is this program all about?

What are its objectives? What are the audience's expectations and needs? Does my audience want to be informed or entertained? The answers to these questions will provide the director with clues about which audiovisual approach will be best to tell the story well.

■ The Director as Production Manager

As managers, directors play a significant role in the proper administration and efficient use of a television program's production resources, especially the human and technical resources. But a director must also be prepared to find creative solutions to everyday production problems, such as crew illnesses, communication problems between team members, and safety. Above all, the director must pay special attention to crew attitudes and behavior. A director must at times act as a psychologist, counselor, and personal advisor to many members of the crew to ensure the creation of an appropriate working environment.

Excellent time management skills are also imperative. Deadlines are at the heart of television production and programming, and whether or not the deadlines are met can make the difference between the successful completion of a television show (artistically and financially) or its failure.

■ Knowledge of Production Technology

Television production takes place in a highly technology-dependent environment. Technology provides the director with the necessary tools to achieve his or her vision of the program. A director should be acquainted with the available technology to make certain that it will be used properly. In addition, knowing the capabilities of the technology and the skill levels of the crew provides the director with knowledge of the limitations of equipment and crew. This is particularly important in college and university production environments, which rely on student crew members instead of paid professional crews. Remember, the director is not only the liaison between the creative and technical personnel, but also the supervisor for the technical crew. As such the director must be able to speak their language and understand the potential problems that may arise in order to be able to suggest possible solutions.

Responsibilities during the Preproduction Process

Preproduction is often considered to be the most important stage in the whole production process. This is a stage of interpretation, preparation, and planning—lots of preparation and planning! Television production is particularly sensitive to Murphy's Law: "If something can go wrong, it

will." So the best way to avoid the pitfalls of Murphy's Law is to do extensive and rigorous planning. The success or failure of the project is most likely to depend on how well preproduction was carried out.

Preproduction provides the director with two important spaces. First, this is an opportunity for the director to get acquainted with the producer's point of view and expectations for the show. Second, the director's process of visualization begins during the preproduction stage. The director starts to interpret planning materials such as scripts and storyboards and begins to identify the aesthetic and technical production values that will determine the look and feel of the program.

This is the time to introduce performers and production crew to the director's particular ways of engaging the tasks of producing a television show in a particular environment. The director begins to establish a rapport with members of the production team, both creative and technical, to facilitate communication between team members. The director needs to be aware of and accommodate the different personalities and skills of talent and crew.

The following are the most common tasks that a director must complete during the preproduction stage. However, please note that not all productions call for the director to engage in all of these activities. The level of involvement of the director will depend on the type of program, the role of producers and writers, the budget, and the organizational structure of the production agency.

■ Script Breakdown

Breaking down the script means dividing it into scenes and shots in a particular order to establish a logical production sequence and to organize production elements, such as locations, performers, times, tasks, equipment, and expenses, so that the production stage can be carried out within the planned schedule. There are many formats for breakdown sheets. Figure 8.2 shows the breakdown of a scene from the script that came from the treatment in Figure 7.4. There are a number of software applications that can help you accomplish the task, such as Final Draft and Cinergy. Before the breakdown of the script (which is often done with the participation of the producer and writers) the director may need to do some rewriting to adjust it to his or her personal style. Breaking down the script will also help the director to solidify the visualization process.

■ Location Scouting (Surveying) for Productions Done in the Field

We will assume that before surveying any location the producer has secured the location by clearing all legal obstacles and acquiring the necessary permits to shoot on that location. One important benefit of a **location**

survey is that it allows the director to experience firsthand the location's characteristics. In doing so, the director can maximize the audiovisual potential of the site by establishing camera angles and talent positions and can also anticipate potential problems. Lighting and sound conditions and the availability of electrical power on location are some of the most chal-

FIGURE 8.2 Script Breakdown

SCRIPT BREAKDOWN SHEET

TITLE: Canvas

DATE:

SCENE#: 15 SCENE NAME: Graffiti Wall

DESCRIPTION: Santos, Laural, Robert talk to graffiti artist, at first he thinks they're cops.

PAGE COUNT: 3
INT./EXT.: Ext

PRINCIPALS: Santoz Robert Laural Graffiti Artist	SETS & PROPS: 6 cans of spray paint Brick wall with graffiti	VEHICLES: Police car
UNDER 5 LINES: Woman with dog	WARDROBE: See Principals Note: Red headband for artist	ANIMALS: Golden Retriever for musician Standard Poodle for Woman with dog
EXTRAS/SILENT BITS: 7 Pedestrians	MAKEUP & HAIR: Principals plus Woman with dog	SPECIAL EFFECTS: Police light flashing off building wall
STUNTS:	MUSICIANS: Street musician violinist with dog	

PRODUCTION NOTES:

lenging aspects of field production. We cannot emphasize strongly enough the importance of planning and surveying a location to ensure that these elements are properly under the control of the production team. The camera operator, audio operator, and lighting director should accompany the director on the day of the location visit. If possible, to ensure that the conditions on the shooting day are similar to what was observed during the survey, the location survey should be conducted at the same time of day and on the same day of week that shooting is scheduled to take place.

Working with the Cast and Crew

The television director may or may not participate in the selection of the cast or crew; either way the director must get acquainted with each member of the production team. The director must be able to coach the program's performers in such a way that they understand the director's interpretation and visualization of the script. The director should become familiar with the skill levels of everyone on the technical crew and make sure that everyone understands his or her role and responsibilities. In all, it is the director's responsibility to create the proper working environment and to foster good interpersonal relationships so that all individuals feel that they are contributing members of the production team.

Selecting Facilities and Equipment

Even though it is most likely the job of the producer to ensure the availability of studio facilities and the necessary production equipment, it is often left up to the director to specify the particular type of equipment needed to accomplish the production objectives. But again, this depends on the type of show that is going to be produced. For instance, news and talk shows are done in a studio, and they usually have permanent setups that may have been established years before a director came into the show. In other program formats there are many occasions when a director will make the decision about what type of equipment is to be used, what the final look of the set will be, and what kinds of facilities are needed in order to translate the abstractness of a script into the concreteness of a broadcast or videotaped program.

Safety and Health

The safety and health of team members must be among the director's top priorities. Safety procedures must be complied with in every studio and field production, not only because of natural humanitarian concerns, but also because of possible legal implications that may result from violating them. General guidelines for workplace safety have been articulated by the Occupational Safety and Health Administration.

Many productions, especially episodic dramatic television series, use special effects or engage in activities such as stunts and chases that place actors and crew members at risk of injury. It is the director's responsibility to ensure a safe working environment for all members of the production team. This may include setting up an educational or training program for cast and crew and establishing mechanisms for reporting accidents or illnesses.

Aesthetics of Production: Continuity, Depth, and Visual Composition

Once preproduction is complete, the program enters the production or shooting phase. Each director, depending on the type and format of the show, will encounter a unique set of problems that can be met and solved with hard work, care, and creativity. Many of these problems may have been anticipated during preproduction. During production the director starts building the show. Just as the architect, blueprints in hand, instructs the construction managers and workers about the steps needed to create a building out of an empty site, the director leads the cast and crew in the difficult task of constructing the television show.

All along we have emphasized the director's creative leadership. Creativity is closely related to adherence to aesthetic principles that are deeply rooted in the performing and visual arts.

Creativity, along with knowledge of essential aesthetic and technical principles, allows the director to construct the illusion of a real world on a television screen. As we mentioned before, each television format calls for its own particular style of presentation. Formats use conventional audiovisual syntax and semantic structures that have been previously established for them and that audiences recognize, accept, and expect. Regardless of the format or a director's visual style, there are certain rules and codes that are meant to be followed. Following are descriptions and explanations of three of the most important sets of aesthetic principles that a director must always keep in mind in order to successfully deliver his or her artistic vision: continuity, depth, and visual composition.

■ Continuity

To tell a story successfully, a director arranges a series of elements in such a manner as to present them to an audience in a logical, coherent, and continuous flow. The viewer must be able to read the television screen in a way that makes sense and must also be able to correlate environmental variables in a video scene—such as space, screen direction, or lighting, and precedent shots or scenes—to form a larger structure.

181

Aesthetics of
Production:
Continuity,
Depth, and
Visual
Composition

Of course, rules are sometimes meant to be broken, and directors do break them when it adds something to the story. However, most of the time a good director abides by certain rules of continuity in order not to confuse the viewer and to provide the program with a sound structure.

Continuity is necessary—built into both shooting and editing. We will focus on visual, sound, and performance continuity as well as continuity of action, keeping in mind that these variables sometimes overlap and that the overall perception of continuity depends on a close interrelationship of these variables. The following discussion contains a series of guidelines that can be followed to maintain that logical flow—continuity—on the screen in the areas mentioned above. Of course, the number one guideline is good planning!

● VISUAL CONTINUITY

Directional Continuity Continuous action on the screen, such as left-to-right motion, must be maintained. If subjects or objects flip from one side of the screen to the other without the director using the proper techniques, such as showing the actual subject changing direction, using panning camera shots, or inserting neutral directional shots (action directly toward or away from the camera) to alter the initial screen direction, the audience may lose its sense of direction. (See Figure 8.3.)

Discontinuous Action Sequence

Action Moves to the Right Action Moves to the Left

FIGURE 8.3 Directional Continuity

Bridging Discontinuous Action with a Neutral Shot

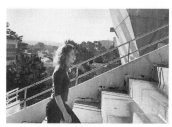 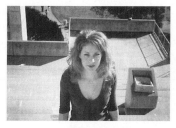

Action ⟶ Neutral ⟵ Action

Action Moves toward Camera

FIGURE 8.4 Spatial Continuity

Establishing Shot

Close-Up

Close-Up

Wide Shot

Spatial Continuity Space is defined as the environment in which the event takes place. It is sometimes wise to start with an establishing shot and then move to medium and close-up shots. Make sure that objects, the location of performers, distance between objects and performers, and their relationship within the frame remain unchanged as you move from shot to shot and change point of view, lenses, and camera angles or perspective. (See Figure 8.4.)

Lighting Continuity Lighting is one of the most important factors in the perception of continuity. Make sure that lighting is consistent in successive shots or scenes and that colors in costumes, faces, and the general appearance of the location remain unaltered. The passage of time, as we experience it in real life, is particularly sensitive to changes in the lighting scheme, so special care has to be taken to ensure that indications of such changes are reflected from scene to scene. One common problem is the editing of adjacent shots that were shot with different cameras that have not been color-balanced to match the color characteristics or the original scene. This is as true for studio production as it is for field production.

● SOUND CONTINUITY

Continuity of Narration, Dialog, and Music Consistency in the delivery of dialog or music is important to maintain the viewer's sense of a continuous flow of events. Keep the tone of voice and volume consistent with the action on the screen. When shooting, keep microphones at regular distances from subjects to maintain the talent's presence throughout the scene.

Background Audio Natural sound (in field production) and music (in both studio and field production) are the most common background sounds. Pay special attention to changes of sounds between scenes. If the location remains the same but shots or scenes were shot at different times, are the background sounds the same? A slight difference may cause the viewer to become confused. Also, be aware of sound perspective. Do the sounds match the visuals? Is the close-up of the motorcycle matched by the loud sound of its engine? Does the soft sound of the engine match the long shot of the motorcycle?

183

Aesthetics of
Production:
Continuity,
Depth, and
Visual
Composition

Audio Levels Make sure that audio levels are properly set during the shooting and are properly maintained during the editing process.

● **PERFORMANCE CONTINUITY** Make sure performers have similar gestures, positions, and expressions from shot to shot. This is particularly applicable to single-camera production in which there may be a need to re-peat an action in successive takes of the shot or scene.

● **CONTINUITY OF ACTION** The **180-Degree Rule** is perhaps the most important rule to follow to maintain consistent screen direction for characters or objects in motion on the screen. When shooting a dramatic scene or an interview or sporting event such as a football or basketball game in which action moves in one direction and then back again, the di-rector must determine the position of the principal line of action and keep all camera shots to one side of the imaginary line that follows the main sub-ject's action. To identify this line, also called the **principal action axis,** look at the direction of the action in a scene and draw a line tracing it. (See Figure 8.5.) For example, in an interview the line of action would be traced by the direction of the looks between the interviewer and the guest. In a basketball or football game the line would extend from one end zone or basket to the end zone or basket at the other end of the field or court.

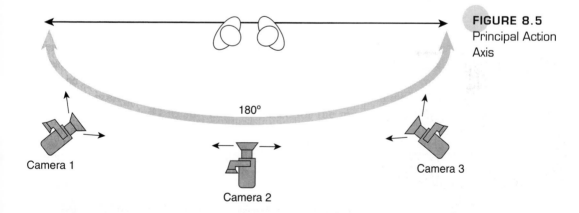

Camera 1 180° Camera 3

Camera 2

FIGURE 8.5
Principal Action
Axis

Camera 1

Camera 2

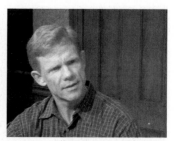

Camera 3

■ Depth

For a director to make the screen image appear to be realistic, the illusion of depth must be created on the screen through the manipulation of a variety of visual tools. The problem, of course, is that the real world is three-dimensional (height, width, depth) but the television or video screen is a flat, two-dimensional (width, height) object.

The following pictorial depth cues have been used by artists going back centuries and they convey to the viewer a sense of depth: the perception of subjects or objects as being near or farther away.[3] More than one of these cues can be used in conjunction with others to further enhance the illusion of depth.

● **INTERPOSITION, OCCLUSION, OR OVERLAPPING PLANES** Objects partially cover part of another object. We perceive the covered object as being farther away than the covering object. In Figure 8.6 the arch is partially covering the building, so we perceive the overlapped building as being behind the arch.

● **LINEAR PERSPECTIVE** Parallel lines receding into the background appear to converge in the distance. (See Figure 8.7.)

FIGURE 8.6 Overlapping Planes

FIGURE 8.7 Linear Perspective

185

Aesthetics of
Production:
Continuity,
Depth, and
Visual
Composition

● **AERIAL PERSPECTIVE** Objects in the foreground appear sharper
and more color-saturated than distant objects in the background, which ap-
pear to be bluish and blurry. We perceive the mountains in Figure 8.8 as
being farther away than the trees.

● **RELATIVE SIZE** On the basis of past experiences and familiarity
with known objects, we perceive smaller objects as being farther away. In
Figure 8.9 the people walking up the stairs are smaller than the people
walking on the sidewalk. Therefore we perceive the people on the stairs as
being farther away.

● **RELATIVE HEIGHT OR HEIGHT IN PLANE** Objects that are
higher in the plane appear farther away than those in the lower part of the
screen. (See Figure 8.10.)

FIGURE 8.8
Aerial Perspective

FIGURE 8.9
Relative Size

FIGURE 8.10 Height in Plane

FIGURE 8.11 Attached and Cast Shadows

● **SHADOWS** Attached and cast shadows also provide visual cues for depth. An attached shadow will render the object as solid, and a cast shadow will affect the viewer's perception of how close or far away the object is. (See Figure 8.11.)

● **LINEAR PERSPECTIVE, RELATIVE SIZE, AND Z-AXIS** Motion on the **z-axis** means to bring the action or subject movement toward or away from the camera. (Movement to the left or right side of the screen is x-axis movement; movement up or down in the frame is y-axis movement.) Using z-axis movement in conjunction with relative size and linear perspective increases the viewer's perception of a three-dimensional space. (See Figure 8.12.)

The above depth cues bring us closer to experiencing reality when we watch a flat television screen. A common characteristic of all of them is that images are constructed with distinct foreground, middle ground, and background elements.

FIGURE 8.12
Z-Axis

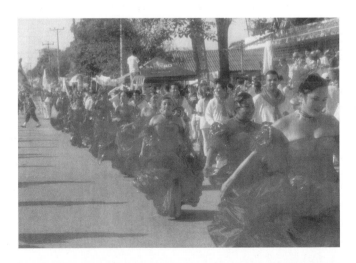

187

Aesthetics of
Production:
Continuity,
Depth, and
Visual
Composition

■ Visual Composition

By now we know that one of the most important roles of the director is to embed his or her vision and style into the program to make it as effective as the producer originally intended it to be. One of the most significant elements of visualization is the way in which the camera and its lens are used to create the visual images that appear on the television screen.

There are two ways in which the quality of a shot can be evaluated: technically and aesthetically. Color saturation, video levels, brightness, and contrast influence the technical quality of a shot. From an aesthetic perspective we must consider factors such as field of view and balance within the frame (composition and framing), screen size and aspect ratio, the rule of thirds, and camera movement, among many others. This section will examine composition, framing, and the rule of thirds. Your awareness of and mastery of these factors will help you to give an aesthetically sound structure to your video.

● **COMPOSITION** Although visual composition, in its broadest sense, may be thought of as including all the aesthetic factors mentioned above, here we will refer to it as **field of view.** The following shot descriptions refer to the field of view that is apparent in the shot—that is, how much of a subject or an object is seen within the screen. It is important to have a terminology for shots because these shot descriptions are used by writers to describe shots in written scripts and by directors and videographers to communicate to the other crew members how they want a shot or scene to look. (See Figure 8.13.)

The **extreme long shot (XLS)** provides the audience with an overall view of the large scene. Although individual details may be hard to see, this shot nevertheless is important to establish the relationship between the parts and the whole or to create impact through the use of wide-open spaces. (See Figure 8.13a.)

The **long shot (LS)** is not as wide as the XLS. However, it shows the positional relationship between subjects, objects, and settings. A long shot is often used as an establishing shot because it establishes locale and the relationships between the individual parts of the shot. (See Figure 8.13b.)

The **medium shot (MS)** is not as wide as an LS or as tight as a close-up. The medium shot is used to show the relationship between people in a shot or a scene but does not present as much information about the setting as the long shot. (See Figure 8.13c.)

The **medium close-up (MCU)** is probably the most widely used shot in video production. It consists of a head-and-shoulder shot that ends at the chest of the subject. The medium close up shows full-face detail of the subject without the extreme impact of the close-up. (See Figure 8.13d.)

The **close-up (CU)** is a very powerful shot that consists of a tight shot of the subject's head (or any part if the body that you wish to show in detail). A close-up of an object practically fills the screen. The close-up is one

of the most effective shots available for providing a close view of the details of a face or an object. (See Figure 8.13e.)

The **extreme close-up (XCU)** is the tightest shot possible for the subject. On a person the XCU frames the subject's eyes and nose or mouth. If both the eyes and mouth will not fit in the frame, it is usually better to

FIGURE 8.13 Field of View

(a) Extreme Long Shot (XLS)

(b) Long Shot (LS)

(c) Medium Shot (MS)

(d) Medium Close-Up (MCU)

(e) Close-Up (CU)

(f) Extreme Close-Up (XCU)

189

Aesthetics of
Production:
Continuity,
Depth, and
Visual
Composition

frame the shot to include the eyes and nose rather than the nose and mouth. (See Figure 8.13f.)

The terms 1-shot, 2-shot, and 3-shot refer to the number of people that appear in the shot. Thus a medium 2-shot is a medium shot that includes two people, a long 3-shot is a long shot that includes three people, and so on. (See Figure 8.13g.)

The **over-the-shoulder shot (O/S)** is widely used in dramatic productions and interviews. It enhances the illusion of depth by placing a subject in the foreground. (See Figure 8.13h.)

The **reverse over-the-shoulder shot (RO/S)** helps to establish direction and continuity in staging a conversation. It also helps to establish the emotional and psychological relationship between subjects by showing facial expressions. It can be used to cover action or as a reaction shot. (See Figure 8.13i.)

● **FRAMING** **Framing** refers to the placement of a person or an object within the video frame. When a person is the subject of a shot, two compositional elements related to framing come into play: headroom and noseroom.

(g) 2-Shot

Headroom is the distance between the top of the person's head and the top edge of the frame. In gauging the correct amount of headroom, the director or camera operator usually tries not to leave too much or too little space at the top of the frame. With too little headroom the person appears to stick to the top of the frame. This simply looks wrong to the viewer.

(h) Over-the-Shoulder (O/S)

(i) Reverse Over-the-Shoulder (RO/S)

Similarly, if the subject is placed too low in the frame (too much headroom), the person appears to be sinking out of the frame.

There is no formula for determining how much headroom is correct, although more headroom is appropriate on longer shots, and less headroom works better on close-ups. (See the examples in Figure 8.14.) Pay special attention to headroom whenever you zoom in or out on a subject. In general, as you zoom out and the subject becomes smaller, headroom will increase. You will need to tilt the camera downward to compensate for this. On the other hand, as you zoom in and the subject becomes larger, the amount of headroom will decrease, creating the need to tilt the camera upward.

Noseroom is the distance between the edge of the nose of the person in the shot and the edge of the video frame. In reality, *eyeroom* might be a better term to use than *noseroom* because it is the person's eyes, not the nose, that create a powerful force within the frame.

Correct framing is based on the direction in which the eyes are focused, the dynamics of the story, and the graphic composition of the picture. (See Figure 8.15.) For example, if the subject looks toward one side of

FIGURE 8.14
Headroom

No Headroom

Too Much Headroom

Comfortable Headroom

Attention Focused in Front of Subject Attention Focused Behind Subject

FIGURE 8.15 Noseroom

the frame, the rules of good framing dictate that the camera pan slightly to allow sufficient eyeroom or noseroom so that the person does not appear to be glued to the side of the frame.

● **RULE OF THIRDS** In the Rule of Thirds the screen is divided into three equal parts both horizontally and vertically. (See Figure 8.16.) The four points that are located one third of the distance from the four corners

FIGURE 8.16
Rule of Thirds

of the frame are considered to be the optimal location for objects and people of importance to the story. In practice, this type of composition offers an unobstructed view of the objects or people that are central to the story but with a relatively neutral treatment.

NOTES

1. "President's Report: Rights and responsibilities," *DGA Magazine,* July 2000.

2. Tetzlaff, David. "Director Television." In Newcomb, Horace (Ed.). *Museum of Broadcast Communications Encyclopedia of Television* (pp. 501–504). London, UK: Fitzroy Dearborn Publisher, 1997.

3. For an extensive discussion of in media aesthetics see Zettl, Herbert. *Sight, Sound, and Motion: Applied Media Aesthetics.* 4th ed. Belmont, CA: Wadsworth, 2004.

CHAPTER 9

Directing:
Part 2

The Director's Role
during Production

Chapter 8 presented an overview of some of the principal aesthetic elements of the visualization process. We will now look at the director's role during production. Some of the important elements to consider here include the role of the director during rehearsals and the procedures and terminology that directors use to direct both multi- and single-camera productions. At this point in the production process a director needs to take control of the production activities even though she or he will delegate some technical and artistic responsibilities to other members of the production team.

Rehearsals

Rehearsals give the director the opportunity to run through the production before it is broadcast or recorded. Rehearsals allow the director to fine-tune the production and give the director the opportunity to exert creative leadership as the director ultimately brings his or her artistic vision of the show to life. There is no rule describing how many rehearsals a director should conduct. It all depends on the type of program and the complexity of shots, graphics, special effects, and the talent's performance. In a soap opera or dramatic show, there is an emphasis on performance during the rehearsal. Much attention is also paid to the position of talent and cameras and the coverage of the performer's movement. In a newscast rehearsal time is nonexistent. Talent and crew present the news program on a daily basis, so

the production follows an established routine. For some sports shows or special events the director will want to rehearse the show's opening and any segments that involve special effects or complex transitions. These rehearsals will also include the technical director, videotape recorder operator, graphics operators, and sometimes other crew members as well as the program's talent in order to work out the specifics of timing and the location of each of these effects or transitions.

There are several different types of rehearsals, each of them best suited to a particular show format. We will briefly describe some of the most common types, with the understanding that some directors or production houses use different terms to describe similar activities.

■ Table or Script Reading

A **table reading** or *script reading* is routinely conducted during preproduction of episodic dramas, situation comedies, and soap operas. The performers, producers, writers, and director sit around a table or walk around a simulated stage and read through the script. During the script reading, the director advances his or her interpretation of how the lines and performance should be delivered. Performers also have a chance to have input into the process as they work to understand the nature of the characters they will interpret. Changes in the script may be initiated by the performers, producer, or director at this time.

■ Walk-Through

The **walk-through** is the rehearsal stage in which the physical movement of the talent and cameras is set. The director concentrates on making sure that camera angles cover the action and that every element of the show is in place. Special attention must be given to ensure that cameras, microphones, and lighting instruments are not visible in any of the shots. Tape marks should be placed on the floor to indicate the various positions to which the performers will move during the scene. For the camera to photograph the scene as planned, performers must accurately *hit their marks*. There can be walk-throughs for talent and the technical crew and they can be performed separately or simultaneously.

■ Blocking

Blocking refers to the positioning of the cameras in relation to the performers. Initial blocking is done during the breakdown of the script. After the walk-through the director will make any necessary changes in the performers' movements and camera positions to ensure that the cameras have the shots that best capture the director's visualization of the scene.

195

Directing
Multiple
Cameras:
Studio and
Remotes

Run-Through

The **run-through** is usually the last step before taping or recording. In a run-through the whole show plays from beginning to end with the director taking notes on any problems and marking the script for corrections. Depending on the amount of rehearsal time available, the run-through may be conducted several times. The run-through can also be used to simultaneously conduct camera, control room, and dress rehearsals.

Notes

The **notes** session is the final step before the actual taping or live broadcast of the program. The director gathers together the performers and crew to discuss the rehearsal. This gives everyone a chance to make suggestions for any final changes for the program. Notes sessions are routinely conducted after the final rehearsal for soap operas, situation comedies, and dramatic programs.

Situation Comedy Rehearsal and Taping Schedule

Every director develops a rehearsal schedule that suits the needs of the particular program that is being produced. The example in Table 9.1 is for a half-hour network-quality situation comedy produced in Los Angeles in front of a live audience. Note that the program is rehearsed and taped over a three-day period.

This schedule includes some elements that we have not discussed. For example, it includes a special run-through for network executives, who preview the episode before it is taped and voice any concerns they may have about the content. Also, because most situation comedies are recorded in front of a live audience, time needs to be allotted to load the audience into the studio. And, although it might seem that all the rehearsing and shooting are complete at 10:00 P.M. on the third production day, additional time is allotted for pickups: retakes of shots that are flawed because of technical problems or problems with the performance.

Directing Multiple Cameras: Studio and Remotes

As we discussed earlier, multicamera production involves the use of two or more cameras that are connected through a video switcher, which is used to accomplish instantaneous editing by switching from one camera to another in real time. Multicamera production requires a high level of coordination among everyone on the production team. Next we'll take a look at

■ **TABLE 9.1** Situation Comedy Rehearsal and Taping Schedule

Friday	
Rehearsal	10:00 A.M.–1:00 P.M.
Lunch	1:00 P.M.–2:00 P.M.
Rehearsal	2:00 P.M.–3:00 P.M.
Network run-through	3:30 P.M.–4:30 P.M.
Notes	4:30 P.M.–5:30 P.M.
Monday	
Set-up	7:30 A.M.–9:00 A.M.
Camera blocking/tape rehearsal	9:00 A.M.–12:30 P.M.
Lunch	12:30 P.M.–1:30 P.M.
Camera blocking/tape rehearsal	1:30 P.M.–4:30 P.M.
Rehearsal tape viewing	4:30 P.M.–
Tuesday	
Set up	11:00 A.M.–12:00 P.M.
Camera blocking/rehearsal	12:00 P.M.–3:00 P.M.
Makeup/hair/wardrobe	3:00 P.M.–4:00 P.M.
Load audience/warm-up	
Crew meal (not catered)	3:00 P.M.–4:00 P.M.
VTR Dress Show	4:00 P.M.–6:00 P.M.
Dinner (catered) and notes	6:00 P.M.–7:00 P.M.
Load audience/warm-up	
VTR Air Show	7:00 P.M.–10:00 P.M.
Pickups (if needed)	

the way in which directors interact with the performers, how the director marks his or her script, and the communication commands that a director uses during multicamera productions.

■ Directing the Performers

As a creative leader, the director has the responsibility to ensure that the talent's performance is appropriately delivered. Each type of program will determine the kind of performance that is demanded of the talent. A talk show or game show host will certainly perform in a much different way than a performer in an episodic drama. In either case the director will guide the performers through the production process so that their performances are credible and effective.

197

Directing
Multiple
Cameras:
Studio and
Remotes

■ Script Marking and Director's Commands

Directors mark their scripts with a special shorthand system of symbols that helps them to keep track of preplanned camera shots and camera movements, special effects, and graphics. A well-marked script helps the director to call these elements into action at the right time. The director also uses special terminology and a special set of commands to communicate with members of the crew. (See Figure 9.1.)

The symbols and commands that directors use are not universal, and even though some of them have been standardized, different directors may use different symbols to express the same action. The important thing to remember is that, whatever the system of symbols and commands that is used, it is in essence a communication scheme, and as such, the director must make sure that the communication flow is smooth and efficient. Table 9.2 lists the most common script-marking symbols used by directors of multicamera television productions. The director also uses abbreviated symbols to describe the framing for the most common camera angles. (See Table 9.3.)

One of the hardest things a director's apprentice encounters early in his or her training is the set of commands that is used to start a program. To illustrate this, we use the example of a program that involves an interview with a host and a guest. Voice is picked up by using lavaliere mics on the host and guest who are seated on the set and do not move around. There is

■ **TABLE 9.2** Director's Common Script-Marking Symbols

Symbol	Command	Action
R	Ready	Alerts crew members of upcoming action. Some directors will use "Stand by" instead of the "Ready" command.
Q	Cue	Cues a performer or announcer to act or speak.
T	Take	Cut to a camera or other video source.
F	Fade	Gradually fade from a video source to black or from black to a video source (camera, VTR, or graphics).
D	Dissolve	A gradual transition from one video source to another video source.
K	Key	Insert a CG (character generator) or other graphic over a source of video.
O	Open	Switch on the microphone.
Roll	Roll Tape	Start VTR to record or play back prerecorded material.
C	Camera	Readies or take a camera means that the director is going to say "Ready camera . . ." or "Take camera"
VTR	Videotape Recorder	Calls for the videotape recorder operator to execute an action.

FIGURE 9.1 Script Marking

Alma Latina (Latin Soul)
Host: Edmond Chibeau

VIDEO	AUDIO

R·VTR
STANDARD OPEN VTR — SOT

R·C2 — R-Q Talent
Standard Establishing Shot on C2

TC2 / Q Talent
→ Edmond: Good evening and welcome to Alma Latina the magazine format program that brings you the Latin happenings at Eastern Connecticut State University.

R-CU C1

T-C1
Edmond turns to C1
→ Today we will be talking to and showing the work of a well known artist and Eastern's art professor from Puerto Rico: Imna Arroyo. Welcome Imna

R-MUSIC
R-LS C2
Q-MUSIC
TC2
Imna walks into set, Edmond gets up and greets Imna. They both sit down.
→ SOT (Puerto Rican Song)

R-MS C3

T-C3
Imna on C3
→ Hello Edmond, glad to be here

R-2shot C2

T-C2
Imna on camera. Turns to C2 when saying " Buenas Noches out there" and waves.
It is always good to return to this great show. Want to extend my regards to your audience . Buenas Noches out there!

R-CU C1

T-C1
Edmond on C1
→ Edmond: We hear you were just invited to Exhibit your latest work at the prestigious Museo de Bellas Artes (The Palace of Fine Arts) in San Juan, Puerto Rico. Tell us about it.

R-MS C3

T-C3
Imna on C3
Imna: Indeed, Edmond. I am very excited about it. (Imna explains).

R-D CU C2
Imna pulls art piece (print of Yoruba Godess) and shows Edmond.
Let me show you what my theme at the exhibition will be.

D-C2
Print on C2
Imna talks about the print.

R- CU CL

T- Cl ⟶
Edmond on C1 Edmond: Why the theme of Yoruba Godess.

R-CU C3

T-C3
Imna on C3 ⟶ Imna: Because of my African heritage. (explains)

R-MS CL

T -Cl
Edmond on C1 Edmond: Well Imna, thanks for having spent some
 time with us tonight. **Congratulations again and
 good luck in your exhibition!**

R-D LS C2

D- C2
Edmond turns to C2 ⟶ To you (looks at audience), we also appreciate your
 being with us. This is your host Edmond Chibeau
R- Roll Credits and on behalf of the Communication Department of
R. F black Eastern Connecticut State University: **Good Night!**
 We'll see you next week!
Roll credits

 CLOSING
Credits
F -black ⟶

a CG keyed over the guest and no music. (Usually, there is some sort of
music or effects at the start of the show. The commands to call them follow
the same rules as commands to call camera shots.) Remember, at this point
everyone is depending on the director to make the right calls, on time, con-
cisely, and precisely through the intercom system.

■ **TABLE 9.3** Framing Terms

Term	Framing
LS	Long shot
XLS	Extreme long shot
MS	Medium shot
MCU	Medium close-up
CU	Close-up
XCU	Extreme close-up
OS	Over-the-shoulder
2-Shot	Two-person shot
3-Shot	Three-person shot

■ TABLE 9.4 Director's Calls at the Beginning of a Program

What the Director Says	What Happens or Needs to Be Done
"Cameras and crew to headset."	Camera operators and crew put on headsets.
"Floor director can you hear me?"	Floor director acknowledges that the communication system is working.
"Quiet everyone." "Stand by in the studio." "Stand by in the control room."	Everyone gets quiet and ready to proceed.
"Are you ready, audio?"	Audio is ready (levels set, music cued).
"Cameras, get your opening shots."	Cameras are ready with their opening shots.
"Line in Black."	TD selects Black on the video switcher before the start of the show.
"Ready to roll tape." "Ready to take bars and tone."	VTR operator gets ready to start the recording VTR. TD and audio are read to start bars and tone.
"Roll tape."	VTR operator starts the recording VTR. When tape is up to speed and recording, the operator says, "Tape rolling and recording."
"Take bars and tone."	Audio tone and color bars are recorded for 30 seconds. VTR operator checks that video recorder audio levels are set to 0 db or equivalent.
"Lose bars and tone."	TD takes Black on the video switcher. Audio cuts out the tone.
"Ready slate." "Ready countdown."	The slate is the program identifier. It is usually generated electronically on the character generator. AD prepares to count down to the beginning of the program.
"Take slate—audio read it."	TD takes the CG on the switcher and audio reads the slate.
"Lose slate. Start the countdown from 10."	TD takes Black on the switcher, and AD begins the countdown: "10, 9, 8, 7, 6, 5, 4, 3, 2, 1."
"Ready to fade up on a medium shot on 2." "Ready to open mic." "Ready to cue talent." "Ready to key CG."	TD will open with a fade-up-on camera 2 on a medium shot (MS) of the host. TD selects camera 2 on the preview bus. Audio operator gets ready to open the mic. Floor manager gets ready to cue the talent. TD gets ready to key the CG over camera 2.

TABLE 9.5 Director's Calls at the End of the Program

What the Director Says	What Happens
"Ready to fade to Black and lose audio."	TD readies Black in preview. Audio gets ready to fade out mics and music.
"Fade to Black and lose audio."	TD fades to Black on the switcher. Audio fades out audio sources.
"VTR, let it roll for 10 seconds."	VTR operator lets the tape roll to record Black at the end of the program.
"Stop the VTR."	Tape operator stops the VTR.
"Thank you, everyone—good show. That's a keeper!"	Thanks to the cast and crew.

Figure 9.2 presents a floor plan for our sample interview. Table 9.4 shows the director's commands at the beginning and end of the show, and Table 9.5 illustrates the director's commands at the end of the interview program.

Interview Floor Plan

Figure 9.2 shows that three cameras are being used to shoot the interview. This is the optimum number of cameras to use in shooting a two-person studio interview. Notice that camera placement follows the 180-degree rule that was discussed Chapter 8.

This three camera setup provides for the following shots:

Camera 1: MCU and CU of guest B, O/S shot A to B.
Camera 2: LS and MS of both guests on the set.
Camera 3: MCU and CU of guest A, O/S shot B to A.

Sometimes this type of interview will be shot with only two cameras, with either camera 1 or camera 2 trucking to the side to cover the shot the third camera would be covering if it were available.

Table 9.6 shows the director's basic commands during the interview show. Notice that from now on the director calls the camera only by its number: 1, 2, or 3. There is no need to say "camera 1," "camera 2," or "camera 3" each time a camera is called for.

FIGURE 9.2
Three-Camera
Interview Diagram

Guest A 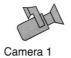 Guest B

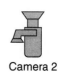
Camera 1

Camera 3

Camera 2

What the Director Says	What Happens
"Fade up on 2, open mic, cue talent."	Show opens with a MS of host and guest. Host introduces the show and guest.
"Ready 1 with MS of guest. Ready to key CG."	TD selects camera 1 on the preview bus and gets ready to key the CG with the guest's name.
"Take 1. Key CG."	TD selects camera 1 and keys the CG.
"Ready to lose CG . . . Lose CG."	TD takes out the CG.
"Ready 3 on a CU of the host."	TD selects camera 3 on the preview bus.
"Take 3."	TD cuts to camera 3.
"Ready 2 on a 2-shot."	TD selects camera 2 on the preview bus. Camera 2 frames up a shot with host and guest (2-shot).
"Take 2."	TD cuts to camera 2.
"Ready 1 on a CU of the guest."	TD selects camera 1 on the preview bus.
"Take 1."	TD cuts to camera 1.
"Ready 3—over the shoulder."	Camera 3 frames up a shot with a MS of host shot over the guest's shoulder.
"Take 3."	TD cuts to camera 3.
"Ready 1 on a medium shot of the guest."	TD selects camera 1 on the preview bus.
"Take 1."	TD cuts to camera 1.
"Ready 3—slow zoom in to a close-up of host."	TD selects camera 3 on the preview bus. Camera 3 quickly zooms in to a CU, focuses, and then zooms back out to the MS.
"Take 3—push in slowly—and hold it."	TD cuts to camera 3. Camera 3 operator zooms in until director says "Hold."
"Ready 2 on a 2 shot and slow zoom out. Ready to fade to Black and lose audio."	TD selects camera 2 on the preview bus. Camera 2 checks focus in the zoomed out position.
"Take 2, zoom out, fade to Black."	TD cuts to camera 2. Host says good-bye. TD fades to Black. Audio closes mics.

203

Directing
Multiple
Cameras:
Studio and
Remotes

◼ Camera Shot Sheets

Once the director has made all the decisions about visualization and continuity for the show, she or he can prepare **camera shot sheets** for each of the camera operators. Shot sheets are attached to the back of the camera to help camera operators prepare for upcoming shots. Shots in these sheets should be numbered as they appear in the script. Table 9.7 shows the camera shot sheet for our interview example.

◼ Rundown

Whereas a script shows every spoken word in a program, a rundown summarizes the major segments of a show and is used by the director as a guide to follow the order of segments as the show goes on. A **rundown sheet** shows the basic structure of the show. It lists the order of the segments, the topic or subject of each segment and its length, and various technical and aesthetic requirements, such as the need to incorporate sources such as VTRs or music. (See Figure 9.3.)

◼ Backtiming

Backtiming is a technique that is used in live or live-to-tape shows to make sure that the planned running time for a show is adhered to. To accomplish this, it is important to know the running time of each of the show's segments. (The rundown sheet is very useful here.) The last segment is the most critical because this is the segment that can be shortened or stretched depending on how much time is left until the end of the show.

It is sometimes more important to keep track of how much time is left until the end of the show than it is to know how far into the show or segment you are. For instance, suppose you are directing a twenty-five-minute live-on-tape show. You have five segments of five minutes each. When your assistant director tells you that there are ten minutes left in the show (fifteen minutes into it), you ought to know that at that moment the third segment should be ending. If you realize that you are four minutes into the segment, you know that you are running one minute late and will have to either wrap up the segment immediately or adjust the timing of the fourth or the fifth (last) segment to adhere to the twenty-five-minute time limit originally planned for the program.

◼ **TABLE 9.7** Camera Shot Sheets

Camera 1	Camera 2	Camera 3
3. MS of guest	1. MS of host and guest	2. CU of host
5. CU of guest	4. 2-shot	6. OS shot
7. MS of guest	9. 2-shot and slow zoom to LS	8. Zoom in to CU of guest

FIGURE 9.3 Rundown Sheet

SOLSTICE: THE DAY THE EARTH STANDS STILL
Revised RUNDOWN (blue)

Seg#	VIDEO	AUDIO	ORIGIN	DUR	CUM. TIME*
		INTRO			
1.	Opening: Bridge/Skyline	SOT	VT#1	0:16	00:16
2.	Warm-up in City Hall	mics	stage	0:24	00:40
3.	Music/Animation/Titles	mics/SOT	stage/VT#2	0:32	01:12
4.	Live Intro Host	mics	stage	1:00	02:12
5.	Morris hands	mics	stage	0:03	02:15
		Ha Ha Hot			
6.	Conch Chorus & Dancers Space Game	mics	stage	1:00	03:15
7.	Conch Montage	mics/SOT	stage/VT#3	0:45	04:00
8.	hands (Lappland)	SOT	VT#3	0:03	04:03
9.	Lappland Music	SOT	LetRoll	0:27	04:30
10.	hands (Taiwan)	SOT	LetRoll	0:03	04:33
11.	Taiwan Music	SOT	LetRoll	0:27	05:00
12.	Conch & Koch	SOT	LetRoll	1:52	06:52
		Deer and Dance			
13.	Sun Parade	mics	stage	0:15	07:07
14.	Cameo: Al Roker	SOT	VT#4	1:46	08:53
15.	Live Intro Deer Theme	mics	stage	0:15	09:08
16.	Deer Dancer/Chorus	mics	stage	3:25	12:33
17.	Cameo: John Cage	SOT	VT#4	2:30	15:03
18.	Animation (City Hall)	SOT	VT#5	2:15	17:18
		Science and Nature			
19.	Live Intro Science	mics	stage	2:12	19:30
20.	Events Montage	SOT	VT#6	1:11	20:41
21.	South Pole Report	SOT	LetRoll	0:52	21:33
22.	Ozone Report	mics	stage	1:01	22:34
23.	CM Performs	mics	stage	1:32	24:06
		Solutions			
24.	Hands	mics	stage	0:30	24:36
25.	Horizon Segment	mics	stage	1:04	25:40
26.	Wedding Segment	mics	stage	1:07	26:47
		Finale			
27.	Jump and Jam	mics	stage	1:03	27:50
28.	Live "goodbye"	mics	stage	1:00	28:50
29.	Credits over Jam	mics	stage	1:10	30:00

*Cumulative time is also known as total running time (TRT).

204

205

Directing
Multiple
Cameras:
Studio and
Remotes

■ Floor Manager Cues

Although the director can communicate with the technical personnel in the studio and control room through the PL intercom system, the director also needs to communicate with the talent in the studio to give them instructions on time remaining, which camera to speak to, and so on. Because the talent do not wear headphones, these instructions must be relayed by the floor manager while the microphones are on; therefore this must be done silently through the use of a system of hand signals. Figure 9.4 illustrates some of the most common hand signals used by floor managers.

Stand-by

FIGURE 9.4 Floor Manager's Hand Signals

Cue

Cut

This Camera

Stretch

(continued)

FIGURE 9.4 Continued

Speak Softer

On Time

Five Minutes

One Minute

Thirty Seconds

Fifteen Seconds

207

Directing
Multiple
Cameras:
Studio and
Remotes

■ Two Typical Multicamera Program Formats

There are a myriad of program formats that can be produced in a multi-camera studio environment or remote environment. In-studio programs are done in a controlled environment. Remote productions are produced on location with significantly less control of the production environment that the studio offers. In the next section we briefly discuss directorial issues for two typical multicamera program formats: the in-studio panel discussion program and remote coverage of a parade.

● **THE PANEL DISCUSSION PROGRAM FORMAT** A panel discussion program usually includes a host and two or more panelists. Panel programs are very common on public television and public access television, and they are a staple of public affairs programs broadcast by the commercial networks on Sunday mornings. Panelists are typically specialists on the topic of interest and usually represent opposing points of view.

Seating arrangements on the set will depend on the particular needs and desires of the producer and director regarding the look and feel of the show or the ease of camera movements and their placement. The producer or director may decide to place the host or moderator in the middle and the panelists on the sides or have the host at one end or on the right or left side of the panel. Remember to follow the rules of continuity and observe the 180-degree rule when deciding where to place the cameras.

In our example (see Figure 9.5) we placed the host on the right side and used three cameras to cover the event. Camera 1 is used mainly to

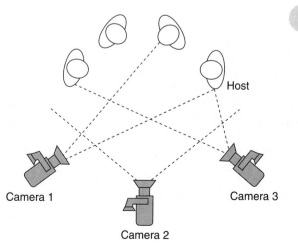

FIGURE 9.5 Panel Camera Setup

Host

Camera 1

Camera 2

Camera 3

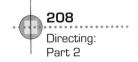
cover the host, although it can also get a 2-shot of the host and the panelist on his right. Camera 2 can shoot the long establishing shot or a 2- or 3-shot of the panelists. Camera 3 covers the panelists for close-ups and 2- or 3-shots or over-the-shoulder shots from behind the host onto the panelists.

Although a director's creativity will ultimately dictate the shooting scheme of the show, there are two important guiding principles that should be followed in directing panel discussion programs: Show close-ups or medium close-ups of whoever is talking, and look for reaction shots—either a close-up of one person or a group reaction—from the other people on the panel.

● **REMOTE COVERAGE OF A PARADE** A multicamera remote is essentially a complex field production, so all the elements discussed in the chapter on producing apply here. This includes the need for location surveys and permits and dealing with the logistics of arranging for all of the audio and video equipment and personnel that will be needed on the remote location.

Remotes may be live or live-to-tape, and they may differ greatly in complexity. A remote can be as big, extravagant, and complex as the Super Bowl with its twenty-plus cameras, a cast and crew in excess of 200 people, and millions of dollars worth of equipment. Or it can be less complex and less demanding in term of human and technical resources, such as the coverage of a parade. Regardless of the complexity of the event, every remote production requires careful planning and very systematic preproduction work.

Figure 9.6 shows the organizational structure for the transmission of a parade. There is a remote truck that serves as a field control room. There are seven cameras and three announcers. One announcer is located at the start of the parade route, and the other two are in the television production area a few miles forward.

Cameras 1 and 5 are placed high above the ground on scaffolds; cameras 2, 3, and 4 are assigned to cover the parade on the ground; camera 6 has the announcer at the start of the parade; and camera 7 has the other two announcers in the production area.

There are two different audio inputs: announcers and parade sounds. The parade sounds include participating bands and marching groups and some ambient sound from the spectators in the bleachers. The audio from the announcers goes straight into the audio board inside the remote truck. The parade audio goes to a separate audio board, where it is mixed and enhanced before being sent to the remote truck. The television signal from the remote truck is sent via microwave from the parade site to a transmission site. The director gives instructions to the crew through a wireless intercom system.

Bleachers

Microwave to
TV Station

Parade
Start

Field Sound

Camera
Assistant

Microphone

Camera
Assistant

Camera
Assistant

Floor/Field
Coordinator

Camera
Assistant

Field Sound

Field Sound

Camera
Assistant

4

3

2

6 Announcer 3

5

Director

Technical
Director

Producer

Video
Engineer

7

Announcer 2

Announcer 1

1

Microwave
Antenna

Production
Assistant

Remote Truck

VTR

Graphics
and CG

Audio
Engineer

Parade Audio Board

Audio
Engineer

Audio

FIGURE 9.6 Carnival Parade Transmission Setup. This was the actual transmission setup for the February 2004 Big Carnival Parade in Barranquilla, Colombia.

Directing Single-Camera Productions

Unlike multicamera production in which a show is edited instantaneously with the use of a video switcher, in single-camera production a director is mainly concerned with shooting repeated takes of individual shots. (See

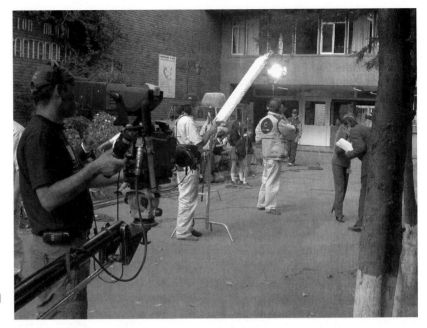

FIGURE 9.7
Single-Camera Field
Production

Figure 9.7.) The final program is then assembled in postproduction. There is a wide range of programs that are shot single-camera style, and each of them requires a different production approach. However, regardless of the type of program, there are certain principles to which a good director must adhere when shooting a single-camera production.

In this section we will learn about the principles of shooting for postproduction. We will also take a look at some of the most common programs done in single-camera style production: on-site interviews, documentaries, music videos, and public service announcements.

■ Shooting to Edit

As we stated above, in almost all single-camera field productions the director shoots material that will be edited together in postproduction. The following guidelines should be considered in shooting material that is going to be edited in postproduction.

● **SHOOT ESTABLISHING SHOTS** The function of the establishing shot is to set the scene; it tells the viewer where the action is happening. Establishing shots, most often in the form of extreme long shots or long shots, show the relationship of the parts to each other and to the scene as a whole.

An establishing shot is essential if the viewer, who otherwise has no knowledge of the scene or setting, is to make sense of the scene.

● **COVER THE ACTION** When you look at a situation or scene, try to identify the principal action or events. Break scenes or events down into their principal components, and then try to cover them. For example, if you are commissioned to videotape a wedding, you could break that event into components like these:

1. Prewedding activities: Bride dressing, arrival of groom at church, bride's drive to church, and so on.
2. Ceremony: Arrival of bride, walk into church and down the aisle, ceremony including exchange of rings and traditional kiss, and so on.
3. After ceremony: Walk down the aisle and out of church, throwing rice or birdseed at bride and groom, drive to reception, reception line, cutting the cake, and so on.

By breaking down the event into component parts, you can determine what you need to cover to faithfully capture the essence of the event. Breaking down an event into components also tells you whether you need one camera or more. If you have only one camera, you can decide which parts of the event are most important and plan to cover these.

● **REPEAT THE ACTION IF POSSIBLE** If you have only one camera to shoot an event and the participants are willing and able to repeat the action, you can shoot the same event from different angles. In traditional Hollywood film–style shooting, the director provides a master shot of the entire scene shot on a wide-angle lens. Then the scene is repeated from several additional angles to provide close-up details of the major characters or actions in the scene.

For example, if you are recording a musical group, you can do one take of a song on a wide shot, then shoot a close-up of the lead singer, and then perhaps do a third take, shooting close-ups of the instrumentalists during solo segments. For editing, this provides a cover shot (the long shot of the whole group) plus repeated action of the significant details from which to assemble your segment.

Whether or not your subject can repeat the action depends to a certain extent on the nature of the action. Product demonstrations and dramatic scenes lend themselves quite readily to multiple takes of repeated action. You will mostly likely have more success in arranging multiple takes with the music recording session just described than with your local hockey team's score of a game-winning goal. Instant replays, unfortunately, are not a characteristic of real life.

If you are shooting a program from a script that involves dialog or action, then the technique of overlapping should be used. Begin each new shot by repeating the action or dialog that ended the previous shot. This shooting technique greatly simplifies the editor's task.

● **SHOOT ESSENTIAL DETAILS** In addition to the overall action or principal of a scene, what are the essential details? Shoot close-up shots of essential details of the event to be used as cut-ins, and shoot other related details that are not part of the scene itself to be used as cut-aways. For example, if you are shooting an interview with a painter who is discussing current events projects, you might also shoot some footage of the artist at work. Shots at work might include wide shots of the painter in the studio as well as close-ups of the brush moving against the canvas. A cut from a shot of the painter talking on camera during the interview to a shot of the painter at work is a cut-away. A cut from the wide shot of the artist in the studio to a close-up of the brush moving is a cut-in.

● **SHOOT MATERIALS FOR TRANSITIONS** Think ahead about how you are going to achieve your transitions from one segment or scene to another. Let's assume that you are constructing a program out of interviews of people from different geographical areas and with different opinions about the safety of nuclear energy. When assembling the program, how will you make a transition between interviewees in different areas and/or with different opinions? Will you use an on-camera narrator to bridge the gap? Or will you use a voiceover and some shots of nuclear plants? You should have an idea of the transition shots that you intend to use before you go out to shoot so that you can be sure to get the appropriate footage on tape.

● **SHOOT SEGMENTS LONG ENOUGH FOR EDITING** The mechanics of most video systems require that any segments of tape to be used during editing must have at least five seconds of preroll material. This means that you must focus your camera and begin recording for a minimum of five seconds before you will have usable video. This is necessary for several reasons. When a videotape is played back in a VCR, it usually takes about five seconds for the tape to get up to speed and for the image to stabilize. If you are using a videotape-based linear editing system, the edit control units that govern the playback and editing VCRs need this preroll time to cue up the tapes and execute edits. If you are using a digital nonlinear editing system, you will want to have at least five additional seconds of material at the head of each shot, not only to allow the playback VCR to

get up to speed before you transfer your footage into the computer in which you will perform the edits, but also to provide additional shot material in case you want to add transition effects such as dissolves or wipes. All shots should therefore be ten seconds and preferably much longer to ensure that you have enough usable video to edit.

Directing On-site Interviews

One of the most common remote shooting situations is the on-site interview. Because television equipment has become so portable, it is a rather simple operation to travel to the home or office of the person you want to interview and shoot the interview in the subject's normal environment rather than in the artificial television studio environment.

Almost all on-site interviews are shot with a single camera, and as a result, the videographer must shoot all the angles needed to edit the interview into a coherent sequence. The interview must have both content and visual continuity.

One of the common techniques used in on-site interviews, especially for news and documentaries, is the **question re-ask** technique. After the interview is over, you can shoot the interviewer asking the questions. Make sure that the questions are re-asked in the same location, with the same background; most important, make sure that the re-asked questions are the same as the original questions. If the questions are in a script, the interviewer can simply re-ask them into the camera after the real interview has been completed. If the questions are ad-libbed, a production assistant should make a record of the questions while the interview is in progress. If there is any doubt about what was actually asked, you can always refer to the video itself, because the subject's microphone will have picked up the question even if the interviewer did not wear a microphone. Directors have the ethical responsibility to make sure that the questions that are re-asked and the answers that are given in the edited version of the program correspond to what was actually asked and answered in the original interview.

The following factors should be considered in setting up an on-site interview: position of the subject, position of the interviewer, position of the camera, and principal action axis.

● **POSITION OF THE SUBJECT** When you travel to the home or office of the subject of your interview, you can show the subject in his or her normal working or living environment. The subject should be placed comfortably, facing the camera, where you can take advantage of the surroundings to provide rich background detail to the interview. In many cases, par-

ticularly when the interview takes place in an office, your subject will be sitting behind a desk. In the home, the subject will normally be sitting in a chair or on a couch. With your subject in position for the interview, examine the background to be sure that it does not distract from the subject. Lamps and pictures on the wall often provide unwanted distractions. If they interfere with the composition of your shot, move them into a more favorable position.

Be careful not to position the subject in front of a window. If there is a window in the background and you cannot move the subject so that the window is out of the shot, close the window blinds or draperies when shooting during the day to avoid silhouetting the subject. Also, be aware that if you need to need to light the subject, you should not mix color temperatures. In your lighting kit, always carry blue gels to place in front of your lighting instruments to match the color temperature of the light coming through the window.

● **POSITION OF THE INTERVIEWER** There are two possible positions in which to place the interviewer: next to the subject or somewhat in front of the subject with the interviewer's back to the camera. The best place for the interviewer is in front of the subject, with his or her back to the camera. Placement of the interviewer next to the subject may make the subject feel more comfortable, since this approximates a normal sitting position for conversations, but it will consistently present the camera with a poor view of the subject, who will have a tendency to turn toward the interviewer and away from camera.

● **POSITION OF THE CAMERA** The camera should be positioned slightly behind the interviewer and off to one side. In this position the camera can easily shoot a three-quarter profile of the subject as well as an over-the-shoulder shot of the interviewer and subject. From this position the subject will always be able to maintain easy eye contact with the interviewer and will present the camera with an almost full-face shot.

When you are setting up the position of the interviewer and the subject, try to keep the distance between them relatively short and keep the camera a few feet behind the interviewer. The camera should be able to zoom in to a tight close-up on the subject, and at the same time the interviewer should be in focus when you zoom out to the over-the-shoulder shot.

● **PRINCIPAL ACTION AXIS** A principal action axis is formed in an interview setting, just as it is in an action-oriented scene, and the camera must remain in the 180-degree semicircle formed by the principal action axis.

Directing the Music Video

Music video segments representing a range of musical styles and target audiences are visible at almost any time of day on most cable television systems in the United States. MTV (Music Television), VH-1 (Video Hits 1), the Disney Channel, and the Country Music Television (CMT) are four cable television channels that regularly feature music video segments. Many music videos are produced as promotional pieces for new musical artists or new songs recorded by established performers. Some music videos, particularly those targeted at children and featured on the Disney Channel or as segments in the PBS television series *Sesame Street,* are designed to teach something to their audience as well as entertain them.

All music videos combine a sound track of a musical performance with appropriate visual images. Some music videos focus exclusively on the musical artist(s) in performance of their work, other music videos dramatize the narrative found in the lyrics of the song, and still others combine elements of the musical performance with images dramatizing the song. Determine which approach best suits your performer and the performance you have chosen to present.

Music videos can be as simple or complex as we want them to be. The planning process for music video production begins by establishing the concept and defining the theme and structure of the video by examining the selected music very closely. Next, select and scout locations to determine their visual potential and ensure the feasibility of the shoot. Produce a storyboard and a shot list. Listen closely to the beat and rhythm in the different parts of the song, and plan your shots to match these elements in the postproduction phase. When working with musicians and other performers, be sure to rehearse the video thoroughly. One final and important guideline is to make sure you have addressed all of the important legal and safety issues. Make sure you have clearance for the music and releases from all the performers.

The Public Service Announcement (PSA)

Public service announcements (PSAs) are a standard feature of commercial broadcast schedules. The Federal Communications Commission defines a PSA as

> "any announcement (including network) for which no charge is made and which promotes programs, activities or services of federal, state, or local governments (e.g., recruiting, sales of bonds, etc.) or the programs, activities, or services of non-profit organizations (e.g., United Way, Red Cross blood donations, etc.) and other announcements regarded as serving community interests, excluding time signals, routine weather announcements and promotional announcements."[1]

Although most PSAs are noncontroversial, some organizations use the PSA format to develop spot messages about controversial issues of public importance.

PSAs attempt to mobilize people to action by making them aware of significant community or social issues. PSAs usually provide a phone number or website address that viewers can use to get more information about the organization or issue featured in the PSA.

Because television stations air the majority of PSAs at no charge as a community service, PSAs are often inserted into the broadcast schedule at off-hours when the number of viewers is small. However, some government agencies and nonprofit organizations purchase airtime in more popular time slots to reach a larger audience and increase the effectiveness of their messages.

Designing and producing PSAs require the development of a strategic plan that includes research and addresses the issues of production, distribution, and evaluation. Research will inform the producer and director of the problem or need that is being addressed and clearly identify the target audience. Also, be sure to contact television stations that are likely to broadcast your PSA to find out each station's requirements for videotape format and length.

Many broadcast stations still prefer spot announcements to be delivered in the professional Betacam format. Nonprofessional formats such as VHS are generally not acceptable. Preferred spot lengths include ten, fifteen, twenty, thirty, and sixty seconds. A script of the PSA should be submitted as well.

Following are some guidelines for producing and directing a PSA:

- Research the subject well, and make sure the PSA recommends a specific action. There needs to be a request for a response from the viewer in the form of change in an attitude or behavior (e.g., "stop smoking" or "visit this website for more information").

- Identify the main issue in the first ten seconds by using strong visuals or a compelling word or phrase that grabs the viewer's attention.

- Keep the message simple, and make sure that every word and visual is carefully chosen. If you have a presenter, make sure she or he is considered to be credible. If your PSA takes a humorous approach to the subject, make sure it is not offensive to your audience. Formative research can help here. (Remember our production model in Chapter 8?) Test the effectiveness of your spot by showing it to a test audience before you finalize it.

- Select your approach—testimonial, demonstration, or real-life scenes—carefully and make sure the language used is appropriate for your audience.

- Show a phone number to call or a website address on the screen for at least five seconds, and reinforce it orally within the PSA. Use a font that is large and easy to read.
- Repeat the main point of the PSA at the end of the message.

Planning and Directing the Documentary

Documentaries can be seen at almost any time of day on most cable television systems in the United States. The documentary format is usually associated with the truthful representation of people and events. Documentaries present a factual representation of reality.

Early documentary makers, such as Flaherty in the United States, Grierson and Rotha in Great Britain, and Vertov and Eisenstein in Russia, conceived the documentary as a film genre attending to social issues in the "real world." They developed and used documentary as an instrument of persuasion and as a tool for influencing public opinion. It was cinema with a social purpose.

Today, the documentary has evolved into a variety of forms, and most documentaries are shot on video, not film. There are many ways to structure a documentary and it is up to the director to decide the best approach to achieve his or her desired objectives.

The elements of a documentary—voice, camera, characters, pictures, and music—can be woven together in many different ways. A director may decide to use a direct address approach in which the story is told by addressing the viewer directly with titles, on-screen commentators, or voice-over. "Talking head" interviews (MCU or CU) of witnesses or experts may be part of the storytelling scheme.

Alternatively, a director may use a direct cinema or cinema verité approach. In **direct cinema** the camera never interferes with the action, it is a passive observer. In **cinema verité** the story is told without voice-over or narration. The camera is more interactive, hand-held, and participants are aware of its presence and may address the audience or members of the crew directly.

A director may also choose to combine approaches or do reenactments in which people and events are recreated by actors on specially designed sets. A good example of this can be found in the documentaries of Ken Burns. Burns became famous because of his eleven-hour documentary series *The Civil War,* which was broadcast on PBS in 1990. He used dramatized voice-overs and narration of Civil War era personal letters and documents combined with extensive camera zooming and panning over still images—photographs, paintings, maps, and documents. This was juxtaposed with present footage of historic sites and interviews with modern-day commentators to recreate a story from the past.

Burns became so well known for using camera motion to animate still images that Apple's popular iMovie video editing software includes a "Ken Burns" effect in its effects menu: The user identifies points in photo to zoom in or out or to pan to, and the iMovie software creates the zooming/panning effect on the image.

Following are some basic guidelines for producing and directing documentaries:

- Choose a topic, research it, identify the key elements about the subject, and develop an in-depth treatment of the topic. Think about your audience, this will help to determine how to tell your story.

- Decide on the structure of your story, and develop your documentary approach. Will you use voice-over? Reenactments of events? An on-camera narrator? Photographs?

- Make a list of the human and technical resources you will need to complete the project. Organize your list into the resources you must have, the ones that would be helpful to have, and the ones that you could do without if necessary.

- Draw up a tentative but sound preproduction, production, and post-production plan. Remember that although planning is essential, things may change during the location shooting. So be prepared to modify your production plans as circumstances dictate.

- Collect all materials related to the topic, and set up a good archiving system.

- During production, make sure you get releases from the people who appear on camera, as well as location releases for the places in which you shoot. Also, make sure you use your best people skills when dealing with people. Treating everyone with respect is a key principle.

- Decide what the role of the camera will be. Will it be active and intrusive or a passive observer? What about camera movement? When will you use a tripod? When will the camera be hand-held? Think about how you will frame the interviewees. Will you use a close-up for all of them for unity, or will framing depend on the setting? Make a list of the questions you plan to ask during each interview. Listen closely to what is said in the interview so that you can plan to shoot appropriate B-roll for cutaways. B-roll is additional video used to visually enhance and support the story. It is mostly used as background for voice-overs and talking heads.

- What are the lighting conditions? Do they meet your criteria for the look and feel that you wish to capture? Will you need to use lighting instruments? If you use lighting instruments, will that create color temperature problems?

- What about audio? How many microphones will you need? What type? Will you use lavalieres or pickup sound with a boom mic? Don't forget to record plenty of natural sound.

- Before you begin postproduction, make sure you make accurate and detailed logs of all your footage. Transcribe all of your interviews, and neatly type up the transcripts. Make notes about shots that are particularly good or bad. Identify critical sound bites in each of your interviews.

- Remember, it is during editing that your documentary story will be constructed. The editing stage will determine how well your story is told.

- Think about your main point. Go back to your original outline and treatment. Does every editing decision reflect your main point? Does your shot sequence tell the story?

- Think about other sound elements. If you use narration, is there too much or too little? Do you have the appropriate person to voice it? What about music? Does it reflect the mood of the story? Do you have the necessary releases to use the music you have selected?

- Think about graphics and transitions. Used effectively, they can enhance and clarify the story.

Of course, there are many other issues to think about in directing and editing your documentary, but if you follow the above guidelines and keep focused on your main point and initial visualization, you will increase your odds of delivering a well-told story.

The Role of the Director
in Postproduction

The director is responsible for making major video editing and audio mixing decisions during postproduction. Remember, however, that if your program was produced by using multiple cameras fed through a video switcher, postproduction time may be reduced significantly because you will already have an instantaneously edited version of the program. But if your program was produced single-camera style, most likely you will have a lot of editing to do to complete your program.

If postproduction editing is required, the first step in the process is to carefully log all the tape that has been shot. Then the director will work with the editor to produce a rough cut of the program. This rough cut is a first draft of the program that can be evaluated by the producers or other interested parties. During this off-line editing stage in which the rough cut is

produced, the director will make initial decisions about shot sequences, the use of voice-over, background music, natural sound, and graphics. Once the off-line version has been completed and reviewed and changes have been approved, the director will work with the editor to make the final on-line version of the program. The entire process of postproduction editing is discussed in greater detail in Chapter 10.

NOTE

1. Code of Federal Regulations 73.18101. Washington, D.C.: U.S. Government Printing Office, 1983, pp. 355-356.

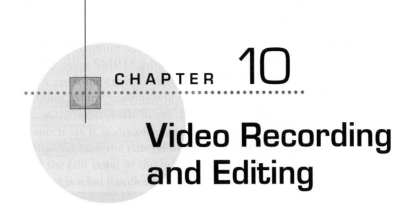

CHAPTER 10

Video Recording and Editing

Video Recording Technologies

Unless you work for a broadcast or cable television station or network that is engaged in the live transmission of programs, the program material that you produce will most likely be recorded. Recording allows us to save programs so that they can be distributed at a later time. Recording also allows us to acquire program material that will be edited into its final form in post-production.

With the advent of digital technologies, methods of video recording are changing. For most of the past fifty years, video recording has been dominated by the process of magnet recording onto videotape. Today, that process is being augmented, and ultimately supplanted, by video recording to optical discs, magnetic computer hard drives, and memory cards.

▓ Videotape Recording

In 1956 a small company called Ampex, located in Redwood City, California, introduced the first practical videotape recorder to provide an all-electronic storage and production medium for video programs. All videotape recording systems are based on a set of similar principles. The video and audio signals pass through one or more recording heads which spin against a moving videotape. A recording **head** is a small electromagnet. **Videotape** is recording tape that is coated with magnetic material. When the heads pass over the tape they encode the signal into the layer of magnetic particles on the tape. In playback, the process is reversed: The playback heads trace over the tape and pick up the signal that is embedded there. (See Figure 10.1.)

All modern VCRs use the **helical scan** method of recording the video signal. This name is used because the videotape is wrapped around the

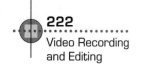

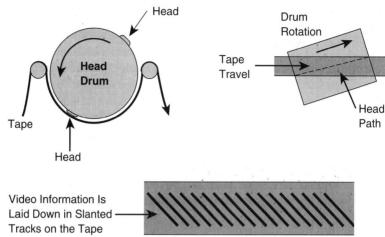

FIGURE 10.1
Videotape
Recording

Video Information Is
Laid Down in Slanted
Tracks on the Tape

head drum inside the machine in the form of a helix. Sometimes this type of recording is called **slant-track recording,** because this describes the angle of the video information on the tape.

■ Videotape Formats

Since the introduction of videotape recording, approximately fifty different **videotape formats** have been introduced with varying degrees of success in the marketplace. You are probably familiar with the terms VHS and DV. These are different tape formats. A videotape's format is described by a number of different factors:

1. *Width of the tape.* Over the years tape width has been reduced from 2 inches to much smaller sizes (giving rise to the term *small format* video-tapes). Today's tape formats are ¼ inch (6.35 mm), 8 mm (Hi-8), or ½ inch wide. (See Figure 10.2.)

FIGURE 10.2
6.35-mm, 8-mm,
and ½-inch
Videocassettes

6.35 mm

8 mm

½ inch

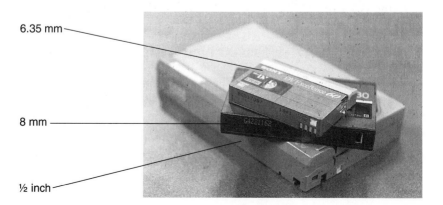

2. *Configuration of the tape.* Is it open reel or cassette? All modern video-tape recorders use video cassettes.

3. *Tape speed.* How fast does the tape run? In the DV tape formats, MiniDV tapes run at a slower speed than DVCAM tapes, which run at a slower speed than DVCPRO tapes. Higher tape speed generally translates into higher recording quality.

4. *How the color information is processed.* Is it composite, S-Video, or component? These terms will be described in more detail later in the chapter.

5. *How the signal is recorded.* Is it analog or digital?

6. *How the various tracks of information are arranged on the tape.* Four different sets of signals are typically recorded onto videotape: the video signal, the audio signal, the control track, and SMPTE time code and/or data tracks.

■ Location of Signals on Videotape

Two of the most widely used videotape recording formats are VHS and DV. **VHS** (the letters stand for video home system) is a ½-inch analog, consumer-quality tape format. **DV** (the letters stand for digital video) is a ¼-inch (6.35 mm) digital videotape format that is used in consumer and professional applications. There are three general variants of the format: DV (or Mini DV), DVCAM (manufactured by Sony), and DVCPRO (manufactured by Panasonic). To illustrate some of the major similarities and differences between various tape formats, we will briefly discuss the track layout for these two tape formats.

● **VHS TRACK LAYOUT** As you can see in Figure 10.3, the largest area of the tape contains the video information. Each track of video information is laid down at an angle on the tape. The top edge of the tape contains two analog audio tracks, and the bottom edge of the tape contains the **control track,** a series of electronic pulses that are used during tape playback to align the video heads with the tracks of recorded information on the tape. Many older VCRs contained a **tracking control,** a small knob that manually adjusted the relationship of the heads to the video tracks until the best picture quality was achieved.

The relationship of the control track pulses to the video tracks is very precise. Note that there is one control track pulse for each track of video information on the tape, and as we discussed in Chapter 4, each video track contains one field of information, and two tracks of information constitute one video frame. (See Figure 10.3.)

SMPTE time code is a digital signal that encodes each frame of information with a unique time reference in hours:minutes:seconds:frames. Thus a SMPTE time code number of 00:10:12:22 indicates that the frame

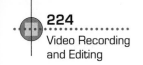

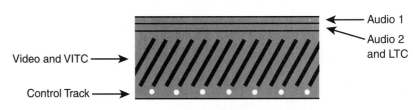

Audio 1

Audio 2
and LTC

Video and VITC →

Control Track →

VHS/S-VHS: Two Video Tracks per Frame

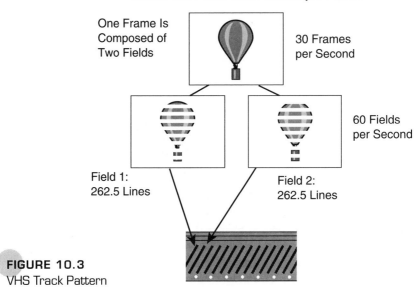

One Frame Is
Composed of
Two Fields

30 Frames
per Second

60 Fields
per Second

Field 1:
262.5 Lines

Field 2:
262.5 Lines

FIGURE 10.3
VHS Track Pattern

is 0 hours, 10 minutes, 12 seconds, and 22 frames into the tape. On VHS format tapes, time code can be recorded in two places: **linear time code,** or **LTC** (pronounced "litsee"), can be recorded in one of the two audio tracks, and **vertical interval time code,** or **VITC** (pronounced "vitsee"), can be recorded along with the video information. Time code is discussed in greater detail later in the chapter.

● **DV/DVCAM/DVCPRO TRACK LAYOUT** As is the case for all videotape formats, in the DV/DVCAM/DVCPRO formats, the video information occupies most of the central area of the tape. However, because the digital video signal is more complex than the signal in analog recording, each frame of video information is broken down into ten sections of approximately fifty-two lines each, which are then recorded into ten separate video tracks on the tape. (See Figure 10.4.) Digital audio can be recorded as two high-quality tracks or four lesser-quality tracks. There is a

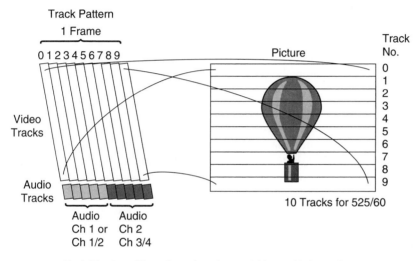

DV/DVCAM/DVCPRO: Ten Video Tracks per Frame

Each Track on Tape Contains about 52 Lines of Information.

FIGURE 10.4
DV/DVCAM/
DVCPRO Track
Pattern

dedicated data track for **insert and track information (ITI)** that contains additional information about the video tracks (e.g., whether it is DV or DVCPRO) as well as the pilot tones that control DV and DVCAM playback. DVCPRO tapes contain an additional track for control track.

■ Composite and Component Recording

The color video signal can be processed and recorded onto videotape in a number of different ways.

● **COMPOSITE RECORDING** Analog recording systems such as VHS record a **composite,** NTSC-encoded video signal in which the luminance (Y) and chrominance (C) are mixed together. This generally produces a low-quality image when the signal is played back. The output on VCRs and DVD players labeled "Video Out" is a composite video output.

● **Y/C SIGNAL PROCESSING (S-VIDEO)** Videotape systems such as Hi8 and S-VHS (Super VHS) record a composite video signal but process the luminance (Y) and chrominance (C) signals separately within the VCR to achieve better color purity and image detail than is possible in conventional composite recording systems. This is referred to as **Y/C signal processing.** When the video signal is fed out of the VCR from the S-Video output and is displayed on a video monitor equipped with an S-Video input, luminance and chrominance travel as two separate signals. This produces a better-quality image than a conventional composite recording.

● **COMPONENT RECORDING** The highest-quality color recordings are made in systems that record the signal through the color difference process. This is often simply referred to as **component recording.**

As in the S-Video process, the luminance signal (Y) is processed and recorded separately from the color components. However, in component recording, the process is carried further, resulting in a recording composed of the luminance signal (Y) and two color difference signals: red minus luminance (R − Y) and blue minus luminance (B − Y). Because the composition of the luminance channel is based on a fixed formula (Y = 30% red, 59% green, and 11% blue), there is no need to create the green minus luminance (G − Y) component because it can be reconstructed from the other three signals.

The R − Y and B − Y designations are used to describe the color components in analog recording systems such as the Betacam SP tape format. In digital systems (e.g., DV, DVCAM, DVCPRO) the color components are Cr and Cb. In both systems the luminance signal is Y.

Component VCRs and DVD players produce pictures with superior picture quality. The images are sharper and the colors are purer than those obtained in composite or Y/C recordings. (See CP-6.)

■ Analog Recording

Like audio signals, the video signal can be analog or digital. An analog signal is one in which the recorded signal varies continuously in relation to the sound or light that produced it. The electrical video signal that is produced through the analog process varies in direct proportion to the light entering the camera lens, and the video waveform that is produced is continuous.

● **THE VIDEO WAVEFORM AND WAVEFORM MONITOR** Figure 10.5 illustrates one scanning line from an analog video waveform. As we discussed earlier, the color video signal is composed of two principal components: luminance (or brightness) and chrominance (or color). The video waveform monitor is used to check the luminance levels of the picture. The

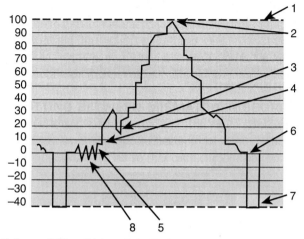

(1) Reference White—Brightest Point TV System Will Produce
(2) Peak White—Actual Brightest Point in the Scene
(3) Peak Black—Actual Darkest Point
(4) Reference Black—Darkest (Black) Possible Point TV System Will Produce
(5) Setup (Pedestal)—Determines the Point at Which Reference Black Is Set
(6) Blanking Level—End of a Scanning Line
(7) Horizontal Sync Pulse—Begin a New Scanning Line
(8) Color Burst—Controls the Phasing of the Color Signal

FIGURE 10.5 Analog
Video Waveform

peak of the waveform represents the brightest part of the scene. This is called **peak white.** Peak white should not exceed 100% (reference white) on the waveform.

If the picture is too bright and the waveform exceeds peak white, the level can be adjusted by closing the camera iris slightly to reduce the amount of light hitting the image sensor or by turning down the gain, a control on the camera control unit that is used to amplify the signal.

Conversely, if the picture is too dark, it can be corrected either by opening up the lens iris slightly or by increasing the gain. Although increasing the gain will make the picture brighter, it can also have some negative effects. When you amplify an electronic signal, you also increase the noise inherent in the system. In video this visible picture noise, in which the picture takes on a grainy quality, is called **snow.**

Just as there is a maximum point for white, there is a minimum point for black. The black level, or **pedestal,** is always set at 7.5% on the waveform monitor. As you can see, the area of the waveform between 7.5% and 100% represents the range of brightness values of the picture.

Note also that the waveform contains the sync pulses that control the scanning of each line of video information as well as a color burst signal that controls synchronization of the red, blue, and green color components to ensure that the reproduced colors are accurate.

Although the waveform monitor is used to monitor brightness and the overall level of the signal, it does not tell much about the color signal, other than whether color is present (visible color burst) or absent (no color burst signal.) The **vectorscope** is a monitoring device that shows which colors are present in the signal and how much of each one is present. (See Figure 10.6.)

● **THE VECTORSCOPE** The vectorscope is used when color adjustments are made to cameras and VCRs. A standard pattern of color bars is used as a reference to makes sure that all components of the color system are

FIGURE 10.6 Color Bars, Waveform, and Vectorscope Displays

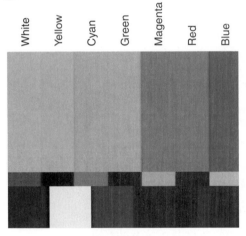

Color Bars

Color Bars Waveform Display

Primary Colors
R — Red
B — Blue
G — Green

Complementary Colors
MG — Magenta
CY — Cyan
YL — Yellow

Color Bars Vectorscope Display

functioning properly. In multicamera shooting situations the vectorscope is used to help match the color quality of the cameras when they are white-balanced so that the color values they reproduce are the same for each camera. Figure 10.6 illustrates a typical color bar display and shows how the color bar display appears on a waveform monitor and a vectorscope. Also shown is a diagram of a vectorscope illustrating where the primary and complementary colors of the color bar are displayed. (See also CP-4 and CP-5.)

■ Digital Recording

In the digital recording process, the incoming analog signal (audio or video) is converted into a digital signal that is composed of a series of on/off pulses, or bits. There are three steps to the process: sampling, quantization, and compression.

● **SAMPLING** Sampling rates for video vary greatly, depending, for example, on whether the signal is standard definition television (SDTV = 13.5 Mhz) or high-definition television (HDTV = @74 Mhz). That is equivalent to 13.5 million samples per second for SDTV and 74 million samples per second for HDTV.

In addition to the overall sampling rate, the color sampling rate describes how often the luminance and chrominance elements of the analog video signal are sampled for conversion into packets of digital information. Three sampling rates are used in digital video: 4:2:2, 4:1:1, and 4:2:0. It is somewhat beyond the scope of this text to explain the technical differences between these different sampling schemes. Suffice it to say that 4:2:2 sampling provides the highest-quality signals and is therefore the standard for broadcast and HDTV; 4:1:1 sampling is used in the DV, DVCAM and DVCPRO formats.

● **QUANTIZATION** As the signal is sampled, it is converted into packets of digital information (quantization). However, the amount of data this process produces is immense. To make it easier to store and transmit the information, compression is used.

● **COMPRESSION** As we discussed in Chapter 5, compression schemes may be lossy or lossless. Lossy compression works by eliminating repetitive or redundant data. Lossless compression works by compressing the file without removing any data.

The amount of compression is typically expressed as a ratio. Higher numbers indicate greater compression, and lower numbers indicate less compression. For example, the 5:1 compression ratio that is used in the DV formats is higher than the approximately 3:1 compression ratio that is used in Digital-S. Signals that are recorded with less compression generally produce better pictures than those that are recorded with more compression.

● **TYPES OF COMPRESSION** Several different compression methods are widely used in video systems:

- **JPEG** (Joint Photographic Experts Group) compression was originally designed for use in digital still photography and has been adapted for use with video (motion JPEG).
- **MPEG-1** (Motion Picture Experts Group) compression is designed for use in CD-ROMs.
- **MPEG-2** is the standard for broadcast television and DVDs.
- **MPEG-4** is used in a range of applications including digital television and streaming media on the Internet.
- **MPEG-3,** more popularly known as **MP3,** is widely used to compress audio files. (This is also called MREG-1 audio layer 3.)

● **DIGITAL ADVANTAGES** Although the digital signal is significantly more complex than the analog signal, it has several distinct advantages over analog recording. Digital signals can be recorded, replayed, and copied with greater accuracy and less noise than analog signals. This makes it possible to make clean copies across generations of tape. A copy that is made from a copy of the original should be indistinguishable from the original if all copies are made digitally. A third-generation copy of an analog tape, by contrast, will show noticeable degradation of picture quality. Digital signals are also preferable to analog ones because they can be processed by a computer and manipulated to create stunning visual effects.

■ Digital Videotape Formats

All of the new videotape formats introduced since 1993 record the video signal digitally. A variety of digital tape formats are marketed to professional and consumer users.

● **DIGITAL VIDEOCASSETTE (DV)** DV is one of the newest and smallest digital tape formats. DV systems record up to four digital audio tracks and a digital component video signal on a small 6.35-mm (¼-inch) cassette. DV tapes come in three different sizes: the small MiniDV cassette and the medium and large cassettes that are designed for use in professional DV, DVCAM, and DVCPRO machines. (See Figure 10.7.) A medium-size cassette adapter is used to play back MiniDV cassettes in full-sized DVCPRO machines. (See Figure 10.8.)

 Image quality and sound quality rival those of the professional analog Betacam SP format, which was the broadcast standard before the current

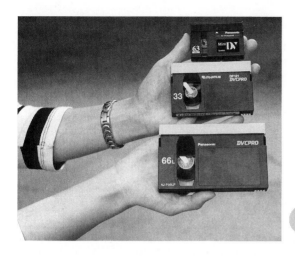

FIGURE 10.7 Small (MiniDV), Medium, and Large DV Cassettes

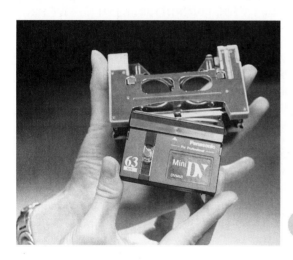

FIGURE 10.8 MiniDV Cassette Adapter

generation of digital tape formats were introduced. There are five variants of the DV format:

1. DV (Digital Video) was originally targeted at the consumer market but found ready acceptance in the professional market because of its high quality and low cost. The first generation of DV equipment exclusively used a very small cassette (MiniDV), as does most DV equipment sold today. However, several manufacturers now offer a professional DV camcorder that can record to either a MiniDV cassette or a standard DV cassette.

2. DVCAM is manufactured by Sony and is targeted at industrial and professional users.

3. DVCPRO (D7) was developed by Panasonic and BTS/Philips and is targeted at the professional and broadcast market. It has found wide use in ENG applications.

4. DVCPRO 50 is a modified version of DVCPRO that features 4:2:2 sampling instead of the 4:1:1 rate that is characteristic of the other DV formats. DVCPRO 50 records twice as much data as does conventional DVCPRO, making it suitable for high-definition as well as standard-definition digital recording.

5. DVCPRO-HD is another modified version of DVCPRO designed by Panasonic for both 1080i (interlaced scanning) and 720p (progressive scanning) high-definition as well as standard-definition digital recording. DVCPRO-HD records at twice the data rate of DVCPRO 50 (100 megabits per second versus 50 megabits per second), with a compression ratio of 6.7:1 versus 3.3:1 for DVCPRO 50 and 5:1 for DVCPRO.

● **HDV** JVC, Sony, Canon, and other manufacturers have all been actively involved in developing relatively inexpensive (under $10,000) camcorders that record a high definition signal onto MiniDV cassettes. The HDV format has a resolution of 1,280 pixels by 720 lines in the 16:9 screen format. MPEG-2 compression is used to compress the data for recording. The HDV format was developed in 2003, but it was not until 2005 that JVC and Sony introduced 3-chip camcorders that took advantage of it. (JVC had previously introduced a single chip camcorder in 2003.) Sony's Z1U HDV camcorder uses the 1080i (interlaced) 30 fps standard, while JVC's GY-HD100U uses the 720p (progressive) standard, running at either 24 or 30 fps, non-interlaced. (See Figure 10.9.)

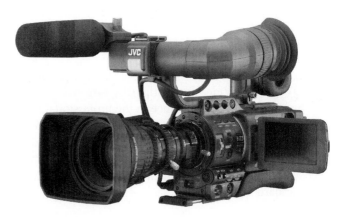

FIGURE 10.9 JVC
HDV Camcorder

Panasonic has eschewed the use of the MiniDV format for high-definition recording, choosing to focus instead on DVCPRO tape to record the high definition signal (DVCPRO-HD), or by using its P2 memory cards as recording media. (These are discussed later in this chapter.)

● **DIGITAL 8** Introduced by Sony in 1999, **Digital 8** records a digital component signal that is the same as DV except that it is recorded onto 8-mm tape instead of 6.35-mm tape. Analog Hi8 tapes can be played back in Digital 8 camcorders and VCRs. This format is targeted principally at the consumer market.

● **DIGITAL-S (D-9)** Developed by JVC for the professional production market, Digital-S records a component digital video signal and four audio channels onto ½-inch metal particle tape. Some VCRs contain a preread feature that can play back and simultaneously record new information, making it possible to create multiple layers of images for special effects and transitions without the use of an editing system or video switcher.

● **DIGITAL BETACAM AND BETACAM SX** Developed by Sony, Digital Betacam records an extremely high-quality component digital signal with four digital audio tracks onto ½-inch tape. Betacam SX is a lower cost digital component ½-inch format that is targeted at ENG users.

● **D-3, D-5, AND HD-D5** D-3 (composite) and D-5 (component) digital VCRs were developed by Panasonic. Like most of the other formats, they use a ½-inch cassette tape. HD-D5, a high-definition version of the D-5 format, is one of the principal formats used for recording HDTV in the 1080i or 720p variants.

● **D-VHS** JVC's D-VHS (digital VHS) is designed for off-air recording of digital television broadcasts. It uses ½-inch tape, and analog VHS and S-VHS can be played back in the D-VHS machine. The quality is slightly better than what can be achieved with a DVD.

■ Analog Videotape Formats

Analog videotape formats are fast disappearing from the marketplace. However, a few formats are still in use.

● **½-INCH VHS AND S-VHS** VHS (video home system) emerged as the dominant format for home video recording in the early 1980s and, until the introduction of DVDs, also served as the dominant medium for the rental movie market. VHS is strictly a consumer format and is generally not suitable for professional production applications.

S-VHS (Super-VHS) was introduced by Victor Company of Japan (JVC) in 1987 and marketed to industrial and professional users as a low-cost alternative to Sony's professional Betacam format. S-VHS systems produced improved resolution and color quality in relation to VHS systems, but they are vastly inferior to DV.

● **Hi8** Hi8 format equipment was introduced by Sony in 1989 to replace conventional 8-mm video equipment and found a niche in the consumer and prosumer markets because of its low cost, extreme portability, and high-quality first-generation recordings. Despite its past popularity, Hi8 is being displaced from the marketplace by the Digital 8 and DV digital tape formats.

● **BETACAM SP** **Betacam SP,** developed by Sony, is a professional, broadcast-quality ½-inch analog component recording format. Betacam SP was the de facto standard for field recording in ENG and EFP in professional broadcast operations in the United States until the late 1990s, when it was supplanted by a variety of digital videotape formats. Sony stopped manufacturing Betacam SP equipment in November 2001, although many Betacam camcorders and VCRs remain in use today.

■ VCR Operational Controls

● **TAPE TRANSPORT CONTROLS** The tape transport controls regulate the movement of the videotape within the VCR. (See Figure 10.10.) The following controls are found on most VCRs and portable camcorders:

- *Eject.* This button is used to eject the tape from the machine.
- *Play.* This is used to play back a tape at normal speed.
- *Stop.* To stop the movement of the tape in any mode, press STOP.
- *Fast Forward.* Pushing this button causes the tape to move forward at a fast rate of speed. Typically the tape disengages from the head drum, and no picture is visible. Use the fast forward button when you want to find a spot on the tape that is a considerable distance from where the tape is now positioned.
- *Rewind.* This functions the same as fast forward, except that it moves the tape in the reverse direction.
- *Pause.* When the tape is in the play mode, pressing the pause button stops the movement of the tape and displays a still frame video image. Do not leave the tape in the pause mode for more than a few minutes as this may damage the tape.

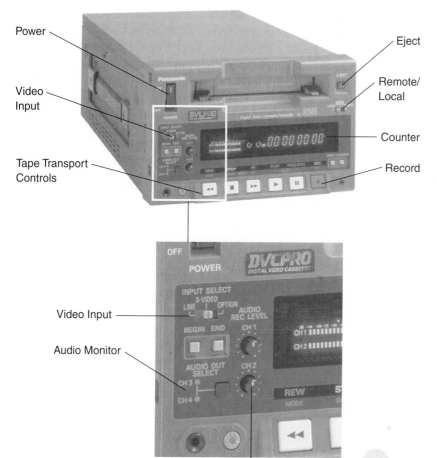

Power

Eject

Remote/
Local

Video
Input

Counter

Tape Transport
Controls

Record

Video Input

Audio Monitor

Audio Record Levels

FIGURE 10.10 Panasonic
AJD250 DVCPRO VCR

- *Forward Search and Reverse Search.* These controls allow you to for-
 ward or reverse the image at a high speed when the VCR is in the play
 mode. Since the tape remains in contact with the heads, the picture is
 visible moving at high speed. Don't overuse this feature. If more than
 a few minutes of forward or reverse movement are necessary, use the
 fast-forward or rewind button.

- *Record.* The record button is used to record new audio and video onto
 videotape. Some machines have one touch recording, which puts the
 VCR into the record mode simply by pushing the record button. Other
 machines require you to push and hold the record button, and then si-
 multaneously press the play button to engage the recording function.

- *Audio Dub.* This is used to record new audio information onto a tape
 without erasing the video information already recorded onto it.

METERS AND TAPE COUNTERS

Meters Audio levels are monitored with the use of the volume unit meter. On full-size VCRs these are typically found on the front panel of the machine, on camcorders they may be located on the side of the camcorder, or they may be visible in the viewfinder display. Camcorder viewfinder displays also typically include a battery meter, which displays the amount of power remaining in the camcorder's battery.

Tape Counters Three selections are commonly found for the tape counter: CTL, TC, or UB.

CTL stands for control track. Consumer quality equipment, not equipped with a SMPTE time code generator, uses the control track pulses on the tape to display the tape position in hours, minutes, seconds, and frames. Remember, however, that for the display to be accurate, the counter must be set to zero at the beginning of the tape. Since control track pulses do not contain data, anytime the Reset button is pushed the counter will reset to zero. Many professional VCRs contain a CTL counter as well as TC and UB counters.

TC stands for SMPTE time code. Professional VCRs and camcorders use SMPTE time code counters. These counters display the SMPTE time code value for the current position of the tape.

UB stands for user bits. This is a feature on some SMPTE time code enabled systems that allows the user to enter additional information about the shot or scene that is being recorded.

OTHER CONTROLS

- *Remote/Local Selector.* Many VCRs can be operated not only from the tape transport controls on the front of the machine, but from a remote control device as well. This switch selects how the machine will be controlled.

- *Video Input Selector.* The video input selector switch tells the VCR where the input video signal is coming from. Typical choices may include: line (composite video), Y/C (S-Video), Y, Pb, Pr (component video), DV, or IEEE 1394 (Firewire).

- *Audio Record Level.* Audio potentiometers (pots) on the front of the VCR can be used to set the record level for incoming audio signals.

- *Record Inhibit.* This switch is used to disable the VCR's record circuitry so that you don't accidentally record over the material already recorded onto the tape that is playing back in the VCR.

- *Audio Monitor Selector.* This switch is used to select which audio channel(s) are routed to the audio monitor or headphones. Audio channels may be selected independently, or in groups (e.g., Channel 1 only, Channel 1 and 2, and so on).

- *Menu.* Modern VCRs give the VCR operator control over many machine functions through the Menu control. One very common menu control is used to display the time code numbers in a window over the background video. By using the menu control, this feature can be turned on or off.

- *Tracking Control.* On older analog VCRs, the tracking control is used in the playback mode to maximize the quality of the playback image by compensating for slight differences in the way different VCRs of the same format record and play back a signal. Modern, digital VCRs automatically provide for accurate tracking and there is no manual control.

■ Other Video Recording Devices

Although videotape has been the principal medium for recording the electronic video signal for almost fifty years, new technologies are evolving that will ultimately replace videotape as the recording medium of choice. A number of these new technologies are in use now.

● **COMPUTER HARD DISKS AND VIDEO SERVERS** A **hard disk** is a magnetic storage system that is widely used in computers. Information is stored on a series of round magnetic platters within the computers. **Video servers** are computers that are equipped with hard disk storage systems that can record and play back video. In editing applications servers are often used to store video footage in a central location, which can then be accessed from individual editing workstations. In broadcast and cable stations video servers are increasingly used in place of VCRs to store commercials and programs. When the server is connected to the central computer that contains the day's program log, commercials and programs can be replayed automatically.

Over the years several manufacturers have developed hard disk–based camcorder recording systems. Currently Ikegami markets a one-piece camcorder with a hard disk drive, and Ikegami and JVC both market dockable disk recorders that function with various professional camcorders cameras (see Figure 10.11). Several other manufacturers make portable hard disk systems that can be connected to a digital camcorder via its Firewire port.

When field shooting is complete, the disk drive is removed from the camcorder and connected directly to a compatible nonlinear editing system via its Firewire connection. This eliminates the need to capture (transfer the digital files) from a videotape. Video clips can be moved directly into the nonlinear editing system's timeline, and editing can begin immediately.

Camcorder with Dockable Hard Disk Recorder

Removable 20 Gigabyte
Hard Disk Drive

FIGURE 10.11 JVC Hard
Disk Drive Camcorder

Video Can Be Recorded to DV Tape or the Hard Disk

● **OPTICAL DISCS** CDs and DVDs are two examples of relatively inexpensive optical disc playback and (in some cases) recording systems. A laser within these systems is used to write (record) and read (play back) program information. Because no recording heads touch the discs, they are much more reliable than tape-based systems. They also have the advantage, similar to that of the hard disk systems described above, of allowing random access to information anywhere on the disc.

DVD Because of their limited storage capacity, CDs are not widely used to store video program information, but DVDs are. **DVDs** (digital versatile discs) have the capacity to record up to 17 gigabytes (GB) of data, though most DVD formats in the consumer market today hold 4.7 GB. This is equivalent to approximately two hours of high-quality video, making DVDs a good choice for the distribution of video program material and feature-length movies.

DVDCAM The first manufacturer to capitalize on DVD technology for use in a camcorder was Hitachi, which in 2001 introduced the **DVDCAM,** a digital camcorder that recorded full-motion MPEG2 video onto a DVD-RAM disk. The system is capable of recording thirty minutes of high-quality (704 × 480) video on each side of the DVD disk. Hitachi has been joined in the marketplace by Sony and Panasonic, which also targets their mini DVD camcorders to the consumer market. Neither of these camcorders is designed to meet professional production specifications.

Sony XDCAM Sony introduced its professional **XDCAM** in 2003 at the National Association of Broadcasters (NAB) annual convention in Las Vegas. XDCAM is a professional optical disc camcorder that is capable of recording in either the DVCAM format or MPEG-2. Each single-sided disc has a storage capacity of 23.3 GB, records eighty-five minutes of DVCAM video or forty-five minutes of MPEG-2, and costs about $30. (See Figure 10.12.)

● **MEMORY CARDS** Memory cards use silicon chips instead of magnetic media to store data. Sometimes also called flash memory, they have the added advantage of retaining the data even when the power is turned off. Memory cards have become quite popular as the storage device of choice in digital still cameras: CompactFlash, SmartMedia, and Memory Stick are some examples.

Panasonic has adapted memory card technology for use in its P2 professional camcorders, which were introduced at the 2004 NAB convention. (See Figure 10.13.) Panasonic touts this system as "having no moving parts," unlike hard disk and optical disc systems, in which motors rotate the disks at extremely high speeds.

FIGURE 10.12 Sony XDCam Camcorder and Optical Recording Disc

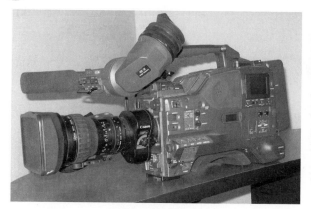

XDCam Camcorder

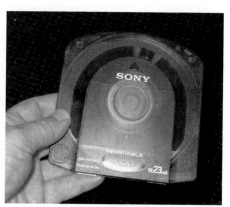

Optical Disc

The initial model P2 camcorder holds up to five memory cards with a capacity of 4 GB each, costing about $2,000 each. Each card stores up to eighteen minutes of DVCPRO or nine minutes of DVCPRO 50. Panasonic projects the development of cards storing up to 128 GB, which would hold 144 minutes of DVCPRO HD, 285 minutes of DVCPRO 50, or 576 minutes of DV/DVCPRO program material. But the success of this system will be heavily dependent on reducing the cost of the memory media.

With the exception of the videotape that is used in camcorders for field acquisition of program material, many production facilities today are tapeless, relying on disk-based digital nonlinear editors for video editing and video servers for storage. The development of professional hard disk, optical disc, and flash memory cards as camcorder storage media marks a significant moment in the transition to an entirely tapeless production environment.

FIGURE 10.13 Panasonic P-2 Recording Systems

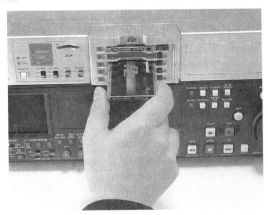

P-2 Recorder

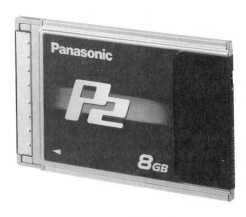

8 Gigabyte P2 Card

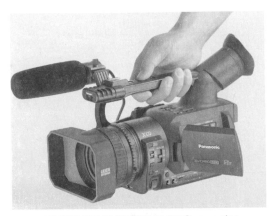

AG-HVX200 DVCPROHD P2 Camcorder

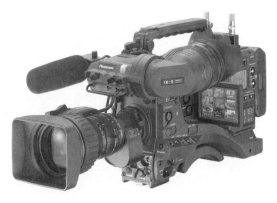

AJ-SPX800 DVCPRO50/DVCPRO/DV Switchable
P2 Camcorder

Video Editing Technologies

Video editing occurs during the postproduction phase of production. From an aesthetic standpoint editing is the process of arranging individual shots or sequences into an order that is appropriate for the program being produced. Editing is used to control the aural and visual elements of the program and to focus them so that they have an effective impact on the viewer. From a technical standpoint editing is often done to fix problems or to make a program longer or shorter to fit the time requirements of the show.

Two principal editing technologies are in use today: linear videotape editing and digital nonlinear editing.

■ Linear Videotape Editing

Linear videotape editing is a process of rerecording information into a desired sequence. Two videotape machines are used: the playback or source VCR, which contains the original videotape, and the record or editing VCR, which contains a blank videotape. Edits are made in a sequential fashion, starting at the beginning of the program and working to the end. Although linear videotape editing originated in the analog production era, many digital videotape formats can be edited in a linear fashion as well.

● **EDITING SYSTEM COMPONENTS** A complete linear videotape editing system generally includes the following components:

1. Playback (source) VCR to play back the original, unedited videotape.
2. Record (editing) VCR capable of performing clean electronic edits on the video signal.
3. Monitors for the source and editing VCRs, to allow the editor to see and hear the audio and video from each source.
4. An edit control unit for controlling both VCRs so that edit points can be found and edits can be precisely made by incorporating an adequate preroll time that allows the machines to reach their edit points at the same time. This component is necessary because in videotape-based editing systems, an edit can be made only when the source and edit tapes are rolling at full playback and record speed.
5. Auxiliary audio components, which may include an audio mixer and CD or audiotape recorders to input additional audio sources such as sound effects and music.
6. A graphics generator to produce titles, credits, and other program graphics.

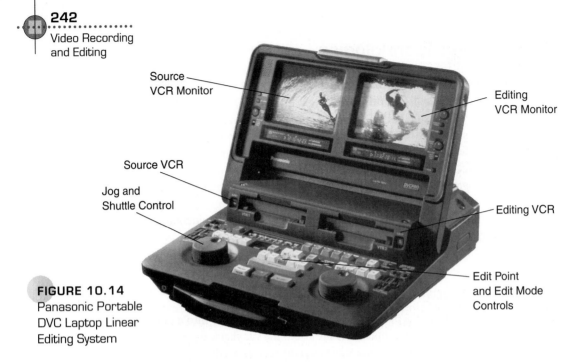

Source VCR Monitor

Editing VCR Monitor

Source VCR

Jog and Shuttle Control

Editing VCR

Edit Point and Edit Mode Controls

FIGURE 10.14
Panasonic Portable
DVC Laptop Linear
Editing System

A linear video editing system may be assembled out of free-standing individual components (VCRs, monitors, edit controller, etc.) or, as in the case of Panasonic's professional DVC editing system, it may be manufactured as one integrated piece of equipment. (See Figure 10.14.)

● **EDIT CONTROL UNIT STANDARD CONTROLS** Edit control units contain a set of standard controls that facilitate the editing process. These include the following:

- *VCR remote controls* for standard VCR operating modes: play, stop, rewind, fast-forward, and pause.
- *Jog and shuttle control,* which is a rotary knob that allows you to shuttle at various speeds forward or backward through the tape. The jog function allows the editor to advance or rewind the tape one frame at a time.
- *Edit mode controls,* which select the two principal editing modes: assemble edit or insert edit. We will discuss this in greater detail later in this section.
- *Edit point controls,* which allow the editor to set in and out points for the edits. Most edit control units use the three-point method of editing: an in point and an out point are set on the shot in the source VCR, and an in point is set on the editing VCR designating the destination of the material from the source VCR. There is no need to set an out point on the editing VCR because the edit will end when the source tape gets to its end point.
- *Trim controls* are used to add or subtract frames from an edit point.

- The *preview control* allows the editor to see what the edit will look like without actually performing the edit.
- The *auto-edit control* automatically prerolls both VCRs the designated amount of time (typically three, five, or seven seconds) and then performs the edit.

Other controls allow the editor to review the edit or go to the edit in and out points.

● **CONTROL TRACK EDITING** Edit control units may use the tape's control track as a reference for the edit cues, or they may use SMPTE time code. The problem with control track editing is that all control track pulses look the same, and the edit control unit controls the tape by counting the pulses before the edit point to cue the tape and by counting the control track pulses between the edit points to perform the edit. For example, if the edit control unit is set to a five-second preroll, when the command to perform the edit is given, the edit controller prerolls (rewinds) the tape five seconds by counting 150 control track pulses. If there are any missing pulses, the edit point will be inaccurate. Similarly, if the machine does not stop and start precisely, that is, if there is a mechanical error in the rewind and stop functions, the edit point will also be inaccurate.

● **EDITING WITH SMPTE TIME CODE** SMPTE time code systems allow for more precise editing because the edit reference point is keyed to a particular time code number. Because of its accuracy, SMPTE time code is widely used in videotape recording and editing. Entry and exit points for each shot can be logged in terms of their time code numbers, and a complete list of all of the shots that will compose the program can be compiled. (See Figure 10.15.)

SMPTE time code is recorded onto the source tapes as footage is acquired in the field. All professional camcorders have built-in SMPTE time code generators. Typically, the **time code generator** is set to the **record-run** mode, which produces time code only when the VCR is recording. This produces continuously ascending time code; the time code for each subsequent shot begins with the next frame number after the end of the previous shot. For example, if shot 1 ends at 00:00:22:12, shot 2 will begin at 00:00:22:13.

Time code numbers are generated in two different ways: drop-frame and non-drop-frame. In the **non-drop-frame time code** mode the numbers are generated at the rate of thirty frames per second. However, the video frame rate is actually 29.97 frames per second. To correct for this discrepancy, which is equivalent to 3.6 seconds or 108 frames per hour, **drop-frame time code** generators drop (do not generate) two frames of time code information per minute each minute of the hour, with the exception of the tenth, twentieth, thirtieth, fortieth, fiftieth, and sixtieth minutes of each hour. To look at this another way, two frame numbers are dropped during fifty-four of the minutes in each hour ($2 \times 54 = 108$).

Keyframe	Name	Reel Name	In Time	Out Time	Tracks	Comments
🔊	BG - music	eno1.M1QA.a...	00:00:00:00	00:03:37:15	A1 A2	
	CU - hands	booktoss	00:01:58:15	00:02:00:12	V A1 A2	
	CU -crayons	booktoss	00:02:39:14	00:02:43:15	V A1 A2	
	Exterior-bldg	booktoss	00:13:59:26	00:14:01:07	V A1 A2	
	Kid's art	booktoss	00:05:55:20	00:05:59:23	V A1 A2	
	MCU - study	booktoss	23:57:28:11	23:57:30:20	V A1 A2	
	OS - math	booktoss	00:04:08:02	00:04:11:21	V A1 A2	

School bin

Shot in and out points are noted in hours:minutes:seconds:frames.

FIGURE 10.15 SMPTE Shot Log.

It is important to note that drop-frame time code generators do not drop video frames out of the picture; they drop time code numbers. The picture is continuous, but there will be some missing time code numbers at each minute mark on the tape. If you look at the time code, you will see that it jumps—for example, from 00:00:00:29 to 00:00:01:02.

DV camcorders with built-in time code generators typically generate time code only in the drop frame mode.

The time code information that is recorded onto the tape is digital data that is not visible in the picture. The time code numbers can be seen in the VCR's counter, and on some VCRs the monitor output (as opposed to the video output) will generate a window with the time code numbers superimposed over the background video. (See Figure 10.16.)

A common step in the process of editing with time code involves making a **window dub.** A window dub is a copy of the original unedited videotape with the time code inserted over the picture. Window dubs

FIGURE 10.16 Video Frame with Time Code Window

are often made on VHS tapes, because VHS VCRs are cheap and readily accessible.

Once a window dub has been made, the tape can easily be logged by playing the tape back into a video monitor. Use the pause/still mode of the VCR to freeze the frame at the beginning and end of each shot, and write down the corresponding time code numbers and some descriptive material about the shot.

Of course, you could also log the tape from the original, using the VCR counter to display the time code numbers. But this method assumes that you have easy access to an appropriate playback VCR. If you shot your footage on DV, this may not be a problem. But what if you shot on digital Betacam? Digital Betacam VCRs are extremely expensive and may not be available for the amount of time it takes to log a tape.

Logging from a window dub rather than from your original field footage has another significant advantage: It eliminates the possibility of damaging the field tapes while you are logging them. DV format tapes in particular are very fragile, and logging involves a lot of pausing and tape shuttling—precisely the actions that are likely to damage a tape. It is much better practice to keep your field tapes safe and log from a window dub than to run the risk of damaging your originals during the logging process.

● **LINEAR VIDEOTAPE EDITING MODES** There are two principal editing modes: assemble editing and insert editing.

Assemble Mode **Assemble editing** replaces all the signals on the edit master tape with new ones (audio, video, and control track) whenever an edit is made. In this mode it is impossible to edit the signals individually. For example, in the assemble mode you could not make a video-only edit or make an audio-only edit to add music. Whatever is on the source tape will be transferred to the edit master tape.

To finish a program that has been edited in the assemble mode, all edits must be made in sequential order, starting at the beginning of the program with the first edit, and working toward the end. (See Figure 10.17.) You cannot go back into the program and make a new edit in the assemble

FIGURE 10.17
Assemble Editing

mode. If you try to do this, you will create a gap in the tape at the end of the edit, and when you play back your program, the picture will become unstable, and there will be a momentary loss of audio and video.

Insert Mode In **insert editing,** audio and video tracks can be edited selectively. They can be edited independently or in combination. For example, you can edit video only, audio 1 only, or audio 2 only or video and audio 1, video and audio 2, or video and audio 1 and audio 2, or audio 1 and audio 2.

In addition, an insert edit does not erase or record control track on the edit master tape. Because control track is necessary for tapes to play back, insert editing requires that a tape with control track be prepared to edit onto. The typical way to approach this is to take a blank tape and record video black onto it. Video black is a black video signal. In studio production facilities video black can be sent out of the video switcher to a record VCR, or a black video generator can be connected to a VCR. If neither option is available, put a blank tape into your camcorder and close the iris and/or cap the lens. The camcorder will record a black picture.

Unlike assemble editing, insert editing does allow you to go back into an edited sequence and insert new video over an existing shot or to replace the audio tracks with new audio. The edit will be stable at the entry and exit points.

However, despite being called an insert edit, this edit mode does not allow you to insert a shot between two other shots. That is, you cannot pull a sequence apart, insert a new shot, and finish with a sequence that is longer than the one you started with. Perhaps it would be more useful to think of an insert edit as overlaying or overwriting new video (or audio) on top of existing audio or video material. (See Figure 10.18.) The old material is erased, and the new material is inserted into its place on the videotape.

FIGURE 10.18
Insert Editing

● **THE LINEAR VIDEOTAPE EDITING PROCESS** The process of editing a program with a linear videotape editing system generally follows these steps:

1. Shoot footage in the field or in the studio. Record SMPTE time code as the footage is being shot.
2. Make a window dub of your source tapes.
3. Log the tapes.
4. Develop a preliminary **edit decision list (EDL)**—a list of all the shots you plan to use in your production with in and out points and a brief description of each shot.
5. Make a **rough cut** of the program. This is a preliminary version of the program.
6. Review the rough cut, and adjust your editing plan as necessary. If your production is being produced for a client, you will want the client to review the rough cut to give you feedback before you produce the final version of the program.
7. Complete the final edit, adding graphics and music to produce a compelling audiovisual program.

◼ Digital Nonlinear Editing

Although videotape remains the recording medium of choice for field acquisition, the use of linear videotape editing systems has largely been supplanted by a new generation of digital **nonlinear editing (NLE)** systems. Nonlinear editing systems provide several advantages over linear tape-based systems. In particular, they allow for random access to footage, and they allow shots to be inserted in front of or in between others in the timeline.

● **RANDOM ACCESS** Videotape editing systems are linear by nature: Shots on the source tapes are recorded in a linear sequence, and they can be accessed only by fast-forwarding or rewinding the source VCR. Edits are made on the editing VCR in sequential, linear fashion.

Nonlinear editing systems provide random access to source footage. Source footage is imported into the computer and stored on the computer's hard disk drives. Shots can be accessed immediately in any order. In addition to providing random access to the video and audio information once it has been imported into the computer, nonlinear systems allow the user to assemble and change shot sequences easily through a cut-and-paste process similar to the way text is edited in a word-processing program.

● **INSERT AND OVERLAY EDITS** In nonlinear editing systems even after a sequence of shots has been placed in the time line, a new shot can be inserted between them. (See Figure 10.19.) This is called an **insert edit.**

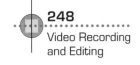
The finished shot sequence is equal to the total length of all of the clips. In addition to inserting shots between two other shots, nonlinear systems make it possible to insert a shot in front of another shot or shot sequence. The new shot becomes first in the sequence, and the other shots slide down in the time line behind it. Neither of these techniques is possible in linear videotape editing systems.

Nonlinear editing systems also allow the editor to overlay or overwrite new video or audio over existing shots or audio tracks. An **overlay edit** does not increase the length of a shot sequence and is similar to what has previously been defined as an insert edit performed on a linear tape-based editing system.

● COMPONENTS OF A NONLINEAR VIDEO EDITING SYSTEM
The principal components of a nonlinear video system (see Figure 10.20) include the following:

1. A computer equipped with a central processing unit that is fast enough to process video information.
2. Nonlinear editing software to perform video editing. Dozens of nonlinear editing software programs are available on the market, ranging from simple programs aimed at home users to sophisticated programs targeted to the professional production market.

FIGURE 10.19 Nonlinear Insert and Overlay Edits

Insert

Shot 2 Is Inserted **between** Shots 1 and 3

Insert

Shot 1 Is Inserted **before** Shots 2 and 3

Overlay

Shot 2 Is Overlaid **on top of** Parts of Shots 1 and 3

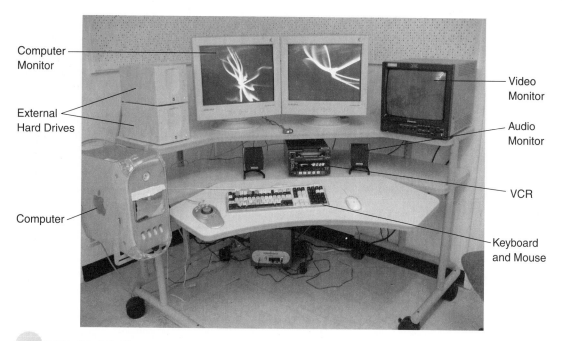

Computer Monitor

External Hard Drives

Computer

Video Monitor

Audio Monitor

VCR

Keyboard and Mouse

FIGURE 10.20 Components of a Nonlinear Editing System

3. A sufficient amount of storage capacity for the computer, usually in the form of hard disk arrays. Not only does editing require a lot of storage capacity, but also the system must be able to move the data around at a fast rate.

4. A VCR to send footage into the computer.

5. VCR/computer interfaces to allow the computer to control the playback and recording functions of the source VCR.

6. A video input/output board to move the video signal into and out of the computer, unless the computer has direct audio and video inputs or a FireWire connector for digital video.

7. High-quality audio and video monitors so that image and sound quality can be monitored during the editing process. It is always recommended to have a video monitor in addition to the computer monitor because image and color quality varies between the two.

● **USER INTERFACE AND EDITING MODEL** Each nonlinear editing system is built around its own proprietary user interface. The user interface describes the visual elements of the editing program that appear on the computer screen. These typically include the time line, bins for audio and video clips, and a preview and editing window, which displays the clips and program as they are edited. (See Figure 10.21.)

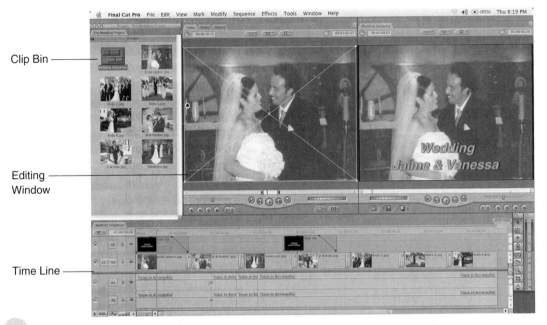

Clip Bin

Editing Window

Time Line

FIGURE 10.21 NLE User Interface

Time Line The time line is a graphical linear representation of the program. The various program tracks (video, audio, graphics) appear in a vertical stack on the screen. (See Figure 10.22.)

Clips and Bins Clips are digital files of the source material that is to be edited. Video footage, audio sources, and graphics are all stored as clips. Clips can usually be displayed as a list or by displaying the first frame of the clip as an icon in the bin window. (See Figure 10.23.)

Editing Window Clips are trimmed in an editing window. Entry and exit points can be selected by eye or ear, by time code numbers, or by selecting either an in or an out point and then specifying the length of the clip. Clips can also be easily trimmed or extended by clicking the computer's mouse on the beginning or end of the clip in the time line and dragging the clip to extend or trim it.

FIGURE 10.22 NLE Time Line

Video Tracks

Audio Tracks

Audio Level Meters

List View Icon View

FIGURE 10.23
NLE Bin

Transitions Once individual clips have been arranged in the proper sequence in the time line, transitions such as dissolves, wipes, and digital video effects can be added between the clips. (See Figure 10.24.)

● **NONLINEAR EDITING PROCESS** Once you have acquired your video footage in the field or studio, the process of nonlinear video editing involves the following four main steps.

Step 1: Log the Tapes Make a window dub of your source tapes and log them using the SMPTE time code numbers on the tape.

FIGURE 10.24 Avid Nonlinear Editing System Interface in Effects Mode

Step 2: Capture/Digitize Your Best Takes First, *select the footage to be captured.* Today, most videotape formats record a digital signal. The process of transferring the footage from tape into the computer is called *capturing.* In nonlinear editing systems the amount of storage is limited by the capacity of the hard drive system. Therefore you must make some preliminary decisions about which shots you plan to use in your final project before you begin to capture your material. If your source footage was recorded on an analog tape format, then as the footage is captured, it will be converted into digital files by the nonlinear editing system.

Next, select a *video compression/quality rate.* When video is converted from analog to digital form, it is compressed. Compression allows the computer to reduce the amount of information that is stored in digital form. Material that is stored at a high rate of compression (lower image quality) will take up less space on the hard drive than will material that has been digitized with a lower compression rate (higher image quality). Managing the available hard drive space by working with different compression rates is an important part of the editing process. (See Figure 10.25.)

For example, at the beginning of a project you might want to capture footage at a high-compression/low-quality rate to have access to a greater amount of the original footage during the initial stages of editing. After the editing decisions have been finalized, the unused clips can be deleted from the computer, freeing up hard drive space, and the clips that remain can be redigitized or recaptured at a higher quality setting so that the final version of the program will have the best quality the nonlinear system is capable of producing.

FIGURE 10.25

Quality Rate

In this media settings window, note that the rough cut (draft) mode uses a low-quality setting of only 10 kb per frame, whereas the final cut (on-line) mode is set to a higher data rate of 120 kb per frame. The spheres identify the hard drive on which the video (V), audio (A), special effects (FX), and graphics (G) files will be saved.

Next, digitize and capture shot by shot. Mark an in point and an out point for each shot using SMPTE time code numbers, or mark the video clips on the fly. Leave some extra footage, called **handles,** at the beginning and end of each shot. Many systems will do this automatically if you activate this feature in the appropriate menu. Handles are useful if you plan to add transition effects such as dissolves to your edit points. Because a dissolve will actually end after the edit point of the first shot in the sequence and begin before the edit point of the first shot, extra footage is needed to cover the effect; that is what handles provide.

Most nonlinear editing systems include a **batch capture** feature. Enter the in and out points for a number of shots along with descriptive material for those shots, and after all the data has been entered into the editing program, the system will automatically find and capture each of the clips. Import additional elements, such as music, sound effects, and digital picture files.

Remember that in most systems digitizing and capturing take place in real time. This can be a time-consuming part of the editing process, particularly when a large amount of footage is involved.

Step 3: Edit Your Captured Material Trim each clip to its actual in and out points, and use the time line to arrange shots in the proper sequence. With the computer's mouse you can drag and drop shots into the time line, and you can easily move them elsewhere if you decide to change the sequence.

Add music and sound effects. Every program contains some mix of voice, natural sound, music, and/or sound effects. These elements can be edited and placed with the same ease as video elements.

Add graphics. Program titles, keyed titles, and other graphics can be created electronically within the editing program and incorporated into the project.

Add transitions between shots if they are not cuts. Most editing software programs allow you to choose from an extensive array of special effect transitions.

Render transitions, special effects, and graphics. **Rendering** is a process through which the computer changes transitions, special effects, and graphics from computer effects to video effects. This means that the effects need to be translated into video fields and frames. Depending on the complexity of the effects and transitions that are involved and the speed of your computer, this process can take some time to complete. Also, remember that in most systems if you move a rendered transition or effect, it may become unrendered, forcing you to go through the rendering process again. For this reason, it is best to leave effects and transitions unrendered until you are confident that the video and audio elements of your program are in their final form.

View the edited project in real time with high-quality audio and video monitoring to judge its effectiveness and acceptability. Don't just view the

program on the computer monitor. If you do not have an external video monitor as part of your editing system, output the project to videotape and watch it on a video monitor.

Make changes as necessary. Review the program and adjust your editing plan as necessary. If your production is being produced for a client, you will want the client to review the first cut to give you feedback before you produce the final version of the program. The real power of nonlinear editing is the ease with which changes can be made to an edited program. Take advantage of it!

Step 4: Print to Tape or DVD Output the final project from the computer to the VCR to make a videotape master, or if your system is equipped with a DVD burner, you may wish to save it on a DVD instead of tape.

● **SOME OTHER THINGS TO THINK ABOUT** When nonlinear video editing was developed, many people saw it as the answer to many of the problems inherent in videotape editing. Indeed, random access to clips and the ability to easily change shots in the time line greatly improved the editing process. However, nonlinear editing is not without its own set of problems.

Computer crashes are a common problem. To minimize damage, save your work often, and make a backup copy at the end of the day.

Although the cost of hard drive storage has come down dramatically in recent years, storage may still be an issue, particularly in systems that are shared by multiple users. Maximize the storage capacity of your system to enable you to capture and store more source material. Also, remember not to fill hard drives to more than 75–80% of their maximum capacity. If the drives are too full, the system may not be able to move the files around as needed, and the system may crash.

File management is a big issue in nonlinear editing. Be sure to label everything clearly. If you have two hundred clips, all named "untitled," you are going to waste a lot of time looking for the clips you need. Set up clearly labeled folders for your work, and do not mix material from one project with material from another.

Finally, budget your editing time. Ultimately, nonlinear editing may be better than linear editing because of its drag-and-drop editing and the ease with which edits can be made and/or changed. However, nonlinear editing is not necessarily faster than linear editing. Digitizing and capturing each clip take time that linear editing does not require. Also, because it is possible to try a variety of different editing decisions and transitions before committing to one, it is not unusual for projects that are edited on nonlinear systems to take more time to complete than projects that are edited on linear systems.

CHAPTER 11

Video Editing
Techniques

Editing for Multicamera and Single-Camera Productions

Editing is the process of selecting and arranging shots or sequences of shots into an appropriate order. Editing can be accomplished during the multicamera television production process, or it can be carried out in postproduction, after the program material has been captured.

In multicamera television production this process of shot selection takes place as the program is being produced. The signals from several television cameras and other video sources are simultaneously fed into the video switcher, and the pictures from each video source are displayed on the monitors in the control room. The director looks at the monitors and calls for the shots desired, and the technical director punches up each shot on the switcher as the director calls for it, instantly creating an edited sequence of shots that can be recorded or transmitted live to the audience. Shot selection in live news broadcasts, sports telecasts, and interview and discussion programs—all typical multicamera productions—is made in this manner by a director and a technical director working together with the camera crew to capture the appropriate sequence of shots.

In single-camera production programs are recorded one shot at a time. Single-camera productions can be shot in the studio or on location. Many dramatic programs are shot single-camera style in controlled studio environments. ENG and EFP programs, by contrast, are typically shot in a variety of remote locations. The recorded footage may include on location interviews with story subjects, stand-ups by the news reporter or program host, and footage of activities in the remote environment. For both dramatic and nondramatic footage that is shot in this manner, a **video editor**

works in conjunction with the program's director and/or producer to select the most appropriate shots and put them together into an effective program sequence.

▩ Multicamera Production: Shooting and Editing

In Chapter 8 we discussed multicamera production from the perspective of the director. Particular attention was paid to issues of visualization, composition, and continuity. All of these elements are important in the live editing process as well.

Multicamera television production was developed and has survived as a viable production technique for over sixty years because it is an extremely efficient mode of production. In particular, it is efficient because it largely eliminates the need for the time-consuming and costly stage of postproduction editing that characterized the feature film production industry, which preceded the development of the television production industry. Even today, feature films are shot predominantly in the single-camera mode, and they require a lot of time and great budgetary support to complete the postproduction phases.

Multicamera television production, by contrast, accomplishes the editing as the program is being produced. When the shooting is done, so is the editing, unless relatively minor adjustments to the program need to be made after the fact. Of course, if the program was broadcast live, then no further editing is possible.

Producers working on single-camera productions can learn a lot about editing—and about shooting to edit—by watching a multicamera production. Most medium- and small-size studio productions typically employ three cameras. More complex productions may call for more cameras, but for our purposes the three-camera method provides a good illustration of how editing needs inform shooting techniques.

In single-camera film production the traditional shooting method is to record a **master shot,** a long shot that records all the essential action of a scene. After the scene is completed, the action is repeated a number of times from various camera angles. This provides the editor with a long shot of the scene as well as medium shots and close-ups of various elements of the scene, which can then be edited into the final program.

Multicamera video production recognizes the need to have a variety of shots of the scene taken from different angles but accomplishes this in real time, without the need for repeated takes. Consider the example of a television newscast with two newscasters sitting at a news desk. In a typical three-camera setup, one camera will be responsible for a wide shot of the scene,

257

Editing for
Multicamera
and Single-
Camera
Productions

and the two other cameras will shoot a medium close-up (MCU) of each of the newscasters. Looking at the control room monitors, the director will most likely see an MCU of newscaster 1 on camera 1, a long shot of the two newscasters at the news desk on camera 2, and an MCU of newscaster 2 on camera 3. The director can call for each shot as needed, putting together a sequence of shots that establishes the set and the newscasters at the outset of the program and then cuts to appropriate MCUs as each news story is read. If the newscast features a weather reporter in front of a chroma key background, one of the three cameras can be swung around to shoot the action in another part of the studio.

The situation is similar for demonstration and interview programs. One camera can shoot an establishing shot of the scene; the other two cameras can shoot MCUs of the individuals who are involved in the interview or demonstration as well as appropriate over-the-shoulder shots and reaction shots. This can be done without repeating the action. (See Figure 11.1.)

■ Multicamera Editing Problems

Effective multicamera switching depends on correct placement of the cameras, making the right camera choice at the right time, and paying attention to the composition of individual shots to ensure that they will cut together well.

● **CAMERA PLACEMENT TO AVOID ACTION REVERSAL** Correct placement of the cameras depends on the correct application of the 180-degree rule that we discussed in Chapter 8. Establish a principal vector line, as illustrated in Figure 8.5, and keep the cameras to one side of the line, within the 180-degree semicircle that circumscribes the action area. If the 180-degree rule is violated, the position of the character or characters in the frame will reverse from one shot to the next. This change in screen position is disruptive to the viewer and looks like what it is: an editing mistake. (See Figure 11.2.)

FIGURE 11.1 Multicamera Coverage of a Studio Scene

Camera 1: MCU

Camera 2: Establishing Shot

Camera 3: MCU

Poor Edit

Woman's Screen Position Changes

Good Edit

FIGURE 11.2
Screen Position
Reversal

Woman's Screen Position Is Maintained

● **AVOID MATCHED CUTS** A **matched cut** is a cut from one shot to another that is too similar in terms of angle of view and camera position. When you cut from one shot to another that is too closely matched in terms of angle of view, the subject appears to jump from one position in the frame to a different position in a subsequent shot. (See Figure 11.3.) If the transition is a dissolve instead of a cut, the transition is equally disruptive as the closely matched images overlap, giving the impression that the shots are momentarily out of focus.

FIGURE 11.3
Matched Cut

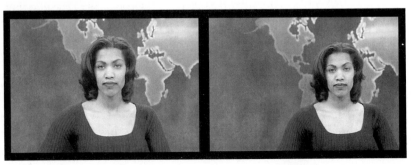

Shot 1 Shot 2
Subject Jumps in Frame When Cutting from Shot 1 to Shot 2.

259

Editing for
Multicamera
and Single-
Camera
Productions

The general rule of thumb in cutting from one camera to another in the studio is to make sure that each successive shot presents new information to the viewer and does it in a way that is visually pleasing. A cut from an MCU to a CU of a person or object is always more effective than a cut from an MCU to another MCU of the same subject.

● **AVOID CUTTING BETWEEN MISMATCHED SOURCES** In multicamera production it is imperative that all video sources have similar color and light values. Each camera needs to be white balanced correctly, and the exposure needs to be set so that each camera shot matches the others. Make sure that the video engineer has white balanced and shaded each of the cameras before the program begins so that when you cut from one camera to another, color and light values are consistent from one camera shot to the next.

■ Postproduction Editing

Video editing in postproduction is an essential part of the production process for programs that have been shot single camera style in the studio or the field. Production personnel concentrate on recording the information they need for the program without worrying about the arrangement of the shots until after they have finished shooting the program. Material may be gathered at a number of locations over an extended period of time. The challenge of the editing process is to put the material together in a seamless fashion, creating the illusion of continuity of action, lighting, sound, and performance, as we discussed in Chapter 8.

Multicamera programs that have been recorded live to tape or a hard disk drive may be edited in postproduction as well. Most often this is done to fix one kind of problem or another with the program material. The most typical problems that need to be fixed are time problems, performance problems, and technical problems.

● **FIXING TIME PROBLEMS IN POSTPRODUCTION** Programs that are produced for broadcast distribution are produced to very specific time limits. Each of the individual program segments must be a specified time to allow for commercials and station breaks, and the overall length of the program must also be precisely timed. During the production of a multicamera program in the studio slight errors in timing the individual segments may be made. In postproduction these errors can be corrected by adding or deleting program material from the offending segments.

● **FIXING PERFORMANCE PROBLEMS IN POSTPRODUCTION** Multicamera programs such as situation comedies rely on precise timing, appropriate reaction shots, and convincing acting to achieve their comedic effect. In the live performance environment there is little room for error. If mis-

takes are made, producers have several options: They can stage retakes after the principal taping is done; they can review the taped dress rehearsal performance to see whether the material was conveyed more effectively there; or if each camera's isolated (ISO) feed has been recorded, in addition to the switched output of the video switcher, ISO shots can be inserted into the master tape to replace less effective shots there. All of these techniques are used to fix performance problems in multicamera, live-to-tape shows.

● **FIXING TECHNICAL PROBLEMS IN POSTPRODUCTION** Technical problems often creep into even the best-planned multicamera production. A shot may be taken on line before the camera is ready, resulting in an image that is out of focus or that contains an unwanted camera movement. Despite the best efforts of the video engineer to achieve consistent light and color values from each camera, problems with image quality may be apparent in one or another shot. Or there may be problems with the audio. Perhaps an audio cue was missed and music was not introduced at the proper time, or perhaps the microphone level was set too low or too high on a particular shot. Postproduction editing allows the production team one more opportunity to fix technical problems that may have crept into the original production. (See CP-13.)

Continuity and Dynamic Editing

There are two general techniques, or styles, of editing. One is continuity editing; the other is dynamic or complexity editing. In truth, editing is seldom done solely with one technique or the other. In most cases it is a combination of the two. So it might be useful to think of these two editing styles as points at either end of a continuum. (See Figure 11.4.) Some programs are edited with a style that draws more heavily on the principles of continuity editing; others lean more heavily in the direction of dynamic editing. In any event, these two terms provide a useful place to begin talking about different types of editing.

■ Continuity Editing

The goal of **continuity editing** is to move the action along smoothly without any discontinuous jumps in time or place. Traditional television programs such as soap operas, situation comedies, and game shows regularly

FIGURE 11.4 Editing Continuum

Continuity
Editing

Dynamic
Editing

apply the principles of continuity editing. Many narrative film and television programs (e.g., dramas) do so as well, although they may be more likely to bend the rules a bit and move down the line in the direction of dynamic editing.

Four general principals are central to the continuity editing style.

● **ESTABLISH AND MAINTAIN SCREEN POSITION** The use of the establishing shot to identify the location of the people in the shot in relation to their environment is an important part of continuity editing. The **establishing shot** is typically a long shot or extreme long shot that orients the viewer to the scene and its constituent parts (actors, set, etc.). (See Figure 11.5.) The establishing shot is always located near the beginning of a shot sequence, particularly whenever there is a scene change. It may be the first shot in the sequence, or it may come after several closer shots.

Once the scene has been established, it is important to present a closer view of the details of the scene. The **cut-in** is a cut to a close-up of some detail of the scene. (See Figure 11.5.) Cut-ins are important because the long shot, while useful in orienting the viewer to the scene, often does not let the viewer see important details. Remember, television is a close-up medium.

Once the viewer has been shown essential scene elements in close-up detail, it may be necessary to **cut out** again to a wider shot, particularly if action is about to take place. In cutting in to a tighter shot from a wide shot, objects and people should maintain their same relative place in the frame.

● **USE EYELINES TO ESTABLISH THE DIRECTION OF VIEW AND POSITION OF THE TARGET OBJECT** An **eyeline** is simply a line created by your eyes when you look at a **target object.** If you look up a

FIGURE 11.5 Establishing Shot and Cut-In

Establishing Shot

Cut In to Detail

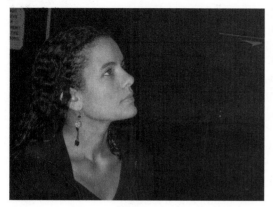
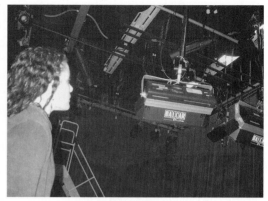

Eyeline Target Object

FIGURE 11.6 Eyelines Establish the Position of the Target Object

lighting instrument on the studio lighting grid, the lighting instrument is the target object, and the eyeline is the imaginary line between your eyes and the lighting instrument. (See Figure 11.6.) Look down at your feet, and a similar eyeline is created between your eyes and their target.

Eyelines are formed between people when they talk and can be used to create continuity when the conversation is edited. The editing process is facilitated if the original material has been shot by using complementary angles. (See Figure 11.1.)

If you are shooting in the field and not in the studio, you don't have the benefit of viewing all three of the shots on the overhead camera monitors. In the field you have to shoot each shot one at a time, and you have to be careful to apply the 180-degree rule and make sure that your shots are carefully, and similarly composed. Figure 8.4 in Chapter 8 illustrates this technique. The first shot in the sequence is the establishing shot, which establishes the relationship of the characters to each other and to the setting. The next two shots are shot one at a time at complementary angles, framing each subject in an MCU. When the shots are cut together the shot sequence reveals the two people talking to each other.

● **MAINTAIN CONTINUITY IN THE DIRECTION OF ACTION** An extremely important component of continuity editing is to maintain directional continuity. Characters or objects that are moving in one shot should continue to move in the same general direction in a subsequent shot. Directional continuity will be apparent in the raw footage if the videographer has paid attention to the 180-degree rule and the principal action axis when shooting the original field material. Mismatches in directional continuity

are most apparent when strong horizontal movement in one direction is immediately followed by another movement in the opposite direction, as in the example in Figure 11.7. The video editor can correct this apparent mistake by inserting a shot with a neutral motion vector—one in which the action moves directly toward or away from the camera—in between the two shots with mismatched vectors. (See Figure 11.7.)

● **USE SHOT CONTENT TO MOTIVATE CUTS** In continuity editing, each edit or cut is usually motivated. That is, there should be a reason for making an edit. The two principal motivators of cuts are action and dialog.

One of the cardinal rules of editing is to cut on the action. This technique is facilitated if the action has been shot from several different angles and the action has been repeated. For example, to piece together a sequence covering the beginning of a swim race using two cameras, use one camera to shoot an establishing shot of the swimmers lined up on the pool deck. Use the second camera to shoot the swimmers from a tighter angle.

Discontinuous Action Sequence

FIGURE 11.7 Maintaining Directional Continuity When Editing

Action Moves toward the Right Action Moves toward the Left

Bridging Discontinuous Action with a Neutral Shot

Action ⟶ Neutral ↓ ⟵ Action

Action Moves toward Camera

When the swimmers dive into the water at the sound of the starter's gun, you will get two shots from different angles of view but with matching action (the dive into the pool). That action provides the logical point to make the edit from the wide shot to the tighter shot. (See Figure 11.8.)

In programs that are based on staged action, it is important to shoot the action from several different angles, repeating the action in each shot. For example, to show someone getting into a car, shoot a long shot of the subject approaching the car and opening the door. Then move the camera inside the car and reshoot the action as the subject approaches the door, opens it, and enters the car. The action of the door opening is repeated in both shots and provides a logical point at which to make the cut.

Much editing is motivated by what is said. In an interview a question demands an answer, and if you show the interviewer asking a question, you most likely will want to cut to the subject as he or she answers the question. In a dramatic scene you may be likely to cut to another character to see and hear the person deliver a line of dialog. Or if one character says something that is particularly provocative, you may want to cut to a reaction shot of the person to whom the line was delivered. In either situation the cut has been motivated by what was said.

● **OTHER CONTINUITY ISSUES** The editor should consider several other continuity issues as well. These were discussed in greater detail in Chapter 8, so we will mention them only briefly here.

Lighting and Color Continuity Make sure light and color values are consistent from shot to shot, particularly within the same scene. Video levels and white balance can be adjusted shot by shot in postproduction to achieve a consistent look.

FIGURE 11.8 Cutting on Action

Shot 1: Swimmers Getting Ready

Shot 2: Cut as They Dive

Sound Continuity Make sure microphone levels are consistent from shot to shot, and use equalization to balance sound quality. Background music or ambient sound from a location can help to unify shots by providing a consistent sound bed.

Appearance of the Subjects Pay attention to the physical appearance of the subject. You don't want clothing or hairstyle to change radically from one shot to another unless there is a logical explanation for the change. Also pay attention to the physical placement of the subject in the frame, facial expressions, and gestures. Edits should flow smoothly with no disrupting distractions caused by these important details.

■ Dynamic Editing

Dynamic editing differs from continuity editing in two important ways: It tends to be a bit more complex in structure, and it frequently utilizes visual material to create an impact rather than simply to convey literal meaning. Dynamic editing, then, is more *affective* than continuity editing. This is not to say that continuity editing must be listless or boring or that dynamic editing cannot be used to convey a literal message. The differences between the two are often differences of degree rather than of substance. Three of the most common dynamic editing techniques are editing to maximize impact, manipulating the time line, and editing rhythm.

● **EDITING TO MAXIMIZE IMPACT** Dynamic editing attempts to maximize a scene's impact rather than simply to link individual shots into an understandable sequence. Shot selection in dynamic editing frequently includes shots that exaggerate or intensify the event rather than simply reproducing it. Extremely tight shots or shots from peculiar angles are frequently incorporated into dynamic shot sequences to intensify a scene's impact.

● **MANIPULATING THE TIME LINE** Dynamic editing is frequently discontinuous in time. That is, rather than concentrating on one action as it moves forward in time (a technique that is typical of continuity editing), dynamic editing often employs parallel cutting: cutting between two actions that are occurring at the same time in different locations or between events that happen at different times. The dynamic editor might intercut frames of past or future events to create the effect of a flashback or a flashforward.

● **EDITING RHYTHM** Continuity editing is usually motivated by the rhythm of the event (either the action of the participants or the dialog of the characters); dynamic editing is more likely to depend on an external factor for its motivation and consequent rhythm. Two common techniques are editing to music and timed cuts.

Editing to music involves editing together a series of related or unrelated images to some rhythmic or melodic element in a piece of music. In the most clichéd type of editing to music, the editing matches a regular rhythmic beat and does not deviate from it. Editing that uses various musical components—the melody or a strong musical crescendo, for example—to motivate the edits is more energetic and interesting.

The process of editing to music is simplified with the use of a nonlinear editing system. Many of today's systems have a feature that makes it possible to display the audio waveform of the music track in the audio tracks in the time line in the nonlinear editing system display. Shots can then be aligned with these visible points in the audio waveform.

A **timed cut** is one in which shot length is determined by time rather than content. You can edit together a sequence of shots that are each two seconds in length, or you can use shot length like a music measure to compose a sequence with a rhythm based on the length of the shots.

Editing Voice-Driven Pieces

Many projects that are shot single-camera style and are edited together in postproduction are interview based, voice driven pieces. News stories, documentaries, and magazine features are all examples of this kind of program material. In these productions the story is told principally through the voice track, which is supported by the other production elements the editor has at his or her disposal, including B-roll video, natural sound, music, graphics, and appropriate transitions and video effects. (B-roll video is described later in this section.)

■ Editing the Voice Tracks

Once all of the tapes have been logged, the editor can begin to piece together the story he or she is working on. A good strategy is to highlight critical sound bites in the typed transcriptions of video interviews and to begin to fashion a script out of them.

Narration may need to be used to link together these sound bites. In the final program narration may be delivered by an on-screen narrator, or the narrator may be off-camera. When the narrator is heard but not seen on screen, this is called a voice-over (VO).

Interviews can be edited in a similar fashion. The person who has been interviewed can be shown on screen, in which case we refer to this as sound on tape (SOT). Or the sound can be used without showing the person in the interview setting, by cutting away to appropriate B-roll. This also is an example of voice-over.

In any case, once the sound bites and narration that are going to be used in the project have been identified, they should all be imported into the nonlinear editing system. Using the script as a guide, drag each of the voice elements, in sequence, into an appropriate audio track. You do not need to be too concerned at this point about editing everything precisely and cleanly; just lay it out in the time line so that you can get a sense of how the story flows.

It is also a good idea to think about keeping each sound bite relatively short. Novice editors frequently put very long sound bites and narration tracks into the time line. In most situations it is better to break up long sound bites into shorter ones (e.g., three 10-second bites instead of one 30-second bite). This helps to pick up the pace of the program. The shorter, individual bites can be linked with narration if necessary, or you can cut to someone else's sound bite and then come back to your first subject.

Once you are satisfied with the general layout of the voice track, you can go back into the time line and trim each clip precisely. Make sure you don't cut your subject off at the beginning or end of the clip. Also, do your best to make your subject sound good. If there are a lot of "ums," "ahs," and pauses in the interview, edit them out. Of course, each time you do this, you will create a jump cut in the video. If there are only a few jump cuts, and depending on the type of program you are editing, you may choose to insert a fast dissolve at the jump cut edit points. This will smooth out the jump cut at the same time that it gives the viewer a clear indication that the shot has been edited. However, if you have a lot of jump cuts, you most likely will want to cut away to B-roll video footage.

◼ Identifying the Interviewee

You should also think about how you will identify the on-camera interviewee to your audience. Two common techniques are to introduce the interviewee with VO narration that identifies the subject (e.g., "Ron Chery is a student at Half Moon Bay High School") or to use a **lower-third keyed title** with the subject's name and affiliation (e.g., "Ron Chery, HMBHS Student").

In short pieces it is almost always preferable to use the keyed title instead of the VO introduction, because the VO takes up valuable story time and the key does not. If the subject's name is keyed, a couple of things need to be kept in mind. First, the key needs to be on screen long enough for the audience to read it easily, and the shot that it is keyed over it therefore needs to be long enough to cover the key. In general, keyed name identifiers need to be on screen five to eight seconds to be read comfortably by the viewer, so the interview shot will need to be at least that long, if not a few seconds longer to allow some room at the head of the shot, before the key is introduced, and at the end of the shot, after the key is removed. In

addition, the shot needs to be composed so that the key does not interfere with the background video. It is not good practice to insert a key over a close-up of the interviewee. Doing so puts the lower-third keyed titles directly over the subject's mouth. This is distracting at best. It is better to use a loosely framed medium close-up of the subject as the background for a lower-third key. This puts the keyed title over the subject's chest rather than over his or her face.

■ B-Roll Video

The terms *A-roll* and *B-roll* were inherited from the days when news stories for television were produced by using 16-mm film. In the early days of television there was no method of electronically recording the video signal, so field production was done by using film. It was not until the mid-1970s that portable ENG systems were developed and film was made obsolete as the field production recording medium for television.

Until that time, however, news stories for local and national television stations were produced by using 16-mm film as the recording medium. Interviews were recorded onto 16-mm film with a **magnetic stripe** (or *mag stripe*) running along one edge of the film. The picture was recorded in the central part of the strip of film, and the audio was recorded in the mag stripe at the edge of the film. When the news story was run on the newscast, two special film projectors called **telecine** were used to convert the 24-frame-per-second film projection standard to the 30-frame-per-second video standard. The interview footage, called the **A-roll,** was run in one projector, and additional edited footage of the visuals for the story, called the **B-roll,** was run in the other projector. The two film projectors appeared as separate sources on the video switcher, and the TD switched from one projector to the other to edit the A-roll and B-roll footage together in real time, on the air, as the news story was being broadcast live.

Today, the term *A-roll* has largely disappeared from use. But we still use the term *B-roll* to describe visual, cutaway video footage that is used to cover voice-over or narration.

Many field producers working on news, documentary, and magazine format projects prefer to shoot their interview material first and then shoot B-roll footage. The reason for this is simple. The function of B-roll footage is to provide visual support for the story. By listening to what is said in the interview, you can get a good idea of the B-roll footage that is needed. If you are interviewing a teenage girl and she says, " Every afternoon when I come home from school, I like to paint my toenails," the alert field producer will ensure that a sequence of shots is recorded showing her coming home from school and then painting her toenails.

As an editor, you will only have the B-roll material to work with that the field production crew has provided for you. Once again, the importance of good tape logging becomes apparent. With a complete transcrip-

tion of the interviews and a detailed log of all the field footage that has been shot, you can begin to make connections between the interview sound bites and the available B-roll footage.

When using B-roll footage, try to think in terms of editing together meaningful shot sequences, rather than simply cutting away to a single shot and then cutting back to the on-camera interview. Apply the principles of continuity editing to your B-roll sequences so that each sequence tells a little story that complements what is being said in the interview.

■ Natural Sound and Music

Natural sound and music are two elements under the control of the editor that have the potential to make a significant impact on the effectiveness of the story that is being told.

Natural sound is actual ambient sound that is recorded on location along with the pictures. Any B-roll footage that is shot should always be shot with ambient sound recorded as well. The editor can then choose to include or eliminate the natural sound during the editing process.

Music and sound effects can be edited into the program as well. Sound effects are often used when natural sound is missing. If no sound was recorded as the car door was slammed shut, an appropriate sound effect can be used to replace the missing natural sound. Keep in mind that the process of using natural sound in an edited sequence is, ironically, anything but natural. By this we mean that natural sound is often used very selectively, to add emphasis to certain shots or parts of sequences. Although some editors insist on using natural sound whenever they cut to a B-roll shot or sequence, others may diminish the use of natural sound in favor of a more dominant music track. Either decision involves making an aesthetic choice about which technique works best in the context of the story that is being told.

Music is one of the most dynamic, emotional elements that can be introduced into an edited sequence. Music is often used to set or change the mood of a scene, to foreshadow something that is about to happen, and to establish the time or place in which an event takes place. It is also extremely important in determining the pace of a scene.

■ Sound Sequencing and Sound Layering

Given all of these sources and given that the editor may have several voices to work with as well, the editor's sound-editing job is rather complex. In addition to determining the sequence of the sound segments, the editor must also determine the kinds of transitions that will be used between them. In editing voice, the most common transition is a straight cut. When one audio segment ends, the next one begins, leaving a natural pause between segments. In other kinds of audio sequences, segues or crossfades may be used.

A **segue** (pronounced "*seg*-way") is a transition from one sound to another in which the first sound fades out completely before the second sound fades in. There is a slight space between the two sounds but no overlap. In a **crossfade,** as the first sound fades out, the second sound fades in before the first one fades out completely. This results in a slight overlap of the two sounds.

In addition to choosing the sounds to be included in the program and putting them into an appropriate sequence, the editor needs to determine how to layer or mix them together. **Sound layering** involves determining which sounds should be heard in the foreground, in the background, or in between. This layering effect is achieved by manipulating the volume of various sound elements during the editing process.

The relative strength of each of the sounds that are layered together is usually determined by its importance in the scene or sequence. The editor must correctly mix the sounds so that their relative volume matches their importance. A voice-over should not be overwhelmed by natural sound or music that is supposed to be in the background. However, in a highly dramatic scene the music may well come to the foreground, overwhelming the natural sound and any other sound elements in the scene.

■ Graphics, Transitions, and Effects

In postproduction the video editor has access to a full palette of video transitions and effects. These were described in detail in Chapter 6.

In addition, the editor has the ability to create or import graphic elements that help to tell the story. These may be as simple as lower-third keyed titles or as complex as animated composited graphics. The rules of unity, clarity, and style that are described in detail in Chapter 12 are important for the editor to consider as decisions about the graphic design elements of the project are created.

■ "Don't Worry, We'll Fix It in Post!"

Producers who work in the field know that their project will not be finished until it passes through the postproduction stage. This has given rise to a phrase that probably has been uttered at least once during the production phase of most programs when something goes wrong: "Don't worry, we'll fix it in post!" Although not every problem can be fixed in postproduction, many can be fixed, particularly given the image editing tools that most nonlinear editing systems now contain. A few of the most common postproduction fixes are as follows.

● **FIXING COLOR AND BRIGHTNESS PROBLEMS** In studio production a video engineer is in charge of camera shading and ensures that each of the cameras is producing an image with similar color and brightness values. The nature of field production requires a program to be recorded

shot by shot, in different locations with different light conditions, over an extended period of time, and often with different cameras and crews.

Professional nonlinear editing systems contain waveform and vectorscope monitors that allow the editor to correctly adjust brightness and color. This can be a slow process because each shot may have to be individually color corrected. However, even severe white balance problems can often be fixed with the software that is available today (See CP-13.).

● **FIXING EYELINE PROBLEMS** Often in postproduction the editor will have a problem matching eyelines or motion vectors. Perhaps a person is looking to the left side of the screen when the sequence calls for the person to look to the right. Assuming that no written material is visible in the shot, it is a rather simple procedure to use the digital video editing tools to flip the shot with the offending eyeline or motion vector. (See Figure 11.9.) Of course, if there is writing in the shot, the writing will be backward in the flipped shot. This is a reason that many field producers ask their subjects not to wear hats or shirts with written material on them.

FIGURE 11.9 Fixing Eyeline Problems

Eyelines do not converge—subjects do not appear to be talking to each other

Horizontally flipping the image on the right makes the eyelines converge—
the subjects now appear to be talking to each other.

● **REFRAMING A SHOT** Novice producers sometimes make framing errors when shooting field material. One of the most common problems is to frame an interview subject too loosely when a tighter shot would be more appropriate. Shots that are too wide can be tightened up by zooming in on them using the zoom tool in the nonlinear editing software program. Images can also be repositioned in the frame. For example, if the subject is framed too loosely and is centered in the frame, you could zoom in and move the image slightly to the left or right to achieve a different framing effect. However, remember that zooming in on the image while editing can affect the quality of the image; if you zoom in too far, the image may begin to pixilate and lose sharpness.

● **CHANGING THE DIRECTION AND SPEED OF A PAN, ZOOM, OR TILT** Most nonlinear editing programs allow the editor to control the direction and speed at which each clip is played back. A pan, zoom, or tilt that is too fast can be brought under control by changing the playback speed of the clip. A clip that looks bad played back at normal speed (100%) might look much better at 70% or 80% of normal speed. Remember, of course, that when you slow down the playback speed of the shot, it takes longer to play it back, so you have actually lengthened the shot. It may be necessary to trim it back to its original length to fit it back into the time line.

Sometimes the direction of a tilt, pan, or zoom needs to be changed. Imagine a shot of the exterior of an office building that begins with a close-up of the entrance and then slowly zooms out and tilts up to the top of the building. As the last shot in a sequence, this might work fine, but if your script calls for an opening shot that is going to be followed by an interior shot of the lobby of the building you would probably be better off if the shot started at the top of the building, and then slowly tilted down and zoomed in, ending on the close-up of the entrance.

Fixing this in postproduction is relatively simple. Once the clip has been imported into the nonlinear editing system, the editor can manipulate the direction of the clip. It can be played back from beginning to end or from the end to the beginning. Reversing the direction will produce the shot that is needed for the sequence.

Storytelling

It is important to note that producers of television news pieces, television magazine features, and documentaries almost universally refer to the video pieces they produce as *stories.* It is also important to note that while dramatic programs are almost always produced with a full script that accom-

panies the production from preproduction through postproduction, news stories, magazine features, and documentaries are almost never fully scripted. There may be an outline script that identifies the main points to be made in the piece, along with a list of individuals to be interviewed. Or the structure of the story may be conveyed from the producer to the editor in a brief conversation, with little or no written guidance provided at all. In these situations the editor has a significant amount of responsibility and creative freedom to structure the field material into a compelling story that will capture and hold the viewer's attention. In approaching such material, the editor can be guided by three of the main conventional elements of any story: structure, characters, and conflict.

■ Story Structure

In their simplest form, most stories have three main structural points: a beginning, a middle, and an end. This concept of story structure dates back to the Greek philosopher Aristotle, who wrote in the *Poetics:*

> Now a whole is that which has a beginning, middle, and end.
> A beginning is that which is not itself necessarily after anything
> else, and which has naturally something else after it; an end is that
> which is naturally after something itself either as its necessary or
> usual consequent, and with nothing else after it; and a middle,
> that which is by nature after one thing and also has another
> after it.

● **THE LEAD OR HOOK**　For the video editor the challenge is often trying to figure out how to begin a story and how to end it. Most editors try to find an interesting introduction to the story. Print journalists frequently talk about writing a **lead** to the story, a compelling first sentence that succinctly tells what the story is about. Video editors look for a similar way into a story and frequently use the term **hook** to describe the interesting beginning of a story that catches the viewer's attention and makes the viewer want to watch the story to find out what happens. The hook may be a statement or question delivered in VO by the narrator, or it may be an interesting sound bite from one of the interviewees who are featured in the story. In either case the hook provides information in a way that provokes the viewer's interest in the piece.

All stories have a beginning, but the narrative does not necessarily have to begin at the beginning of the story. That is, you can begin the story in the middle of things (*in medias res* is the Latin phrase that is used to describe this technique) and then go back to an earlier point in time to bring the viewer up to date with what is happening.

● **THE NARRATIVE IN THE MIDDLE** Once the main story idea has been introduced, the middle or body of the story provides the important details of the story. This may be presented principally through narration or through the use of interviewees who function as the "characters" in the story.

In either case the editor of short-form video pieces such as news and magazine features should keep a couple of things in mind. Magazine features tend to be short (three to five minutes), and news stories are shorter still, often a minute and a half or less. To be told in such a short amount of time, the story must be relatively compact. Complex stories are hard to tell in a short amount of time. Simple stories are easier to tell, and for that reason most news and magazine features are kept relatively simple. As we discussed in the chapter on production planning (Chapter 7), you should be able to state the essence of the story in one simple sentence. If you can't, you may have difficulty making your story conform to the strict time limits that television imposes.

A simple visual device to help you track the complexity and development of your story is the story wheel. (See Figure 11.10.) Each of the spokes of the wheel corresponds to one significant element of the story. Most short news and magazine feature stories have two or three spokes; any more than that and you will not be able to tell the story within the allotted time.

● **THE END** Once the story has been told, it needs to be brought to some kind of reasonable conclusion. If the story began with a question, the end of the story might restate the question and answer it. If the story started with an assertion, the close might support or contradict that assertion, depending on the point of view that is presented in the story. And if the story has been structured around some kind of conflict, then the end of the story

FIGURE 11.10
Story Wheel

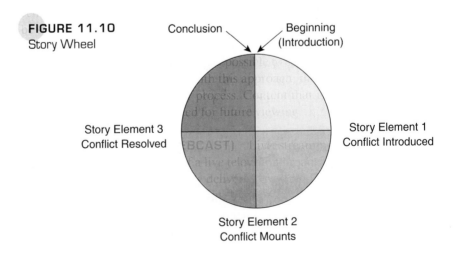

Conclusion

Beginning
(Introduction)

Story Element 3
Conflict Resolved

Story Element 1
Conflict Introduced

Story Element 2
Conflict Mounts

FIGURE 11.11
Beauty Shot

provides a resolution of the conflict or explains why there is no resolution if the conflict hasn't been resolved. News producers refer to the ending statement in a story as the **closer.**

● **VISUAL ELEMENTS** Story structure also can be thought of in visual terms. Stories often begin and end with significant attention to visual detail. An edited **montage** of shots might provide a high-energy introduction; and a **beauty shot** of a striking visual element that seems to summarize the story and provide a final coda (*coda* is the Italian word for "tail") for it might conclude the story. (See Figure 11.11.) In old-style Hollywood Western films the clichéd ending typically shows the hero riding off into the sunset, combining beauty shot and coda into one shot.

Characters

> "Videographers speak of A-roll and B-roll, but I focus on shooting C-roll—character roll."
>
> —Dr. Bob Arnot, NBC correspondent and independent
> documentary producer.

Good stories always revolve around interesting characters. It is no different for news, magazine, and documentary television programs. Characters are important because they humanize a story—they present the issues in a way that viewers can empathize with.

It is important to try to let the people in the story tell the story. Whereas narration is useful in providing expository detail and transitions

from one story element to another, the characters within the story provide a unique first-person narrative of the events or issues that the story is exploring. And although narration is effective in presenting information in a concise manner, characters in the story can present an emotional response that narration cannot.

Many television and video productions are cast in ways that bear great similarity to casting in dramatic programs. At a public screening of *Surfing for Life*, a video documentary broadcast nationally on PBS, that chronicles the lives of nine geriatric surfers (now in their sixties, seventies, eighties, and nineties), San Francisco Bay area independent producer David Brown described how he interviewed over 200 people before deciding on the six that he would use in his documentary. (Go to www.surfingforlife.com for more information about this program.)

Similarly, for news and magazine stories a producer may have the main story elements in mind, and then do research to find appropriate characters to tell the story. A story about new advances in the treatment of cancer in children cannot be effectively told without showing the impact of cancer on children. Families that have tragic or triumphant stories to tell about childhood cancer will have to be identified and interviewed, and the editor will have to find the most compelling sound bites to help tell the story.

■ Conflict and Change

The concepts of conflict and change are central to many news, magazine, and documentary productions. A conflict is a situation in which there is a clash between people, people and organizations, or points of view. Most compelling stories have some kind of conflict at their core. The task of the editor is to create interest and suspense around the central conflict, to show how the conflict is resolved (if there is a resolution), and to show how the individuals in the story have been affected or changed by this conflict.

An editor can add visual counterpoint to the conflict by juxtaposing statements that express opposing points of view in consecutive shots. This oppositional counterpoint can be enhanced if the footage has been shot with the interviewees on opposite sides of the frame. For example, all those on one side of the issue might be framed on the left side of the frame looking slightly to screen right; all those on the other side of the issue might be framed on screen right looking slightly to screen left. When the sound bites are edited together, the interviewees will literally be on different sides of the screen, representing their differences in position on the central issue.

Graphics and Set Design

Graphic elements within television and video programs include a variety of visual materials ranging from simple titles to elaborate settings. Graphics are an increasingly important part of the creative process of television and video production because they contribute significantly to the unique look and feel of each program.

Graphic elements are used in a variety of ways, from displaying the name of a person on the screen to depicting a whole setting in which action is staged. Graphics can catch the viewer's attention at the start of a show, they can provide information about the people who appear on screen, or they can immerse the viewer in a completely artificial environment. Increasingly, electronic means of designing titles and sets are displacing the traditional mechanical methods of the past. (See Figure 12.1.)

FIGURE 12.1
Computer-
Generated Graphics

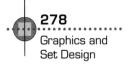

There are three main stages in the design and production of graphics for television and video: design, creation, and integration. (See Figure 12.2.) This chapter will deal mainly with the design stage because the creation and integration of graphics for television and video often require specialized production tools and software that demand a more complex treatment than we are able to provide here.

Design: The Guiding Principles

Regardless of the type of graphics or their content, there is a set of principles that can be applied to assist in their design and production. Of paramount importance are the concepts of unity, clarity, and style.

■ Unity

For a program to be effective, it must contain unity. All graphics must be in harmony with the overall content and look of the program. Each graphic element must be coordinated with the others to support the major theme or purpose of the program. Despite the many different graphic elements that may be found in a program, they must all have a constancy of purpose—**unity** in diversity—to provide continuity and coherence to the program. Failure to coordinate these elements may cause the viewer to be distracted or to focus on some unique quality of the graphics rather than on the content of the program itself. For example, look at the following series of numbers:

uno, two, three, 4, funf, six, seven

This list obviously lacks unity of expression; it mixes three different languages as well as words and numerals. The use of these numbers in a docu-

279

Basic Factors in
the Design of
Graphics for
Television and
Video

mentary or news report would most likely be dysfunctional. However, in a comedy or language program it could provide effective visual or content support.

Unity of expression includes control of all aesthetic elements and expositional factors that enhance the presentation of the message, including elements such as color, sound, lighting, camera angles, and editing, which were discussed in the previous chapters.

Clarity

The concept of **clarity** involves both simplicity of expression and the visibility of the graphic elements or characters themselves. It is important to keep the inherent audiovisual characteristics of the television screen in mind. For instance, the display of a full page of newsprint on a video screen means that each word will be too small to be readable. In this case the value of the content is lost because the graphic presentation was incompetent and the principle of clarity has been violated. Functional and practical factors in the preparation of television graphics must be considered if clarity and intelligibility are to be preserved.

Style

The **style** of a video presentation can take many forms. It may be realistic (as is the case for most news and documentary programs), expressive (as in a music video), or abstract (as in experimental drama and dance). Again, the style has to do with the look and feel of the program that the producers are trying to capture.

Once the question of basic style has been answered for the program, attention can be given to the design and preparation of graphic elements that will reinforce its expression. Graphics should be compatible with settings and costumes. For example, lettering for graphics for a program that is set in a modern hospital should reinforce elements of that setting (e.g., modern, antiseptic, scientific). Use of an Old English alphabet to identify modern surgical procedures would distract the audience. All lettering, regardless of source, much match the other visual elements of the production.

Basic Factors in the Design of Graphics for Television and Video

In designing graphic materials for television and video, a set of basic factors that will determine the effectiveness of those materials needs to be considered. These factors include the aspect ratio, screen size, and essential area of the television screen and the color and brightness of the graphics themselves.

■ Aspect Ratio

The aspect ratio is the relationship between the width of the screen (horizontal dimension) and its height (vertical dimension). Regardless of its size, the screen is a rectangle with an aspect ratio of four units wide by three units tall (expressed as 4 × 3 or 4:3) for the conventional NTSC signal or sixteen units wide by nine units tall (16 × 9 or 16:9) for high-definition television. (See Figure 12.3.)

With the advent of high-definition television several problems have arisen with respect to accommodating both the conventional and wide aspect ratios. Feature films that were shot in wide-screen formats fit well on the 16:9 screen but not on the 4:3 screen. To make them fit, only a 4:3 portion of the picture is shown (either the center is shown or the view is "panned and scanned," depending on the center of interest in the shot), or the entire picture is shrunk down into a **letterbox** in the center of the 4:3 screen. Shrinking the size of the picture leaves a gap at the top and the bottom of the screen that is filled with black. (See Figure 12.4.)

Producers who want to avoid letterbox displays on 4:3 format screens often use the *shoot and protect* method of shooting. The principal action is recorded in the central area of the 16:9 frame, leaving essential scene details out of the left and right sides of the picture. In this way the picture can

FIGURE 12.3 TV or Video Screen Aspect Ratio

FIGURE 12.4 Letterbox and Widescreen Safe Area

Letterbox

Safe Area

281

Basic Factors in
the Design of
Graphics for
Television and
Video

be cropped down to 4:3 without losing important scene elements. (See Figure 12.4.) Viewfinders on cameras that are capable of wide-screen recording typically have a 4:3 safe area template that helps the cameraperson keep the action within the safe area.

■ Screen Size

The major problem related to size is the tendency to put more information on the screen than the viewer can see clearly at a normal distance. This concept of audience distance from the screen is very important.

Computer users sit very close to the screen and are accustomed to looking at screens with a large amount of textual information. Television and video viewing presents a different situation because the audience sits much farther away from the screen and cannot see small detail as well. For example, the home viewer sits six to eight feet from the screen, and the student in a classroom might be more than thirty feet from the screen and forced to view the screen from less than an optimum angle. For this reason graphics that are designed for television are most effective when they rely on strong, simple expressions in both text and symbols. Although large-screen home theater displays make it easier to see complex graphic displays, remember that most viewers still watch television on a screen that is relatively small.

■ Essential Area

Because of differences in the amount of the picture that different television receivers and monitors display, in preparing graphics for video, it is important to leave a margin around the edges of the screen. All graphics must fit within a screen space that excludes the outer 10% of the top, bottom, left, and right edges of the screen. This space is known as the **essential area.** (See Figure 12.5.)

FIGURE 12.5
Essential Area

FIGURE 12.6

Lower-Third Title

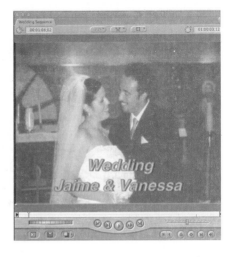

Another term for essential area is *safe title area.* Some camera viewfinders display a safe title area template superimposed over the image the camera sees as an aid to framing. Many computer-based video graphics programs that are used in the design of titles and animation contain safe title templates as well.

A very common situation arises when individuals, places, or objects that appear in a program need to be identified visually on the screen. The conventional treatment is to superimpose some brief identifying information in the lower third of the frame. This is particularly important when the picture on the screen is a medium close-up of someone talking. You do not want the titles to appear over the subject's mouth. (See Figure 12.6.)

■ Color and Brightness

The visibility of objects and lettering is most often improved through the use of contrasting colors. For example, yellow letters against a dark blue background will be easier to read than will light blue letters against the same dark blue background. In general, if we use highly saturated (rich) colors, it is best to use them against dull background tones. Besides making the graphics more readable, it allows the saturated colors to bring attention to a particular attribute or aspect of a graphic. In addition, attention must

FIGURE 12.7

Contrasting Colors
in Black and White

Good ⟶
Contrast

Poor ⟶
Contrast

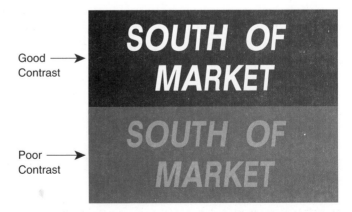

283

Create:
Production
Processes and
Sources of
Graphics

be given to the relative brightness of those colors. This is particularly important if the video will be viewed on a black-and-white screen. (Contrary to what most people believe, there are still many black and white televisions in use.) (See Figure 12.7.)

Create: Production Processes and Sources of Graphics

In multicamera television studio production graphics are integrated in real time as the program unfolds. For edited programs graphics are added during postproduction.

■ Mechanical/Nonelectronic

Although mechanical means of producing graphic material for television are still in use, they no longer represent the mainstream of television production, having largely been replaced by computer-generated graphics. Nevertheless, some small-scale (and low-budget) productions still make use of photographs mounted on a card and placed on an easel in front of a camera. The camera can then be used to introduce motion to the picture by panning, tilting, or zooming in on the photo.

However, even this technique is fading away because photographs are now routinely scanned and imported into computer systems for further enhancement and processing. Even simulated camera movements can be performed on digital photo files by sophisticated software programs such as Combustion, or relatively inexpensive ones such as Apple's iMovie.

■ Computer-Generated Graphics

Most graphics used in television and video today are computer-generated. Even the simple titling feature in consumer camcorders relies on a computer chip. In the professional production arena two of the most common sources for computer-generated graphics are character generators (CGs) and graphic and image-processing software.

● **CHARACTER GENERATORS (CGS)** Character generators are used to create text (titling) on a television screen. Even though all nonlinear editing software incorporates some sort of CG capabilities, character generation for high-end productions is usually done with sophisticated stand-alone character generator workstations made by Pinnacle, Quantel, and Chyron, among others.

Not only can lettering in a variety of styles be generated electronically by a character generator, but many CGs include animation, paint, and digital effects functions as well.

● **GRAPHIC AND IMAGE-PROCESSING SOFTWARE** Software programs such as Adobe Photoshop and Adobe After Effects are widely used to create still graphics and animated images. These programs work with layers of images that can be combined in different ways and also allow the use of color correction and effects filters. One of the latest examples of these kinds of graphics software programs to enter the market is Apple's Motion.

Two-Dimensional (2-D) Graphics Advances in 2-D software make drawing, painting, and animation effects available to almost anyone, including low-budget studio and field producers. (See Figure 12.8.) In drawing systems the artist uses an electronic pen to draw on a special tablet that translates the pen's movement into a digital image. Painting systems allow the artist to add shadow and texture, and animation allows the artist to move the graphic within the frame.

Three-Dimensional (3-D) Graphics Advances in 3-D graphics are even more spectacular. Some systems provide hundreds of predesigned images that can appear to be illuminated from any angle, can be seen from any angle, and can be made to rotate and move from foreground to background. These systems allow the artist to create unique environments by manipulating volumes, objects, image layering, shadows, and animation. (See Figure 12.9.)

FIGURE 12.8
Two-Dimensional
Graphic

FIGURE 12.9
Three-Dimensional
Graphic

285
Create:
Production
Processes and
Sources of
Graphics

Compositing Compositing programs allow multiple layers of video to be manipulated. Character generation software is an example of a simple compositing program, in which a layer of letters is combined with a background layer of video. Sophisticated software allows the artist or video editor to manipulate the images in multiple layers of video with varying degrees of transparency or opacity. (See Figure 12.10.)

Digital compositing is responsible for some of the most dramatic special effects in modern television and feature films. Through compositing, graphic images can be merged with live footage to create stunning effects, as was done in *Jurassic Park* (real people, electronically generated dinosaurs) and *Titanic*.

Although these large-budget productions garner the most attention, compositing is quickly entering the realm of smaller video productions as well. An increasing number of nonlinear editing applications that are available for small editing workstations now include some degree of compositing capabilities. The three leading computer platforms for video compositing are the Apple Macintosh, the PC, and the very specialized SGI (Silicon Graphics Incorporated) workstations.

FIGURE 12.10 Compositing

Integrate: Integrating Graphics into a Video Production

As we noted above, there are several ways to integrate graphics into television or video programs. In multicamera studio production graphics are integrated into the program in real time with the use of the video switcher. As we discussed in Chapter 6, the video switcher can be used to introduce keys and a variety of digital video effects that can be used in conjunction with the program's graphic elements.

For edited programs graphics are incorporated during the editing process. Program titles, credits, and name keys can be created by using the built-in CG software or by importing graphics created in appropriate software applications elsewhere.

It is important to note that new graphic tools are appearing every day in the marketplace with hundreds of prefabricated graphics and effects. This makes the creation and incorporation of graphics more accessible to low-budget productions and the average video producer. However, keep in mind that the effectiveness of graphics, like any other aspect of production, depends more on planning and design than on the sophistication of the systems that are used to create them.

Set Design

All along we have emphasized the importance of teamwork in the video production process. Set design is just one more aspect of that process. Set design brings together various people with different skills for the purpose of providing the show with a particular setting to enhance the viewer's audiovisual experience.

Designing and building a set require the creativity of the producer or director, the talent of the set designer, the skills of the lighting director, the handiness of the builders, and the overall efforts of the production team. Depending on the complexity of the program, the responsibility for designing and building the set may fall on one or several members of the production team.

Regardless of complexity, set design involves a sequential series of steps that have to be taken in order to successfully construct the desired set. Figure 12.11 shows the steps involved in the creation of a performing space—the set—for a video production.

■ The Concept

Set design is a key element in the visualization of the concept established by the director and/or producer during the early stages of the production process. Sets can be designed to recreate real-life environments, as in the case of soap operas and dramatic series, or they can be designed to provide

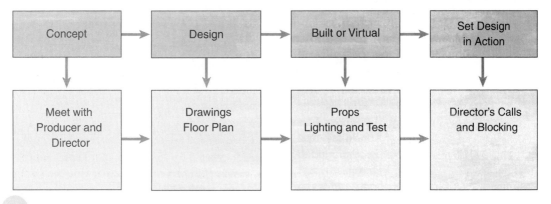

```
┌─────────────┐     ┌─────────────┐     ┌─────────────┐     ┌─────────────┐
│   Concept   │ ──► │   Design    │ ──► │ Built or    │ ──► │ Set Design  │
│             │     │             │     │  Virtual    │     │  in Action  │
└─────────────┘     └─────────────┘     └─────────────┘     └─────────────┘
      │                   │                   │                   │
      ▼                   ▼                   ▼                   ▼
┌─────────────┐     ┌─────────────┐     ┌─────────────┐     ┌─────────────┐
│  Meet with  │     │  Drawings   │     │   Props     │     │ Director's  │
│ Producer and│ ──► │ Floor Plan  │ ──► │ Lighting and│ ──► │   Calls     │
│  Director   │     │             │     │    Test     │     │ and Blocking│
└─────────────┘     └─────────────┘     └─────────────┘     └─────────────┘
```

FIGURE 12.11 Set Design Steps

a more abstract presentational space, as in newscasts. (See Figure 12.12.) The set can be as simple as sitting a performer in front of curtains in the background or as complex as the set for the Emmy Awards telecast.

During the concept development stage the set designer meets with the director and producer to go over the idea for the program and the script in order to understand the basic, underlying concepts of the story and the functions of the set. Is the set meant to recreate a specific environment? What mood is it to establish? How will the performers use the setting? Two important issues to discuss during this stage are deadlines and the amount of resources (money, props, crew, computer system and software if a virtual set, etc.) that are available to accomplish the task.

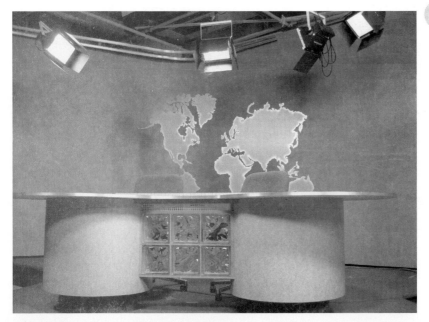

FIGURE 12.12
News Set

■ Design

During the design stage the designer prepares drawings or sketches of the proposed set for the producer or director. A very important step in the set design process is the design of a floor plan. A floor plan is a diagram of the studio floor showing the design and arrangement (layout) of set **properties** (*props* for short) such as furniture, potted plants, and doors and windows if applicable, drawn to scale and as seen from above. (See Figure 12.13.) The

FIGURE 12.13
Floor Plan

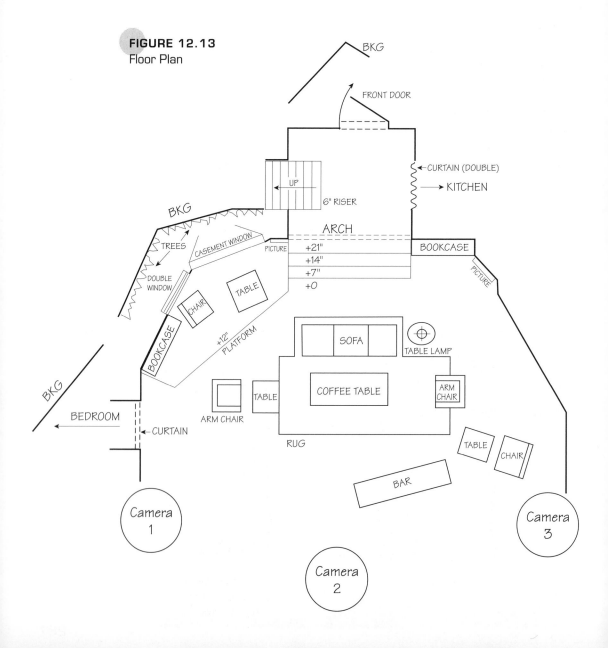

289

Integrate:
Integrating
Graphics into
a Video
Production

most common scale is ¼ inch equals 1 foot. You can find stencils or templates with cutouts in this scale for furniture and other common set pieces. In addition, several drawing and design software packages are available on the market, such as Microsoft's Visio.

A well-designed and accurately drawn diagram of a floor plan will lay the basic foundation for a good lighting plot. (See Figure 3.23 for the lighting plot for the set illustrated in Figure 12.13.)

■ Built or Virtual?

Set design is part art (creative finesse) and part craft (technical skills). Once the artistic work of the design has been completed, the technical phase of craftsmanship begins.

● **BUILT SETS** Sets can be built by simply bringing into the studio some props such as sofas, end tables, and desks, or they can be constructed from a variety of materials, including fabrics, plywood, metal, and cardboard. Whichever the case, one of the most common set building units is the flat.

Flats Flats are panels that are designed to create the illusion of interior settings and walls. Figure 12.14 shows the diagram of a flat with an opening for a door. A flat's frame is usually made out of 1-inch by 3-inch wood with ¼-inch plywood corner blocks to reinforce the corners.

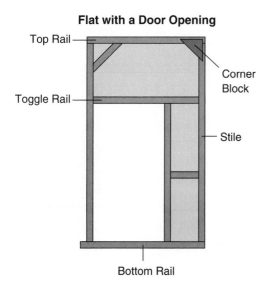

Flat with a Door Opening

Top Rail

Toggle Rail

Corner Block

Stile

Bottom Rail

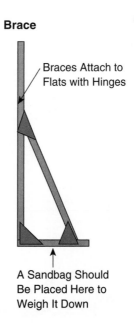

Brace

Braces Attach to Flats with Hinges

A Sandbag Should Be Placed Here to Weigh It Down

FIGURE 12.14
Flat and Brace

Flats are also supported by horizontal braces called *toggle bars* and side braces called *stiles*. In most situations more than one flat is required to represent a setting. You should use a piece of cord or clothesline to secure each flat to the next. Flats are usually eight or ten feet high and anywhere from two to five feet wide. A brace is attached to the back of the flat to support it in the studio, and sandbags are used to weigh down the brace so that the whole assembly remains securely in place.

There are two types of flats: soft and hard. Soft flats are made of wood and fabric. They are lightweight, so it is easy to move them around the studio, but they require good care to avoid damage. Hard wall flats are made out of lumber; they are usually very heavy but can take much more use and abuse than a soft flat without being damaged.

There are also modular set design pieces on the market that can be assembled in different configurations to construct a variety of settings for television shows such as news and instructional programs. These modules can be quickly taken apart and stored on carts for ease of movement around the studio.

Set pieces used as backgrounds may have scenery painted onto them, or they can be "painted" with colored light to provide an interesting background for interview or talk shows. (See Figure 12.15.)

Risers Another common set piece is the **riser,** a low platform constructed out of plywood. The function of the riser is to raise the set so that the cameras are at the performers' eye level, particularly when the performers are seated. Risers are widely used on news and interview sets.

FIGURE 12.15
Painted Scenic
Background

291

Integrate:
Integrating
Graphics into
a Video
Production

● **VIRTUAL SETS** A **virtual set** is a system in which a live performer is placed in a computer-generated three-dimensional environment. The insertion process is similar to that of the chroma key—removing a blue or green background and replacing it with another image or video clip—except that in a virtual set the actors or talent appears to be immersed in and interacting with a three-dimensional setting. (See Figure 12.16.)

In a traditional chroma key setting, the camera cannot move because the two-dimensional background remains static. In a virtual three-

FIGURE 12.16
Virtual Set

dimensional setting, when the camera moves, sophisticated computer graphics software connected to a camera tracking system matches perspective and size changes in the background with those in the foreground. For this reason a virtual set designer must have knowledge of and expertise in studio settings as well as in computerized 3-D modeling.

Virtual sets are used today in a wide variety of video programs, including newscasts, children's programs, dramas, and scientific and educational programs. As the technology improves and becomes more affordable, we will see even more frequent use of virtual sets in an even wider range of television and video programs.

■ Set Design in Action

Set design must take into account the interrelation between the movement of the talent, camera angles, and director's calls. For instance, in a newscast the full set may be shown only at the beginning and end of segments within the program from different angles and only for a few seconds at a time. Most of the time during the newscast the viewer will see medium and close-up shots of anchors and reporters or video clips. But those few seconds should be enough to create a lasting impression of the program's identity. The set designer and director must work together on this issue and make sure that every detail regarding the position and form of the set is in harmony with talent's movements and the desired camera angles and framing.

In summary, set designers must work closely with producers and directors and become very acquainted with the program conceptualization and script. Every set piece must add value to the program's overall visual quality. Set pieces should have not only form, but function, and allow for effective interaction with movement of the talent or performers.

CHAPTER 13

Video on the Web

Types of Video on the Web

One of the fastest-developing areas for distribution of video content is via the Internet, including the World Wide Web. Web distribution of video has become extremely popular. This chapter explains the basic concepts of video on demand and streaming media, the steps in the process of preparing video and audio for streaming over the Internet, and the technology that is involved in this process.

If you have surfed the Web lately and watched any videos, most likely you have experienced video on demand or streaming video.

■ Video on Demand

Beginning in the 1990s, Web-based video was modeled on the concept of **video on demand** that had been developed by the cable television industry. At that time cable television companies attempted to provide subscribers with the option to select their preferred programs at any time of the day or night from a large digital database of program material. Subscribers would select a program, and the cable company would transmit it to the viewer's home television. Today, video on demand is found on many cable and satellite television systems and in hotels, where guests can select from a relatively small menu of movie and other program titles.

Web-based video on demand systems require that video be downloaded onto a computer hard disk and then played back on the subscriber's personal computer. In other words, Web video on demand is mainly a download-and-play technology. Because video files were usually very large and typically downloaded over 28, 33, or 56 kbps dial-up modems, it took most users too long to download the files. As a result, Web-based video on demand was avoided by most Internet content providers because it was too time consuming and inefficient.

■ Streaming Media

With the advent of faster computers and networks, increased adoption of broadband services such as DSL and cable modems, and the development of more efficient video and audio compression systems, a more convenient launching platform for streaming media on the Internet has developed.

Streaming media is a technology that is widely used today to deliver different types of media via the Internet. The term has come to exemplify the digital convergence of communication and information technologies, such as video, graphics, voice, text, and data. These elements come together on line to provide a wide range of audiovisual experiences that make the content much easier to understand and much more fun to interact with.

Many people consider streaming media to be a new delivery medium comparable to broadcast television or cable television. It is revolutionizing the ways in which organizations communicate with their employees, their customers, and the public in general. Many news media organizations are streaming news clips from their regular broadcast newscasts. For example, Reuters, an international news agency, unveiled a service in March 2003 offering raw footage of the U.S. military campaign in Iraq. Film studios and producers regularly stream movie trailers for upcoming theatrical film releases. Major league baseball, in open competition with the broadcast networks, started to stream live baseball games during the 2003 season. Yahoo broadcast the 2003 NCAA basketball tournament through its Platinum Internet service. The Harvard School of Public Health and Stanford University, among many other educational institutions, deliver on-demand and live streaming video of courses, commencements, services provided by their departments, and important events taking place on their campuses and provide links to research sites with streaming content. Table 13.1 shows some of the areas in which streaming media, particularly video, are being used.

These examples illustrate some of the most common uses of streaming video. Often, as in the case of news clips or sportscasts, streaming content is regular television programming that was originally produced for viewing on broadcast or cable television but now has been repurposed for delivery through the Internet. In other cases, content (programs) is produced with specific streaming (Web) values and characteristics in order to optimize, both aesthetically and technically, the experience for the Web viewer, thus improving the chance of achieving the program's objectives.

■ What Is Streaming Media?

Streaming media is a technology that delivers dynamic content, such as video or audio files, over a local computer network or the Internet. It transmits files in small packets that "stream" for immediate, real-time viewing or listening. While the user watches or listens to the first packet, the next

295

Types of
Streaming:
Progressive,
Real-Time, and
Live Progressive
Download

■ TABLE 13.1 Typical Uses of Streaming Media

Areas	Uses
Entertainment	Music
	Movie Trailers
	Sports
Information	News
	Weather
Government	Training
	Military
Education	Distance Learning
	Academic events
	Research
Corporate	Training
	Sales
	Advertising
	Videoconferencing
Community	Services
	Reach community members

one is buffered or downloaded to the computer's memory and then released for continuous viewing and/or listening. The stream (packet of information) is encoded at the sender's end and decoded at the user's end by using appropriate computer software.

Streaming media can be delivered from a streaming media server or from a web server at different speeds or data rates. Higher delivery speeds or data rates produce better-quality streaming media than do slower delivery speeds.

Types of Streaming: Progressive, Real-Time, and Live Progressive Download

■ Progressive Streaming

Progressive download is very similar to the video on demand approach described earlier; however, the file does not have to be downloaded completely before viewing. In this approach, a media file to be delivered over a specific network's bandwidth is placed on a regular Web server, also

known as a standard HTTP server. **HTTP** is the abbreviation for "hypertext transfer protocol," a computer standard that defines how messages are formatted and transmitted over the World Wide Web.

After being accessed by the client computer, the server starts downloading the file, and after a few seconds of downloading, the user can play the video or audio while it is being downloaded. What the user sees is the part of the file that has been downloaded up to that time. Progressive download is best suited for playing short movies over modem speeds of 28 kbs or 56 kbs.

■ Real-Time Streaming

The **real-time streaming** approach follows the traditional model of prerecorded television broadcast delivery of programming with the big difference being that the program can be accessed by multiple users at the same time and at different places in the file. (This differs from the broadcast model, in which everyone watches the program at the same time and all viewers are at the same place in the program.)

With real-time streaming, archived (previously recorded) material residing on a server is viewed while being downloaded (broadcast). In other words, the user sees the video in real time, as it is streamed.

The computer systems that are used for real-time and live streaming require special dedicated servers called *streaming media servers* that keep the bandwidth (capacity) of the network matched to that of the viewer. This approach supports random access to the streamed signal, which means that the user can move to any part of the file or video at any time during delivery. This mode of streaming offers anytime and anyplace delivery of archived (on demand) media to users anywhere in the world.

■ Live Streaming

Also known as **Webcasting,** live streaming follows the traditional model of live broadcast delivery. The live streaming technology allows for an event to be viewed in real time as it is transmitted live. Afterwards, it can be archived and then viewed or "rebroadcast" using the real-time mode of delivery.

The Process of Preparing Streaming Video

The process for preparing streaming video can be divided in two stages: (1) creating/acquiring and editing the media and (2) encoding, delivering to servers, and streaming the media. (See Figure 13.1.)

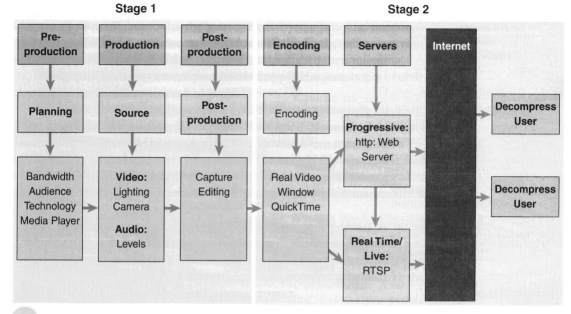

FIGURE 13.1 Complete Streaming Process

In stage 1, during preproduction, scripts or storyboards are finalized, and decisions on which streaming technologies to use are made. During production and postproduction the video and audio are recorded, captured to a video card as a digital signal, and edited.

In Stage 2, the signal is sent via the video card to a streaming encoder, which prepares it for distribution over a network. The signal is then delivered to a media server (streaming server) for distribution over the Web. The media server is connected to a web server, which acts as a bridge between the media server and the end users. End users log onto the web server through a regular web page with HTML links. HTML is the abbreviation for "hypertext markup language," the standard computer protocol that is used to format web pages. When a user accesses a link by clicking on it, a reference pointing to the media server is generated, and the media is accessed.

■ Stage 1: Creating and Encoding the Media

As you can see in Figure 13.2, the creating and encoding stage involves some of the already familiar steps seen in our production model in Chapter 3. Preproduction, production, and postproduction are all part of the process. However, as you will see in a moment, production values and postproduction procedures for streaming video operate on a different set of principles than those for traditional video. Furthermore, streaming tech-

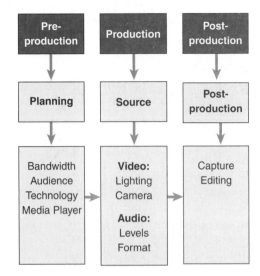

FIGURE 13.2 Stage 1
of the Streaming Process:
Creating and Encoding

nology works with different network protocols and tools that have to be taken into account during the very early preproduction stage. In other words, as in any video production, careful planning is required to accomplish a successful streaming session.

● **PREPRODUCTION** As we mentioned earlier in the book, planning is at the heart of any media production process, and the preproduction stage is critical in preparing your video for the Web. Besides the regular steps in the production model that was presented in Chapter 7, when preparing video content for the Web, you also need to consider the following:

1. What type of production do you want or need to do? Is it going to be a single talking head or are you going to use a large cast?

2. How is your intended target audience going to access your video? Through a phone line–based dial-up modem, or a high-speed connection? Large-scale streaming requires high bandwidth capability. **Bandwidth,** the capacity of your delivery channel, is measured in bits per second (bps). **Dial-up modems** have speeds of 28, 33, or 56 kilobits (thousand bits) per second (kbps). Other channels such as **DSL (digital subscriber line)** or T1 lines have download speeds that range from around 384 kbps for DSL to 1.544 megabits (million bits) per second (mbps) for T1 lines. In general, the larger the bandwidth, the better is the quality of your video on the Web. For example, if your message is going to be delivered through a 28-kbps dial-up modem, then you should not plan a video with lots of motion and effects. If you plan to deliver over a 300-kbps channel, then you will have more flexibility in enhancing your video with more effects, transitions, and animated graphics.

3. What kind of delivery platform and media players (QuickTime, RealVideo, Windows Media Player, or Flash) will be used to encode and deliver your video? How much interactivity do you wish your audience to experience?

● **PRODUCTION**

Shooting Video for the Web There are significant differences between shooting video for distribution via traditional broadcast or cable television and shooting video for the Web. Although in both cases high aesthetic standards are to be applied, Web technology such as compression codecs and bandwidth limitations can in many cases change your design approach to video shooting.

The first important thing to understand is that before getting to the Web, video has to be compressed (made smaller). Video compression works by eliminating redundant information. When compression is employed, each frame of information is analyzed to identify which information in the frame is repetitive and which is new. If there are a lot of changes between one frame and the next, it will take more bandwidth to transmit the signal. If there are few changes between one frame and the next, only the new information needs to be transmitted. So when we shoot video for the Web, we are concerned with keeping the scene as unchanged as possible.

1. *Motion.* Avoid unnecessary camera or subject movements. Pans, tilts, zooms, and other camera movements radically change the content of the shot from one frame to the next. Unfortunately, when video is compressed and distributed over the Web, these camera movements will mostly appear to be blurry on the screen. If you must pan or zoom, do it as slowly as possible. Try to keep your subject's motion to a minimum. Also use a tripod whenever you can. Shaky pictures are as bad for compression as a moving image is.

2. *Background.* The background should be kept as static and uniform (a single color) as possible. Excessive motion in the background will cause the picture to be blurry. Remember, compression is about change, and the less change your compressor has to worry about, the better your video is going to look. A talking head against a dark blue background is a good option for streaming video.

3. *Framing and focus.* Video is, in general, a close-up medium. Video for the Web is even more a close up-medium. Most likely, your video will be displayed in a small window on a computer screen and not as a full-screen image. Close-ups will help the viewer to appreciate the details of your production. Also, make sure that your images are in sharp focus.

4. *Lighting and colors.* Do not have talent wear white, black, or clothes with fine patterns (e.g., herringbone). Try to create good contrast between foreground and background. A well-lit and sharp scene will un-

doubtedly look much better that a poorly lit one. Although today's cameras allow you to shoot in very low light and your video may look acceptable when viewed on a regular television monitor, these images will degrade considerably by the time they are ready to be streamed.

5. *Animation.* If you are going to use animation in your video, it is best to use vector-based animation software instead of bit-mapped software; the latter takes up a larger chunk of bandwidth.

Audio for the Web As in regular video production, there is a tendency to concentrate on the picture elements and take the audio for granted, thus degrading the whole production because of poor audio. However, keep in mind that audio and video both take up bandwidth. So the more complex the audio portion of your program is, the less bandwidth you will have for the delivery of the video. Again, planning becomes essential to find the proper balance between audio and video. Here are some basic guidelines for dealing with the sound side of your production.

1. *Use external microphones.* High-quality external microphones will usually give you better sound quality than will the camera's built-in microphone. The idea is to create the best audio signal possible, clear and clean, because it will be degraded somewhat when compressed.

2. *Ambient sound.* Natural background sound, also called **ambient sound,** is probably desired in most video productions shot on location. However, make sure the background sound your microphone is picking up is not simply background noise. And make sure that the background sound is not so loud that it competes for attention with the principal foreground sound in your program.

3. *Audio levels.* Especially when working with DV, make sure your levels are high but do not peak into the red, which can cause serious distortion of the sound. When converting analog audio into digital files, remember that the analog peak of 0 VU is equivalent to –12 db in the digital domain. (See Chapter 5 for more discussion about audio levels.)

● **POSTPRODUCTION** Once your video and audio have been recorded, the next steps in preparing your media for distribution on the Web involve capturing, digitizing, and editing your media. You have already reviewed general principles of video editing in previous chapters. The following editing guidelines should help you to enhance the quality of your streaming video.

Capturing and Digitizing Media producers use these two terms to describe the process of putting media into digital form and bringing media into a computer hard drive. Capturing describes the process of transferring a digital video clip onto a hard drive. **Digitizing** occurs when the video

card converts the analog media (audio or video) into digital form. For example, an analog VHS videotape can be captured by outputting the signal from a VHS player into the computer's video card, converting the signal into digital form, and then storing it on the computer's hard drive.

However, some media, such as DV, are already in digital form. Although some producers may refer to the process of transferring digital video through an IEEE 1394 connector (Firewire or iLink) as *digitizing,* in reality no digitizing process is involved. The media is already in digital form, and all that is happening is that the signal (video and audio) is being transferred from DV tape via Firewire to a computer hard drive or from a hard drive onto a DV digital tape.

Capturing or digitizing not only converts an analog signal into a digital one, but compresses the signal as well. (DV signals are compressed when they are recorded by the camcorder.) Files must be digital before they can be encoded into a streamable format. Later, when they are encoded, these files will be compressed again into RealVideo, Windows Media, or QuickTime files to make them streamable.

Video File Formats There are three main digital video file formats: QuickTime MOV files, Windows AVI files (to be replaced soon by the Advanced Streaming Format, or ASF), and MPEG open standard files. Digitized video files are brought into your hard drive in one of these video file formats.

Editing Editing is the process of constructing your completed video project out of individual shots, audio clips, titles, and animation. The guidelines that follow are specifically geared toward producing video for the Web. The first principle to adhere to is to make sure that your video and audio source material is recorded and captured at the highest quality level, because there will be some inevitable quality loss when it is compressed for the Web.

1. *Avoid unnecessary transitions and special effects.* Just as we avoid camera movement and subject motion when shooting for the Web, we must avoid some of the transitions and special effects that we normally use when editing for the television screen. Dissolves, wipes, and other effects look good on the television screen, but they require a lot of bandwidth to transmit via the Internet, and they may not look very good after they have been compressed.

2. *Deinterlace.* The NTSC television system produces an image by a process called interlaced scanning: Two fields are combined to produce a video frame. Conventional video monitors then display this interlaced signal. All video on the Web is going to be viewed on a computer monitor, which uses progressive scanning. If you produce a

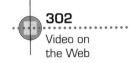

program on a regular NTSC video system (e.g., DV) and are planning
to view it on a progressive scan display (computer monitor), you need
to **deinterlace** the signal. Deinterlacing converts the interlaced fields
of a video frame into a single frame that can be progressively scanned.
In addition, deinterlacing gets rid of the **jaggies** (jagged edges in the
picture) that appear in standard interlaced video frames when they are
viewed on a computer monitor.

3. *Titles.* Titles are part of almost every video, but again, you should not
give them the same treatment that you do in regular video production.
For the Web, keep your titles simple, and avoid any motion. Use as
large a font as is practical because it is likely that your video will be
viewed in a smaller size than full frame on the computer screen.

■ Stage 2: Encoding, Servers, and Delivery

Figure 13.3 presents a model of the principal elements in streaming media
over the Internet.

● **ENCODING AND COMPRESSION** Encoding is a term that is used
to describe the compression of files into specific formats. In the case of on-
demand or streaming video files, encoding refers to the compression (re-
ducing the file size) of those files into video files that can be viewed on de-

FIGURE 13.3 Stage 2 of
the Streaming Process:
Servers and Delivery

mand or via streaming over a network. Keep in mind that any type of compression lowers the quality of the image.

Data transmission rate and file size can also be affected by **frame rate** and **window size.** A regular NTSC video or television signal plays at a frame rate of 30 frames per second (fps) with a window size of 640 × 480 pixels. (DV is 720 × 480 pixels.) Most computers, unless they have special acceleration hardware or software, cannot play a file at that frame rate or window size. Typical for use on the Web are frame rates from 5 to 15 fps (multiples of 5) and window sizes of 320 × 240 pixels (half screen) or 160 × 120 (one fourth of screen), or 240 × 180 (somewhere between half and one fourth of screen). Of course, you can always make it smaller. (See Figure 13.4.)

FIGURE 13.4 Window Sizes

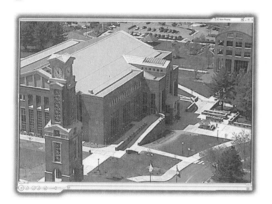

640 × 480 Pixels (Full Screen)

320 × 240 Pixels (Half Screen)

240 × 180 Pixels (Between Half
and One Fourth Screen)

160 × 120 Pixels (One Fourth of Screen)

Once your video has been edited and finalized, you need to create files that are streamable. During the preproduction steps you made some decisions about your audience, what bandwidth you were going to use to deliver your video, and the type of media player that would be used to view it at the user's end. Keep in mind that if you are going to deliver your video from a web server, you will need to create a separate file for each speed that you intend to stream to. If you intend to stream your video from a streaming media server, then you will need to create only one single file with the capability of being streamed at different speeds. This is where codecs come in.

Codec is an abbreviation for "compression/decompression." A codec is a mathematical algorithm that is used to squeeze media files into a smaller format for streaming. Compression occurs during the encoding stage and decompression occurs when the file is viewed at the user's computer. Codecs are also used to prepare files before they are recorded to CDs or DVDs.

There are three widely used video on demand and streaming technologies: RealNetworks Media Player, Windows Media Player, and QuickTime. However, Macromedia Flash Video has been making important inroads as a streaming technology since its introduction in 2002 and has become very popular. These technologies consist mainly of three components: the *encoding software* that compresses and converts the media files to a format that can be viewed by a player, the *server software* that delivers the stream to multiple users, and the *media player* that allows the end user to view (decompress) the media files.

TABLE 13.2 Streaming Technologies

	Developer	Encoder	Server	Player
RealMedia	Real Networks	Helix Producer: Real Video, Real Audio	Helix	Real One Real Player
Windows Media	Microsoft	Windows Media Encoders	Windows Media Server Series	Windows Media Player
QuickTime	Apple	QuickTime Broadcaster Sorensen	QuickTime Streaming Server	QuickTime Player
Flash Video	Macromedia	Flash Video Exporter	Flash Communication Server	Flash Player

The developers of these technologies are continually improving the quality of the encoding and media player products and developing new ones that are making the area of video on the Web more and more attractive to both content providers and end users. Table 13.2 gives a description of the basic characteristics of these technologies. (If you need up-to-date information on these technologies, it is recommended that you visit their websites.) In addition to these streaming technologies, some attention should be paid to MPEG-4 and MPEG-4 Part 10 (also known as H-264), compression technologies that promise to standardize the encoding and delivery for streaming and multimedia in general.

RealVideo RealVideo is a product of RealNetworks. The RealNetworks streaming technology has several components. The streaming media itself is called RealMedia, which can have two separate components: RealVideo for streaming video and RealAudio for streaming audio. RealVideo is a streaming media architecture that offers HTTP and real-time (true) streaming. It is widely used for network delivery of multimedia, especially video and audio. It provides full-screen video and dial-up data rates.

Windows Media Windows Media is Microsoft's streaming architecture that runs only on a Windows server protocol and not on the **standard real-time streaming protocol (RTSP).** Windows Media uses Active Streaming Format (ASF) files and supports true streaming and limited HTTP streaming (progressive download).

QuickTime QuickTime is a multiplatform and multimedia architecture. It runs on Windows and Apple operating systems and supports HTTP and RTSP. QuickTime is widely used to deliver media not only via the Internet, but also to optical storage media such as DVDs and CD-ROMs. Sorenson was the QuickTime de facto codec. Its latest version QuickTime 7 features the H.264 codec.

Macromedia Flash Video Flash is a **plug-in**—a program that is designed to add to or change the functionality or specific features of a larger program or system. The new component just "plugs in" to an existing program and enables it to do additional tasks. Developed by Macromedia, Flash has become the standard for interactive graphics and streaming animation software for the Web. Flash uses SWF files, which are very small. Flash has now added the capability of video streaming by incorporating FLV—files containing audio and video—within the original SWF file. Flash Video uses Flash Video Exporter to encode audio and video to the FLV file format. For live streaming, FLV files are delivered from a Flash Communication Server and can be viewed by using Flash Player.

MPEG-4 MPEG-4 is a standard developed by the Moving Pictures Experts Group, an international committee dedicated to standardizing video encoding algorithms. This group also developed the MPEG-1 and MPEG-2 standards that made possible interactive video on CD-ROM and DVD and the MPEG-3 standard, more popularly known as MP3, that has become a standard for storing and sharing audio files. The objective of the group in developing MPEG-4 is to develop a compression standard that would enable the integration of content production, delivery, and access in the areas of interactive multimedia on the Web, interactive graphics applications, and digital television. More recently the Motion Pictures Experts Group (MPEG) and the International Telecommunications Union (ITU) joined efforts to develop the H.264 or MPEG-4 Part 10 standard. H.264 has a high level of compression efficiency. It can deliver video with the same quality, at half the data rate, as a DVD encoded with MPEG-2, the codec used in standard- and high-definition digital television and in DVDs. In addition, it has a broad range of applications—it can deliver high-quality video across a wide bandwidth range, from mobile phones to HD video.

● **SERVERS** There are two primary ways to stream video over the Web. The first method is the HTTP approach, in which a regular web server provides the content to the end user. The second method is the streaming media server approach, in which the streaming content is supplied to the end user by a highly specialized server.

HTTP Streaming Server In this approach, the video or movie files are placed directly onto a web server. The media files are completely downloaded to the hard drive of the end user's computer, where the files can be viewed at any time and at a higher data rate for better quality.

RTSP Streaming Server RTSP uses a dedicated streaming server that sends the media files as they are requested and does not require that the file be stored on the user's computer as HTTP streaming does. Because RTSP streaming works without saving files to the receiving computer, it is possible to do live streaming, and it is also possible to send files at different data rates (speeds) simultaneously. With this approach, the server and end user can interact during the delivery process. Content that is delivered through this method can also be archived for future viewing.

● **LIVE STREAMING (WEBCAST)** Live streaming, also known as webcasting, is the equivalent of a live television broadcast, except that in a webcast live audio and video are delivered over the Internet. The process for producing a live streaming event, like that for a live television broadcast, requires extensive and careful planning. Efficient preproduction is the key to success.

One important issue that a producer must think about when planning a webcast is what kind of computer hardware and Internet connectivity the target audience has. This is very different from a live televised event, in which the producer does not worry about the type of television set or how the audience is receiving the signal (e.g., over-the-air broadcast, cable, satellite) because it can be assumed that every television set can decode and display the television signal. For webcasters, by contrast, the type of technology the target audience has—bandwidth, computer, connection to the Internet—will determine many of the technical and aesthetic aspects of the streaming event.

Figure 13.5 illustrates one way in which a live event can be streamed and the different elements that come into play for this particular event. Notice that in this case the live signal is encoded onsite and then delivered through the Internet.

FIGURE 13.5 Live Streaming. A Live Event Is Captured and Encoded Onsite and Then Distributed via the Internet.

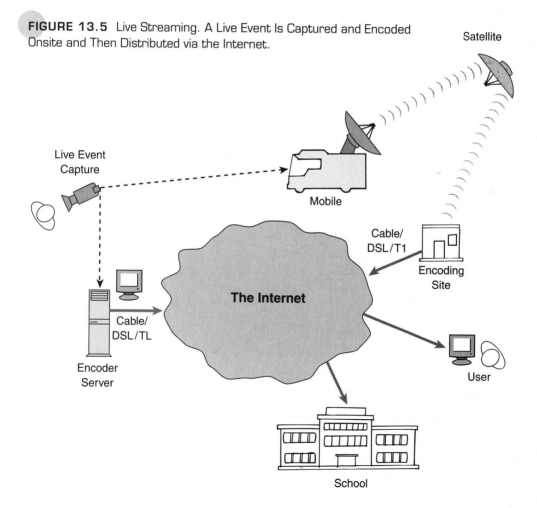

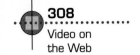

As the technology moves forward and broadband channels become more readily available to home computer users, we will likely see a large increase in the number of live streaming events. Furthermore, as the convergence between video and computers moves them closer to becoming an integrated medium, we will probably be able to receive both television broadcasts and webcasts through the same channel and view them on the same monitor.

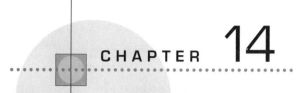

CHAPTER 14

Anatomy of Production

Two Case Studies

The following section uses two case studies to illustrate the procedures and techniques that are used in two of the most common video production situations: multicamera studio production and single-camera field production. These examples have been drawn from two real programs: one produced for cable in a university setting and another produced for broadcast on a regional television network.

The first case examines a multicamera studio production of a presidential election day live broadcast produced by students in an advanced television production workshop. The second case is based on a six day shooting schedule for a nature documentary. Note that in both cases the production model described in Chapter 7 has been applied. Figure 14.1 presents the central elements of the production model.

In the model, the *need* refers to the reason why this program should be produced. The *vision* refers to how the message or content is to be presented (conceptualization, format, audience, etc.). The *technical and aesthetic elements* are the various technical aspects of the production, such as the type of camera to be used, tape format, types of microphones, and lighting control, and some aesthetic issues, such as visualization and composition, lens control for depth of field, and set design. *Formative evaluation* refers to the constant feedback during the entire production process from different sources to ensure that corrective measures are applied to the program when needed. Finally, the *end product* is the finished program and its subsequent summative evaluation, which is used in order to find out whether the objectives that were set out in the initial stages of the production process were achieved.

FIGURE 14.1 Production Model Central Elements

Need ➡ Vision ➡ Technical + Aesthetic ➡ Formative ➡ End
 Elements Evaluation Product

Anatomy of a Live
Multicamera Studio Production

The election day program was a political panel discussion produced by the Eastern Connecticut State University Communication Students' Association and scheduled to be broadcast live on the university's cable channel from 5:00 P.M. to 6:00 P.M. on Tuesday, November 2, 2004. The following case study describes the program from its inception to its airing.

■ The Production Time Line

● **WEEK 1** At the first meeting of COM 420, the directing and advanced television workshop class, the production plan for the program was set in motion. Professor Martinez, the class instructor, firmly believed that one of the most important contributions that she could make to her students' academic and personal growth was to make them aware of their social responsibilities as communicators. Her goal was to help her students to focus on real-world problems and guide them in the use of television to address issues of social relevance. She was also glad that she had an appropriate vehicle to help her implement her teaching philosophy: Channel 22, the university's cable station, which reached a large part of their community and featured community-oriented programming.

Professor Martinez and the fifteen students in her class agreed that the semester's video projects were going to deal with issues that affected the community's daily life. It did not take long for the group to decide that the upcoming presidential elections fulfilled this requirement.

Students Babakar, Carmen, and Therese volunteered to be the producers for the three shows they decided to produce. Two shows were to be cablecast before and after the election. They were to be recorded live on tape in the studio and would include some prerecorded material. As a result, some postproduction would be required to edit these prerecorded segments. One show would be broadcast live.

The first show would be recorded live on tape on October 12, the seventh week of classes, and would air on October 20. The second show would be a live, one-hour show, cablecast on Election Day. The third show would be formatted similarly to the first one and would air two or three weeks after the elections, near the end of the semester. We will concentrate on the production process for the live show.

● **WEEK 2** Because the workshop was also a directing class, Professor Martinez made everyone aware of the amount of time involved in learning how to direct in the studio and how complex the producing part of the project would be. There would have to be a lot of hard work and much disci-

311

Anatomy
of a Live
Multicamera
Studio
Production

pline to accomplish the class's objectives. She emphasized the importance of teamwork and proper planning and the significance of meeting the deadlines established in the planning process.

During this meeting, producers and directors for each show were designated. Babakar volunteered to produce the live show, and he would be assisted by Ivette and Carlos. Ivette volunteered to direct the program as well. Carlos would be the associate director. Jeff and Ann volunteered to work on the promotional aspects of the show. They all believed that if they were engaging in such a large production project, then they would better make their best effort to ensure that somebody was watching the show. The more viewers, the better. That is how television works.

● **WEEK 3** The next step in the production process was to develop and write a proposal for Professor Martinez. The producer, director, and assistant director set out to write the proposal and design the production. For the proposal format they would follow the guidelines presented in the production model. Because most of class time was spent on instruction on directing and producing, the producers had to meet on their own time outside of class to shape their vision and write the proposal.

■ The Production Proposal

● **NEED** The need (justification) for the program was based on the class discussions on the role of television in society, its functions and dysfunctions, and the significance of the upcoming elections in the lives of everyone. In addition, there was the desire to experiment with a live studio production. So far, the students had worked on several live-on-tape productions, but none of them had ever participated in a live production.

Once the need was defined, Babakar, Ivette, and Carlos went to work on the vision statement: how the program was to be presented.
A brainstorming session on formats and content by the production teams for each show ensued.

● **VISION** Ivette was a member of the Communication Students Association, and she was aware that members of the association were planning to schedule a series of panel discussions and debates around the time of the presidential election. She suggested that they could work together to set up a panel that could serve as the basis for the live show.

Babakar agreed to develop a survey questionnaire that would be distributed among the members of the community to find out what issues they were most concerned about. This would help the producers to choose the guests for the panel and develop a list of questions for the hosts. One important element to consider was the fact that the show was to be broadcast at

5:00 P.M., a time by which the majority of votes would already have been cast. Therefore the program content would have six main components:

- Updates on election results taken from different sources, including government and media reports.
- Prerecorded segments on the most important issues at stake at the local and national levels (derived in part from Babakar's survey) and their possible implications as perceived by the panelists.
- Sound bites from polling sites recorded by field production teams using portable camcorders. Babakar thought that they could cover two or three polling sites.
- Questions and answers with the panel of experts.
- There would be public service announcements (PSAs) rolled into the show for "commercial" breaks. They would use PSAs produced in the advanced nonlinear editing class. These PSAs dealt mainly with local and university issues. Some were of a humorous nature, so they would provide a nice break from the discussion and allow for smooth transitions between program segments.
- There would be a dedicated time to receive live calls from the audience.

● **TECHNICAL AND AESTHETIC ELEMENTS** It was decided that the show would be hosted by Mike, one of the students in the class, and Professor Stanley from the Business Department. Professor Stanley had some on-camera experience because he hosted a show produced by the local public television channel. The following production points were agreed on:

- There would be no more than two guests on the set at any time during the show.
- The set should be simple, with four chairs, a picture of the university library tower hanging in the background, and perhaps a couple of small American flags on the side of the set. They would assign the task of designing and acquiring the set pieces and props to Kate and Omar. Kate, who was also a performing arts student, had shown an interest in and talent for set design.
- The lighting, although not completely flat, would be high key.
- There would be prerecorded material: Several three- to four-minute field packages consisting of sound bites from people recorded at various polling places would be used as a way to introduce the points of discussion. This meant that there needed to be a video monitor in the studio for the talent to watch the prerecorded material as it was being played back during the program.

313

Anatomy
of a Live
Multicamera
Studio
Production

- There would be three cameras, and the show would be hosted by a professor and a student.

- There would be a special animated graphic opening. Therese and Jeff volunteered to work on it.

- Babakar wanted to have direct participation from the audience, so telephone lines would have to be set up in the studio to receive live calls from the viewers of the program.

- The show would be taped for future reference on S-VHS and DVCPRO tapes.

- A meeting with Rick, the engineer, had to be set up for the next class meeting in order to resolve technical and engineering matters of the live transmission and to determine all their technical needs for the show. After the meeting with Rick, they would be able to fill out the studio production request form, which would include all the equipment necessary for the production, such as microphones and studio-to-cable connections for the cable feed (the signal to be broadcast over cable).

FORMATIVE EVALUATION It was agreed that at each class meeting there would be a progress report to the class members (the crew) on all of the planned activities and each of the program segments. All prerecorded segments would be viewed by the whole class for class members to provide feedback on content, aesthetic, and technical elements before final editing. There would also be a weekly written report to Professor Martinez documenting the group's progress.

FINAL PRODUCT AND SUMMATIVE EVALUATION The one-hour show would be informative in nature. The live calls would serve as a barometer to assess audience interest in and involvement with the program. The final summative evaluation would consist of group analysis, reflection, and discussion. Professor Martinez's feedback and grade on the project would cap the summative evaluation.

Once the proposal was developed, it was presented to Professor Martinez and the whole class. It was important to receive everyone's feedback because the proposal was in essence the blueprint for the live show. After reviewing the proposal and discussing it with the rest of the class, Professor Martinez expressed her concern that the plan to record sound bites at the polling sites was not very feasible. They would take a lot of effort and would require additional technical and human resources (a remote crew, DVCPRO field kit, vehicles for transportation to and from the polling places, time, etc.) that were already stretched thin because of the complexity of the project. Everyone agreed to this, so the sound bites from polling sites were scratched from the plan.

Using the revised and approved proposal as a guide, Babakar, Ivette, and Carlos created a plan for their weekly tasks and activities leading up to the production day. Following is a summary of the activities carried out during the ensuing weeks ending with a more detailed account of the activities during the day of the show.

■ Back to the Time Line

● WEEK 4

- Meet with Rick to finalize technical details and formalize the final request for access to the studio and airtime.
- Schedule activities and assign principal responsibilities to the production crew.
- Present promotional activities plan.

● WEEK 5

- Present the structure of the show in outline form.
- Present the survey questions to the class for review. Distribute the survey to individuals in the community and analyze their responses.
- Contact professors who could provide advice related to the topics to be discussed.
- Finalize and approve the promotional plan.

● WEEK 6

- Propose guests and topics on the basis of the survey and feedback from the professors consulted about the program.
- Decide on topics for the prerecorded segments.
- Assign team responsibilities for the prerecorded materials.
- Begin promotional activities.

● WEEK 7

- Confirm guests and hosts for the live show.
- Work on scripts.
- Preproduction of prerecorded segments.
- Present to the class the design of the opening animated graphics and the set design of the show for final feedback and group approval.

● WEEK 8

- Production of the prerecorded segments.
- Present preliminary run down.

- Meet with hosts and guests.
- Hosts: Professor Stanley, and Mike, a student.
- Guests: Segment 1: Professors Caldwell and Rojas, Segment 2: Professor Free and Ms. Kim, Segment 3: Mr. Arias and Ms. Willis.

WEEK 9

- Postproduction and viewing of off-line edited segments for feedback before final editing.
- Finish postproduction of opening graphics.
- Finish postproduction of prerecorded segments.
- Finish teaser.

WEEK 10: THE SHOW

Babakar was up early the morning of Election Day. He was worried and anxious. He and his partners had spent a great deal of time preparing for this show. He wanted to succeed. He wanted the whole class to succeed. He thought they all deserved it. Professor Martinez and every student in the class had worked very hard on producing this program. When he first volunteered to be the prime producer of the show, Babakar had not realized the amount of work that would be involved in such an endeavor. But he was glad he had volunteered. So far, it had been a great learning experience, and Professor Martinez had been extremely supportive throughout the entire planning process. Babakar was looking forward to seeing how much progress had been made on the lighting and set when he came to the studio at 2:00 P.M.

The preproduction process had been not only extensive and exhaustive, but also exhausting. This was the only way to overcome Murphy's Law ("If anything can go wrong, it will"). Overall, the class had been very careful and paid meticulous attention to detail during the planning process. The opening graphics, the teaser, and all the prerecorded material had been edited, and they now had three three-minute mini-documentary style packages, produced by classmate teams, ready to be aired.

However, one can never be too careful when dealing with a video program that is going to be broadcast live. Therefore Carlos, Ivette, and Babakar had decided to meet at the nonlinear editing lab at 9:00 A.M. to go over the material and make sure there were no glitches whatsoever. They wanted everything to be perfect. Babakar looked at his watch. It was 7:30 A.M. He had time to drive to school, stop for a light breakfast at the cafeteria, and make it to the editing lab by 8:50. Being on time is very important, but arriving a little early may be even more important. He had worked on many productions in which everyone wished they had a few more minutes to get their work done.

Babakar walked over to his desk, opened his portfolio, pulled out his schedule for the day, and looked it over once again, although he was al-

315

Anatomy
of a Live
Multicamera
Studio
Production

■ **TABLE 14.1** Babakar's Shooting Day Schedule

Editing lab	9:00 A.M.–11:45 A.M.
Lunch	12:00 P.M.–12:50 P.M.
Lighting/set crew	1:00 P.M.–3:00 P.M.
Final script pickup/hosts	1:00 P.M.–1:15 P.M.
Crew call	2:00 P.M.–6:30 P.M.
Audio setup	2:00 P.M.–3:00 P.M.
Producer/director/crew meeting	3:00 P.M.–3:30 P.M.
Test signal out to cable	4:00 P.M.
Run-through	4:00 P.M.–4:30 P.M.
Live broadcast	5:00 P.M.–6:00 P.M.

most certain that he had it memorized by now from working on it so many times. (See Table 14.1.)

He had a good feeling. Everything seemed to be in place, and everyone seemed to be ready. He was excited and confident that all would go well. Rick, the engineer, had taken care of all the technical details; Ivette, Carlos, and Babakar had met the day before with the program's hosts and guests to go over the discussion topics and the information generated from the questionnaires. They had developed a list of questions that would serve as introductory material for each of the topics.

Earlier in preproduction it had been decided that three topics would be discussed during the program. The first show segment would explain the voting process and the role of the Electoral College, which was something that not everyone understood very clearly. The second segment would focus on the economic plans of the presidential candidates and discuss the implications their different plans would have for the country. The third segment would focus on the candidates' views on the war in Iraq.

Putting aside his thoughts, Babakar finished dressing quickly and walked into the bright sun and cool breeze of an autumn morning. He jumped into his classic 1974 Ford Mustang and drove off to his encounter with the long-awaited moment: his own one-hour live television show. Even though he knew how much everyone else had contributed to this production, he wanted to call it his own. After all, he had led the team. It was not selfishness, simply pride and self-respect, and it felt good.

It was 10:45 A.M. when Babakar, Ivette, and Carlos finished reviewing the prerecorded segments. They had adjusted some audio levels and rechecked video and brightness levels. Rick expected very high technical standards to be met for program material that was broadcast on the cable

317

Anatomy
of a Live
Multicamera
Studio
Production

channel. They output the segments from the nonlinear editing system to DVCPRO tapes and sat down to review the rundown and scripts.

Carlos had to leave at 11:40 for his environmental science class but said that he would make it back by 1:00 P.M., when they would meet with the hosts to review the final script. Then he would enter the script into the teleprompter.

Babakar and Ivette pulled out the crew assignment list. They needed to make sure, once again, that every position was covered and that everything was in place.

"Let's go over this one more time," Babakar said.

"It's 11:50. Let's grab something to eat first," Ivette replied. "I'm a little bit hungry, and it doesn't do any good to be hungry on a day like this. The lighting and set crew will come in at 1:00 P.M., and the general crew call is at 2:00 P.M. So let's take a little walk over to the cafeteria and relax for a few minutes. I think we need it."

Babakar agreed. They grabbed their jackets and left the editing lab. 5:00 P.M. was rapidly approaching, they thought to themselves.

At 12:55 P.M. Babakar and Ivette entered the television studio. All was quiet; the studio was empty. They could barely hear the sound of the central air conditioning, but they could definitely feel that it was doing what it was supposed to do. The studio felt very cold.

"Where is the lighting crew?" asked Yvette.

"Relax," said Babakar. "It's not 1:00 P.M. yet. They'll be here any minute now. They know how important it is to stick to schedules."

No sooner had Babakar finished talking when Angel and Robert, the lighting crew, entered the studio. They were followed by Kate and Omar, the set designers.

Robert enjoyed doing lighting very much, and he was very good at it. He had spent much time volunteering to work for Professor Rogers, a lighting expert, on many of his projects, and now everyone looked to Robert for lighting assistance.

Angel did not say anything; he just smiled. He was in good spirits, as usual. He walked into the studio looking at the floor plan and lighting plot that he held in his hand. Then he started to look around, as if all of a sudden the studio was a very unfamiliar place to him. He walked across the studio floor, went into the prop room in the back of the studio, and came back carrying a pack of colored lighting gels.

"Okay, gang, let's do it," he said, handing the lighting plot to Robert and the floor plan to Kate and grabbing the studio lighting ladder himself.

Babakar and Ivette looked at each other and smiled: two less things to worry about. They knew that the lighting and the set would be good. The team had met several times to talk about the lighting plot and set design, and now they knew all those meetings and planning were going to pay off. No finger crossing, just good preproduction work.

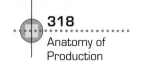
The hosts came into the studio at 1:00 P.M. to pick up their final script so that they could rehearse a little beforehand. They left ten minutes later and agreed to return at 3:30 P.M.

Carlos arrived at 1:15 P.M. He apologized for being late and explained that he had had to talk to his environmental science professor after class about his next project and an upcoming quiz. He went to the control room and started to input text into the teleprompter.

"Okay, Babakar, it's getting closer to show time," Ivette said. "Let's look over the crew list and the rundown sheet. I want to make sure that we have it all together. I'm starting to get butterflies in my stomach."

"Yeah, I know what you mean. Let's do it," said Babakar.

Babakar and Ivette went into the control room and pulled out the crew list, set diagram, and rundown sheet.

Here is the crew list:

1. Babakar: Producer
2. Ivette: Director/assistant producer
3. Carlos: Assistant director/assistant producer (AD)
4. Michelle: Technical director (TD)
5. Carmen: Audio
6. Therese: Character generator (CG)
7. Robert: VTR
8. Jeff: Teleprompter
9. Ann: Floor manager
10. Kate: Camera 1 (1-, 2-shot of hosts)
11. Omar: Camera 2 (LS of set)
12. Angel: Camera 3 (1-, 2-shot of guests)
13. Mary: Telephone coordinator
14. George: Talent coordinator

"We don't have a shot list for the cameras because the shots may vary depending on the dynamics of the conversation," Babakar said, "but I've include basic shots for each of the cameras."

He continued, "The set is sort of an isosceles triangle (two equal sides) with the vertex oriented toward the top of the screen and a small table placed on this vertex and a large picture of the University Tower in the background. The hosts sit on the right side and guests on the left facing the hosts. Camera 1, situated on the left will be getting 2-shots and close-ups of the hosts, camera 2 in the center will have the long and medium shot of the set (the establishing and 'safe' shots), and camera 3 will get 2-shots and close-ups of the guests." (See Figure 14.2.)

319

Anatomy
of a Live
Multicamera
Studio
Production

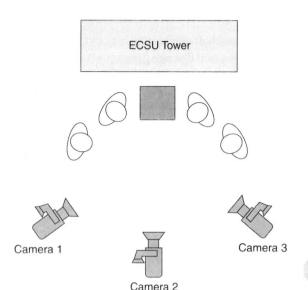

Camera 1

Camera 3

Camera 2

FIGURE 14.2
Set Diagram

Ivette knew all of this because they had gone over the set diagram and script many times, but it was certainly good to review it again. The setup was a good one to follow the conversation and to have reaction shots. She thought that reaction shots were a very important component of the storytelling scheme. She intended to use them as she had in previous projects, and Professor Martinez had always insisted that they do so. "Let's move on," she said to herself.

"Babakar, where are the PSAs for commercial breaks? Have they been logged and timed?" Ivette asked.

"Glad you asked," Babakar answered. "I have the PSAs on a DVCPRO tape in my locker. Yes, they were logged and timed yesterday. I did it with Carlos. So we have two tapes for Robert, the VTR person. Here is the sheet. I'll go get the tapes."

"Good," Ivette said.

When Babakar had returned with the tapes, Ivette said, "Now, let's take a look at the rundown. What time is it?"

"It's 1:35. We should be ready for the crew, Rick, and Professor Martinez when they arrive at 2:00 P.M."

Ivette pulled out the rundown sheet and placed it on the computer teleprompter desk. Babakar moved over to her side, and they began going over the rundown sheet. (See Figure 14.3.)

By the time they had finished going over the rundown sheet and clarified the commands and instructions for the floor manager during transitions between segments, it was 1:57 P.M. They left the control room and went into the studio. Professor Martinez was already there, chatting with

FIGURE 14.3 Rundown Sheet

SEG#	VIDEO	AUDIO	ORIGIN	DUR	CUM. TIME
		INTRO			
1.	Opening Graphics	SOT	VTR#1	0:15	00:15
2.	Welcome by Hosts	mics	set	0:15	00:30
3.	Teaser	SOT	VTR#2	0:30	01:00
4.	Hosts	mics	set	0:10	01:10
5.	PSA Break	SOT	VTR #1	1:50	03:00
		SEGMENT 1: The Voting Process			
6.	Intro S1 Hosts	mics	set	0:30	03:30
7.	Intro Guests	mics	set	1:00	04:30
8.	Prerecorded S1	SOT	VTR#2	3:00	07:30
9.	Segment 1 Panel	mics	set	8:30	16:00
10.	Audience Calls/Update	tel/mics	set	4:00	20:00
11.	PSA Break	SOT	VTR#1	2:00	22:00
		SEGMENT 2: Economic Implications			
12.	Intro S2 Hosts	mics	set	0:30	22:30
13.	Intro Guests	mics	set	1:00	23:30
14.	Prerecorded S2	SOT	VTR#2	3:00	26:30
15.	Segment 2 Panel	mics	set	9:30	36:00
16.	Audience Calls/Update	tel/mics	set	4:00	40:00
17.	PSA Break	SOT	VTR#1	2:00	42:00
		SEGMENT 3: The War in Iraq			
18.	Intro S3 Hosts	mics	set	0:30	42:30
19.	Intro Guests	mics	set	1:00	43:30
20.	Prerecorded S3	SOT	VTR#2	3:00	46:30
21.	Segment 3 Panel	mics	set	8:00	54:30
22.	Audience Calls/Update	tel/mics	set	4:00	58:30
23.	Summary Hosts	mics	set	1:00	59:30
24.	Roll Credits/End	music	CD/CG	0:30	60:00

321

Anatomy
of a Live
Multicamera
Studio
Production

Robert and Angel about the positioning of a key light. Kate and Omar were almost done with the set. They were having a little trouble hanging the large picture of the library tower in the background. Despite this, the set was looking pretty good.

By 2:05 the rest of the crew was in the studio. Babakar gathered everyone together, read the crew assignments again, and sent everyone to take care of their responsibilities. He reminded them that they would meet at 3:00 P.M. The set, lighting, microphones, telephones, and everything else should be in place by then.

Babakar was very concerned about the two telephone lines the telecommunications office had placed in the studio for the incoming calls. Rick told him not to worry. They had already tested the lines, and everything was fine. They would retest again at 3:30, just before the runthrough.

By 2:50 the studio was ready. There had been a couple of bad XLR cables, but after a little troubleshooting, Carmen and Michelle had taken care of the problem. One of the microphones needed new batteries. Carmen did not want to take unnecessary risks, so she had requested plenty of AA batteries. They would do all the testing with the batteries that were already in place. But just before the beginning of the show, she would make sure that each microphone had new batteries installed in it. There was a ten-minute break, and everyone reconvened promptly at 3:00 P.M.

At 3:00 P.M. Babakar, the producer, and Ivette, the director, presided over the meeting. Now the people in front of them were no longer their classmates or friends. They were all professionals about to engage in one of the most complex aspects of television production: a live transmission.

Babakar went over the rundown sheet and explained how the transitions between segments were going to be done. These were critical because they had to change guests—George, the talent coordinator, would have to be alert and on top of things—and reset audio levels in two minutes while the PSAs were playing. Ann, the floor manager, would have to be quick taking off and clipping on microphones. If necessary, Angel, on camera 3, would help her and get back quickly to his camera. His shots were going to be called thirty seconds into the segment, so he would easily have time to frame his 2-shot of the guest.

Ivette was growing anxious. She felt that she was ready, but she still needed to talk to her crew, especially the camera operators and floor manager. She wanted to rehearse some shots and calls with the crew in the studio, make sure each camera operator knew what she meant by each call, and make sure the floor manager would use the proper hand signals to cue the talent. She also wanted to go over the program's opening with Michelle, Carmen, Robert, Jeff, and Therese (TD, audio, VTR, Teleprompter, and CG, respectively). She also needed to get reassurance from Carlos, the assistant director that he had the backtiming calls under control.

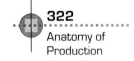

There were some variables that could change the projected time of some of the segments, particularly the segments that involved the telephone calls from the audience. Whatever happened, it was Carlos' job to keep her on track with the time. Backtiming ensures that segments get adjusted on the fly so that they adhere to rundown times and finally to the program time: sixty minutes on the nose.

It was 3:15 now, and the run-through was scheduled to take place from 4:00 to 4:30. Ivette wanted to go over the script and make the necessary markings before the run-through. She quickly ended the meeting and sat down with her camera operators and floor manager. After talking with them as a group, Ivette walked with each camera operator to his or her camera and operated the camera to point out camera angles and framing references.

Babakar sat with George to go over the guest protocols and cues.

The guests arrived at 3:30. A little after that, the hosts came in. George brought them into the studio and had them sit in the set so that Robert could make any minor lighting adjustments that might be needed.

At 3:35 P.M. Ivette came into the control room and went over the opening with everyone. She reminded Carlos once again of the backtiming issue and thought that she had a few minutes to do a fresh script marking, especially for the opening and the introduction to the first segment. Openings were always the hardest, but once you went past that point in the program, everything else would fall into place.

At 3:55 P.M., five minutes before the run-through, Ivette had her script marked and was ready for rehearsal. (See Figure 14.4 and Table 14.2.) She looked at it once again, took a deep breath, and spoke into the talkback mic (a microphone that allows a person in the control room to be heard in the studio): "Five minutes to first run-through." She figured that she would need three run-throughs of the opening and the introduction to the first segment to perfect them.

Carmen and Ann set the audio levels for the hosts and guests, and the speed and brightness of the TelePrompTer was adjusted so that it could easily be read by the hosts. The telephone lines had been tested and were connected to the audio board in the control room.

At 4:00 P.M. everyone was set and ready for the run through. Ivette took her headset and told Ann to alert everyone that the first run-through was two minutes away.

At 4:35 P.M. Ivette was happy that she had planned for three run-throughs. It took three practice runs get the opening right. Now they were only twenty-five minutes away from airtime. She could not believe it. A great deal of the last nine weeks of her life had gone into this production that would last only one hour. "But I still love it," she said to herself.

During the run-through, Babakar was sitting in the darkest corner of the control room. He would occasionally get up, walk up to the audio

board, watch the levels, and walk back to his seat and glance at the papers he held in his hands. Then, realizing that it was too dark to read, he would hold his head in his hands, look at the monitors, and get up and walk again over to the audio board. The pressure of producing this live show was taking its toll, and the program had not yet even started!

At 4:45 P.M., when it seemed that everything was going well, havoc broke out.

"We don't have a signal!" Rick, the video engineer, cried out as he came into the control room and ran to the back of the video console to check the video outputs and cables.

Ivette sighed, took her headset off, and sat down. Babakar jumped from his seat and stood there, in the middle of the control room. Everyone seemed to be frozen in time. But time kept passing.

TABLE 14.2 Ivette's Command Table

Symbol	Command	Action
RVTR1	Ready VTR #1	Alerts VTR operator (Robert) that the tape in the VTR #1 is about to be called for playback
TVTR 1	Take VTR #1	Instructs Robert to hit the play button in VTR #1.
RC2	Ready camera 2	Alerts everyone, especially TD (Michelle) and operator of camera 2 (Omar), that this camera is going to be on air next. Michelle brings C2 to the Preview monitor.
RO	Ready open mics	Alerts the audio person (Carmen) that she is about to switch on the microphones on the audio board.
RQ Talent	Ready to cue talent	Alerts hosts (Mike and Professor Stanley) that they are about to speak.
RP	Ready to run Teleprompter	Alerts the Teleprompter operator (John) that he is about to hit Run on the Teleprompter keyboard.
RK	Ready to key (CG)	Alerts Michelle and CG operator (Therese) that a CG or other graphic over a source of video is about to be inserted.
TC2	Take camera 2 (From now on, the word *camera* is omitted. The director will call "2.")	Instructs Michelle to bring (cut to) camera 2 to air.
RDC2	Ready to dissolve to 2	Alerts the TD that there is going to be a gradual transition from the present video source (VTR 1) to camera 2.

*These commands were introduced in Table 9.2.

FIGURE 14.4 Ivette's Marked Video Script

LIVE SHOW: ELECTIONS
Produced by Babakar
Directed by Ivette
Duration: 60 minutes

Opening Commands
Count down

VIDEO	AUDIO

RVTR 1

Roll VTR 1
STANDARD OPEN VTR 1
T VTR 1 ⟶ SOT

RC2 - RO - RQTalent - RP - RK
Establishing Shot (LS) on C2
TC2 - O - QTalent - P - K ⟶ Mike: Good evening. Welcome to this special program. 60 minutes, live , brought to you on a very special day.

Prof. Stanley : Today is a decisive day on the lives of every American, and why not? Perhaps on the lives of every citizen of the world.

RVTR2

Mike: Let's take a look at the topics we are bringing you tonight.

Roll VTR2
Teaser: VTR 2
T VTR 2 ⟶ SOT
RC1
CU of C1
TC1 ⟶ Prof. Stanley: So these are the issues. There will be answers when we come back after a few messages from our community. Stay with us. We'll be right back.

R VTR 1
Roll VTR 1
PSA Break: VTR 1
T VTR 1 ⟶ SOT

R DC2
LS of C2
DC2 ⟶ Prof. Stanley: Hi, welcome back.
R C1 - RP
Prof Stanley turns to C1
MS of C1
TC1 - P ⟶ Our first segment deals with what is perhaps the most basic question in any type of democratic, electoral process: How does it work?
R C2
LS of C2

TC₂ ————————→ Mike: Today we will be talking to two experts in the electoral process.

RC₁
Mike turns to C1

TC₁ ————————→ After we watch a video on this issue, we'll have some questions for which they will provide answers. You will have a direct line to call us too.

RC₂
Mike turns to C2
LS of C2

TC₂ ————————→ Welcome Professors Jill Caldwell and Francisco Rojas. We thank you for being here today on such special occasion.

RC₃
2-shot of C3

TC₃ ————————→ Professor Caldwell and Rojas teach in the Political Science Department of the University of Connecticut.

RC₁
MS of C1

TC₁ ————————→ Prof, Stanley: How many times have we heard about electoral college and about the complex process by which presidents are elected?. Next, we are going to watch a short video dealing with this issue and when we come back we'll have our two distinguished guests professors to answer questions and clarified these issues for us.

RK

Key CG ————————→ Viewers can call this number : (860) 463-0000 and ask their questions. Let's see it.

RVTR2
ROLL VTR 2
Segment 1 Video: VTR 2 SOT

T VTR 2 ————————→

Rick's words had filtered through the intercom system into the studio. The floor manager and camera operators had been unintentionally informed of the catastrophic news: There was no signal going to the cable transmitter. They all looked at each other and started wondering: Who's fault was it? What was going on? Why was this happening? Did it mean they all would get an "F"? Where was Professor Martinez? The hosts and guests, innocently unaware of the circumstances, sat in their chairs on the set, exchanging thoughts and going over the election updates that George kept bringing in.

Professor Martinez came into the control room and found everyone in distress. Rick was frantically juggling cables and connectors, holding a

radio in his hand and talking to his assistant in the cable broadcast room. Babakar, still standing in the middle of the control room, was staring at Ivette. Both were speechless. Now was the time for some creative problem solving.

Professor Martinez told Ivette to get up, put on her intercom, and tell everyone to get ready—the show was going on. If the worst came to the worst and there was no signal from the control room to the broadcast room, they would start airing the show fifteen minutes late. Segments would be recorded on tape in the studio, hand-carried to the broadcast cable room, and then aired directly from there. For all practical purposes they would still be doing a live show.

Suddenly, they all felt better. Words filtered again through the intercom system. So that's where Professor Martinez was, they all thought. They had not been abandoned to their fate.

Babakar reacted and ran over to the Media Services office to get more DVCPRO tapes. Luckily, the office was just around the corner from the studio.

At 4:55 P.M., just as Babakar ran into the control room holding four videotapes, Rick emerged from behind the video console. Smiling and calmly, he said, "We got it. It was just a connector."

"Two minutes to air time," called Ann in the studio.

Ivette smiled, took another deep breath, and thought, "Well, now it's show time!"

"Camera 1, are you ready?" Ivette asked. Kate pushed the Talk button on her intercom box attached to the back of the camera, and said, "Ready." (Camera operators turn the Talk button on the intercoms *only* when instructed to do so. Otherwise, it is turned off to avoid interfering with the director's commands and instructions.)

"Two?"

Omar said, "Yes."

"Three?"

Angel replied, "Ready"

"Audio? VTR? CG? Teleprompter?" called Ivette as she looked at each person in charge in the control room. They all acknowledged her. They were all ready.

"Quiet in the studio, quiet in the Control Room."

"One minute to air time," called out Ann in the studio again.

"Ready to roll tape."

"Ready to take bars and tone."

"Ready to roll VTR 1."

"Roll tape," called Ivette.

"Tape is rolling and recording," Robert called back.

"Take bars and tone for 30 seconds."

"Lose bars and tone."

"Count down . . ."

"10 . . . 9 . . . 8 . . . 7 . . . 6 . . . 5 . . . 4 . . . 3 . . ."
"Roll VTR 1."
"Take VTR 1 with audio."
So the show was on! (See Figure 14.5.)

327

Anatomy
of a Live
Multicamera
Studio
Production

FIGURE 14.5 The
Show Is On!

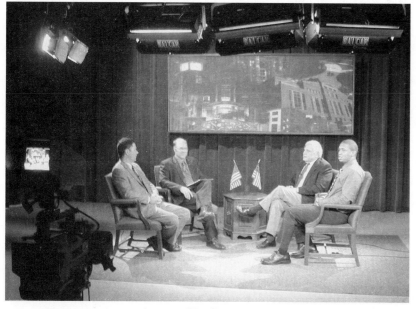

The Set

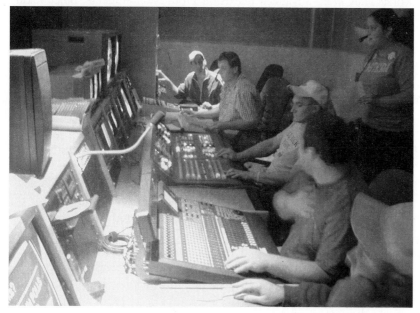

The Control Room

As the first images from the opening appeared on the program monitor, Ivette knew that there was no turning back—not that she wanted to anyway, for she had been waiting for this moment ever since the instant that she volunteered to direct. They were live on the air, and she was in charge. She was proud of herself, and she would make everyone look good. That was the team spirit!

"Ready long shot on C2, ready to open mics, ready to cue talent, ready to key CG, and ready to roll Teleprompter," she called.

"Five seconds," Robert called out. It meant that the fifteen-second opening was about to end.

Ivette had her eyes fixed on the camera monitors, for they represented her windows into the studio. Even though there was a large glass window between the studio and control room, she had no direct view to the studio because the window was blocked by a dark blue curtain. The story that she was about to tell the audience relied on only three views of the reality inside the studio: the images produced by cameras 1, 2, and 3. She would decide which camera would show what and when the viewers would see it. "Cool," she thought. That was a little power. On the other hand, it was also a huge responsibility. She glanced over to the program monitor just as the opening was about to end.

"Take 2, open mics, cue talent, key CG and roll the Teleprompter," Ivette called.

In the studio the floor manager cued the hosts by using hand signals. In the control room everyone's eyes were glued to the program monitor. They were all part of this show. The television production system was at work. They were advanced television production students. Since taking their first introductory class, they had learned and lived by the principle that television production worked like a system—an integrated, organized whole in which groups of individuals working independently but in unison strive to achieve a common goal. Everyone was responsible for his or her own job. The failure of anyone to perform accordingly was a failure for everyone. Good performance by everyone would mean success for all. Their ability to work as part of a team, an essential qualification for anyone involved in video production, was being tested.

Ivette saw the hosts and guests appear on the program monitor with a CG keyed over them. Then on the audio board the audio engineer pressed the On buttons for microphones 1 and 2, Mike's and Professor Stanley's microphones, respectively. The floor manager cued the hosts, the Teleprompter began rolling, and Mike calmly introduced the program: "Good evening and welcome to our special election day live program."

The rest of the show went well. Transitions between segments were smooth. There were nine calls from viewers, which pleased everyone because it meant that were real viewers watching the program. Carlos's back-

329

The Sierra
Nevada de
Santa Marta:
The Making of a
Documentary

timing cues and CG warnings kept Ivette on track, and the CGs kept the viewers informed about who the guests were. By the time the hosts said good-bye and Ivette gave the command to roll the final credits, everyone was exhausted but satisfied that they had accomplished their mission.

Professor Martinez was impressed and happy. Her long hours of dedication and patient instruction had paid off.

Babakar felt a kind of special numbness flowing through his body. "Boy, am I glad this is all over," he sighed to himself. He recalled the many times that Professor Martinez had told them that a live transmission entailed a tremendous amount of preproduction work. However, she had emphasized, one of the best feelings they could ever have was the one after ending a live transmission in which everything went well, because once it was over, it was over. No postproduction.

The summative evaluation still had to be completed, but as far as Babakar was concerned, their work was over. Professor Martinez was right. "What a great feeling," Babakar thought. He moved into the studio with a big smile on his face to congratulate everyone and to help strike the set. He was already thinking about his next project.

The Sierra Nevada de Santa Marta: The Making of a Documentary

■ The Setting

The Sierra Nevada de Santa Marta, located in northern Colombia at the top of the South American continent, rises 19,000 feet above sea level, making it the highest coastal mountain in the world. Its two summits harbor permanent snow and glaciers, yet it is only thirty miles away from the turquoise waters and tropical beaches of the Caribbean Sea.

The United Nations Educational, Scientific, and Cultural Organization (UNESCO) has declared the Sierra Nevada de Santa Marta a "historical patrimony of humanity and a biosphere reserve of the world" because of its unique landscape—a habitat of numerous species of flora and fauna. Despite its beauty and idyllic location, the Sierra Nevada de Santa Marta is a place in which conflict abounds. This has been so for the past four decades. Yet to its native population, engaged in a war of survival against the destruction of their environment and surrounded by conflict between armed groups, the Sierra is *El Corazon del Mundo*—the heart of the world. It is a land of beauty and biological diversity. (See Figure 14.6).

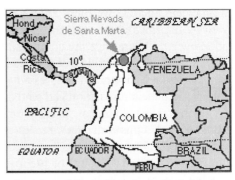

Location of Sierra Nevada de Santa Marta

FIGURE 14.6 Sierra
Nevada de Santa Marta

Sierra Nevada de Santa Marta

◼ The Theme

It was a Sunday in early May. The abrasive sun of the Colombian
Caribbean coast was up, radiating heat and fostering tropical life. The doc-
umentary team meeting was set for 10:00 A.M., and Julio, the documentary
director, knew that he would be late. He came out of his two-room apart-
ment, walked into the bright Sunday morning, and immediately felt the

331
The Sierra
Nevada de
Santa Marta:
The Making of a
Documentary

typical heat and humidity that embraced the city at that time of the year. "How I miss the balmy weather of December," he said to himself.

As he walked past the huge mango tree in the front yard, he looked to the side and found what he was looking for: the large, lime-green iguana that, as usual, was perched on the thickest branch, basking in the sun. It was a good sign. For the past two years he had grown a little superstitious, and the iguana had become his amulet. The few times that he had come out of the apartment and had not seen the iguana, things had not turned out so well.

Julio got into his VW and drove off to meet with the whole documentary team: executive producers, videographer, soundperson, and assistant producer. They were leaving early in the morning for the Sierra for a six-day, three-stage video shoot, and there were still many logistical issues to clarify.

The Sierra was a fascinating place, regardless of the many risks that its geography and its people presented. Although he had been to the Sierra several times, every time felt like a completely new adventure. He remembered the last trip, when he had fallen while trying to get a close-up of a white-tipped quetzal, a species that is native to the Sierra. He hurt his knee badly and consequently was forced to endure a painful two-day mule ride to the town of San Pedro, where there was a vehicle waiting for the video crew. He would be more careful on this trip.

For him this documentary was very special. All of his previous video work in the Sierra had been done either on behalf of an ecological organization or as an assignment for the television network at which he was a producer and director. This time it was *his* documentary. He had had the idea, conceptualized it, researched it, and wrote the first draft of the script, although he was certain that after this trip a major script rewrite would most likely be imperative.

He also had the title for the documentary: "Sierra Nevada: An Island of Life." He thought this was appropriate because the documentary was going to present two different views of life in the Sierra: those of the native Kogis and Arhuacos on one hand and the subsistence farmers and settlers on the other.

The indigenous population, who lived off the land, considered it to be their mission to care for the mountain and preserve the rain forest. The new settlers, who took over the fertile lower slopes of the mountains, deforested a large area for agricultural and grazing purposes. This was just one of the many conflicts in the region, and this was what his documentary was all about.

He was also thinking that he had a tight production time line in front of him. The documentary was scheduled to air on the regional television network on June 7. This meant that he would have only about three weeks for postproduction. He felt a little chill running through his body. Now, more than ever, he needed to think and act on the basis of shooting to edit.

■ The Team

Julio had convinced his friend and producer Carla to work with him on this documentary. She had worked with him on several projects and was very good at doing meticulous planning and conducting thorough research. In addition, she had great people skills, and this certainly would make it much easier to engage the inhabitants of the Sierra. She would also become a great asset in writing the final script.

Along with Carla, there were Nicky, the camera operator; Gino, the audio person; and Becky, the all-around assistant. "What a great team," Julio said to himself.

Nicky was a veteran of the Sierra and had been Julio's camera operator on every previous trip. Julio was grateful that Nicky had decided to take time off from his regular job at the network to come with him. In essence, this would feel almost like a network assignment because Becky also worked for the network. Gino was an independent producer who had become an excellent audio person. He was very well acquainted with field production and was great at capturing ambient sound as well.

Julio had worked with all of them—as a team—with great success while producing a couple of cultural and musical documentaries two years earlier in the Colombian Caribbean islands of San Andres and Providence. Although the Sierra documentary was an independent endeavor, financed by several independent organizations and the Delta Group—a group of local people dedicated to fostering the art of video to improve the quality of life in the region—the network's general manager had donated the use of equipment and transportation.

Julio was excited. Today's meeting would be crucial for the success of the project. He pushed harder on the accelerator, the VW jolted forward, and man and vehicle felt the rush of adrenaline and gasoline, respectively, pushing them onward to a much-anticipated adventure.

■ The Final Preproduction Meeting

When Julio opened the door of the meeting room, everyone was already sitting there waiting for him. Julio apologized for being late (he knew that the director should be the first one to show up at a production meeting), sat next to Carla at the table in the front of the room, and pulled a stack of papers from his briefcase. Even though by that time everyone knew almost every detail of the project and their roles as part of the team, Julio always liked to begin from the beginning. He wanted everyone to be absolutely clear about every step of the process.

"We will spend six days in the Sierra," he began. "We will leave tomorrow at 5:30 A.M., so we will meet here precisely at 5:00 A.M. By the

333

The Sierra
Nevada de
Santa Marta:
The Making of a
Documentary

way, we will be shooting DV not Betacam. We want the equipment and our team to be as unobtrusive as possible, and the Betacam camcorder has a somewhat imposing presence. Keep in mind that we will find electric power only at Alto de Mira station (Mira Heights), our first stop, and then four days later at San Jose de la Sierra, our last stop. Remember that there is no electricity in San Miguel. The Indians there believe only in nature, and as strange it may seem to you city people, electricity is not part of nature," Julio said with a sarcastic smile in his face. He liked to make jokes and tease his teammates.

He paused, looked at Nicky, and said, "Nicky this bring us back to our number one production problem: charging the camera batteries and their rational and efficient use. We'll talk about this later."

Julio continued. "Since we will get everything ready today, it should not take us more than thirty minutes tomorrow morning to load the van and go. A network van will take us to Carmel, at the bottom of the Sierra. In Carmel there will be another vehicle that will take us a few miles up to Pueblo. From there we will walk and ride mules to the Alto de Mira station. We should be arriving around 6:00 P.M. Are there any questions?"

There were no questions. Everyone had made the trip before and pretty much knew the routine to get to Alto de Mira.

"We have secured permission to videotape from the Mamo, their tribal chief and spiritual leader, and the settlers," Julio continued. "Also, the Nature Conservancy people staying at Alto de Mira sent us a message saying that we could interview them," Julio said, and looked at Carla, as if waiting for her to corroborate his statement. Carla nodded in confirmation.

"We have also secured permission from the two armed groups that we are most likely to encounter. Our contact in the Sierra just confirmed that they have no objections to our presence in the area as long as we videotape only our own business. So if we encounter any member of these groups, do not, I repeat do not, videotape them or approach them to ask questions about their business. As a matter fact, if we need to approach them for any reason, let Carla or myself do it."

Julio knew that this was something that could never be emphasized enough. He had seen and lived through some very uncomfortable situations because of a camera operator photographing something or someone without clearing it first with whoever happened to be in charge of the place. That was one of the most important rules to follow in shooting in a foreign or hostile environment.

"As a matter fact," he continued, "if you find yourself in a situation when I or Carla are not around, and you are not certain that we have permission to photograph there, don't do it until you get confirmation—no matter how important or visually rich the subject seems to be." Julio was now looking at Nicky, the camera operator. This message was directed mainly to him.

"We will shoot in three stages, two days each," Julio continued and repeated himself: "In the first stage we will interview some Nature Conservancy members about the importance of the Sierra as an ecosystem at the Alto de Mira station and get shots of the fauna and flora around there. During the second stage we move up to San Miguel, in the indigenous territory, and interview the Mamo—the Chief—Jose and some of the natives as they are working their crops." He paused, opened his notebook, and looked at some of the notes he had made the night before when going over the whole schedule and structure of the project. The natives' testimonials should reflect their religious beliefs, which he knew were linked to their idea of maintaining a harmonious relationship with nature. (See Figure 14.7.)

"Again, we videotape only when we are told we can. We'll spend the night in San Miguel and move on early the next day to San Jose de la Sierra, for the third shooting stage. Here, we'll photograph and interview settlers and the environment. We were told that they are cutting down trees and clearing the forest around this area. We expect to head back about noontime on Saturday, and we should be getting back into the city by

FIGURE 14.7
Sierra Natives

335

The Sierra
Nevada de
Santa Marta:
The Making of a
Documentary

7:00 P.M. Carla has made arrangements for food and lodging for the journey, so we should not have any problems with this. She will give us more details in a minute."

The meeting went on. Carla spoke next. She went over all the logistical arrangements. She also gave a description of the different geographical aspects of the areas they were going to visit and reminded them all that they were in for a long walk carrying video equipment and personal effects, so they should travel light. After all the logistics were reviewed and the production issues were clarified, the meeting broke up.

Julio walked with Nicky and Gino to a corner of the room where the equipment bags were located. He wanted to go over equipment with them and make sure that everything they needed was there and functioning properly.

First, they went over the audio equipment. They were planning to record two types of sound: interviews and ambient sound. For the interviews they had decided that whenever possible, they would use a boom—a long pole—with a dynamic, unidirectional microphone attached at the end. The ruggedness of dynamic microphones was very suitable for the task at hand. Each microphone had a windscreen because it often gets very windy in the mountains.

They were also taking with them the wireless kit, which included a lavaliere and a cardioid microphone with three sets of new AA batteries for each. The lavaliere would be used for interviews indoors if the use of the boom was not practical.

The shotgun microphone was ideal for ambient sound pickup. Gino was very good at this, especially in tropical forest environments. He would sit or stand patiently with his portable mixer, headset on, and shotgun mic in hand and listen very carefully to where all the sounds were originating. He would first slowly scan the air with the microphone as if to ascertain the type of sound and establish levels. Then he would tell the director what he thought should be done.

Directors had learned that most of the time Gino would record a very rich and exquisite blend of natural sounds captured on either a DAT recorder or the camcorder videotape. Julio went over the possible audio scenarios with Gino and Nicky and asked Gino for the list of the audio gear he was bringing. Gino commented that he had tested all the equipment early that morning and produced the following list:

1. Boom pole
2. Portable mixer
3. Headphones
4. Wireless mic kit: cardioid, hand-held, and lavaliere mics

5. Wired lavalieres (2)

6. Wired cardioid mics (2) to be used on the boom in interviews

7. Supercardioid shotgun mic (to pick up natural sound)

8. XLR cables: two (2) 25-foot and four (4) 10-foot

9. Audio adaptors

10. AA batteries

Julio read the list and could not think of anything else to add to it. Next, he said to Nicky, "Let's take a look at your list, and then we need to talk a little about aesthetics." Nicky knew that the aesthetics part would be coming. It always did. He had been a camera operator for Julio on several projects in many different locations, and he had come to know his professional style pretty well. Julio always dedicated time before production started to discuss with his team the conceptual aspects of the project followed by the aesthetic and technical elements and how to achieve the desired look and feel of the show. In that way, he believed, everyone was aware of what he wanted and could make significant contributions to the final product.

"Here is the list," Nicky said. "Everything has been tested and retested. All the batteries are fully charged. But let's go over it once again. So, Julio, read the list out loud, and I will pull each item to make sure that everything is in order."

Nicky gave the list to Julio, and they began going over each item in the list. The list looked like this:

1. One 3-CCD DV camcorder

2. Tripod

3. Batteries (12)

4. Headset

5. DV tapes (20 @ sixty minutes each)

6. Lighting instruments (one 350 watts and one 650-watt Fresnel)

7. Blue and amber gels (for color temperature matching)

8. Diffusers and reflectors

9. Video field monitor

"Looks good," Julio said. "Keep in mind that we can charge batteries only at the Alto Mira station and San Jose de la Sierra. Even so, there are only a limited number of outlets we can use, probably one or two at the most. This means that we can only charge about four batteries during the

337

The Sierra
Nevada de
Santa Marta:
The Making of a
Documentary

night. Have Becky charge the batteries as soon as you change them, if possible." Julio continued talking about some of the technical logistics, mainly the problems posed by the lack of electrical power.

"Aesthetically, there are three main points I want to emphasize." he told Nicky. "First, depth of field. Use long focal lengths so that we get minimal depth of field. I want sort of blurry backgrounds when shooting the testimonials. This means keeping your lens diaphragm as open as possible, somewhere between f-16 and f-4.0. In any case this might be necessary because of the low light in some of the indoor locations."

Julio paused, folded his hands together, bowed his head down, collected his thoughts, and then after a few seconds looked back at Nicky and continued: "When we shoot nature, then I want to reverse the depth of field issue. We use f-16 or higher. We want to show the magnificence and magnitude of the landscape." Another pause.

"Our second aesthetic point is lighting," Julio said. "We want to use natural light whenever possible. We'll use the lighting instruments only when absolutely necessary or as a means to add head lights or kick lights. Otherwise, we'll use natural light and reflectors." Julio knew that all of this would ultimately be decided in the field, during the actual shooting. But he thought it was always good to give your camera operator this information well in advance. Even the audio person should be aware of the expectations for the visual treatment. For Julio the more each member of the team knew about the other members' aesthetic and technical requirements, the more they could support each other.

"The third major aesthetic concern," Julio continued, "is camera movement. For interviews or testimonials we will use the camera mounted on the tripod. However, there will be some times when I will call for a hand-held camera, *cinema verité* style. At this point, the camera will no longer be an observer. The camera will become intrusive and a participant in the scene. Of course, this will be decided according to the circumstances of the moment, but I want you to be prepared. Other than the interviews, there will be no chance for repeating or staging the action, so always stay alert and be involved in the situation."

Julio slowly started to get up from his chair, and Nicky and Gino knew that their little chat was about to end. "Even during the interviews it will be difficult to ask the subject to go back and repeat something, as those are spontaneous statements and we want to keep them that way." Julio was now standing in front of Nicky and Gino. He looked at his watch.

"It's 3:30 P.M. and I have a few things to take care of. Finish packing the equipment and get everything ready to be picked up and loaded, and I will see you at 5:00 A.M. tomorrow. Don't forget your water canteen, flashlights, and mosquito repellent." (See Figure 14.8.)

FIGURE 14.8 On the
Way to the Sierra

■ Stage 1: Alto de Mira

As planned, the documentary team arrived at 6:30 P.M. at the station. The station was an Indian settlement built more than 500 years ago. Larger Indian settlements were built along ridges for visibility and exposure to sunlight, with a large number of terraces for draining and controlling rainwater. The station had been unearthed and partially restored, and it served now as a base for many ecological and academic organizations that came to the Sierra to study either the ecosystem or the social system of the Sierra natives.

Julio and the crew were greeted by the station caretakers and introduced to the Nature Conservancy members and Hans Klauss, a German biologist and professor at the University of Lundgrem, who was visiting the station. After unpacking, they ate a frugal meal, socialized with the people at the station, and set up the shooting schedule for the next day. Then they all went to bed. It was 10:00 P.M.

Julio awoke at 5:15 A.M. and immediately rose. He was the first one up. He loved to see dawn in the Sierra. He took a quick bath (two buckets of cold water poured over his body with a large wooden ladle), brushed his teeth, and came out of the barracks to his dreamy rendezvous with a Sierra dawn. (See Figure 14.9.)

By 9:00 A.M., after having had breakfast, including a large cup of tasty Colombian coffee, the team was ready to interview the two members of the Nature Conservancy and Professor Klauss. Two of those interviews would be in English and would have to be translated. Julio would decide later whether they should be dubbed to Spanish, translated, and delivered with the narrator's voice-over, or whether he would simply use captions for the translation.

339

The Sierra
Nevada de
Santa Marta:
The Making of a
Documentary

He figured that each interviewee would speak for about ten minutes. He had already picked out three different spots around the station for the interviews. They would spend the morning shooting the interviews and finish up just before lunch. The afternoon would be dedicated to capturing the flora and fauna around the station. Then they would pack and get ready for the next day. They were leaving at 6:00 A.M. and would walk for about six hours to San Miguel. He figured that they would arrive a little before 1:00 P.M.

It was a very bright morning. They would have to watch out for harsh shadows. The first interviewee was Roger, a biologist with the Nature Conservancy. He was very tall and had very light skin. Julio had found an appropriate shaded spot under a large tree. The camera and boom mic were set. Gino ask Roger to speak in normal voice so that he could set the audio level. Julio stood behind the camera and looked through the viewfinder. He showed Nicky the framing he wanted. Nicky set the lens iris at f-5.6. Becky put new batteries into the microphone, and two minutes later the interview with Roger was videotaped. The interview with the second Nature Conservancy member was about the same, except that it was recorded in a different spot to provide some variety in the background.

The videotaping of Professor Klauss turned out to be more complex than the previous interviews. Julio wanted him to start while standing at one place, then speak and walk slowly about twelve feet toward a very special plant. There he would stop and kneel down while holding the plant's flower, and Nicky would slowly zoom in to a close-up of the flower.

After that take, Professor Klauss would sit in another spot, with the Sierra as a background, and talk some more. For this take Gino recommended that they use the wireless lavaliere. After a couple of rehearsals they tried the real thing, and it came out nicely. The first take was a keeper.

This ended the morning shoot. They collected all the equipment, brought it back to the station, and set it on the floor in a corner, ready to be picked up after lunch for the afternoon shoot. Becky placed two camera batteries on the charger.

FIGURE 14.9
Dawn in the Sierra

■ Stage 2: San Miguel

They arrived in San Miguel a little after 2:00 P.M. the next day. (See Figure 14.10.) The journey had taken longer than they expected because they had stopped several times to videotape the landscape, flowers, and fauna. They had encountered a couple snakes and several colorful birds. They were greeted by a member of the tribal council and were taken to a special tent that the Indians used to accommodate visitors. No visitor was allowed to stay in a native house or hut.

The Mamo (chief) lived on the outskirts of the village in a very small hut. Once they were settled, they received the message that he would see them at 4:00 P.M. From 3:00 P.M. to around 4:00 P.M. they videotaped the village, houses, people, animals, pets, and so on. They arrived at the Mamo's hut precisely at 4:00 P.M. He was sitting outside his hut waiting for them.

Julio told Nicky to set the camera at an angle, pointing up to the top of the hut. When the Mamo started to speak, Nicky was to begin a slow tilt down, frame up a medium shot on Julio's signal, and then zoom in to a tight close-up when Julio signaled again. The testimonial went very well. They would stop taping, talk to the Mamo for a little while, and then start taping again. They ended about 5:00 P.M. and had about 25 minutes of recorded material with the Mamo.

FIGURE 14.10
The Village of San Miguel

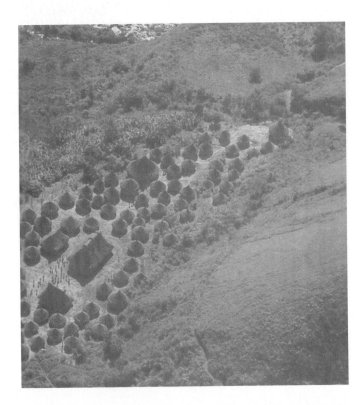

341

The Sierra
Nevada de
Santa Marta:
The Making of a
Documentary

The next morning (Thursday) they were all up at 6:00 A.M. Breakfast was a cup of juice and some bread. Indigenous people did not drink coffee.

They videotaped the crops, got some testimonials from some of the Indians, and then packed and were on their way by noon. They had another six-hour walk to get to San Jose de la Sierra, and Julio wanted to get there before dark. So they were cutting it close, but if they walked at a steady pace, they could make it. Any more videotaping of nature would have to be very limited.

■ Stage 3: San Jose de la Sierra

The next day Carla was the first one up. It was 5:30 A.M., and she just could not sleep any longer. She felt very tired. The team had arrived in San Jose at 6:30 P.M. the night before, just before dark. It had been a long walk. They had stopped only to shoot a couple of times and only for a few minutes. The rest of the time it had been uninterrupted walking. She was glad that this was the last day of shooting. Tomorrow, Saturday, they would start their journey back to the city at 9:00 A.M.

After a quick breakfast Julio and Carla met with some of the settlers and began to set up the interviews and the videotaping of the surroundings. They wanted to photograph the settlers cutting down some very large trees. At first, Julio and Carla thought that the settlers would object to the team showing them bringing down the trees. Deforestation was a very sensitive issue.

However, the settlers—*colonos,* as they called themselves—wanted the issue to come to the light of the public outside of their region. They claimed that they understood the ills of deforestation, but as much as they had discussed this issue with government representatives and environmental advocates, they had not been given any viable alternatives for their subsistence.

By 10:00 A.M. they were taping the testimonials. It took until noon. At 1:00 P.M. they began taping the town and its surrounding. At 3:00 P.M. one

FIGURE 14.11
Tree Cutter

of the settlers took them to the area where they were cutting down trees. Julio decided that after a few establishing shots with the camera on the tripod, it was time to tape with a hand-held camera. He wanted to ask questions to the settlers in the field who were sweating and covered with wood chips from cutting the trees. (See Figure 14.11.)

Nicky walked around with the hand-held camera and photographed the tree cutters at work with hatchets and chain saws. Some of them stopped to say a few words to the camera and continued with their activity. Soon it was 4:30 P.M. and all activity ceased. The tree cutters were done for the day, and so were the documentary makers. The next day, the team would head for home.

■ Postproduction

Julio and Carla spent the next week logging the video footage and structuring the final script. They would write the final script after all the logging was done and they had seen all the footage available. The journey to the Sierra had yielded eight videotapes with sixty minutes of material on each. The video footage and audio were mostly good. If they needed something that was not there, Julio could use footage from the network's video archives.

Ramiro and Vicky would be working with them in postproduction. Ramiro would work on graphics and special effects, and Vicky would do the editing in a nonlinear system. It was all set for next week. Julio thought that the whole postproduction process should take about two weeks. The program was scheduled to be completed just three days before the scheduled broadcast on June 7.

■ June 8

The documentary team met at Julio's apartment at 6:00 P.M. "Sierra Nevada: Island of Life" had aired the night before, and Julio had received many calls from friends, environmentalists, government officials, academicians, and people in general to commend him on the documentary. It had been a complete success in terms of both content and video making. The regional newspaper had called him. They wanted to do an in-depth interview with him about the Sierra and the documentary. He was happy, and he wanted to share that with his team. Everyone had worked very hard on this project and had contributed to its success. Julio raised his glass filled with champagne and toasted his crew: "Here's to the Sierra and its people . . . to the documentary . . . and to you."

A Brief History of Audio Recording Media Technologies

Audio recording media technologies have been in use for over one hundred years. Following are brief descriptions of some of the most popular recording media and recording technologies that were developed during that time. For our purposes we have placed them into two categories—analog and digital—along a time continuum. (See Figure A.1.)

The Age of Analog Audio Recording

Because most analog recording technologies and media are based on magnetic tape technology, we can describe the first stage of audio recording as the magnetic tape era. (We should note, however, that some digital recordings are also done on magnetic tape.)

The concept of magnetic storage was developed in 1894 by the Danish telephone engineer Valdemar Poulsen of the Copenhagen Telegraph Company while trying to record telephone messages. In 1898 he patented the first magnetic recording device, known as the telegraphone. At the 1900 Paris Exhibition Fair he recorded the voice of the Emperor Franz Joseph of Austria. This recording is still preserved at the Danish Museum of Science and Technology as the oldest magnetic sound recording.

In 1935, during the Radio Fair in Berlin, the German company AEG Telefunken introduced the magnetophone, the predecessor of today's magnetic tape recorder. Magnetic tape had been developed and provided by BASF, another German company in 1934. (Before the development of magnetic tape, early recordings were done on metallic drums.) The AEG's magnetophone made its debut as a recording device on November 19, 1936, with a performance of the London Philharmonic orchestra in Ger-

344
• • • • • • • • • • •
A Brief History
of Audio
Recording
Media
Technologies

many. Since then many different sound-recording technologies have been developed, and many different media formats have been introduced into the marketplace. Some of the most important ones are described below.

The Reel-to-Reel Format

Originally, this magnetic tape format had no name because it was the only format available in the market. Its name came about as a way to differentiate it from other types of tape media that were introduced in the early 1960s, such as cartridges and cassettes. Reel-to-reel became the standard recording media in professional audio and radio studios until it was supplanted by the development of digital optical disc and hard drive recording technologies. Because of the width of the tape and its frequency response, this technology allowed sound technicians to edit the tape and to record with a high degree of sound fidelity. Reel-to-reel consumer formats were also widely used in the home market throughout the 1960s and 1970s.

8-Track Cartridge

Introduced in 1966, the 8-track cartridge was developed by a consortium that included Ampex (best known as the U.S. company that invented videotape recording in 1956), Lear Jet, and RCA Records. First introduced as a car accessory, it was later marketed as a home system. The 8-track car-

FIGURE A.1 Recording Media Time Line

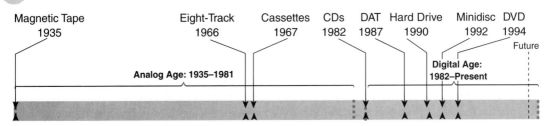

Analog Age	
Magnetic Tape	1935
Eight-Track	1966
Cassettes	1967

Digital Age	
CDs	1982
DAT	1987
Hard Drive	1990
Minidisc	1992
DVD	1994

tridge technology was preceded by a 4-track version introduced in 1956 that disappeared with the introduction of the 8-track format. The 8-track format was notable as the first tape format that was marketed to take advantage of prerecorded material that could be played and listened to while driving. Portability became its greatest asset. Both 4- and 8-track cartridge technologies all but disappeared in the early 1980s and are found today only among collectors and in a few radio stations at which the old analog "cart" machines are still used to play back commercials and music.

■ Audiocassette

Audiocassettes were introduced in 1963 by Phillips and marketed as a low quality-recording device for voice dictation. Later improvements in the technology, including Dolby's hiss reduction technology and metal particle tape coatings, and the introduction in 1978 of Sony's Walkman, a small portable cassette player, made the compact audiocassette the most popular, almost universal, device for listening to prerecorded music. The Walkman also enabled home recording, a practice that was condemned and bitterly fought against by the music industry. Audiocassettes came in several different sizes and formats and were also widely used for purposes other than music listening and recording. Some of those uses, such as interview recording by journalists and classroom lecture recording, mimicked the initial voice dictation use envisioned by Phillips. Cassettes were displaced by the development of the compact disc (CD).

The Age of Digital
Audio Recording

Digital audio, as described in Chapter 5, refers to the digital reconstruction of the physical (analog) audio waveform. The telephone industry pioneered the use of digital recording technology to digitally compress telephone conversations so that more voice data could be handled by the narrow bandwidth of the available telephone lines. Since the early 1980s, when the CD format was first introduced, digital recording technology has been widely used in both the professional and consumer markets.

Digital recording media comes in many different flavors, each supported by a different technology and a different format. Despite differences in technology and media, two very important characteristics of the digital formats are that there is no generation loss (degradation of sound and video quality from copy to copy) in digital transfers and that they provide for fast random access to the recorded material.

346

A Brief History
of Audio
Recording
Media
Technologies

■ Compact Disc (CD)

Introduced to the public in 1982 by Sony and Phillips, CDs have become one of the most convenient and most popular ways to store music and information (data) in general.

CD optical technology uses a red laser at a wavelength of 650 to 780 nanometers to read the recorded material. CD audio technology is based on a 44.1-kHz audio sampling rate at 16-bit quantization. Audio CDs are used to play music in cars, portable CD players, and home audio systems. The **CD-ROM,** which stands for "compact disc–read only memory," became the leading technology for multimedia use with prerecorded CDs. The CD-R, which stands for "compact disc–recordable," is used to record music and data in home audio systems and personal computers. Practically every computer nowadays incorporates a CD recorder, popularly known as a CD burner.

CD-R discs can be recorded onto only once. CD-RW (compact disc–rewritable) can be recorded over several times. Most CD devices in computers allow you to listen to audio CDs and to view data CDs. However, you should be aware that there are some issues of physical compatibility because of the optical characteristics of the different types of discs that may prevent one type of disc from being read by all drives or players.

The storage capacity for a CD-ROM is 640 megabytes (MB); for an audio CD it is 740 MB.

■ Digital Audio Tape (DAT)

Introduced by Sony in 1987, DAT is similar in appearance to a regular audiocassette but only half the size. The DAT recording standard does not use data compression. As a result the digital copies are identical to the source from which they were created.

DAT recorders can record audio using four different sampling rates: 32 kHz at 12-bit quantization and 48, 44.1, and 32 kHz at 16-bit quantization. Some special recorders can record at 96 kHz and 24-bit quantization.

All DAT standards use the same type of tape, with the length of the recording depending on the quality of the sampling. For instance, the same tape will allow for a longer duration of recording when sampling media at 32 kHz and 12 bits than when sampling at 48 kHz and 16 bits.

DAT recorders are used principally in the professional and semi-professional music and video recording fields because of the quality of the sound recordings. In addition rewinding and forwarding the tape are very fast, thus facilitating access to any segment on the DAT tape.

DAT technology uses a recording method that is similar to what is used on video recorders: Rotary heads scan the tape helically and record the tracks of audio information diagonally on the tape.

DAT tapes are also used by the computer industry to store data backups. The storage capacity of a DAT is 1 gigabyte (GB).

Minidisc

Introduced by Sony in 1992, minidiscs can be prerecorded or recordable, similar to a CD. Minidisc media come in 60-, 74-, and 80-minute discs and have several recording options: the standard CD-quality mode, also known as SP; MiniDisc Long Play, or LP2, which doubles the recording time of a regular cassette (160 minutes on an 80-minute cassette); and LP4, which allows four times more recording than the conventional SP mode (320 minutes on an 80-minute cassette). The quality of the sound that is reproduced will depend on the recording mode that is used, with SP producing a high-quality, CD-like sound and the LP4 mode producing a medium-quality sound.

Minidiscs are used in home audio systems, in portable devices, for studio recording, and in car systems. In 2004 Sony introduced the Hi-MD format (fully compatible with the MD format), which can store up to 1 GB of music, images, or data and can record up to 45 hours of high-quality music.

Hard Disk Recording

Hard disk recording is the process of recording and storing audio on a computer hard disk drive. In the not-so-distant past, hard disk recording was associated with expensive studio equipment that was available only to professional audio engineers. Today, a variety of reasonably priced computer-based software and hardware are available in the consumer market.

In hard disk recording, audio is recorded to a computer hard disk drive via a sound card from an analog source, such as an audiocassette or a microphone, or from a digital source, such as a DAT or a CD. Recording capacity is determined by the size of the hard drive in the computer and the free space available on the drive. Hard disk recording devices are also known as digital audio workstations, which are discussed in Chapter 5.

DVD

CD laser technology served as the basis for the development of DVD technologies. Introduced in its first version by Pioneer in 1994, DVD, like CD, is an optical disc storage media system that is used today mostly for high-quality playback of movies. Originally, DVD stood for "digital video disc," but as its uses diversified to include data and high-definition sound, the name was changed to "digital versatile disc." DVD drives are backward compatible with CDs, which means that they can read most CD formats. This makes DVD players and recorders likely replacements for CD drives.

Like CDs, DVDs come in several formats. Although most of today's DVD players can read almost all of the important formats, some compatibility issues remain. The most common DVD formats are as follows.

348

A Brief History
of Audio
Recording
Media
Technologies

Pre-recorded DVD-ROM ("DVD read-only memory") discs are used mostly for multimedia applications and computer games. DVD-ROM discs can be viewed on both computer screens and televisions. DVD-ROM is backward compatible with the CD-ROM format and forward compatible with future recordable (R) and rewritable (RW) DVD formats.

DVD-RAM ("DVD random access memory") is a rewritable format; it is not compatible with most other DVD drives and players.

DVD-R ("DVD minus recordable") discs can be recorded onto only once but have a high rate of compatibility with older DVD drives and players.

DVD+R ("DVD plus recordable") discs have technical standards similar to those of the DVD-R and are partially compatible with it. The plus and minus signs have to do with different sets of technical standards used to record the discs. About half the industry supports one format, and the other half of the industry supports the other format.

DVD-RW ("DVD rewritable") discs are rewritable, but they have little compatibility with older DVD drives and DVD players.

To protect marketing strategies, most commercial DVDs have a regional coding that makes it impossible to play a particular disc in different regions. There are six regions in the world as follows:

- Region 1: United States, Canada
- Region 2: Europe, Japan, Middle East, South Africa
- Region 3: Southeast Asia, Taiwan
- Region 4: Australia, New Zealand, Central and South America, Mexico, Pacific Islands, Caribbean
- Region 5: Russia, India, Pakistan, part of Africa, North Korea, Mongolia
- Region 6: China

The next generation of DVD technology will most likely see the development of HD-DVD, which stands for "high-definition or high-density DVD." These systems will use "blu ray" technology (a blue laser with a wavelength as short as 400 nanometers) and will be able to store several more times the amount of information than the current versions are capable of storing.

A/B-Roll Editing: The technique of rolling two source VCRs (the A machine and B machine) simultaneously while editing to perform special audio or video effects.

AC Adapter: A device that is used to convert alternating current (AC) to direct current (DC). Most portable video equipment requires the use of an AC adapter to convert regular household current to DC.

Active Streaming Format (ASF): The file format used in Windows Media to store and deliver media over the Internet or any other network.

Additive Primary Colors: Red, green, and blue are the additive primary colors of light. A color separation system based on these primary colors operates in all color video cameras.

Aesthetic Elements: Production variables and the ways in which they can be manipulated to affect audience response to the video message.

Alternating Current (AC): The type of electrical power that is supplied to households in the United States and Canada.

Ambient Sound: Natural background sound.

Amplitude: The height of a wave. With respect to sound, amplitude determines the intensity or loudness of the sound.

Analog Signal: A signal that is continuously proportional or analogous to the input.

Aperture: The size of the iris opening of the lens, usually calibrated in f-stops.

Aperture Ring: A device that controls the size of the iris opening (aperture) of the lens.

Arc: Semicircular movement of the camera and its support around a scene.

A-Roll: Interview footage with sound on tape.

Aspect Ratio: The relationship of the width of the television screen to its height, expressed as a ratio of 4:3 or 16:9.

Assemble Editing: (1) Linear videotape editing mode in which new control track and audio and video information are recorded onto the tape in the editing VCR. (2) The process of adding new information to a tape shot by shot, or scene by scene, in sequence.

Associate Director (AD): The production team member who is responsible for keeping track of the overall time of a program and its individual segments.

Associate Producer: The assistant to the producer who assists with financial, logistical, or creative matters.

ATSC (Advanced Television System Committee) Standard: Technical specifications for U.S. digital television set by the ATSC and adopted by the FCC in December 1996.

Audio: Sound that has been changed into electrical signals so that it can be recorded, transmitted, and replayed; the sound portion of a video program.

Audio Board: Equipment that combines a number of independent audio inputs into one output signal; also called the *audio mixer*.

Audio Tone: Reference audio signal used to set audio levels on audio and video recording equipment.

Audiovisual Semantics: The meaning that is conveyed to the audience by the arrangement of the production elements in a program.

Audiovisual Syntax: The purposeful arrangement of sound, color, text, and images in a video program.

Automatic Aperture: An electronic device that automatically sets the lens iris for correct exposure in the available light.

Automatic Focus (Autofocus): An automatic focusing device on some cameras; operates by emitting a beam of infrared light or ultrasound.

Automatic Gain Control (AGC): An electronic device that automatically adjusts the amplification of an audio or video signal. See also *Manual Gain Control.*

Back Focus: A camera focus adjustment that ensures that an image is in focus at the lens's widest angle of view.

Background Light: Light that falls on the background of a scene, often used to create mood or indicate time of day.

Back Light: Hard, focused light above and behind the subject that is used to separate the subject from the background by outlining the subject with a thin line of bright light.

Backtiming: A technique used in live or live-to-tape-shows to make sure that the planned running time for a show is adhered to. The Associate Director keeps track of how much time is left until the end of the segment or show, and the Director then shortens or stretches the segment or show length to meet its planned length.

Balanced Line: A professional-quality audio cable or connector with two signal leads and a shield that protects the signal from outside interference.

Barn Door: Metal flaps that are attached to a spotlight to control the way in which the light is thrown onto a scene.

Bandwidth: The speed or capacity of a delivery channel such as broadcast television, dial-up modem, or DSL.

Baselight: The amount, or intensity, of light required to make a scene visible to the camera.

Batch Capture: A feature on a digital nonlinear editing system that allows a group of shots on the same source reel of videotape to be digitized or imported as a group rather than one at a time.

Bayonet Connector: See *BNC Connector.*

Bayonet Mount: A type of lens connector on professional video cameras in which the end of the lens is inserted into the opening in the camera head and turned until it locks into place.

Beauty Shot: The final shot in a program that features a striking visual element that seems to summarize the story.

Betacam SP: A professional-quality ½-inch component analog videotape recording format that was developed by Sony Corporation.

Bin: A window in which audio, graphics, and video clips are stored in the nonlinear editing model.

Bit: Abbreviation for "binary digit"; a number that can have a value of either 0 (off) or 1 (on). Eight bits equal one byte.

Bit Depth: Describes the number of bits contained in each digital sample. Higher bit depths produce higher quality samples.

Bit Rate: The number of bits that are transferred between devices per units of time.

Black Balance: Adjustment of the camera's black level or pedestal level, usually set at 7.5 IRE.

Blocking: Positioning the cameras in relation to the performers to ensure that the cameras have the shots that best capture the director's visualization of a scene.

Blocking Diagram: A plan that indicates the position and movement of people and equipment in a production.

BNC Connector: A bayonet-type twist-lock connector that is used as a video connector on almost all professional video equipment.

Body Pack: A wireless microphone system transmitting unit that is manufactured as a unit separate from the microphone, typically hidden on the body of the person who is the source of the sound.

Boom: An extendable pole on a tripod base, sometimes wheeled, by which the microphone is suspended close to the action.

Brainstorming: A group activity in which participants are encouraged to generate possible solutions to a problem without making value judgments.

Brightness: The range of values from black to white in the television picture. In color television, brightness is called *luminance.*

Broadcast: Transmission of radio and television signals through the air. Video and/or audio signals are transmitted from an antenna through the use of a carrier signal.

Broadcast Quality: (1) Technical standards set by the Federal Communications Commission for broadcast television signals. (2) Program content and production values of broadcastable material.

B-Roll: Visual, cutaway video footage that is used to cover voice-over or narration and which enhances and supports the story.

Bus: A row of buttons corresponding to different video inputs on a video switcher.

Byte: A group of binary data consisting of eight bits.

Cablecast: Transmission of radio and television signals via a wire or cable. Receivers must be connected to the cable to receive the signal.

Camcorder: A one-piece video recording system in which the camera and videocassette recorder are combined into one easily carried unit.

Camera Control Unit (CCU): Electronic circuitry that regulates the way in which the camera produces the video signal.

Camera Head: Main part of a video camera consisting of the beam splitting system, imaging device(s), and the camera's internal electronics.

Camera Light: A battery-powered light that is mounted directly onto a video camera.

Camera Microphone: A microphone that is built into or attached to a portable video camera.

Camera Setup: Adjustment of the electronic parameters of the camera to provide accurate recording, including registration, white balance, black balance, and gain.

Camera Shot Sheet: A list of shots that a particular camera is responsible for capturing during the program.

Capturing: The process of transferring digital video clips into a computer hard drive.

Cardioid: A directional, heart-shaped microphone pickup pattern that is characterized by sensitivity to sound in the front but less sensitivity to the sides and rear.

Cassette: A plastic device that holds videotape or audiotape. The tape moves from the feed reel to the take-up reel inside the cassette when playing or recording. Cassette systems are self-threading, eliminating the need to manually thread the tape around the record and playback heads.

Cathode-Ray Tube (CRT): A large vacuum-type picture tube in television and video monitors and receivers. An electron beam scans a layer of red, green, and blue phosphorescent dots in the inside face of the tube to create the color video picture.

CD-ROM: Compact disc read-only memory. A small disc that is used to store computer data or digital audio or video data in compressed form.

Center of Interest: The most important part of a picture in terms of the visual interest it generates.

Character Generator (CG): An electronic device that is used to generate electronic lettering for use in video productions. Usually contains a keyboard, screen, and memory system for information storage.

Charge-Coupled Device (CCD): A camera pickup device that uses silicon chips to generate the video signal.

Chroma Key: A special matte effect in which a particular colored area is eliminated from one shot and filled in with new video information from another source.

Chrominance: The color part of the color video signal, composed of hue and saturation. The three chrominance channels in the color signal are red, green, and blue.

Cinema Verité: A production approach that is more interactive than direct cinema and in which the camera is almost always hand-held. In this approach participants are aware of the camera's presence and may directly address the director or members of the crew. The term comes from the French and literally means "true film."

Clarity: A concept that in terms of graphics involves both the simplicity of expression and the visibility of the graphic elements or characters themselves.

Clip: Digital copy of audio, graphics, and video source material in a nonlinear editing system.

Clipper: A control on a video switcher that is used to adjust the level of a key.

Closer: The ending statement in a news story.

Close-up (CU): A tight shot that fills the screen with an object or the head of a subject.

Clustering: A type of unstructured free writing that works more by free association of ideas than by their clear relationship, as in concept mapping.

Codec: Abbreviation for "compression/decompression" or "coder/decoder." A specialized computer algorithm that is used to compress and expand the size of a digital file.

Color Bars: A standard display of white, yellow, cyan, green, magenta, red, and blue bars used as a color reference by video engineers.

Colorizer: The electronic component of a video switcher that is used to generate color, often for the purpose of coloring letters. Also called a *color background generator.*

Color Temperature: Variations in the quality of what appears to be white light, measured in degrees Kelvin (°K). Standard television lights operate at 3,200°K. Light with a higher color temperature appears bluish; light with a lower color temperature appears reddish.

Compact Disc (CD): A high-quality audio storage medium in which recorded information is read and reproduced via a laser beam.

Complementary Angle: A shooting technique in which the eyeline of one person looking to one side of the screen is balanced by the converging eyeline of another person. Each person becomes the target object of the other's eyeline.

Complementary Metal Oxide Semiconductor (CMOS): A high quality silicon chip that is gradually replacing CCD image sensors.

Component Recording: A high-quality video recording process in which luminance and chrominance information is recorded separately on the videotape.

Composited Image: A multilayered image.

Composite Signal: A video signal that includes both video information and sync.

Compression: A digital data recording technique that reduces the amount of information that is stored in digital form as it is being converted from an analog signal. See *Lossy Compression* and *Lossless Compression.*

Compression Ratio: A ratio that expresses the degree of compression that has been applied to a file. Higher ratios indicate greater compression.

Concept Map: A visual representation of the interrelationship between ideas arranged in a hierarchical order, often used to provide an overview of the main elements in a television or video program.

Condenser Microphone: A high-quality microphone that uses an electric capacitor to generate the audio signal. Requires battery or phantom power to operate.

Consumer Equipment: Audio and video equipment that is marketed to home users for their personal use.

Continuity: The consistent arrangement of components in a production so as to present them to an audience in a logical, coherent, and continuous flow.

Continuity Editing: Editing of dialog or action without discontinuous jumps in time or place.

Contrast Range: The range or ratio between the darkest and brightest part of an image. Most video cameras function with a maximum contrast range of approximately 50:1. Also called *contrast ratio.*

Control Room: A production room separate from a video studio where the director and other production personnel manage the production of a multicamera video production.

Control Track: A series of electronic impulses recorded directly onto the videotape in their own track that regulate the playback timing of the system. Helical scan systems have 30 control track pulses per second.

Control Track Editor: An automatic edit control unit that backtimes the videotape and executes edits by counting control track pulses on the tape.

Convertible Camera: A video camera that is designed to be used either in the studio or in the field.

Crossfade: A sound transition that is similar to a visual dissolve. As one sound fades out, the next one fades in, with a slight overlap of the two sounds during the transition.

Cut: An instantaneous transition from one video source or shot to another.

Cut-In: A cut to a close-up detail of a shot or scene.

Cut-Out: A cut to a wide or establishing shot after a close-up.

Cycles per Second (CPS): See *Hertz (Hz).*

Cyclorama (Cyc): A background curtain that is typically suspended on a curved metal track around the perimeter of a video studio. May also be constructed as a hard wall.

DAT: Digital audio tape.

Decibel (dB): A standard unit, or ratio, of measure for gauging the relative intensity of a sound.

Degrees Kelvin (°K): A measure of the quality of light or the degree of whiteness of light. The hotter the filament, the whiter is the light that radiates from it.

Deinterlace: Conversion of the interlaced fields of a video frame into a single frame that can be progressively scanned.

Depth of Field: The portion of a scene in front of the camera that is in focus. Measured from the point in focus closest to the camera to the point in focus farthest from the camera.

Desk Stand: A small microphone mount used to support a microphone on a desk or table in front of someone who is speaking.

Development: The production phase in which the program idea is developed.

Dialog: Conversation between two or more people.

Dial-up Modem: Modem stands for modulator /demodulator. A device that uses traditional copper phone lines to connect computers to the Internet.

Diffuser: See *Scrim.*

Digital Audio Workstation (DAW): A computer equipped with appropriate hardware and software for the manipulation and editing of sound.

Digital 8: An 8-mm digital component video recording format introduced by Sony in 1999.

Digital Nonlinear Editing: See *Nonlinear Editing.*

Digital Signal: A signal in which the input is converted into bits of information that can be stored as numerical data.

Digital Still Store: The digital "frame grabber" in a video switcher that is used to store still images.

Digital Video Effect (DVE): Special effects that are made possible by signal-processing equipment that digitizes and processes the video signal. Image compression and expansion are common types of digital effects.

Digital Zoom: A camcorder lens effect in which the image is magnified electronically to extend the range of the optical zoom lens.

Digitize List: A list of each of the shots on the unedited field tapes that will be digitized (if the source tapes are analog) or imported (if the source tapes are digital) into a digital nonlinear editing system.

Digitizing: The conversion of an analog signal into a digital signal. See also *Capturing.*

Dimmer: A device that changes the intensity of a light by varying the voltage supplied to the lighting instrument.

Direct Cinema: A production approach in which the camera is a "passive observer" that never interferes with the action.

Direct Current (DC): The type of current that is supplied by batteries. Most portable video systems require a 12-volt DC power source.

Directional Continuity: Characters or objects that are moving in one shot continue to move in the same general direction in a subsequent shot.

Director: The production team member who has principal responsibility for a program during the time of the actual production; responsible for coordinating the visual and aural elements of a production and directing the performers and the production team.

Dissolve: A gradual transition in which one visual source slowly fades out while another slowly fades in and the two sources overlap during the transition.

Distribution: Final phase of production that describes how the program is delivered to the target audience.

Distribution Switcher: A video switcher that is used to send video signals to different destinations in a video production facility. Also called a *routing switcher.*

Dolly: (1) A three-wheeled camera support that is attached to a camera tripod or pedestal. (2) Movement of the camera and its wheeled support toward or away from the scene as in "dolly in" or "dolly out."

Downstream Keyer: A device on a video switcher that introduces a key or matte over the line output, leaving the mix/effects buses free to perform other effects.

Drag: A control that introduces varying degrees of resistance to a tripod or pedestal head so that the camera operator can pan and tilt smoothly.

Drop-Frame Time Code: A type of SMPTE time code that drops (skips) two frames per minute except the tenth minute of each hour. See also *Non-Drop-Frame Time Code.*

Dropout: Loss of particles of magnetic coating from the surface of a videotape; adversely affects picture quality and stability.

DSL (Digital Subscriber Line): High-speed data transmission along copper telephone lines; requires the use of a special modem to receive and send information.

Dub: (1) A copy of a videotape or audiotape. (2) To transfer video or audio information from one tape to another.

DV (Digital Videocassette): A 6.35-mm (¼-inch) videocassette recording format that records digital audio and digital component video signals. Principal variants include the consumer- and prosumer-level DV format, Sony's professional DVCAM and Panasonic's DVCPRO.

DVD (Digital Versatile Disc): A high-density compact disc used to store data, text, and large audio or video files.

DVDCAM: A consumer camcorder introduced by Hitachi in 2001 that uses a DVD-RAM disc instead of videotape to record the video signal.

Dynamic Editing: An editing technique that utilizes visual material to create an impact rather than simply to convey literal meaning or achieve continuity of action. More effective and complex than continuity editing. Also called *complexity editing.*

Dynamic Microphone: A rugged, professional quality-microphone that is widely used in field production.

Dynamic Range: The range from the lowest audio level to the highest audio level that can be reproduced or heard, expressed in decibels.

Edit Decision List (EDL): A list of all the edits for a program. Specifies all the edit in points and out points, often with reference to SMPTE time code. Also called the *edit list.*

Editing: The process of arranging individual shots or sequences into an appropriate order.

Editing Window: The window in which clips are trimmed in a nonlinear editing system.

Editor: See *Video Editor.*

Electret Condenser: A small, battery-powered condenser microphone.

Electronic Field Production (EFP): Video production that takes place in a location outside a television studio. Usually refers to single-camera productions that are shot to be edited in postproduction.

Electronic News Gathering (ENG): The use of electronic video equipment for reporting news from field locations. Also called *electronic journalism.*

Electronic Shutter: Controls the amount of time that light passing through the camera lens hits the camera's image sensors.

Ellipsoidal Spotlight: A lighting instrument that is used to throw a controlled beam of light over a great distance; frequently used to project patterns onto the scene's background.

Equalization (EQ): The audio component that allows the level of various ranges of frequencies within the signal to be manipulated to shape the overall quality of the sound.

Essential Area: The central, usable area of a video screen.

Establishing Shot: An overall wide-angle view of a scene, usually a long shot. Shows the relationship of the parts to each other and to the scene as a whole.

Extreme Close-Up (ECU): The tightest shot possible on a person or object. Also called a *tight close-up (TCU).*

Extreme Long Shot (XLS): A very wide-angle, panoramic shot of the elements of a scene.

Eyeline: A line that is created by the eyes when someone looks at a target object. Eyelines and the position of the target object are very important in creating continuity through editing.

Eyepiece Viewfinder: The most common type of viewfinder found on portable video cameras. Allows the camera operator's (videographer's) eye to be placed firmly against the camera.

Fade: A gradual transition from black to an image or sound (fade-up) or from an image or sound to black (fade-down or fade-out).

Fader Bar: A device on a video switcher that controls the output of the mix/effects bus. Used to perform fades, dissolves, and wipes.

F-Connector: A video connector that is frequently used on coaxial cables carrying an RF signal, such as a cable TV connection, or the RF output from a VCR.

Feedback: (1) Electronic distortion that is caused when a live microphone is placed near a speaker that is reproducing its output or when a video camera shoots into its own monitor. Audio feedback is audible as a loud screech; video feedback appears as an undulating pattern of light and color. (2) The part of the communication process in which audience responses to the production are transmitted to the producers.

Field: One half of a video frame (262.5 lines in NTSC).

Field of View: Description of a shot that indicates how much of a subject or object is seen on the screen (long shot, close up, etc.).

Field Production: See *Electronic Field Production (EFP).*

File Format: Describes the structure of the data that is stored in digital audio, video, or graphics files.

Fill Light: (1) Nondirectional light, set at one half to three fourths of the intensity of the key and positioned opposite to it. Used to fill in, but not eliminate completely, the shadows that are created on the subject by the key light. (2) Any light that is used to fill in shadows.

Film-Style Lighting: A lighting technique in which the lighting setup is changed each time the camera position is changed. Lighting done that is shot by shot. Also called *single-camera lighting.*

Filter: A device that is used to eliminate certain frequencies of light or sound.

Filter Wheel: A component built into a video camera that is used to correct the color temperature of incoming light.

FireWire: A high-speed digital interconnect standard (IEEE 1394) that allows digital video and audio to be moved directly into and out of a computer.

Fishpole: A handheld telescoping metal rod that is widely used as a microphone support in field production.

Fixed Focal Length Lens: A camera lens that produces only one angle of view. Compare with the *zoom lens.*

Flag: An opaque card with a handle that is used to control the way in which light falls on a scene.

Flash Memory: Digital audio, video, and graphics storage cards that use silicon chips instead of magnetic media to store the data.

Flat: A hard or soft panel that is used to create the illusion of interior settings and walls in studio productions.

Flatbed Scanner: A device that is used to convert photographs and flat artwork into a digital file.

Floodlight: Light that produces a wide beam of relatively soft, unfocused light. Also called *broadlight.*

Floor Director: The production team member in the studio who gives cues to the performers and assists the camera operators as needed.

Floor Plan: A diagram of the studio floor showing the design and layout of set pieces and properties, usually drawn to a scale of ¼ inch = 1 foot.

Floor Stand: A telescoping stand that is used to support a light or microphone.

Fluid Head: A high-quality tripod head that allows extremely smooth camera movement (panning and tilting).

Fluorescent Lamp: A gas-filled glass tube coated on the inside with chemicals that glow when electrical power is applied to the lamp.

Focal Length: The distance from the optical center of the lens to the point where the image is in focus (the face of the CCD). The angle of view of a lens is determined by its focal length.

Focus: Sharp detail in the important parts of the image. Pictures may be in focus or out of focus.

Focus Group: A qualitative research technique in which a small group of people is gathered together to discuss their views on a particular topic.

Focus Ring: A device that controls the distance between lens elements, thereby allowing the lens to focus on objects at different distances from the camera. Located at the far end of the lens on portable video cameras.

Foot-candle (FC): A measure of the intensity of light.

Format: See *Videotape Format.*

Formative Evaluation: An assessment of a project that is conducted while it is in production.

Frame: One of the basic units of the video signal. There are 29.97 frames per second in the American NTSC system.

Frame Rate: The number of frames per second (fps) in a given video signal. The frame rate for NTSC video is 29.97 fps, although it is popularly referred to as 30 fps.

Frame Synchronizer: A time base corrector that is capable of storing a full frame of video information. Often used to synchronize nonsynchronous remote signals to other synchronous signals in a television station or video production house. Also widely used to produce video graphics.

Framing: The placement of people or objects within the video frame.

Frequency: The number of times a wave repeats itself in one second. Usually measured in hertz (Hz). The frequency of a sound wave determines its pitch.

Frequency Response: The ability of any video or audio component to accurately reproduce a wide range of frequencies.

Fresnel Spotlight: A popular lighting instrument that contains a lens at the front of the instrument that focuses the beam of light produced.

Friction Head: An inexpensive tripod head that gives fair control over camera movement.

F-Stop: A standard calibration of the size of the aperture opening of a lens.

Gain: Control of the amplification or level of an audio or video signal. May be automatic or manual.

Gain Boost: A special switch on a video camera that boosts the amplification of the video signal. Used most often in low-light situations to improve color reproduction. May make the picture look noisy.

Gel: A plastic or polyester filter, sometimes called *color media,* that is used to change the color or color temperature of a light source. Short for "gelatin."

Graphics: Printed, drawn, photographed, or electronically generated graphic material that is incorporated into a production.

Gray Scale: A test pattern of seven to ten shades of gray, which correspond to the brightness range that the video system is capable of reproducing.

Green Room: A waiting room that is used by guests before they appear on a television program. May include makeup mirrors, a restroom, and a video monitor.

HMI (Hydragyrum Medium Arc-Length Iodide) Light: A highly efficient professional light instrument that produces light matching the color temperature of daylight.

Handles: Extra footage left before and after shot in and out points of a clip when it is imported into a nonlinear editing system.

Hanging Microphone: A microphone that is hung above a scene for sound pickup.

Hard Cyc: See *Cyclorama.*

Hard Disk: The usual magnetic storage system for a computer.

Head: A small electromagnet that is used to record a video or audio signal onto magnetic tape or to play back the signal from tape.

Headphones: A device that is used for monitoring audio. Consists of two small speakers attached to a flexible band that is worn on the head, positioning the speakers over the listener's ears.

Headroom: (1) Audio: The range beyond the standard operating level that a signal can be safely amplified before distortion occurs. (2) Video: The distance within the television frame between the top of the subject's head and the top edge of the frame.

Helical Scan: Tracks of video information laid down at an angle on the tape. Characteristic of all modern VCRs. Also called *slant-track recording.*

Hertz (Hz): The standard unit of measure of the frequency of a wave in cycles per second.

High-Definition Television (HDTV): A digital video recording and transmission system that features improved resolution resulting from an increase in the number of horizontal scanning lines and a wider aspect ratio (16:9 versus conventional 4:3) than the traditional NTSC broadcast standards.

High Key Lighting: A lighting technique that is characterized by bright illumination. Used when uniform visibility of a scene is required or to create an emotional tone that is upbeat or happy. Compare with *Low Key Lighting.*

Hook: Something of extreme interest at the beginning of a story that catches the viewer's attention and makes the viewer want to watch the story to find out what happens.

Hot Spot: An overexposed portion of a picture; a bright, glowing spot in which color and detail are lost.

HTTP: Abbreviation for "hypertext transfer protocol," a computer standard that defines how messages are formatted and transmitted over the Internet.

Hue: A recognizable color: red, blue, green, or the like.

Image Compression: A digital video effect that squeezes the horizontal and/or vertical dimensions of the picture, thereby reducing it in size within the frame.

Image Expansion: A digital video effect that stretches the horizontal and/or vertical dimensions of the picture, causing it to grow larger within the frame.

Impedance (Z): The amount of resistance in a circuit, measured in ohms (Q). Audio equipment may be high-impedance or low-impedance. Professional equipment is low-impedance.

Incandescent Lamp: A light bulb that is similar in construction to a common household bulb. Has a tungsten filament within an evacuated glass bulb.

Incident Light: The light radiating directly from a source or sources that falls on an object or scene.

Insert and Track Information (ITI): A data track in digital videocassette (DV) tape formats.

Insert Editing: (1) The linear videotape editing mode in which new audio or video information is recorded onto the tape in the editing VCR, leaving the control track undisturbed. (2) The process of inserting a shot or sequence into a preexisting sequence.

Interactive Television (ITV): Program material that gives the audience an opportunity to provide direct feedback to the program producers or to make choices about which part of the content they choose to see and/or hear.

Interlaced Scanning: The process by which the odd and even lines of a video picture are scanned. First one field of odd lines is scanned, and then one field of even lines is scanned. Also called *2:1 interlaced scanning.*

Interruptible Feedback (IFB): A communication system that allows the producer and director in the control room to communicate with the program talent in the studio via a small earphone.

Inverse Square Rule: A method of calculating the intensity of light falling on a scene from a given instrument. Reducing the distance between the source instrument and the scene by one half produces four times as much light on the scene.

Iris: A circular diaphragm composed of overlapping leaves that can be manipulated to create a hole of variable size in its center that controls the amount of light passing through the lens. May be controlled manually or automatically.

Jack: The female receptacle for a pin-type audio connector.

Jaggies: Jagged edges or a stair step pattern that appears on curved or diagonal lines when viewed on a video or computer monitor.

Jib: A fulcrum-mounted camera support system that allows the camera to be raised high above the scene to be recorded.

Joystick: (1) On a video switcher, a joystick is often used as the wipe positioner, which allows selected wipe patterns to be moved up or down on the screen. (2) A sticklike control on an edit control unit that can be used to move the tapes forward or backward in a number of different modes: frame by frame, slow motion, normal motion, or fast motion. Performs the same function as a search dial.

JPEG (Joint Photographic Experts Group) Compression: A digital compression standard for still or moving images.

Jump Cut: A discontinuous transition from one shot to another that is caused by a difference in the size and position of the subject in the two shots. Jump cuts often occur when the middle of a shot is removed and the two remaining pieces are joined together, as in editing dialog.

Kelvin (°K): See *Degrees Kelvin (°K).*

Key: A special effect that is used in titling in which one video source (usually the keyed graphics) appears as opaque letters over the background video. See also *Luminance Key* and *Chroma Key.*

Key Light: The brightest light on the scene. Establishes the form of the subject by providing bright illumination and producing shadows on the subject.

Lavaliere Microphone: A small microphone pinned onto someone or hung around the subject's neck with a string.

LCD Viewfinder: Liquid crystal display camera viewfinder.

Lead: A compelling first sentence that succinctly tells what a story is about.

Leader Sequence: Information that identifies a program, usually recorded at the beginning of a videotape.

Lens: The optical component of a camera. Collects incoming light and focuses it on the camera image sensor.

Lens Cap: A protective cap that can be attached to the end of the lens barrel when the camera is not in operation.

Lens Flare: Optical distortion of a picture that is caused when a light shines directly into the camera lens. Can be prevented by changing the position of the light or camera or by shielding the lens with a lens hood.

Lens Hood: A rubber extension at the front of a lens that works like a visor to prevent unwanted light from hitting the lens and causing lens flare.

Letterbox: A technique for displaying 16:9 aspect ratio images on 4:3 screens; the wide screen image fills the width of the 4:3 screen, and the gaps at the top and bottom of the frame are filled with black.

Light Batten: A moveable light mounting system that is used to raise and lower studio lighting instruments.

Lighting Board: A lighting system device that is used to control lighting instruments.

Lighting Director: The production team member who coordinates all elements of lighting for a program and selects and installs appropriate lighting instruments.

Lighting Plot: A plan that indicates the type and position of each of the lighting instruments in a scene or shot.

Light Meter: A device that is used to measure the light on a scene.

Line: In the NTSC system each television frame is composed of 525 lines of information. ATSC formats include 480-, 720-, and 1,080-line variants.

Linear Editing: A videotape editing system in which edits are made in sequential fashion, one after the other, starting at the beginning of the program or segment and working to the end.

Linear Time Code (LTC): SMPTE time code that is recorded in a linear audio or address track of a videotape or audiotape. Compare with *Vertical Interval Time Code (VITC).*

Line-Level Signal: An amplified audio signal that is considerably stronger than a microphone level signal. A line-level audio signal is 1 volt.

Line Producer: The assistant to the producer who is in charge of daily production activities and responsible for meeting production deadlines.

Liquid Crystal Display (LCD): Flat-panel television/video display screen.

Location Survey: An assessment to gather technical and aesthetic information about a remote location in which a program will be shot.

Long Shot (LS): A shot from a wide angle that shows the relationship between actors or actresses and their setting. Often used as an establishing shot.

Lossless Compression: Compresses an audio or video file with no loss of information.

Lossy Compression: Eliminates repetitive or redundant information from a digital audio or video file.

Lower-Third Keyed Title: Graphic information that is inserted into the lower-third section of the video frame.

Low Key Lighting: A lighting technique characterized by low-level illumination and dark backgrounds. Used to create the illusion of night in an indoor setting, or an emotional tone that is somber or ominous. Compare with *High Key Lighting.*

Lumen: A unit of measure of the flow of light.

Luminance: See *Brightness.*

Luminance Key: A video titling effect in which lettering is electronically inserted over a background picture based on the brightness of the lettering. Compare with *Chroma Key.*

Lux: A unit of illumination.

Macro Lens: A lens that is used for extreme close-ups.

Macro Lever: A lever on the barrel of a lens that activates the macro lens.

Magnetic Stripe: A thin strip of magnetic recording material at the edge of 16-mm film. Formerly used to record news interviews; now obsolete.

Manual Gain Control: Manual control of the amplification of an audio or video signal. See also *Automatic Gain Control.*

Master Gain Control: A slide fader or rotary potentiometer on an audio mixer that simultaneously increases or decreases the loudness of all the mixed audio sources.

Master Shot: A long shot that captures all the essential action of a scene.

Matched Cut: A cut from one shot to another that is too similar in terms of angle of view and camera position. Similar to a jump cut.

Matte: A special video effect that combines three separate sources. Often used to add color to titles in a video production.

Medium Close-Up (MCU): A head-and-shoulders shot that ends at the chest of the subject. One of the most frequently used shots in television.

Medium Shot (MS): A shot from a medium angle of view. Often used to show the relationship between people in a shot or scene.

Microphone: A transducer that changes sound waves into electrical energy.

Microphone-Level Signal: Unamplified output of a microphone. A very weak signal that is usually measured in millivolts.

Microphone Proximity Effect: Tendency of a microphone to overemphasize the reproduction of low frequencies in relation to higher frequencies as the distance between the sound source and microphone decreases.

Mini-Cassette: A videocassette in a small tape housing designed to be used in a portable camcorder.

Mini-Plug Connector: A small single-pin plug that is frequently used as a microphone and earphone connector.

Mix: The technique of combining several simultaneous sound sources in such a way that their relative volume matches their importance.

Mix/Effects Bus: Row of buttons on a video switcher that are used to perform special effects such as dissolves, superimpositions, fades, wipes, and keys.

Modeling: Creating the illusion of three-dimensional subjects and objects on the two-dimensional video screen through lighting.

Modem: A combination of "modulate" and "demodulate"; a device that enables computers to send and receive data over telephone lines.

Monaural: Monophonic (single-channel) sound.

Monitor: (1) To check the audio or visual quality of a recording by listening to it or looking at it. (2) A device that is used to display an audio or video signal. (3) A video set that is not capable of receiving a broadcast signal.

Monopod: A single telescoping support tube that is attached to the base of a camera. Often inserted into a belt pouch and used on portable cameras with rear-mounted eyepiece viewfinders.

Montage: An edited sequence of images.

MPEG (Motion Picture Experts Group) Compression: A series of digital compression standards for CD-ROMs (MPEG-1), DVDs (MPEG-2), broadcast television (MPEG-2), digital television streaming media (MPEG-4), and audio (MPEG-3, or MP3).

Multicamera Production: A type of video production that utilizes multiple video cameras and real-time video switching to produce a program.

Multimedia: A computer program that incorporates animation, sound, text, illustrations, and video, frequently produced for distribution on CD-ROM.

Narration: Description of a visual scene provided by a narrator, frequently as a voice-over (VO).

Natural Sound (Nat Sound): Sound that is naturally present on a location that is organically connected to the visual action taking place.

Neutral Density Filter: A filter that reduces the amount of light hitting the camera CCD without affecting its color temperature.

Noise: (1) Unintended sound. (2) Unwanted electrical interference. Video noise, or snow, makes the picture look grainy; audio noise is audible as static or hiss.

Non-Drop-Frame Time Code: SMPTE time code numbers, generated at the rate of 30 frames per second.

Nonlinear Editing (NLE): A type of video editing made possible by magnetic-disk-based editing systems that allow random access to the audio and video information that is stored on the disk. Differs from the sequential linear editing characterized by videotape-based editing systems.

Noseroom: The distance within the television frame between the edge of the subject's nose, seen in profile, and the edge of the frame. Also called *eyeroom.*

Notes: A review session that is conducted after the final rehearsal for soap operas, situation comedies, and dramatic programs in which the director, performers, and crew make suggestions for final changes in the program.

NTSC (National Television System Committee) Standard: Early technical standard for U.S. television line and frame scanning rates, as well as the system for television color.

Ohm (Q): A measure of electrical resistance.

Omnidirectional: A microphone pickup pattern that is sensitive to sound coming in from all directions.

180-Degree Rule: See *Principal Action Axis.*

1-Shot, 2-Shot, 3-Shot: Refers to the number of people who appear in the shot.

On-Line: (1) In video editing, refers to editing the final version of the program or program segment, usually on a high-quality editing system. (2) When using a video switcher, refers to the source that is going out as part of the program that is being broadcast or recorded.

Operating Light Level: The amount of light, measured in foot-candles, that a camera needs to produce a picture. The optimum light level is the recommended amount; the minimum light level is the smallest amount of light the camera must have but usually results in an inferior picture.

Optical Disc: Audio, video, or data storage and playback systems that encode the data on a small plastic disc with the use of a laser, such as compact discs (CDs) and digital versatile discs (DVDs).

Optical-Video Transducer: In a video camera the CCD or CMOS image sensor that changes incoming light into an electrical video signal.

Overlapping Edit: The process in which the end of one shot is erased and recorded over by the beginning of the next shot during the process of editing.

Overlay Edit: In nonlinear editing systems a shot that is used to replace and/or cover up a shot of similar length in the time line.

Over-the-Shoulder Shot: A camera shot, usually of two people. The person in foreground has his or her back to the camera; the second person is slightly in the background and faces the camera.

Page Pull or Page Push: A digital video effect in which the picture appears to be pushed or pulled off the screen.

Page Turn: A digital video effect in which the picture appears to turn like the page of a book, revealing a new picture (or page).

Paint: Adjustment of camera color reproduction to achieve a particular mood or effect.

Pan: Horizontal movement of the camera head only. Short for "panorama."

Pan Handle: A metal handle attached to a camera tripod or pedestal that is used to control the panning and tilting action of the camera.

Pan Pot: A control on an audio mixer that determines how loud a sound will be in the left and right audio channels.

Parabolic Floodlight: An open-faced lighting instrument that uses a brushed metal parabolic reflector to produce a wide beam of soft, diffuse light.

Patching: Connecting audio and video inputs and outputs with a cable.

Peak Program Meter (PPM): An audio meter that monitors loudness peaks in an audio signal.

Peak White: The highest part of the video waveform, equivalent to the brightest part of the scene being shot. Should not exceed 100% on the waveform.

Pedestal: (1) A large three-wheeled camera support that is often used in studio production. (2) Black level; control over the reproduction of the deepest shades of black reproduced by the camera. Usually set at 7.5% on the waveform monitor.

Perceptual Coding: An algorithm (process) used to encode (compress) an audio signal by removing information not detectable or perceivable by the human ear in a given context. It is based on psychoacoustic models.

Phantom Power: Power supplied to a condensor microphone from an external source (e.g., an audio mixer) rather than an internal battery.

Phone Connector: A large, unbalanced single-pin plug that is used as a headphone or microphone connector.

Pickup Pattern: The pattern of directions in which a microphone is sensitive to incoming sound.

Pistol Grip: A small handle attached to a shotgun microphone.

Pitch: The high or low tonal quality of a particular sound. Results from differences in the frequency of sound waves.

Pixels: Literally "picture elements." Extremely small silicon semiconductors arranged in precise horizontal and vertical rows on a CCD or CMOS chip that change incoming light into electrical energy.

Plasma Display Panel (PDP): A high-quality flat screen television/video display.

Plug-In: A computer program that adds to or changes the features of a larger computer program or system.

Postproduction: The stage of production after field production is complete. The principal component is usually editing.

Potentiometer (Pot): Used to increase or decrease the gain amplification of an electronic signal.

Preinterview: An interview with the potential subject of a program or program segment that takes place before the actual production date. Used to gain familiarity with the subject and to put novice subjects at ease before they appear on camera.

Preproduction: Production planning before the production begins.

Pressure Zone Microphone (PZM): Crown International's registered trade name for its boundary microphone with a hemispheric pickup pattern.

Preview Bus: A row of buttons on a video switcher that is connected to the control room preview monitor. On multifunction switchers it is called the *preset bus*.

Preview Control: On a linear editing system, allows the editor to see what an edit will look like without actually performing the edit.

Preview Monitor: A control room video monitor that is used to set up special effects and camera shots and view them before they go out on line as part of the program.

Principal Action Axis: In staging for continuity, the camera stays within an imaginary 180-degree semicircle created by the line formed by the principal action in a scene and thus stays on one side of the action. Also called the *principal vector line* or the *180-degree rule*.

Principal Vector Line: See *Principal Action Axis*.

Printing to Tape: Recording onto videotape a finished program or segment that was first edited in a computer-based digital nonlinear editing system.

Prism Block: A glass prism in high-quality video cameras that breaks incoming light into its red, green, and blue components.

Private Line (PL): A headset communication system linking the director and production crew.

Producer: The member of the production team who is responsible for the overall organization of a production.

Production: (1) The shooting stage of the video production process. See also *Preproduction* and *Postproduction*. (2) The video program itself.

Production Assistant (PA): The member of the field production team who serves as a general assistant. Often has responsibility for setting up audio, helping with lighting, carrying equipment, and logging tapes.

Production Switcher: See video switcher.

Professional/Broadcast Equipment: Very high-quality audio and video equipment that is designed for professional production applications.

Program Bus: A row of buttons that controls the line output of the video switcher.

Program Monitor: A control room video monitor that displays the image that is being recorded or broadcast.

Progressive Scanning: Scanning each of the lines in the video frame in successive order. Scanning begins at the top of the frame and continues to the bottom.

Properties (Props): Items on the set such as furniture and plants. Small items that may be picked up and used by the performers are called *hand props*.

Prosumer Equipment: Audio and video equipment with more features and higher quality than consumer equipment but not equivalent to professional/broadcast equipment.

Proximity Effect: A microphone effect that is characterized by increased sensitivity to low frequencies of sound sources close to the microphone.

Public Service Announcement (PSA): In the United States a public service announcement (PSA) is defined by the Federal Communications Commission (FCC) as "any announcement (including network) for which no charge is made and which promotes programs, activities, or services of federal, state, or local governments (e.g., recruiting, sale of bonds, etc.) or the programs, activities, or services of non-profit organizations (e.g., United Way, Red Cross

blood donations, etc.) and other announcements regarded as serving community interests, excluding time signals, routine weather announcements and promotional announcements."

Quantizing: The process of sampling an analog waveform and converting it into digital information. Also called quantization.

Question Re-Ask: A technique that is frequently used in single-camera production; questions asked by an interviewer are recorded onto videotape after the interview has been completed.

Quick-Record Button: A camcorder control that bypasses the standby mode and instantly puts the camcorder into the record mode.

Quick-Release Plate: A mounting system that is used on a camcorder and tripod head to allow for fast mounting and release of the camcorder on the tripod.

Radio Frequency (RF): The range of electromagnetic frequencies used to transmit broadcast or cablecast signals. Different frequencies correspond with different channels of reception.

RCA/Phono Connector: A small unbalanced audio connector often used for line-level audio inputs and outputs. Also used as a video connector in home video equipment.

Reaction Shot: A cut, usually to a close-up of a person, that shows a reaction to what was just seen or said.

Real Time Streaming Protocol RTSP: Live streaming of media files from a dedicated server to the user's computer.

Receiver: A television that is capable of picking up an RF-modulated video signal.

Record-Run: The operating mode of a time code generator in which time code is produced only when the VCR is in the record mode.

Record Safety: A safety device that is built into a videocassette to prevent accidental erasure of the tape. A red button on ¾-inch cassettes; a small plastic tab or switch on ½-inch, 6.35-mm, and 8-mm cassettes.

Record VCR: In an editing system the editing VCR. Also refers to any VCR that is capable of making a recording from a camera or line input, from another VCR, or off the air.

Reference White: Brightest possible point a video system will reproduce. Should not exceed 100% on the waveform.

Reflected Light: The light reaching the camera from the scene.

Reflector: Any opaque substance, usually bright metal or treated fabric, designed to redirect light back onto a scene.

Remote Production: Any video production that takes place outside a studio. It may be as simple as a single-camera production or as complicated as large-scale coverage of a sports event.

Remote Survey: See *Location Survey.*

Rendering: A time-consuming process through which a computer creates special effects, transitions, and animation frame by frame or, in some cases, field by field.

Resolution: A measure of the amount of detail in a picture.

Reverse Angle: A complementary angle of videotaping people so that their eyelines converge when the individual shots are edited together.

Reverse Over-the-Shoulder Shot (ROS): A shot from the opposite side of the over-the-shoulder shot that preceded it.

RGB Signal: Unencoded red, green, and blue video signals.

Ribbon Microphone: A high-quality voice microphone that was designed originally for use in radio. Also called a *velocity microphone.*

Riser: A low platform that is used to raise the set so that the cameras are at the performers' eye level. Widely used on news and interview sets when the performers are seated.

Robotic Camera System: A computer-controlled camera system that eliminates the need for individual camera operators. Can provide control of camera pan, tilt, and zoom functions. Advanced systems also control camera movements along the studio floor.

Room Tone: Ambient sound that is present on location. Sometimes recorded and dubbed back onto an audio track during editing to preserve sound continuity.

Rough Cut: A preliminary edited version of a program.

Rule of Thirds: A compositional rule stating that the screen can be divided into three equal parts both horizontally and vertically. The four points of intersection located one third of the distance from the four corners of the frame become the optimal location for objects and people of importance to the story.

Rundown or Rundown Sheet: An outline of the principal segments in a program, including each segment's length, subject, and technical requirements.

Run-Through: Rehearsal of a program before the final production, involving all the performers and the technical crew.

Safe-Title Area: The essential area; the central, usable area of the video screen where titles and graphics should be placed to be legible.

Sampling: See *Quantizing*.

Sampling Rate: In audio and video recording, describes how often the elements of the analog signal are converted into packets of digital information. See *Quantizing*.

Saturation: The intensity or vividness of a color. For example, pink is a lightly saturated red, whereas deep red is highly saturated.

Scrim: A type of light diffuser that is used to reduce the amount of light and make it softer.

Script Format: Describes the layout and presentational style of a television script. Examples include the single-column standard screenplay format or film-style script and multiple-column (two-column) audio/video script format. See also *Storyboard*.

Search Dial: A circular control on a VCR or edit control unit that is used to move a videotape forward or backward at various speeds.

Segue: Pronounced "*seg*-way." A transition from one sound to another, in which the first sound fades out completely before the second sound fades in. There is no overlap of the two sounds.

Selective Focus: The technique of keeping some parts of the picture in focus while others are out of focus.

Set: Abbreviation for "setting." Real or virtual elements, such as desks, chairs, and walls in a studio or field production environment.

Shock Mount: A rubber cradle that is used to attach a shotgun microphone to a boom and insulate it from noise.

Shotgun Microphone: Microphone with an extremely directional pickup pattern, often used to pick up sound at a distance.

Shoulder Mount: A contoured brace that is attached to the bottom of a portable video camera. It allows the camera to be carried on the camera operator's shoulder.

Silk: A giant cloth diffuser that is used to control light intensity and color temperature in outdoor productions.

Single-Camera Production: Use of a single camera to record program material. Almost always indicates that the final program will be assembled with postproduction editing. See *Electronic News Gathering (ENG)* and *Electronic Field Production (EFP)*.

Slant-Track: Helical scan recording.

Slate: Audio or video information that is used to identify the material that will immediately follow on a videotape.

Slide Fader: Control on an audio mixer that increases or decreases the amplification of the signal when it is pushed up or down.

Smear: A unique type of CCD image distortion, visible as a bright vertical band running through the image, that is caused by a very bright point of illumination in the scene.

SMPTE Time Code: Society of Motion Picture and Television Engineers time code. A binary electronic signal that is recorded onto videotape. Identifies each frame in terms of hours, minutes, seconds, and frames; aids in computer editing. Two main types of time code are *linear time code (LTC)* and *vertical interval time code (VITC)*.

Snow: Visible noise in a video picture that is often caused by excessively increasing the gain.

Soft Light: A floodlight that produces a bright, shadow-free light.

Software: (1) A computer program that contains a set of commands that allow a computer to perform various tasks, such as word processing or video graphics generation. (2) A video program or program segment, in contrast to video equipment, which is called hardware.

Sound: (1) A pattern in the vibration or movement of molecules of air. (2) Any aural component of a program that is intentionally present.

Sound Bite: (1) Voice segment of the subject of an interview. (2) A sound-on-tape (video and audio) segment of a person speaking on camera. (3) Any sound-on-tape or voice-over use of an individual's voice in an edited program.

Sound Effects (SFX): Prerecorded or live sounds that are added to a production, often to reinforce the visuals or to convey a sense of place.

Sound Engineer: The production team member who is responsible for coordinating audio elements of a program, setting up microphones, and operating the audio mixing console; also called the *audio engineer*.

Sound Layering: Manipulating recorded sound to place it in the foreground, in the background, or in between. This layering effect is achieved by manipulating the volume of various sound elements during the editing process.

Sound on Tape (SOT): Picture and synchronous sound recorded onto videotape.

Source VCR: In a linear editing system the playback VCR.

Split Screen: A special effect in which two images are displayed simultaneously on the television screen. Usually activated by stopping a horizontal wipe at the halfway point.

Spotlight: A lighting instrument that produces a narrow beam of hard, focused light. May have a variable or fixed beam.

Spreader: A device that is attached to the legs of a tripod to hold the legs firmly in place.

Standard-Definition Television (SDTV): Video pictures with 480 active scanning lines in either 4:3 or 16:9 aspect ratio.

Standby Switch: A switch found on many video cameras that reduces the camera's power consumption. Allows the camera electronics and image sensor to warm up but does not cause the image sensor to produce an image.

Stand-up: A sound-on-tape segment in which the reporter is seen on camera and talks directly into the camera. Commonly used in electronic news gathering.

Steadicam®: A gyroscopically controlled camera mounting system that allows a camera operator to carry a camera and achieve extremely smooth camera movement. Registered trademark of The Tiffin Company.

Stereo: Dual channel (left/right) stereophonic sound.

Sticks: A wooden tripod.

Storyboard: A script that contains illustrations of the principal visual elements of a production.

Story Outline Script: A script format that is used for magazine-style production. Often includes a description of the story, a list of locations to be used, essential visual material to be recorded at the various locations, and the names of individuals who will appear in interview segments.

Streaming Media: Delivery of video, graphics, voice, text, and/or data over the Internet in small packets that "stream" for immediate real-time viewing or listening.

Stripe Filter: A color separation device that is found on the face of the image sensor in single-CCD cameras. Breaks incoming light into its red, blue, green, and luminance components.

Studio Viewfinder: A large viewfinder that is mounted on top of a video studio camera.

Style: A concept that in terms of graphics relates to the way graphics are presented in the screen. They can be realistic, expressive, or abstract depending on the look and feel of the program or segment.

Subtractive Color: A color theory that is concerned with mixing pigments, paints, and dyes. Subtractive primary colors are magenta, cyan, and yellow.

Summative Evaluation: Assessment done when the production is completed.

Supercardioid: A very directional microphone pickup pattern that is sensitive to sound in a very narrow angle in front of the microphone. Characteristic of shotgun microphones.

Superimposition: A special effect in which two video sources are combined through the use of a video switcher. Both sources appear on the screen simultaneously and are somewhat transparent because neither is at full strength. Formerly used to superimpose titles; most title graphics are now keyed over the background video.

S-VHS: Super-VHS. A ½-inch video recording format with greatly improved luminance- and chrominance-recording capabilities in comparison with the conventional VHS format.

S-Video: See *Y/C Signal Processing.*

S-Video Connector: A video input/output connection on monitors and VCRs that is used in conjunction with Hi8 and S-VHS systems in which luminance (Y) and chrominance (C) signals are processed separately. Such systems yield better color purity and image detail than do conventional signal processing and display.

Sync Generator: A device that generates horizontal and vertical sync pulses. Typically used when several cameras are used simultaneously in conjunction with a video switcher; it synchronizes them with all the other equipment that is used in the production.

Sync Pulse: The synchronizing signal that controls the scanning of individual lines of information (horizontal sync) and individual fields of video information (vertical sync).

Synopsis: A short summary of a television program or story idea.

Table Reading: A rehearsal technique in which performers, producers, writers, and director read through the script before production.

Talent Release: A standard agreement that is signed by an individual who appears in a video production. Gives the program producer or production agency permission to use the subject's image and/or voice.

Talkback System: A microphone and loudspeaker system that allows the control room director's voice to be heard in the studio.

Talent: A performer in a video production.

Tape Format: See *Videotape Format*.

Tape Log: A list and description of every shot on a particular videotape.

Tape Operator: The production team member who has responsibility for operating the record and playback VCRs.

Tape Transport Controls: Buttons that control the movement of a videotape within a VCR. Typical controls include PLAY, STOP, FAST FORWARD, SEARCH, REWIND, RECORD, and PAUSE.

Target Object: The end point of an eyeline; the object or person at which someone is looking.

Technical Director (TD): The production team member who operates the video switcher.

Technical Elements: Principles of video equipment operation; understanding how the components of the video field production system function and interrelate.

Telecine: A special television camera and film projector that is used to transfer film to video by converting the 24-frames-per-second film projection standard to the 30 frames per second video standard.

Telephoto Lens: A lens with a long focal length and a narrow angle of view. Magnifies a scene by making distant objects appear to be large and close.

Television: The traditional term that is used to describe a system of broadcast stations and networks that produce and distribute video programs. Literally means to "see at a distance."

Television/Video Studio: Controlled environment designed for video production.

Theme Music: Music that is used at the beginning and end of a program to cue the viewer to the upcoming program and to set an appropriate mood.

Three-Point Lighting: A traditional lighting technique that utilizes a key light to establish the form, a backlight to separate the object from its background, and a fill light (or lights) to reduce the intensity of the shadows created by the key.

Tight Close-Up (TCU): Very close framing of the subject. See *Extreme Close-Up (ECU)*.

Tilt: Vertical (up-and-down) movement of the camera head similar to the movement of the head when a person looks up or down.

Time Base Corrector: An electronic device that is used to correct timing errors in the video signal on a videotape as it is played back.

Time Code: See *SMPTE Time Code*.

Time Code Generator: An electronic component that produces time code.

Time Code Reader: Displays time code as a visual digital readout in hours, minutes, seconds, and frames.

Timed Cut: An editing technique in which shot length is determined by time rather than by content. A cut, or a series of cuts, each of a certain duration.

Time Line: A graphical linear representation of a program in a nonlinear editing system.

Tone Generator: An audio oscillator that generates an electronic tone that is used to set the levels on audio equipment.

Track: (1) An area of video, audio, or control track information on a tape. (2) Music, voice, or sound effects that are recorded onto the audio channel of a videocassette so that they can later be edited into the edit master tape.

Tracking: Adjustment that controls the way in which the video heads line up with the tracks of video information on a tape. The video heads must be precisely aligned with the video tracks to produce a clear and stable playback picture.

Tracking Control: A device that adjusts the position of the video heads in relation to the tracks of video information on the tape. Used to optimize the level of the playback signal.

Tracking Shot: A moving camera effect that is typically created by rolling a wheeled camera dolly, often mounted on a set of rigid tracks, in front of the scene being photographed.

Treatment: A brief, narrative description of a program that describes the basic program design and provides an outline of the major components of the program.

Trim: To add or subtract frames to or from an edit point after it has been entered into the control unit.

Trim Control: (1) The potentiometer on an audio mixer that is used to boost the level of an incoming microphone signal. (2) The control in a linear or nonlinear editing system that is used to add or subtract frames to/from a shot at its edit point.

Tripod: A three-legged device that is used to support a camera. Tripods contain legs (which may telescope) and a head (where the camera is attached) and may include wheels (a dolly) to allow easy movement. Also called *sticks.*

Truck (Left or Right): Horizontal movement of the camera and its support in front of a scene. Also called *tracking.*

Tungsten Halogen Lamp: A lighting instrument in which a quartz bulb is filled with halogen. The filament is tungsten. These bulbs burn at a constant color temperature of 3,200°K.

Umbrella: A special fabric device that is used to soften and diffuse the quality of light produced by open-faced spotlights and floodlights.

Unbalanced Line: An inexpensive two-wire audio cable or connector that is widely used on portable audio and video equipment; susceptible to electrical and RF interference.

Unidirectional: A very narrow microphone pickup pattern, typical of shotgun microphones. See also *Cardioid* and *Supercardioid.*

Unity: The principle of graphic material design in which all materials act together in support of the major theme or purpose of the program.

VCR: See *Videocassette Recorder (VCR).*

VCR Trigger: The button on camcorder lens assembly that stops and starts the camcorder recording process.

Vectorscope: A special oscilloscope that is used to monitor the color video signal.

Vertical Interval Time Code (VITC): SMPTE time code inserted in the vertical blanking area of the video signal. Compare with *Linear Time Code (LTC).*

VHS: Video home system. A popular ½-inch consumer videocassette format.

Video: The picture portion of the television signal; an electronic signal that is used to record or transmit television images.

Video Black: A black video signal that contains horizontal and vertical sync pulses along with color burst. Also called *crystal black.*

Videocassette: A videotape that has been packaged in a cassette housing.

Videocassette Recorder (VCR): A videotape recorder that records the video and audio signals onto a videocassette.

Video Editor: The member of the video production team who is responsible for editing the field video footage into its finished form.

Video Engineer: The production team member who has principal responsibility for the technical integrity of the video signal and the look of the pictures the cameras are producing, accomplished by camera shading.

Video Field Production: Video production that takes place in a location outside a television/video production studio. Usually refers to single-camera productions that are shot to be edited in postproduction.

Videographer: In video field production the camera operator. Also called the *shooter.*

Video In: Line-level video input; the place where the video signal feeds into a piece of equipment.

Video Insert: See *Insert Editing.*

Video on Demand (VOD): A form of interactive television in which video material is delivered to an individual viewer in response to the viewer's request to receive that material.

Video Out: Line-level video output; the place where the video signal comes out of a piece of equipment.

Video Server: A computer equipped with a hard disk storage system that is used to record and play back video, often in a configuration in which it is connected to other computer workstations.

Video Shading: Adjustment of the picture and color quality of a video camera.

Video Signal: An unmodulated electrical signal containing the synchronizing and picture information that forms the video picture.

Video Switcher: A production device that allows several video sources to be mixed and manipulated. Used to perform dissolves, wipes, and other special effects.

Videotape: Oxide- or metal-particle-coated plastic (polyester or mylar) that is used to record video and audio signals.

Videotape Format: Describes differences in the width and physical configuration of a videotape; the location of audio, video, control track, and time code information on the tape; and the type of recording process employed. Popular videotape formats include Hi8/Digital8, VHS/S-VHS, DV/DVCAM/DVCPRO, and Betacam SP.

Viewfinder: A small video monitor that is attached to the camera. Used by the camera operator to frame the scene being shot. See also *Eyepiece Viewfinder, Studio Viewfinder, Liquid Crystal Display (LCD) Viewfinder.*

Virtual Set: An electronically generated image of a scene that is used instead of an actual setting as the background for a subject.

Voice-Over (VO): Narration that is delivered from off camera. The voice of the narrator is heard over background visuals, but the narrator is not seen.

Volume: The relative intensity or loudness of sound.

Volume Unit (VU) Meter: A meter indicating audio levels in a standard calibration of signal strength.

VTR: Videotape recorder. See also *Videocassette Recorder (VCR).*

Walk-Through: The rehearsal stage in which the physical movements of the talent and cameras are set.

Watt: A unit of electrical power. Watts = amps × volts.

Waveform: The form of a video signal when it is displayed on a waveform monitor, a special oscilloscope that is designed to display the video signal.

Webcasting: Live streaming of audio and video files over the Internet.

White Balance: Adjustment of the relative intensity of the chrominance channels in a color video camera to allow the camera to produce an accurate white picture in the light that is available on location. Compensates for differences in the color temperature of light.

Wide-Angle Lens: A lens with a short focal length and a wide angle of view.

Window Dub: A copy of a videotape that includes the time code display in a black box, or window, keyed into the picture information.

Window Size: The number of pixels per line and lines per frame in a computer or video image. NTSC window size is 640 × 480. Video transmitted on the Web may use a half-screen window (320 × 240), a quarter-screen window (160 × 120), or other variants.

Windscreen: A foam cover that is placed over a microphone to eliminate wind noise. Also called a *wind filter.*

Wipe: A transition in which one screen image is replaced by another. The second image cuts a preselected hard- or soft-edged pattern (such as a circle, square, diagonal, or diamond) into the frame as the transition takes place. Accomplished with the use of a video switcher or special effects software.

Wired Microphone: Any microphone that is connected to an input via a cable.

Wireless Microphone: A microphone that sends its signal to a receiver via RF transmission rather than through a cable. Also called a *radio microphone.*

XDCAM: A professional optical disc recording system that was introduced by Sony in 2003.

XLR Connector: A three-pin connector that is used on professional-quality equipment for audio inputs and outputs. Also called *a cannon connector.*

Y/C Signal Processing: A set of video signals with separate luminance (Y) and chrominance (C). Color purity and image detail are of higher quality than those in composite recording. Also called *S-Video.*

Z-Axis: The dimension toward and away from the camera; the imaginary line from the camera passing through the object. Movement to the left or right side of the screen is x-axis movement; movement up or down in the frame is y-axis movement.

Zebra-Stripe: A type of camera viewfinder video level indicator.

Zoom: Apparent motion created by moving the lens elements in or out. Brings the scene closer to, or moves it farther away from, the viewer.

Zoom Lens: A variable-focal-length lens.

Zoom Ratio: The ratio of the wide-angle and narrow-angle focal lengths on a zoom lens. A zoom lens with a wide-angle focal length of 8 mm and a narrow-angle focal length of 160 mm has a zoom ratio of 20:1. Also called *zoom range.*

Zoom Ring: A device that controls the focal length adjustment on a zoom lens. May be automatic or manual.

BIBLIOGRAPHY

Alten, Stanley R. *Audio in Media* (6th ed.). Belmont, CA: Wadsworth, 2002.

Anderson, Gary. *Video Editing and Post-Production* (4th ed.). Boston: Focal Press, 1999.

Avgerakis, George. *Desktop Video Studio Bible: Producing Video, DVD, and Websites for Profit.* New York: McGraw-Hill, 2003.

Benedetti, Robert. *From Concept to Screen: An Overview of Film and Television Production.* Boston: Allyn and Bacon, 2002.

Brenneis, Lisa. *Final Cut Pro 4 for Macintosh.* Berkeley, CA: Peachpit Press, 2003.

Compesi, Ronald J. *Video Field Production and Editing* (6th ed.). Boston: Allyn and Bacon, 2003.

Donald, Ralph, and Spann, Thomas. *Fundamentals of Television Production.* Ames, Iowa: Iowa State University Press, 2000.

Fritz, Mark (Ed.). *Streaming Media Industry Source Book: 2004 Edition.* Medford, NJ: Information Today, 2004.

Gloman, Chuck B., and Letorneau, Tom. *Placing Shadows: Lighting Techniques for Video Production* (2nd ed.). Boston: Focal Press, 2000.

Gross, Lynne S., Foust, James C., and Burrows, Thomas D. *Video Production: Disciplines and Techniques* (9th ed.). New York: McGraw-Hill, 2005.

Goddman, Robert M., and McGrath, Patrick J. *Editing Digital Video: The Complete Creative and Technical Guide.* New York: McGraw-Hill, 2003.

Hart, John. *The Art of the Storyboard: Storyboarding for Film, TV, and Animation.* Boston: Focal Press, 1999.

Herlinger, Mark. *The Multi-Camera Director* (2nd ed.). Denver, CO: Western Media Products, 1998.

Herlinger, Mark. *The Single-Camera Director* (2nd ed.). Denver, CO: Western Media Products, 2000.

Hickman, Howard. *Television Directing.* New York: McGraw-Hill, 1991.

Holman, Tomlinson. *Sound for Film and Television.* Boston: Focal Press, 1997.

Hunter, Lew. *Lew Hunter's Screenwriting 434.* New York: The Berkley Publishing Group, 1993.

Kindem, Gorham, and Musburger, Robert B. *Introduction to Media Production: The Path to Digital Media Production* (3rd ed.). Boston: Focal Press, 2005.

Kubey, Robert. *Creating Television: Conversations with the People behind 50 Years of American TV.* Mahwah, NJ: Lawrence Erlbaum Associates, 2004.

Kuney, Jack. *Take One: Television Directors on Directing.* New York: Praeger, 1990.

Lee, John Lee, Jr. *The Producer's Business Handbook.* Boston: Focal Press, 2000.

Lester, Paul Martin. *Visual Communication: Images with Messages* (2nd ed.). Belmont, CA: Wadsworth, 2000.

Lyver, Des, and Swainson, Graham. *Basics of Video Lighting* (2nd ed.). Boston: Focal Press, 1999.

Mack, Steve. *Streaming Media Bible.* New York: Hungry Minds, 2002.

Medoff, Norman J., and Tanquary, Tom. *Portable Video: ENG & EFP* (4th ed.). Boston: Focal Press, 2001.

Menin, Eyal. *The Streaming Media Handbook.* Upper Saddle River, NJ: Prentice Hall, 2002.

Miller, Philip. *Media Law for Producers* (4th ed.). Boston: Focal Press, 2002.

Musburger, Robert B. *Single-Camera Video Production* (2nd ed.). Boston: Focal Press, 1999.

Newcomb, Horace (Ed.). *Encyclopedia of Television* (2nd ed.). Chicago, IL: Museum of Broadcast Communications, 2004.

Ohanian, Thomas A. *Digital Nonlinear Editing: Editing Film and Video on the Desktop* (2nd ed.). Boston: Focal Press, 1998.

Rabiger, Michael. *Directing the Documentary* (3rd ed.). Boston: Focal Press, 1998.

Rabiger, Michael. *Directing: Film Techniques and Aesthetics* (3rd ed.). Boston: Focal Press, 2003.

Roberts-Breslin, Jan. *Making Media: Foundations of Sound and Image Production.* Boston: Focal Press, 2003.

Rubin, Michael. *Beginner's Final Cut Pro.* Berkeley, CA: Peachpit Press, 2003.

Rea, Peter W., and Irving, David K. *Producing & Directing the Short Film and Video* (2nd ed.). Boston: Focal Press, 2001.

Rose, Jay. *Producing Great Sound for Digital Video.* San Francisco, CA: CMP Books, 1999.

Rosenthal, Alan. *Writing, Directing, and Producing Documentary Film and Videos* (rev. ed.). Carbondale and Edwardsville, IL: Southern Illinois University Press. 1996.

Shook, Fred. *Television Field Production and Reporting* (4th ed.). Boston: Allyn and Bacon, 2005.

Shyles, Leonard. *Video Production Handbook.* Boston: Houghton Mifflin, 1998.

Thompson, Roy. *Grammar of the Edit.* Boston: Focal Press, 1998.

Topic, Michael. *Streaming Media Demystified.* New York: McGraw-Hill, 2002.

User's Guide. *Discreet Cleaner 6: The Essential Video Encoder.* Canada: Autodesk Canada, 2002.

Wales, Lorene M. *The People and Processes of Film and Video Production: From Low Budget to High Budget.* Boston: Allyn and Bacon, 2005.

Whitaker, Jerry C. (Ed.). *Master Handbook of Audio Production.* New York: McGraw-Hill, 2003.

Zettl, Herbert. *Television Production Handbook* (9th ed.). Belmont, CA: Wadsworth, 2006.

Zettl, Herbert. *Sight, Sound, and Motion: Applied Media Aesthetics* (4th ed.). Belmont, CA: Wadsworth, 2004.

Zettl, Herbert. *Video Basics 4.* Belmont, CA: Wadsworth, 2004.

INDEX

CREDITS

COLOR INSERT

CP-6, Ronald J. Compesi; CP-7a-b, Ronald J. Compesi; CP-7c-d, Jaime S. Gomez; CP-8, Jaime S. Gomez; CP-10, Eastern Connecticut State University Media Services; CP-11, Jaime S. Gomez; CP-12, Jaime S. Gomez; CP-13, courtesy of Avid Technology

CHAPTER 1

Page 1, Jaime S. Gomez; page 2 top, Jaime S. Gomez; page 2 bottom, Martin Seymour; page 4, Jaime S. Gomez; page 7, Jaime S. Gomez; page 9, Jaime S. Gomez

CHAPTER 2

Page 12, Jaime S. Gomez; page 13, Martin S. Seymour; page 15, Jaime S. Gomez; page 22, Jaime S. Gomez; page 24, Ronald J. Compesi; page 25, Ronald J. Compesi;

CHAPTER 3

Page 28, Ronald J. Compesi; page 29, Ronald J. Compesi; page 32, Ronald J. Compesi; page 33, Ronald J. Compesi; page 34 left, courtesy of Kino-Flo, Inc.; page 34 right, Jaime S. Gomez; page 36, Jaime S. Gomez; page 37 top, Ronald J. Compesi; page 37 bottom, Jaime S. Gomez; page 38, Ronald J. Compesi; page 39, Jaime S. Gomez; page 40, Ronald J. Compesi; page 41, Jaime S. Gomez; page 42, Jaime S. Gomez; page 43 top, Jaime S. Gomez; page 43 bottom, Ronald J. Compesi; page 45, Jaime S. Gomez; page 47, Ronald J. Compesi; page 50, Ronald J. Compesi

CHAPTER 4

Page 58 top right and left, Ronald J. Compesi; page 58 bottom, Jaime S. Gomez; page 59, Ronald J. Compesi; page 60, Jaime S. Gomez; page 61, Ronald J. Compesi; page 64, Jaime S. Gomez; page 65, Ronald J. Compesi; page 66, Jaime S. Gomez; page 68, Ronald J. Compesi; page 69, Ronald J. Compesi; page 70, Ronald J. Compesi; page 74, Ronald J. Compesi; page 76, Ronald J. Compesi; page 78, Jaime S. Gomez; page 79 top, Ronald J. Compesi; page 79 bottom, Jaime S. Gomez; page 80 courtesy of Steadicam®/The Tiffen Company; page 81, Ronald J. Compesi; page 82, Ronald J. Compesi; Page 83, Ronald J. Compesi; page 84, Jaime S. Gomez; page 86, Ronald J. Compesi; page 87, Ronald J. Compesi; page 90, Jaime S. Gomez; page 93, Ronald J. Compesi

CHAPTER 5

Page 101, Ronald J. Compesi; page 103, Jaime S. Gomez; page 105, Ronald J. Compesi; page 106, Ronald J. Compesi; page 108, Jaime S. Gomez; page 109, Ronald J. Compesi; page 111, Jaime S. Gomez; page 112, Jaime S. Gomez; page 114, Jaime S. Gomez; page 121, Jaime S. Gomez; page 122, courtesy of Eastern Connecticut State University Media Services and Digidesign; page 123 courtesy of Adobe Systems, Inc; page 124, Ronald J. Compesi

CHAPTER 6

Page 128 top, Ronald J. Compesi; page 128 bottom, Jaime S. Gomez; page 129, Jaime S. Gomez; page 131, Ronald J. Compesi; page 134, Jaime S. Gomez; page 135, Jaime S. Gomez; page 136, Jaime S. Gomez; page 137, Ronald J. Compesi; page 138, Ronald J. Compesi; page 139, Jaime S. Gomez; page 140, Jaime S. Gomez; page 141, Jaime S. Gomez; page 142, Jaime S. Gomez

CHAPTER 7

Page 162, Jaime S. Gomez

CHAPTER 8

Page 173, Jaime S. Gomez; page 181, Ronald J. Compesi; page 182, Ronald J. Compesi; page 183, Ronald J. Compesi; page 184, Jaime S. Gomez; page 185, Jaime S. Gomez; page 186, Jaime S. Gomez; page 188, Jaime S. Gomez; page 189, Jaime S. Gomez; page 190, Jaime S. Gomez; page 191, Jaime S. Gomez

CHAPTER 9

Page 205, Jaime S. Gomez; page 206, Jaime S. Gomez; page 210, Jaime S. Gomez

CHAPTER 10

Page 222, Ronald J. Compesi; page 231, Ronald J. Compesi; page 232, courtesy of JVC/Victor Company, Japan; page 235, Jaime S. Gomez; page 238 left, courtesy of DTE Technology FireStore; page 238 right top and bottom, courtesy of JVC/Victor Company, Japan; page 239, Ronald J. Compesi; page 240, courtesy of Panasonic Corporation; page 242, courtesy of Panasonic Corporation; page 244, Ronald J. Compesi; page 249, Ronald J. Compesi; page 250, Jaime S. Gomez; page 251 top, Jaime S. Gomez; page 215 bottom, courtesy of Avid Technology; page 252, Jaime S. Gomez

CHAPTER 11

Page 257, Ronald J. Compesi; page 258, Ronald J. Compesi; page 261, Ronald J. Compesi; page 262, Jaime S. Gomez; page 263, Ronald J. Compesi; page 264, Ronald J. Compesi; page 271, Ronald J. Compesi; page 275, Ronald J. Compesi

CHAPTER 12

Page 277, Jaime S. Gomez; page 281, Jaime S. Gomez; page 282 top, Jaime S. Gomez; page 282 bottom, Ronald J. Compesi; page 284, courtesy of Eastern Connecticut State University Media Services; page 285, Edgardo "Nicky" Rodriguez; page 287, Ronald J. Compesi; page 290, Ronald J. Compesi; page 291, Jaime S. Gomez

CHAPTER 13

Page 303, courtesy of Eastern Connecticut State University Media Services

CHAPTER 14

Page 327, Jaime S. Gomez; page 330, Juan Mayr; page 334, Juan Mayr; page 338, Jaime S. Gomez; page 339, Jaime S. Gomez; page 340, Juan Mayr; page 341, Jaime S. Gomez